D1592145

SAVE VENICE INC.

SAVE VENICE INC.

AMERICAN
PHILANTHROPY AND
ART CONSERVATION
IN ITALY, 1966–2021

CHRISTOPHER
CARLSMITH

UNIVERSITY OF MASSACHUSETTS PRESS
Amherst Boston

ISBN 978-1-62534-675-9 (paper); 676-6 (hardcover)

Designed by Sally Nichols
Set in Adobe Caslon Pro and Arapey
Printed and bound by Books International, Inc.

Cover design by Frank Gutbrod
Cover image: Titian, *Madonna di Ca' Pesaro,* 1519–26, oil on canvas, Church of Santa Maria Gloriosa
dei Frari, during conservation. A landmark in the development of the altarpiece in Venice, Titian's
picture depicts nobleman Jacopo Pesaro at left and his male relatives at right as they are presented
to the Virgin and Child by Saints Peter, Francis, and Anthony of Padua. Restored in 1978 by
Antonio Lazzarin with funding from John McAndrew, Giulio Bono (shown here) conducted
conservation treatment between 2013 and 2017, sponsored by Save Venice with partial support from
the Thompson Family Foundation, Inc. and the Leona M. and Harry B. Helmsley Charitable Trust
Photo: Matteo De Fina, courtesy Save Venice Photo Archives.

Library of Congress Cataloging-in-Publication Data
A catalog record for this book is available from Library of Congress.

British Library Cataloguing-in-Publication Data
A catalog record for this book is available from the British Library.

Contents

Preface

FOR MORE than a thousand years, the city of Venice has flourished in a unique environment between land and sea, defying repeated predictions of its demise. From the late Middle Ages to the modern period, the Serenissima (Most Serene Republic) boasted political stability, artistic creativity, diplomatic ingenuity, and economic vitality, earning the sobriquet Queen of the Adriatic. A catastrophic flood in November 1966, however, temporarily submerged the city and threatened its extraordinary patrimony of art and architecture. This book tells the story of Save Venice Inc. (SV), an American nonprofit organization that for fifty years has raised funds to conserve and restore paintings, sculptures, mosaics, and entire buildings at risk from human and environmental impact in Venice. Since its founding in 1971, SV has expanded to become the largest of more than twenty private committees devoted to historic preservation in that city; in addition to sponsoring nearly seven hundred projects, it has published books, established a library, founded local chapters, and organized hundreds of lectures. Drawing on extensive archival research, oral interviews, and published accounts, each chapter of this book analyzes events, individuals, and policies for discrete periods of time. Each chapter traces several themes (e.g., executive leadership, conservation activities, fundraising methods, educational outreach), thus providing comparative analysis throughout the work. The vital question of how, and for whom, Venice should be "saved," as well as the evolving context of contemporary Venice and the actions of other historic preservation committees, are examined here too.

I suggest that SV represents a remarkably successful example of an American nonprofit and that it has become a model for other cultural heritage organizations. Analysis of its origins and methods will provide scholars, conservators, and policy-makers abundant data about how to approach issues of historic conservation and restoration. Venice has a valuable role to play as a pilot program for historical pres-ervation and policy globally; the issues involved in saving Venice are surely relevant to preserving other historic cities in vulnerable locations, particularly seaports. I

posit that SV has been able to combine academic expertise and financial acumen with social flair and organizational creativity, thus positioning itself as a leader in raising funds and awareness on behalf of Venice. My research indicates that its accomplishments are due to decisive leadership, top-notch scholars, a consistent mission, and careful financial management. This comprehensive account of the achievements and occasional challenges faced by SV can serve as a touchstone for analyzing the performance of nonprofits, charities, and volunteer groups in the United States and abroad. Beyond a detailed case study of SV and its fellow organizations in Venice, the book contributes to the history of American philanthropy, the history of art conservation, and a deeper understanding of the history of Venice through the eyes of a foreign organization. Utilizing the methodologies of cultural history, I employ extensive documentation of relevant textual, visual, and oral sources. The numerous endnotes signal both my academic background and my goal: a contribution to scholarship.

The genesis of this project dates to a cold February day in 1985 when I traveled north by train from Florence to Venice with my study-abroad classmates to experience the festival of Carnevale. Stepping off at the Santa Lucia station, I was mesmerized by the busy canal traffic, the imaginative costumes, and the majestic buildings. Within an hour I had purchased a mask and scarf to create an impromptu costume, thus becoming indistinguishable from the other revelers and even being photographed at the foot of the Accademia Bridge. I kept my mask on all day, pausing only to sip water and gobble pizza. At midnight I boarded the last train for Florence, arriving there disheveled, exhausted, and still *in maschera* at 4:30 a.m. From that day forward, I was captivated by Venice; in subsequent years the history of the early modern Venetian empire would become the subject of my Ph.D. dissertation and two books. My introduction to SV occurred in 2004 with a fundraising event where I had the glorious job of addressing invitations and inflating balloons. Within several years I joined the executive committee of the Boston chapter and began to gain familiarity with its mission and operations.

The decision to document and describe the history of SV through this book has been inspired by several factors. In fall 2014 charter member Eleanor Garvey spoke eloquently to the Boston chapter as part of a panel on "Why Save Venice?"; her death just months later made me realize that those with direct memories of the early years of SV were frail and fading. It seemed important to capture those memories, and the documents that supported them, and I began to do so informally. The deaths of Lilian Armstrong (2021) and Janice Hunt (2022)

in Boston, along with directors David Rosand (2014), Larry Lovett (2016), and Sarah Schulte (2020), among others, were reminders of the urgency of the project. The fiftieth anniversary of the *alluvione* (great flood) in November 2016 provided additional impetus to move ahead with the writing, as did SV's semi-centennial in 2021–2022. The absence of any previous institutional history has left me room for deeper research, interpretation, and analysis. Above all, I believe that the story of SV and of its contributions to Venice deserves to be more widely known by scholars, philanthropists, art conservators, and the general public. Indeed, understanding Venice through the example of Save Venice may well offer ways to help secure the city's future.

Acknowledgments

I AM grateful to Peter Fergusson, whose kindness, erudition, and devotion to SV have been an inspiration for me. His death in January 2022, as the book was going through copyediting, is a profound loss, and I hope that this volume will honor his memory and dedication to the cause. I am equally grateful to Frederick Ilchman, who has served SV in a wide variety of roles, from intern to chair, and who has been my *carissimo amico* since we met in Venice a quarter-century ago. Both steadfastly encouraged me to pursue this project and tendered valuable insights on earlier drafts. Two anonymous external reviewers selected by University of Massachusetts Press offered sound advice and strong encouragement. Amy Gross, Sarah Blake McHam, and Charles Tolbert reviewed the whole manuscript and submitted useful suggestions and correctives. The late Theodore K. Rabb read the opening chapters and provided wise counsel from his experience with both SV and the study of history; Shelagh Hadley, Juan Prieto, and Melissa Conn shared their expertise on individual chapters. I acknowledge the dozens of individuals who agreed to be interviewed via Zoom, telephone, and in person; their insights and memories helped me to better understand the organization.

I am thankful to SV for the opportunity to consult board minutes and correspondence in its New York office and to review additional files in its Venice office. I wish to express gratitude to those members of Save Venice Boston who entrusted me with their documents, particularly Donna and Christian Hoffman, Peter Fergusson, Susan Angelastro, and Juan Prieto; I hope that this book will prove worthy of their generosity. *Grazie* also to the staff in New York (Amy Gross, Kim Tamboer Manjarres, Brendan Davey, Laura Sico, and previously Jill Oakley and Amanda Albanese) and in Venice (Melissa Conn, Leslie Contarini). Alberto Brunello kindly shared some of his research about SV while completing his M.A. thesis at Ca' Foscari in 2019; Randolph (Bob) and Bea Guthrie verified key quotations.

Bernard Aikema (Stichting Nederlands), Jonathan Keates (Venice in Peril), Jérôme Zieseniss (Comité Français), Simonetta Brandolini d'Adda (Friends

of Florence), Bonnie Burnham (World Monuments Fund), and Edward Muir (Friends of the Marciana) each taught me about their respective organizations. Carla Toffolo and Paola Marini helped me to understand the history of the Association of International Private Committees, while John Millerchip shared his experiences with Venice in Peril and UNESCO. Thanks are due to archivists Anthony Sampas (UMass Lowell), Margot Note (World Monuments Fund), and Jane Callahan (Wellesley Special Collections), who provided guidance and expertise. Librarians George Hart (UMass Lowell), Louise Shelby (Hunter College), and Clay Williams (Hunter College) facilitated scanning of important documents in Lowell and New York, respectively. Many of the images in the book were taken by Matteo De Fina and graciously provided by Melissa Conn on behalf of Save Venice. For additional images I am grateful to the staff at the Isabella Stewart Gardner Museum, Villa I Tatti, and the World Monuments Fund, as well as to Roger Farrington, Peter Fergusson, Amy Gross, and Bob and Bea Guthrie.

Throughout this project I have been fortunate to have the assistance of a series of unusually bright undergraduates from my home institution of the University of Massachusetts Lowell (UML). Megan Shea and Magdalene Stathas were part of the UML Emerging Scholars program and were instrumental in initiating and concluding the project, respectively. Noah Thompson and Jacob Strout helped with organization and digitization of files; Amariah Condon displayed uncommon tenacity and insight in helping me to organize and understand archival materials during an Honors College fellowship. The UML History Department offered a summer research grant that permitted me to travel to Venice, while Dean Luis Falcón supported several trips to New York as well as a sabbatical in 2016–17. This book could not have been written without the support of my colleagues, students, and friends, and I am grateful to them all.

The Delmas Foundation granted a fellowship for a summer trip to Venice, as well as a publication subvention, and the Vittore Branca Center at the Cini Foundation on the island of San Giorgio Maggiore provided an ideal scholar's home. Copyeditor Margaret A. Hogan sharpened my prose and saved me from errors. Editor in Chief Matt Becker at University of Massachusetts Press expressed interest in the project from the beginning and together with managing editor Rachael DeShano has steered it through the production process.

Lastly, *grazie di cuore* to Laura, Margaret, and Peter, who listened patiently to my stories about Save Venice and who endured my absences (both mental and physical) with good humor and love.

Christopher Carlsmith, May 1, 2022

Abbreviations

I USE the following abbreviations and acronyms:

APC = Association of International Private Committees for the Safeguarding of Venice (aka "private committees")

CRIA = Committee to Rescue Italian Art

IFM = International Fund for Monuments (later renamed the World Monuments Fund)

RLSC = Rosand Library and Study Center

SV = Save Venice Inc. (founded 1971)

SVB = Save Venice Boston

SVNY = Save Venice New York

SV/NY = Save Venice of New York Inc. (founded 1987)

SVV = Save Venice in Venice

UNESCO = United Nations Educational, Scientific, and Cultural Organization

VC-IFM = Venice Committee–International Fund for Monuments

VC-USA = Venice Committee-USA (predecessor to Save Venice Inc.)

The board of directors for Save Venice is referred to as both "the board" and "the directors"; individual chapters generally had an "executive committee" and/or a local chairperson. Boston and New York have each had a paid executive director at different times. For the first twenty-five years, executive authority of SV rested primarily with the SV president. When Bob Guthrie transitioned from president to chair in 1998–99, however, chair became the more powerful position, and it has remained that way.

The SV archives in Boston, New York, and Venice are each divided into subseries. The SVB archives, currently held at O'Leary Library of the University of Massachusetts Lowell, are numbered according to those who donated the documents (i.e., Eleanor Garvey: 1.1.1, Susan Angelastro: 2.1.1, Christian and Donna

Hoffman: 3.1.1, etc.), where the numbers refer to the series number, box number, and folder number. The items within the folders preserve the original order in which each series of files were kept and thus are occasionally duplicative. The SVNY archives, held at the office of Save Venice Inc. in Manhattan, are arranged according to type of document (board minutes, correspondence, etc.), and then subdivided chronologically or alphabetically within each series. The SV board minutes have been particularly important for my research. The SVV files—primarily technical ones pertaining to restorations in Venice—are arranged by the name of the project. Additional files on fellowships, publications, and conferences in Venice, as well as two volumes of early correspondence, are also held in SVV. A complete run of SV newsletters are conserved in both SVNY and SVV. The SV *Gala Journals* are preserved in SVV and a nearly complete run is duplicated in SVB 10.1.1.

In general I have rendered the names of people and places in Italian (Palazzo Ducale, Piazza San Marco) unless there is a widely recognized form in English (Titian instead of Tiziano). For works of art I have generally given the title in English (thus *Pillars of Acre* instead of *Pilastri Acritani*).

Among the challenges of writing this history of Save Venice are the issues of nomenclature and identity: how and when did its name change, where was it based, and who "owned" it? These topics are discussed further in the book, but a very brief sketch can identify the salient issues. Initially the "Venice Committee" of the International Fund for Monuments (IFM) in New York during the late 1960s, it broke away to become an independent corporation in Massachusetts in December 1970 and adopted the name "Save Venice Inc." in October 1971. Under the leadership of John McAndrew, SV promptly established chapters in other cities, including Boston, New York, New Orleans, and Washington, DC. During the 1970s and 1980s the composition of the board tilted from Boston to New York. In 1986 the corporate charter of SV was temporarily revoked by the Massachusetts secretary of state for failure to file timely annual reports (and subsequently reinstated in 1990). In 1987 the SV board of directors established a new organization with the name "Save Venice of New York, Inc.," with the intention of reincorporating in that state. Subsequent confusion with tax identification numbers meant that both the Boston group and the New York group professed ownership of the title "Save Venice Inc." and each referred to the other as a "chapter." After a decade of negotiations, a 2009 agreement formally made Boston a chapter of the New York entity, which would function both as head office and umbrella organization. The challenge of how, and when, to refer to the organization's different branches remains an issue for anyone

writing a comprehensive history. For the sake of simplicity, I use "SV" and "the board" for the Massachusetts-based group for the period 1971–86, and for the New York–based group from 1987 to the present. This approach mirrors the organization of the minutes kept by the SV Board; for the period 1971–86 the minutes are bound together in two volumes and conserved in SVB 3.1.1 and 3.1.2, while the minutes from 1987 to the present are stored at SVNY headquarters in loose-leaf binders and (more recently) in digital format.

SAVE VENICE INC.

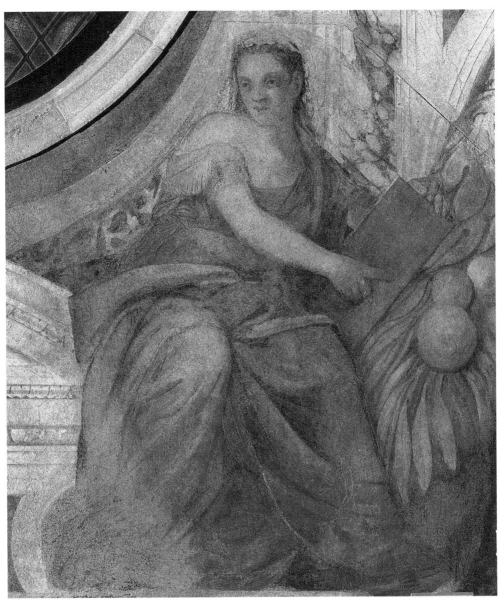

FIGURE 1. Paolo Veronese, *Sibyl Pointing to Her Book*, 1558–60, fresco, Church of San Sebastiano, after conservation treatment. This sibyl indicates the prophecy of the coming and triumph of Christ; she is one of many pagan seers painted by Veronese to decorate the walls of San Sebastiano. Veronese decorated nearly the entire church, working in different media from floor to ceiling.
—Photo by Matteo De Fina, courtesy Save Venice Photo Archives

Introduction

Oh Venice! Venice! When thy marble walls
Are level with the waters, there shall be
A cry of nations o'er thy sunken halls
A loud lament along the weeping sea!

—Lord Byron, *Ode to Venice* (1818)

FROM MARIN Sanudo in the sixteenth century and Lord Byron in the nineteenth to John Julius Norwich and Garry Wills in the twentieth, the history of Venice has intrigued generations of chroniclers, poets, and historians. The history of *saving* Venice—from invasion, heresy, or pestilence, as well as from the contemporary dangers of climate change, pollution, and over-tourism—is an equally compelling tale, albeit less well-known. Venetians and foreigners alike have undertaken attempts to "save" Venice, whether from itself or from outside threats, for hundreds of years. The city of Venice was founded during the late Roman Empire by refugees from Padua, Aquilea, and Treviso who sought to save themselves from successive waves of German migrants on the mainland. Protected by marshy lagoons, these early residents gradually achieved independence, and by the twelfth century Venice became an established naval power and flourishing commercial hub. Late medieval and early modern Venice was famous for its political stability and its intricate system of government committees, all painstakingly designed to save Venice from both absolutist monarchy and mob rule. Conflict with the Ottoman Empire, the papacy, and European powers in the fifteenth and sixteenth centuries, and the devastating plagues of 1348, 1575, and 1630, each required different solutions to preserve the Republic of Venice. From the 1606 Interdict of Pope Paul V and the conquest by Napoleon in 1797 to the creation of an industrial zone at Marghera and Mestre in the 1920s, Venice has been the object of repeated interventions, all with the goal of "rescuing" the fragile city. The most recent effort to save Venice has been the sea barrier project known as Project MOSE, initially conceived in the 1970s and finally realized in 2020.

The question of who should be in charge of such preservation or development activities, or even what those activities should be, is a perplexing one for Venetians

and Venetophiles around the world. Of course Venetians should control their own destiny. But as the population dwindles, and the problems become ever more complex, outside help has been, and will be, necessary. The Italian government has repeatedly sought to provide assistance, but frequent changes of government in the 1960s and 1970s, coupled with regional rivalries and overlapping responsibilities, have limited that effectiveness. American, British, and other private groups, sometimes under the aegis of the Association of International Private Committees for the Safeguarding of Venice (APC), have sought to provide funds and expertise to Venice as well, viewing the Serene Republic as an entity that must be preserved for the sake of civilization. UNESCO adopted this language too, identifying Venice as a World Heritage Site in 1987 because of its "unique artistic achievement" and "incomparable series of architectural ensembles."[1] However, the balance between Venetian autonomy and foreign assistance remains a tenuous one. For whom should Venice be saved? Which aspects of the city's cultural patrimony should be valued above others? How does one balance economic development with historic preservation? Such questions are not unique to Venice, of course, but they come into sharp relief because of Venice's storied history, unusual physical environment, and rich cultural legacy. Urban planners and preservationists have for years recognized that Venice is a likely harbinger for issues of development, environment, and tourism—the proverbial "canary in the coal mine" that can be a test case for other cities and regions.[2] The increasing peril of climate change, and of concomitant sea rise, has particular urgency for a city literally built out of the sea.

The location of Venice in the midst of an enormous lagoon has provided more than a millennium of military protection and natural resources while simultaneously triggering unusual creativity in commerce, diplomacy, and the arts. Medieval Venice gained wealth from trade in the Adriatic and Mediterranean Seas as well as to the East; Renaissance Venice expanded into boatbuilding, the silk trade, and glassblowing, along with establishing dominion over the North Italian mainland (*terrafirma*). In the modern age, from the eighteenth-century Grand Tour and today's cruise ship industry to the Biennale for contemporary art and the Venice Film Festival, Venice has repeatedly demonstrated its ability to readapt and succeed in a changing world as a perennially favorite tourist destination. Yet in recent decades the challenges of rising sea levels, falling population, and ever-expanding tourism, to name just a few, have provided new impetus to find solutions for saving Venice, particularly in the area of its cultural patrimony.

This book focuses on the efforts of Save Venice Inc. (SV), an American non-profit organization established officially on 1 October 1971 to protect and preserve the extraordinary heritage of art and architecture located in Venice. Founded by Professor John McAndrew and his colleagues in response to the devastating flood of 1966, SV has grown from a modest, all-volunteer organization in Boston to a professionally staffed fundraising enterprise headquartered in Manhattan that routinely nets about $1 million from a single evening's ball. Over the course of five decades, SV has become the largest of more than twenty private organizations working on historic preservation in Venice; indeed, it has occasionally contributed more funds to Venice in a given year than all other private committees combined. SV has raised millions of dollars to execute its mission of conservation and education pertaining to paintings, sculptures, drawings, frames, manuscripts, books, wellheads, and more. More specifically, as of November 2021 SV has contributed to 693 restoration projects and educational initiatives. That includes conservation of 1,667 works of art in more than 100 locations across Venice, as well as support of 145 exhibitions, conferences, publications, and fellowships.[3] SV has repeatedly won prizes from Italian institutions and government, pioneered novel conservation techniques, and unearthed new information about the works being conserved. It is the only private organization in Venice to have restored two entire churches from top to bottom: Santa Maria dei Miracoli (1987–97) and San Sebastiano (2007–present). In 2015, the organization created the Rosand Library and Study Center (RLSC) in Venice to provide access to a collection of English- and Italian-language books on Italian art history. All of these activities have been inspired by SV's founding purpose, as defined in its original seventy-two-word charter.[4] The organization has also served as a model for other cultural heritage organizations created subsequently to help conserve the art and architecture of Italy, including Venetian Heritage and Friends of Florence. Today it is a relatively common practice for U.S. citizens to establish a nonprofit organization and engage in raising funds for a cause in a foreign country, but fifty years ago SV was a pioneer. Its size, longevity, and influence make it a formidable prototype.

Who founded Save Venice and why? Which projects were chosen, and by whom, and how was it paid for? Where did the name come from? How does SV compare to similar organizations, and what has contributed to its enduring appeal? More broadly, how has the organization evolved over these five decades beginning about 1970, and what has been its impact on Venice? Despite such challenges as

recessions, a weak dollar, and differences of opinion among its leaders, the organization has prospered. The reasons for SV's triumphs are explored in the following chapters; among the causes of its success are the positive outcome of its many restoration projects, the effective raising of funds, strong leadership at the executive and chapter levels, and the powerful lure of Venice itself. Also important for members and donors has been the opportunity to learn about art and culture and to participate with like-minded people in an endeavor to do good in the world. A study of SV not only provides a case study of an efficacious charitable organization but also helps illuminate the history of American philanthropy and the nonprofit sector after World War II. If the twentieth century can be considered "the American century," then SV stands as one small example of American influence extending across the ocean. Furthermore, an analysis of it demonstrates how tensions among academic, philanthropic, and business goals in the operations of a nonprofit can be identified and surmounted. Finally, SV's example speaks to the role of UNESCO and other nongovernmental organizations, and to the premise that Venice's unique cultural heritage belongs not just to its residents, nor just to Italy, but to the world.

The tradition of philanthropy has deep roots and manifests itself in diverse ways, depending on religious traditions, economic status, and societal expectations.[5] Medieval and early modern Venice had a robust system of institutional charity, with local churches, lay organizations, and the uniquely Venetian institution of the *scuole grandi* (literally, "great schools" and effectively large confraternities) granting alms to those in need. The six *scuole* in Venice provided dowries, supervised hospitals, buried paupers, sponsored artists, and patronized musicians. They were particularly important as one of the few Venetian institutions where non-noble citizens could exercise power, since nobles were forbidden to serve as officers.[6] These charitable organizations helped to preserve the social fabric and contributed to Venice's robust civic life.

American society has also had a rich history of charitable giving and organization, with early treatises and essays penned by John Winthrop (1630), Cotton Mather (1710), and Benjamin Franklin (c. 1793).[7] In his work *Democracy in America* (1835), French author Alexis de Tocqueville commented favorably on the American predilection to create private, voluntary organizations for mutual assistance and aid.[8] In the late nineteenth century Andrew Carnegie promoted the obligation of philanthropy through his essay "The Gospel of Wealth" (1889), encouraging affluent Americans to engage in the "wise distribution" of surplus wealth for the common

good.[9] Carnegie himself funded nearly 1,700 public libraries in the United States, and his example led to further public libraries, museums, and other cultural institutions. The 1913 Revenue Act passed by Congress codified this concept with tax exemptions for institutions organized for religious, charitable, scientific, or educational purposes.[10] The result during the twentieth century was the proliferation of the American nonprofit, focused on social betterment through a combination of traditional volunteerism and "investment" in society. By the end of the twentieth century approximately 1.5 million organizations existed in the nonprofit sector in the United States, of which nearly half, like Save Venice, were 501(c)3 "charitable" organizations.[11]

In comparison with major foundations, hospitals, or universities, which have annual revenues in the tens or hundreds of millions, Save Venice is a relatively small player. Yet it can be viewed as a characteristic example of the desire by Americans to band together to address domestic or international problems. SV is representative of broader nonprofit trends in several ways. Based initially in Boston and later in New York, it reflects the dominance of the Northeast region, both in overall numbers of nonprofits and in that region's focus on arts and culture.[12] During the decade of SV's swiftest expansion (1987–97), the number of nonprofits dedicated to arts and culture across the United States increased by more than 40 percent.[13] During the half-century in which SV has been active (1971–2021), annual philanthropic giving nationwide has increased dramatically, from less than $25 billion to nearly $450 billion; SV has seen proportional growth in individual and corporate donations.[14]

The Italian phrase *com'era e dov'era* (as it was, where it was) has been a popular mantra for many in Venice (and elsewhere) as they have sought to preserve or reconstruct buildings, revive crafts, and maintain local traditions. The swift rebuilding of the *campanile* (bell tower) in Piazza San Marco after its collapse in 1902 is a telling example of this propensity to recreate something exactly as it was. Efforts to preserve churches, palaces, and gondolas in the first half of the twentieth century utilized a similar philosophy of *com'era e dov'era*. A different approach was adopted by Vittorio Cini in the 1950s when he restored various buildings on the island of San Giorgio Maggiore in memory of his son Giorgio. The large complex had been home for centuries to a wealthy Benedictine monastery but was suppressed by Napoleon and then used to billet troops by the Austrian and Italian armies for 150 years. Cini sought to rehabilitate the island by establishing a set of

institutes, libraries, and schools, as well as bringing back the monks. His goal was to return the island to productive use and to help prepare Venetians for modernity. Cini recognized that the complex could not simply return to its former role as a religious institution because the society around it had changed so drastically.

This modernist approach was codified and extended in 1964 in the document known as the "Venice Charter," drawn up by two dozen international conservation professionals to provide a framework for the conservation and restoration of historic buildings.[15] That seminal charter criticized reconstruction *com'era e dov'era,* calling instead for any additions or changes to be completed in a distinct and contemporary style. In subsequent decades the charter was vigorously challenged, and the importance of visual harmony and aesthetic balance in the essential character of a place has been emphasized anew.[16] SV has faced a similar challenge in its efforts to preserve and restore monuments and works of art that constitute part of the urban fabric and cultural patrimony of Venice. There is no doubt it is vital to conserve such works, but can they be adapted to new roles for modern Venice? SV does not own any of these properties or works of art, of course, and so it is in some sense shielded from the ultimate responsibility of deciding how they should best be used. But at the same time it is clear that SV and its fellow committees have an impact on the city in their decisions about which projects to support and how to conserve them.

What does it mean exactly for SV or other institutions to "restore" or "conserve" the cultural patrimony of Venice? Conservation focuses on preserving an object in its original form, usually through cleaning and repairing. Conservators in recent decades have emphasized the importance of noninvasive, reversible interventions so that the original work remains largely unchanged and so that any alterations are evident with close viewing. Occasionally this means that physical changes to the object will be preserved if those are deemed important to the history of the object.[17] Modern conservation emphasizes the importance of abundant documentation, both written and visual, as the voluminous files of SV attest. Newer technologies, such as infrared cameras, permit conservators to look under the top layer of paint or to use advanced software to determine minute variations in color or texture. Restoration of artwork, by contrast, generally attempts to reinstate a piece to its original appearance or function, typically through replacing or retouching lost and damaged areas. Such sections are thus modern additions, generally with the goal of aesthetic harmony. The two terms of "restoration" and "conservation" are

sometimes used interchangeably, as John McAndrew did in SV's founding charter, but modern curators and scholars are more careful to distinguish between them, with the term "restoration" having slipped from favor.[18] Art conservation (and restoration) is by necessity interdisciplinary, drawing on historical research and scientific analysis in equal measure in order to formulate specific treatments to stabilize or preserve the object.[19]

Conservation work in Venice is complicated owing to the humidity and salinity that permeate most surfaces, as well as the logistical challenges of a city without roads. The transportation of scaffolding, sculptures, or paintings typically needs to happen by boat, which can be expensive and cumbersome. Few buildings in Venice offer the kind of climate control—above all steady temperature and relative humidity year round—that experts recommend for the preservation of fragile art and that are found in most major art museums. For example, many Venetian churches vary from excessive warmth and humidity in the summer to bitter cold in the winter, with periods of dryness from intermittent heating. Such fluctuations, not to mention the presence of insects, occasional flooding, and pollution damage, present further threats to artworks and architecture. SV has utilized multiple methods of conservation across various kinds of media, from a freshwater bath for a salt-permeated marble cladding to the removal of yellowed varnish or candle smoke from the surface of a painting. Parchment, canvas, wood, stone, bronze—each medium or support, and indeed each project, requires a specific type of treatment, especially if there are mixed media or if the object(s) remain *in situ*. As a work of history, this book generally omits technical details about conservation projects in favor of historical documentation and analysis of the organization itself, but I have endeavored to explain the significance of important discoveries or technical breakthroughs at various points in the story.

The track record of SV—hundreds of completed conservation treatments, prominent publications, numerous educational activities, and enviable fundraising—recommends it as a model nonprofit organization. It is surprising, then, that virtually no history of it exists. In 1986 Chair Rollin van Nostrand (Bump) Hadley compiled a two-page overview of the 1966 flood and the response of SV.[20] In 2005 John Berendt devoted one and a half chapters of his book about Venice, *The City of Falling Angels*, to SV and the controversy that enveloped its leadership in the late 1990s, but he included no citations and listed no more than a handful of written sources in his bibliography. Berendt's book is very different than mine in tone,

scope, and purpose.[21] In 2009 Wellesley College professor emeritus Peter Fergusson, who had served twice as the chair of the Boston chapter, wrote a six-page history of the early years that was distributed privately to SV supporters.[22] In 2018 a short Wikipedia page outlined the organization's history, leadership, and activities.[23] In my view, each of these efforts tells only part of the story. An organization this prosperous and influential deserves a more comprehensive institutional history. Such a work should place SV in its historical context, assess its activities relative to similar organizations, and be based on a firm documentary foundation. Only then can its role(s) be understood. My perspective results from several factors, starting with my background as a historian. I took up this project as an independent scholarly endeavor and not as a commissioned work, but I have taken advantage of my knowledge of the organization as a member of the Boston chapter. The book has been improved by the observations of outside scholars as well as those within SV, but the ultimate interpretations are mine alone.[24]

In contrast to the understudied history of SV, the history of Venice has been analyzed by scholars, in multiple languages and with divergent points of view, for nearly a thousand years. Medieval chronicles, humanist orations, and the famously detailed diaries of Marin Sanudo (1466–1536) were followed by a series of "official" accounts produced by Venetians between 1516 and 1716, and then in the nineteenth century by the multivolume efforts of French scholar Pierre Daru, Italians Samuele Romanin and Pompeo Molmenti, and English authors Rawdon Brown and Horatio Brown.[25] The trend in the twentieth century was for monumental histories written by teams of scholars (primarily Italian). Simultaneously, Anglo-American historians fomented a revived interest in early modern Venice beginning in the 1960s and 1970s, including J. R. Hale, John Julius Norwich, Frederic Lane, Anne Schutte, Edward Muir, James Grubb, and others. Recent histories of Venice, such as those by Thomas F. Madden (2013), Elizabeth Horodowich (2009), and Joanne Ferraro (2012), consider the broad sweep of Venetian history but rarely devote more than a couple of pages to the 1966 flood and its aftermath.[26] Margaret Plant's *Venice: Fragile City* (2002) offers a detailed and erudite examination of the two hundred years after Napoleon, covering 1797 to 1997, but treats literature, film, and architecture as much as historical events.[27] Similarly broad in focus, Robert C. Davis and Garry Marvin's *Venice, the Tourist Maze* (2004) devotes one chapter to excoriating SV and similar organizations for ignoring substantive issues that have bedeviled Venice, such as loss of affordable housing and steady depopulation.

Indeed, they charge, rather unfairly, that SV and its brethren have made things worse by encouraging the "museumification" of the city and converting it to a playground for global elites.[28] Journalists Stephen Fay and Phillip Knightley adopted a similarly pessimistic view of modern Venice three decades earlier in *The Death of Venice* (1976), pointing to the ravages of the flood and the insufficient response to it.[29] Peter Lauritzen's *Venice Preserved* (1986) is a useful account of how Venice recovered (or didn't) from the 1966 flood, concentrating on the role of the Italian government and private committees in that process. Lauritzen, together with photographers Jorge Lewinski, and Mayotte Magnus, describe the restoration of paintings, stonework, and churches in detail, but their focus is on the general reader and draws as much from his personal experiences as from scholarly sources.[30] *Venice in Environmental Peril? Myth and Reality* (2012), by Dominic Standish, challenges the narrative of the disastrous 1966 flood by pointing to previous floods and criticizing environmentalists who (in his view) have denied contemporary Venice the chance to modernize.[31] Salvatore Settis is among the more recent scholars to weigh in on Venetian history and cultural heritage; the blunt title of his work, *If Venice Dies* (2016), captures his warning that Venice and other historic cities face impending ruin from over-tourism.[32] Other relevant sources include UNESCO's reports, as well as materials published by various private committees, such as Venice in Peril's *Un Restauro per Venezia* (2006).[33]

In light of this scholarship, my book aims to accomplish several goals. First, I seek to provide a deeply researched, impartial, and comprehensive history of Save Venice that narrates its activities and its impact on the cultural sector of Venice. Second, I analyze SV's mission, contributions, and challenges as a case study, firmly situated in the context of a changing Venice. Third, I want to position SV more prominently in the literature that describes nonprofits and cultural heritage organizations, so that scholars and practitioners can utilize my data and analysis to assess both this organization and its place in the broader field. Lastly, I expect that the book will aid SV, the other private committees, and perhaps the city of Venice itself to understand the past fifty years and thus to better anticipate and shape the next fifty years. It is my belief that Venice can indeed be preserved and strengthened, and that SV's example offers crucial lessons to be applied in the years ahead.

The catastrophic flood of November 1966 is the obvious place to begin the story. Chapter 1 briefly describes Venice in the months before the catastrophe, the causes of the flood, the resulting damage, and the responses of the international

community. The two key figures are Colonel James Gray and Professor John McAndrew, and their efforts through the International Fund for Monuments (IFM) and its "Venice Committee." Chapter 2 traces the rupture between these two men and the subsequent founding of Save Venice as an independent organization in 1971. Chapter 3 explores the rather modest history of SV from 1974 to 1986 under the direction of Rollin Hadley and the creation of "chapters" in various American cities. During the late 1980s and 1990s three transformational leaders— Larry Lovett, Bea Guthrie, and Bob Guthrie—sparked dramatic growth of SV. The broader ambitions and significant achievements from 1986 to 1996, including the restoration of the entire church of Santa Maria dei Miracoli, are the subject of chapter 4. Chapter 5 explains two internal schisms from 1997 to 1998. Chapter 6 tracks the rebuilding of SV from 1999 to 2006, as the Guthries stabilized and then greatly expanded its financial position, as well as its educational and public relations efforts. Chapter 7 marks the departure of the Guthries from day-to-day leadership, the rapprochement between New York and Boston, and initial efforts to restore the church of San Sebastiano, all in the period 2007 to 2014. Chapter 8 summarizes the most recent developments: the transfer of the Venice office across the Grand Canal to Palazzo Contarini Polignac and the opening of the Rosand Library in Venice (both in 2015), new executive leadership (2016), the Tintoretto 500 celebrations (2018–19), the double catastrophes of a major flood and the coronavirus pandemic (2019–21), as well as the preparations for SV's semi-centennial (2020–22). Chapter 9 compares SV to similar historic preservation organizations and briefly assesses the role of UNESCO. The conclusion contemplates why SV has been so successful and offers a prognosis for the future.

For an organization focused on preserving and restoring the past, it is surprising that SV has no formal, unified archive for its own history. Donor files, early correspondence, publications, and recent financial documents are maintained in the New York headquarters. Technical files about restoration as well as about fellowships and conferences are housed in the Venice office. Owing to the generosity of Boston-area supporters, I have been able to amass chapter meeting minutes, newspaper clippings, correspondence, budgets, invitations, and other ephemera, chiefly for the Boston chapter and the early history of SV. Save Venice board minutes are preserved in the SVB archive for the earlier period (1971–86) and in the New York headquarters of SV for the later period (1987–present). Oral histories

gathered from longtime friends of the organization have increased my understanding of many important details. Additional material from the archives of the IFM and from the papers of John McAndrew at Wellesley College help to round out the story. From these documents and conversations, the history of Save Venice can be reconstructed.

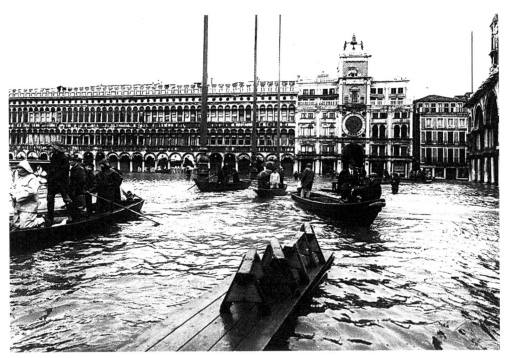

FIGURE 2. Piazza San Marco, Venice, 5 November 1966. On the day after the catastrophic flood of 1966, and with water still covering Piazza San Marco, Venetians used boats to survey the damage.

—Photo courtesy of Wikimedia Commons

Chapter 1

ALLUVIONE

The Flood of 1966 and the International Response (1966–1970)

During the first days of November, Tuscany and Venetia were devastated by floods of extraordinary magnitude and violence. To the toll in human lives and the loss of property were added the destruction of creations of the human spirit in culture and art … that Italy has given to the world. … Florence and Venice! Venice sinking into the waters, it is as if one of the most radiant stars of beauty were suddenly engulfed; Florence bemired, it is the springtime of our hearts which is forever disfigured.

— René Maheu, director-general of UNESCO (1966)

IN HIS poignant description of the destruction wrought upon Venice and Florence by the 1966 floods, René Maheu articulated his concern that these two beacons of Italian civilization might be irretrievably damaged.[1] Part of the shock of the 1966 flood was that the period preceding it had been relatively calm. A tranquil summer of tourism, bolstered by good weather and the absence of student-led agitation that would spark in 1968, led Venetians and visitors alike to embrace a sense of ease. Encouraged by the opening of the Marco Polo Airport in 1961 and of the artificial island Tronchetto as an automobile parking lot soon thereafter, as well as the creation of hotels like the Cipriani (1958), the number of Venetian tourists had increased to about 1 million annually during the 1950s and continued to grow in the 1960s.[2] That expanding tourist trade was fueled by films like *Summertime* (1955) and by books like Jan Morris's *Venice* (1963), which extolled the mystique of the city and presented it as an idyllic haven. The increase in visitors was offset by a steady decline in the number of Venetian residents in the historic center (*centro storico*) year over year, from a peak of 175,000 in 1951 to 123,000 in 1966 (and only 52,000 in 2019).[3]

In the decade or so prior to the 1966 flood, Venice had been the site of substantial innovation in the arts, cementing its avant-garde reputation in many areas.

From Peggy Guggenheim's embrace of modern art in the Palazzo Venier dei Leoni
to the innovative advances in glassblowing on Murano with the Seguso family,
and with the restoration of the Biennale and its many pavilions, Venice confirmed
its artistic vitality. Emilio Vedova and Giuseppe Santomaso—friends of Peggy
Guggenheim and champions of abstract expressionism—were among the propo-
nents of new styles of painting, while Luigi Nono pioneered novel approaches in
music. Venice's architectural legacy in the 1950s and 1960s was more mixed—the
rejection of designs by Le Corbusier, Frank Lloyd Wright, and Louis Kahn sig-
naled that a conservative streak could not be shaken off.[4] It was buildings, both
commercial and residential, that would be especially hard hit by the floodwaters of
November 1966. Corrosion and pollution were only two of the problems the flood
identified and indeed magnified; the impact on Venice's cultural patrimony would
be equally severe.

The floods of early November 1966 ravaged northeastern Italy with a combina-
tion of rain, wind, and storm surge, swelling over walls and riverbanks with terrify-
ing swiftness. The water level in Venice rose to 194 centimeters above the median,
inundating shops, churches, and residences alike. Tidal *acqua alta* (high water) is
nothing new in Venice, of course; generations of Venetians have worn hip wad-
ers or walked on top of the temporary platforms set out during high water, which
generally occurs in late autumn or winter.[5] *Acqua alta* usually lasts a few hours and
covers low-lying streets with several centimeters of water before the tides recede or
the winds shift. In early November 1966, however, the floods were a different order
of magnitude, with water reaching a depth of nearly two meters in Piazza San
Marco and completely submerging the island of Sant'Erasmo.

Fueled by a combination of heavy rain, high tide, a full moon, and the strong
scirocco wind from the south, an unusually large amount of water gathered in the
lagoon on the morning of 4 November. After six hours of moderate flooding, the
tide should have turned so that the water could flow out of the lagoon and back
into the Adriatic. Yet the powerful northbound *scirocco* trapped the water within
the lagoon and pushed it continuously against the islands, breaching some of the
seawalls (*murazzi*) that had protected Venice for centuries. A second high tide
arrived on top of the first so that water covered the streets, submerged gardens
and vineyards, and streamed into ground-floor buildings. By nightfall, Venice was
paralyzed. Electrical and telephone systems failed, oil tanks ruptured, and many
building foundations were rocked to the core. Massimo Roisin recalled the flood
as a formative event in his childhood: "An eerie silence fell in the early evening. It

seemed to herald a looming misfortune of enormous proportions. The total dark-ness obscured the city [and] the persistent hiss of the scirocco was the only sound. From the top floors of the houses the dim lights of the candles illuminated the water that rose and rose."[6]

After nearly twenty hours of flooding, the wind shifted and the tide slowly receded, revealing how badly the city had been thrashed by the sea. American his-torian Peter Lauritzen was living in Venice then and recalled that "by nine o'clock that night the Venetians could walk about dryshod to inspect the damage. They found rubbish and detritus scattered everywhere and a slimy coating of black fuel oil stained walls and pavements. . . . Electricity was still out of order and the waters had ruined central heating units installed in ground-floor rooms."[7] British journal-ists Stephen Fay and Phillip Knightley quoted the mayor of Venice that year as observing, "On that single night of the floods, our city aged fifty years."[8] Two years after the flood, the British art historian John Pope-Hennessy observed how the 1966 cataclysm brought Venice's decaying infrastructure to light: "It was not just a matter of the flood; rather it was a matter of what the flood revealed, of the havoc wrought by generations of neglect. For centuries Venice lived off tourists, and almost none of the money they brought into the city was put back into the maintenance of its monuments. And that had been aggravated by problems of pollution, an issue of the utmost gravity."[9] Although Venice suffered no deaths from the flooding—perhaps the result of the city's longstanding wariness of the power of water—the damage to the city's cultural resources was comparable to that of Florence, and the damage to urban architecture was probably worse.[10] The city nicknamed the *Serenissima* was anything but calm during those terrifying days and nights.

Although nature had punished Venice, humanmade changes to the lagoon ecosys-tem over the previous century had unwittingly exacerbated the impact. The develop-ment of large factories and a huge commercial dock in Porto Marghera beginning in the 1930s, and the carving of deep-water channels for oil tankers (and later cruise ships), increased the amount of water at high tides and doubled the total volume of water in the lagoon. The creation of fish-rearing enclosures in the nineteenth and twentieth centuries, especially the transition from nets to earthen dams, further restricted the flow of tides. These changes allowed greater quantities of water to rush toward Venice, simultaneously decreasing the wetlands that had traditionally absorbed the storm surge. As the factories of Marghera extracted groundwater from the aquifers below the lagoon for industrial use, this pumping caused subsequent subsidence (i.e., sinking) of the land above. Some buildings in Venice, including the

campanile in Piazza San Marco, sank as much as eighteen centimeters between 1908 and 1961.[11] The extraction of methane gas from under the Adriatic may also have contributed to subsidence.[12] Industrial pollution in the air and water, combined with sea salt, weakened the bricks and stone on which Venice was built. Lack of maintenance on the seawalls facing the Adriatic, and the cessation of canal dredging inside Venice, exacerbated the decay. A gradual global rise in sea levels, the loss of salt marshes around the edge of the lagoon, and increased motorboat propeller wash all have taken a toll. Lastly, land reclamation along the shore for commercial and residential development meant there was less space for the same amount of water to move within the lagoon.[13] The result of all these changes in 1966 was a city paralyzed and isolated for more than twenty-four hours as water poured into buildings and rocked the pilings on which Venetian structures rested.

Responses: UNESCO, Italian Art and Archives Rescue Fund, the Committee to Rescue Italian Art, and the International Fund for Monuments

The alarm went up immediately over the plight of these ravaged Italian cities. Newspapers provided substantial coverage and dramatic photographs. Hundreds of young volunteers, known as *angeli del fango* (mud angels), rushed to Florence to transport paintings and sculptures to higher ground and to begin the laborious process of removing dirt, oil, and other pollutants off buildings and of hand-drying precious books.[14] The Imperial Armory at the Kunsthistoriches Museum in Vienna restored the weapons collection at the Bargello Museum, a Dutch committee sponsored the Casa Buonarroti Museum, and the city of Edinburgh sent double-decker buses to temporarily replace those that had been damaged.[15] The Italian government did not respond immediately to the crisis, and thus it was primarily nongovernmental organizations and foreign governments that led the way.

In Venice, the nonprofit organization Italia Nostra (Our Italy) was among the first to respond by raising awareness of the danger to cultural and environmental heritage.[16] UNESCO provided administrative expertise and limited funding as part of its mission of "protection of heritage" and coordinated the international response to the floods. On 2 December 1966 UNESCO created the Campaign for the Safeguarding of Venice; the appeal launched that month by the director-general, René Maheu, prompted fifty-nine private committees to gather funds dedicated to restoration of buildings, monuments, and works of art.[17]

From Britain, the Italian Art and Archives Rescue Fund (IAARF, later renamed the Venice in Peril Fund) was established by former British ambassador to Rome Sir Ashley Clarke and his wife, Lady Frances Clarke, to focus on Florence and Venice.[18] By the end of 1967, the IAARF was shifting its attention from Florence to Venice, believing that Florence was en route to recovery while Venice remained in serious trouble. As historian Peter Fergusson has noted, the Clarkes moved to Venice in 1969 and were early leaders in the process of collecting reliable information about conditions on the ground there, identifying specific restoration projects, and formulating preventive measures.[19] Similar private committees on behalf of Venice were founded by the citizens of other European nations.[20]

Americans too were moved by the plight of flooded Italian cities. Much of the publicity and early restoration efforts focused on Florence. The first initiative was the Committee to Rescue Italian Art (CRIA), chaired by art historian Millard Meiss and with Jacqueline Kennedy as honorary president. An editorial appeal in the December 1966 edition of *Life* magazine identified an initial goal of $2.5 million as a "first aid" rescue operation and projected a long-range cost of $30 million, calling on all Americans to recognize the importance of Florence to Western heritage.[21] CRIA's members included many of the leading historians and art historians of the day: Frederick Hartt, Paul Oskar Kristeller, Felix Gilbert, Myron Gilmore, and Sydney Freedberg (the last would be a founder of Save Venice). A CRIA fundraising office in New York was complemented by two local offices in Florence, at historic Palazzo Pitti and at Harvard University's study center, Villa I Tatti.[22] Although its principal focus was Florence, CRIA was responsible for a number of projects in Venice too, including the ceiling by Giovanni Antonio Fumiani in the church of San Pantalon, paintings by Niccolò Rondinelli in the church of Santa Maria degli Angeli on Murano, and additional paintings and frescoes in the churches of San Moisè, San Polo, Santi Giovanni e Paolo, and San Martino di Castello.[23] In less than a decade (1966–73), CRIA raised almost $2.5 million; equally important, it was a pioneer in identifying best practices of conservation work. As we shall see, CRIA bears a consistent resemblance to SV in terms of its scholarly founders, binational operation, Harvard connections, and synthesis of academic/philanthropic activities. Unlike SV, however, CRIA lasted only a few years, closing down once it had attained its initial goals in Florence.

The damage to Venice drew the attention of other American organizations, such as the International Fund for Monuments (IFM), which moved quickly to assist Venice.[24] The IFM had been established in New York on 15 March 1965 by

Colonel James A. Gray when he realized the absence of a private, nonprofit orga-
nization to preserve the world's great examples of art and architecture. The IFM's
initial projects had focused on the Leaning Tower of Pisa, followed by others in
Ethiopia and Easter Island (Rapa Nui), but immediately following the November
floods it pivoted to Venice.

The Venice Committee

On the day after the 1966 floods, the IFM offered its assistance to the Italian con-
sulate in New York.[25] Over the next two years, Gray realized that he needed an
expert in Venice to coordinate administrative and academic aspects of the project.
He identified John McAndrew, professor of art history and architecture at Welles-
ley College, as the best man for the job. McAndrew was not in Venice during the
floods, but he had been campaigning on his own in previous years to help protect
the art of Venice. Gray persuaded McAndrew to join forces with IFM and to form
a fundraising committee that would target donors across the United States, with
Gray as executive secretary and McAndrew as chair. In December 1968 McAndrew
promised to identify supporters and ask for money.[26] After an initial meeting in
February 1969, the "Venice Committee" (VC) began to solicit donations and estab-
lish local chapters in American cities.[27] A press release of 31 March 1969 by Gray
explained the importance of the VC and its intentions to combat "the erosion and
decay of hundreds of important works of art, paintings, sculptures, and even entire
buildings."[28] As Gray noted years later, "The concept was that each Chapter would
select (from a list of priorities) a particular monument or work of art and then
endeavor to raise the necessary funds."[29] An IFM newsletter in the spring of 1969
offered four reasons guaranteeing the success of the VC: "1. Much of the threat-
ened art of Venice CAN be saved by prompt and vigorous application of modern
restoration techniques. 2. The Committee has a logically thought-out and work-
able program for the rescue of this art. 3. Contributions go NET to actual work in
Venice since IFM is taking care of administrative overhead. 4. Disbursements are
rigorously controlled."[30]

The focus was never on the large-scale engineering problems faced by Venice;
instead the VC focused on preservation and restoration of individual works of art.
As the VC explained in its initial newsletter, "In our first meeting in February 1969,
the group adopted the name Venice Committee and approved its concept of opera-
tions which, in brief, leaves to the Italian Government the Engineering problems,

but accepts as an international responsibility the rescue of important works of art, paintings, sculpture, etc."[31] Administrative support and tax-exempt status came from the IFM; close cooperation with UNESCO was always present. In July 1969 McAndrew sent an eloquent letter to "Friend of Venice" outlining likely projects and closing with his signature line: "Will you help?"[32]

James Gray and John McAndrew

Who were these two men so driven to play a pivotal role in the preservation of Venice? Both came to Venice relatively late in their lives. James A. Gray was born in 1909 in San Francisco and educated as an electrical engineer before being called to active duty in the U.S. Army Reserve in November 1940, after which he saw extensive action as a paratrooper with the 82nd Airborne Division. He served as assistant military attaché in Rome after the war and then as an intelligence analyst in Tokyo during the Korean War, before returning as inspector general of the U.S. military base at Livorno in 1954. During that year he married Countess Alessandra Asinari di San Marzano and authored a brief study about the historic walls of Verona from the Etruscans to the nineteenth century.[33] Retiring from active duty in 1960, Gray settled in Rome and later observed, "I don't know anything about art but I was fascinated by the engineering problems in some of these restoration projects."[34] Gray believed that the fragile monuments of the world could be preserved through a combination of private fundraising and direct intervention.[35] He formed the IFM initially as a vehicle through which to stabilize the famous Leaning Tower of Pisa; his proposal was to freeze the soil underneath.[36] That project never came to fruition, so Gray turned next to preserve the rock-hewn churches of Lalibela in Ethiopia and the *moai* (giant heads) of Easter Island (Rapa Nui) in the Pacific Ocean.[37] His interest in Venice was spurred by the devastation of the 1966 floods, and he remained passionate about the Serenissima for much of his life.

John McAndrew was an inspired choice to lead the IFM's VC. An architectural historian with two degrees from Harvard, his intellectual horizons were vast.[38] He published books and gave lectures on medieval French architecture, sixteenth-century Mexican churches, eighteenth-century Italian architects, and all aspects of modern art, industrial design, and contemporary architecture. McAndrew was an important contributor (along with Philip Johnson, Henry Russell Hitchcock, and others) to the definition of modernism during the interwar period. Born in 1904 and homeschooled until the age of eight by his schoolteacher father, McAndrew

FIGURE 3. Colonel James A. Gray, observing conservation at the Scuola Grande di San Giovanni Evangelista, ca. 1969. Gray founded the International Fund for Monuments (IFM) and later collaborated with John McAndrew to run its Venice Committee, which sponsored multiple restorations, including this one, in the years immediately after the 1966 flood. The building served as headquarters in Venice for the IFM from 1971 to 1981.
—Photo courtesy World Monuments Fund

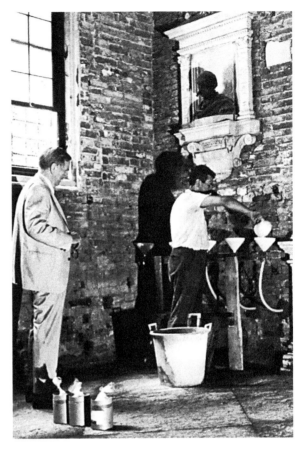

finished high school at sixteen and earned his Harvard B.A. at nineteen; he was a graduate student in architecture at Harvard for several years but preferred traveling in Europe or working as a draftsman. Following a brief stint in architectural practice (1927–31) and as an assistant professor at Vassar (1931–35) where he designed a stunning new library (1935), he served as the curator of architecture at the Museum of Modern Art (MoMA) in New York (1937–41). At MoMA he designed the world's first urban sculpture garden in a modernist idiom and mounted a show on Frank Lloyd Wright's recent masterpiece, the house known as Fallingwater. During World War II McAndrew was coordinator of Latin American affairs in Mexico City for the State Department, a role that likely involved him in intelligence work. The latter half of his career was at Wellesley College, where he taught courses in art history and history of architecture, chaired the art department, and directed the college art museum (1945–68).

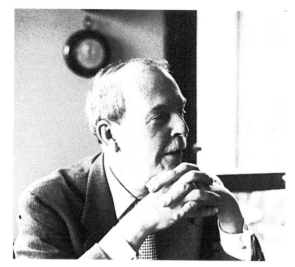

FIGURE 4. John McAndrew, Wellesley College, ca. 1965. Professor of art history (1945-68) and director of the Wellesley College Art Museum (1947-57), McAndrew cofounded Save Venice Inc. in October 1971 and served as its president (1971-73) and chair (1974-78).
　　　　—Photo courtesy Peter Fergusson

John McAndrew was accompanied on these life adventures by his wife, Betty Bartlett McAndrew, who played a quiet but vital role as his silent editor, social hostess, and financial backer.[39] Descended from two Boston Brahmin families (Bartlett, Lee), Betty McAndrew's significance to the early history of SV is largely unsung; clearly it could not have enjoyed its early success without her charm, humor, and ability to soften the edges of her husband. She was an important donor of paintings and sculptures to the Museum of Fine Arts Boston, the Fogg Museum at Harvard, and the Wellesley College Museum, and would eventually see her husband's book on Venetian architecture through to publication after his death.[40] The McAndrews lived an enviable life together, initially in Wellesley and later moving back and forth each year between a double suite on the top floor of the Hotel Europa in Venice and a double apartment in Back Bay—each blessed with beautiful views across the water.

John's colleague and friend Peter Fergusson described him thus: "He sparkled as a brilliantly intelligent polymath . . . , witty raconteur, gifted writer, discerning critic of ballet and music, and excelled as a cook, gardener, traveler, ballroom dancer, and ebullient companion."[41] The *Boston Globe* described McAndrew in 1969 as "a sprightly, grey-haired man with beatle brows [*sic*] and neatly clipped mustache."[42] Fergusson further explained that McAndrew's interest in Venice arose out of a commission from the Royal Institute of British Architects in London to analyze the architectural drawings of the eighteenth-century architect, Antonio Visentini. Probing the roots of Visentini's work, and realizing the paucity of English-language material on the earlier period, McAndrew resolved to write a comprehensive account of Venetian

architecture of the early Renaissance, published posthumously in 1980 by MIT Press.[43] At the time of the 1966 flood, then, McAndrew was a senior professor on the eve of retirement, immersed in his research about Venetian architecture and history; he possessed the scholarly expertise and the personal contacts sorely needed by Gray.

McAndrew's passion for Venice is evident in the hundreds of letters he wrote from the mid-1960s to his death in 1978. One example among many is a 1972 letter to his friend Rollin Hadley regarding the recent campaign to preserve the church of the Gesuiti (Santa Maria Assunta) in the neighborhood of Cannaregio. This excerpt illustrates both McAndrew's determination and the sometimes headlong way in which he proceeded: "We have stuck out our necks for the Gesuiti, promising to pay for a study of what is the matter, a prognosis and prescription for cure, and then pay for the actual cure; we do not have anything like the money, but the church will collapse any minute unless something is done, and so someone has to do something, and since no one else does, we will."[44] While in Venice the McAndrews often entertained guests and organized dinner parties. Their guest lists included Venetians, and doubtless their friendships with locals was part of their social success.

John McAndrew offered more than his skills as an advocate, host, or scholar; he created opportunities to raise the needed funds on behalf of Venice. In late 1968, for example, McAndrew proposed to Gray that they ask American and European art collectors to donate museum-quality drawings and prints to the IFM, to be published in a special catalogue by Boston-based art dealer Robert M. Light.[45] The IFM would then receive the proceeds from the sale of approximately one hundred works on paper as well as royalties from the sale of the catalogue.[46] McAndrew framed the rationale in this way: "This scheme would tap a source of people who might like to do something for Venice, but who might not just happen to be in a position of giving away money. Many would be willing to give away a $500 drawing or print (for which perhaps only $100 had been paid a few years ago) which would be a tax-deductible gift, whereas if they sold it they would be liable for a capital gains tax."[47] McAndrew adapted this technique in subsequent years too; his newsletters regularly encourage his well-off supporters to donate art, silver, and other items to the cause. As McAndrew phrased it in 1975, "With almost no bother you can gain a tax deduction, some otherwise unattainable free space, and a nice feeling of virtue."[48]

Nor did McAndrew limit himself to seeking donations from others. In 1968 the McAndrews selected a famous icon, the *Madonna Nicopeia* in the basilica of San Marco, as their personal choice for a restoration. The superintendent of galleries and works of art, Francesco Valcanover, later lauded this choice as the early twelfth-century icon represented "by far the Venetians' most cherished sacred image."[49]

Originally located in the monastery of Saint John the Theologian in Constantinople and carried into battle by Byzantine emperors to inspire the troops, this icon was looted during the Fourth Crusade of 1204 by Christian armies traveling on Venetian ships. It was returned to Venice and kept in the treasury of the basilica of San Marco, where it was one of many objects that demonstrated Venice's role as a "hinge" between East and West. Also in 1968 McAndrew donated to the IFM prints and drawings from his own collection, including (at least) "the Picasso, the two Vuillards, and the Klee lithograph," valued together at $10,000.[50] From 1968 to 1978 the McAndrews routinely donated artworks and personal items to auctions and sales at special events on behalf of SV. Combined with their cash donations, this made them among the most important donors to the fledgling organization.[51]

The VC benefited from good connections with Italian government officials, especially in Venice: Piero Gazzola (inspector general of fine arts in the Ministry of Education), Francesco Valcanover, and Renato Padoan (superintendent of monuments in Venice). Both Valcanover and Padoan were good friends with John McAndrew. Also on the VC, and later instrumental in helping to promote SV, were Countess Anna Maria Cicogna (head of the Venice chapter of Italia Nostra), Count Alessandro Marcello (director of the Ateneo Veneto), and Sir Ashley Clarke (founder of the British group Venice in Peril).[52]

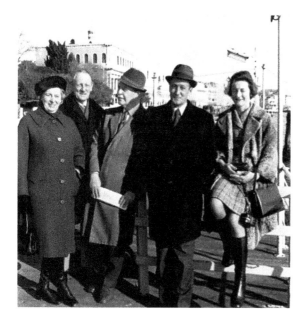

FIGURE 5. From left, Betty McAndrew, Sir Ashley Clarke, John McAndrew, Superintendent Francesco Valcanover, and Lady Frances Clarke, ca. 1976, at the San Marco Vallaresso vaporetto stop. This gathering epitomizes the international cooperation of the early years. The Clarkes founded Venice in Peril, and the McAndrews founded Save Venice Inc., both in 1971. As superintendent of fine arts, Valcanover collaborated with both organizations to conserve the cultural heritage of Venice.

—Photo courtesy Peter Fergusson and Save Venice Photo Archives

Under John McAndrew's leadership, the VC identified several projects requiring immediate attention. The first was the facade of the Ca' d'Oro (House of Gold), specifically a number of small rosettes by Matteo Raverti and Giovanni Bon, rapidly restored in 1969.[53] That facade is one of the most recognizable along the entire Grand Canal, with five arches opening to the canal surmounted by two more sets of pointed arches on each of the floors above. Clearly inspired by the Palazzo Ducale, the elaborately decorated facade shielded a typical palace-warehouse where a merchant could store his goods on the ground floor and house his family on the upper levels. Numerous similar palaces were built in the first half of the fifteenth century but the Ca' d'Oro featured the richest and most complex gothic tracery.[54] By April 1970 the VC could boast of having raised almost half a million dollars in cash, pledges, and contributed art—an astonishing achievement for a group in existence just over one year.[55] The IFM newsletter in that year made clear that Venice was now the top priority of the whole organization.

The VC's next major project was the conservation of thirty-eight paintings by Jacopo Tintoretto in the Scuola Grande di San Rocco; this three-year project was underwritten by a major grant from the Edgar J. Kaufmann Charitable Trust of Pittsburgh.[56] At the same time, the VC commenced conservation of fifty-eight painted wood panels (*tavole*) in the ceiling of Santa Maria della Visitazione in Dorsoduro, with funds from the America-Italy Society of Philadelphia, as well as emergency repairs to the Scuola Grande di San Giovanni Evangelista. (The latter building would house the IFM's headquarters in Venice until it moved in the 1980s to the Procuratie Nuove and, later, the church of the Pietà.)[57] Plans were announced for restoration of three Tiepolo frescoes in the church of the Pietà, repairs in the cathedral of San Pietro di Castello, and an intervention to preserve the twelfth-century mosaic floor of Santi Maria e Donato on the island of Murano.[58]

VC Chapters

On 1 February 1970 the Venice Committee published a memo that would prove crucial to providing a clear model for the later structure and history of Save Venice.[59] In outlining the role of individual chapters, the VC indicated its intention to retain centralized supervision while delegating actual fundraising to the local chapters. According to the memo, each chapter "will operate under an indefinite but revocable charter from Venice Committee of the IFM." To reduce administrative costs, the chapters "will make maximum utilization of volunteer help" and

refrain from employing professional fundraising firms. Each chapter was to have its own executive committee of three to five members. Furthermore, "Local initiative is encouraged, subject to approval by Venice Committee, which will normally be given for projects in good taste, which present reasonable assurances of low cost-to-return ratio, and provided that formal responsibility is fully underwritten by [the] local chapter."[60] In other words, the local chapters were expected to do most of the work and to assume most of the risk. Contributions (usually in the form of a check) were to be sent directly to the IFM, with acknowledgments and tax receipts returned to donors and copies to the chapter. The VC promised to furnish each chapter with a periodic accounting of donations and disbursements. Each chapter could select for sponsorship a specific project on the VC list of priorities. Lastly, the VC reserved the right, in what it considered to be an extreme emergency, to divert any contributed funds for more urgently needed restorations.

The VC wasted little time in founding local chapters, beginning in Los Angeles and Boston, and soon followed by Washington, DC. In the winter of 1970, under the leadership of philanthropist Terry Stanfill as chair, *Los Angeles Times* art critic Henry Seldis as secretary, art collector Gifford Phillips as treasurer, and University of California at Los Angeles chancellor Franklin Murphy as honorary co-chair, the Los Angeles chapter committed to raise up to $100,000 to restore the cathedral of San Pietro di Castello.[61] Other notable members of the committee included authors Pier Maria Pasinetti and Irving Stone, art historian Carlo Pedretti, and designer Henry Dreyfuss.[62] John McAndrew noted in an interview at the time that "because of its age and historic significance San Pietro di Castello is perhaps the saddest victim of time and tide in Venice. It is rather moving to me that one of the youngest and most vital cities in our country, Los Angeles, has chosen to restore this ancient edifice so many miles away."[63] Stanfill and her colleagues organized a November 1971 chamber music concert entitled "Viva Vivaldi!" in Pasadena. Soon thereafter she arranged for a premiere of the 1971 film *Death in Venice* and organized a benefit at the studio of artist and interior designer Tony Duquette.[64] The repair of the church's pavement, walls, roof, and bell tower took a decade to complete, which is not surprising given the extensive damage from the 1966 flood, as Seldis described in the autumn of 1970:

> At the extreme end of the city, the church took the full force of the violent storms and floods in fall of 1966. Roof tiles were blown off and the walls and the dome were cracked so water has been soaking in ever since. A recent

visit to San Pietro di Castello gave appalling evidence of the continuing effect of the building's disastrous condition. The waters have washed out the earth under its marble floors and where the present church is not set on its older, smaller predecessors, the floor has sunk several feet. Overhead there are gaping holes in several parts of its roof which were being temporarily and primitively boarded up.[65]

A New England chapter—distinct from the VC executive committee with McAndrew—was organized in 1969–70 by Muriel Howells, with Ambassador Henry Cabot Lodge and Anne Seddon Kinsolving as honorary co-chairs.[66] With the exception of Ambassador Lodge, the committee consisted entirely of married women.[67] In the spring of 1970 the New England chapter announced its intention to host a gala "Venetian evening" at the Fogg Museum in March 1971.[68] In a chapter meeting several months later, the women confirmed the date and "voted to have a Dutch Treat Dinner available at the Harvard Faculty Club under the chairmanship of Mrs. Peter Wick."[69] At the same meeting, the committee agreed to continue working on a request for donations entitled "Appeal for Friends of Venice." One month later on 6 October 1970, the first annual meeting of the whole chapter was held in Cambridge, with thirty-two members in attendance. The first order of business was to change the name of the chapter from "Venice Committee—New England" to "Venice Committee—Boston" and to select a project at the Scuola dei Carmini.[70] In other business, there was a report on the catalogue sale of artwork previously donated to the VC, as well as remarks by Lodge about his "great and active interest in Italy and of his personal visit to Venice on July 15th of this year when he took a tour of inspection of the most important art objects to be restored under the expert guidance of Prof. John McAndrew."[71] In a subsequent meeting on 10 November, the Boston chapter began to organize a pair of "Venetian tours" featuring "red carpet treatment" in Milan and Venice, scheduled for May 1971.[72]

A third chapter in Washington, DC, was founded in early 1970, under the leadership of Virginia Murray Bacon.[73] The Washington chapter voted to repair the walls and roof of the church of Santa Maria del Giglio west of Piazza San Marco. By the end of 1971 nearly $40,000 had been raised on the strength of individual donations and a June gala event held at the Fine Arts Theater.[74] Additional chapters were under consideration in Cleveland, Detroit, New Orleans, St. Louis, San Francisco, and Durham, North Carolina.[75] The VC also claimed credit for inspiring other national committees, such as those organized by French, Swiss, and Italian private citizens, which were recruiting members and raising money on behalf

of Venice.[76] Despite its small size and recent origin, then, the VC was exceedingly active and making an impact in Venice and across the United States.

In addition to the funds raised by its individual chapters, the VC began to consider additional events to boost its revenue and presence. For example, the VC offered its own "elite tour" in September 1970, focusing on the Palladian villas in the provinces of Venice, Vicenza, and Verona and conducted by Richard Howland of the Smithsonian. The VC further proposed an exhibit of seventeenth- and eighteenth-century Venetian art at the Wildenstein Gallery in New York in spring 1971 and recruited an "Art Committee" of curators to assist with the planning.[77] The committee was pursuing several conservation projects simultaneously, with impressive results already in hand. In short, the VC (and its nascent chapters) seemed to be firing on all cylinders; the leadership of executive secretary James Gray and chair John McAndrew had positioned the VC for great success in the first years of the decade.[78]

Tension on the Venice Committee

The McAndrews and Gray worked closely with representatives from UNESCO, the Italian Superintendencies, and CRIA, as well as with the Clarkes of Venice in Peril. The McAndrews tapped their academic and philanthropically minded friends in Boston, many of whom joined the VC or the New England chapter. Among these colleagues and friends, Professor Sydney Freedberg, the noted Renaissance art historian at Harvard who subsequently directed the Fogg Museum and served as chief curator of the National Gallery of Art (1983–88), was especially important. Before cofounding SV, he was vice chair of CRIA (1966–74) and later president of the Advisory Council to the Vatican Museums for the Sistine Chapel restoration (1990–93). An obituary in the *New York Times* observed that Freedberg's prose was "laced with sharp opinions, passionate empathies, and piquant turns of phrase."[79] Like his good friend John McAndrew, Freedberg held dual degrees from Harvard, worked in intelligence during World War II, was passionate about the importance of Renaissance art, and maintained a certain sartorial elegance and formality throughout his life.

McAndrew, Freedberg, and Gray collaborated with each other and with the VC chapters, obtaining good results but also exhibiting occasional strains or friction. Correspondence and memoranda from the earliest years of the VC demonstrate the kind of work they were engaged in on behalf of Venice: solicitation of funds, selection of projects, cultivation of new supporters, and so forth.[80] These letters

reveal the camaraderie shared by the Boston-area professors and their allies, as well as their increasing disdain for the tactics and personality of Gray. In late May 1969, for example, McAndrew sent Freedberg a sample appeal letter, intended for distribution to about twelve thousand people in early September of that year. In a cover letter, McAndrew complained to Freedberg that Gray was circulating a sensationalist article about the environmental threats to Venetian art.[81] By September the appeal letter and an accompanying explanatory brochure had been mailed out, with text by McAndrew and a solicitation for funds. In a letter from Freedberg to Commonwealth School headmaster Charles E. Merrill Jr., Freedberg described McAndrew as "the distinguished architectural historian who is the pro-tem chairman of the Venice committee, a half-time resident of Venice, and the initial moving spirit of the Committee."[82] The Merrill Trust did indeed respond positively to the solicitation, donating $15,000 to the VC that year for the Scuola Grande di San Giovanni Evangelista; a few months later, however, Merrill contacted Freedberg to express his displeasure over the lack of acknowledgment from Gray.[83]

Tension continued to percolate between McAndrew and Gray. In January 1970 Gray traveled to Washington, DC, to meet with State Department officials, UNESCO representatives, and *National Geographic* editors; then, in February 1970 Gray spent three weeks in Italy where he met regularly with Superintendents

Valcanover and Padoan and others in Venice. Immediately following each of these trips, Gray wrote dense, single-spaced "Memorandum for Record" recording all of his conversations; the one for Venice runs to more than fifteen pages and demonstrates his grasp of details.[84] McAndrew, however, was not impressed; in the margin of Gray's memorandum about a possible exhibition using sepia photographs to document the restorations, McAndrew wrote "nonsense!" Gray was not immune to McAndrew's negativity; indeed, in the same memo Gray acknowledged the "pessimism" of McAndrew about such an exhibition. Two months later, in a letter from McAndrew summarizing the most recent meeting of the VC on 13 April, McAndrew again expressed his dissatisfaction with Gray's plans.[85]

By the late spring of 1970 McAndrew and Freedberg were demonstrating their desire to operate more independently of Gray and the VC. For example, on 12 May Freedberg sent another $15,000 check from Merrill to Gray, noting, "I shall get in touch with John McAndrew to discuss a special project on which it might be spent. I shall let you know what we decide."[86] The curt tone left little doubt that Freedberg and McAndrew saw themselves rather than Gray as primarily responsible for soliciting, and spending, the money raised by the VC. In early October of that same year McAndrew wrote to Freedberg that the VC must obtain a legal opinion on whether it could restore privately owned buildings. There was considerable interest in restoring the Palazzo Barbaro, with its many connections to Boston, and McAndrew was impatient to get going: "The palaces of Venice are in a desperate state. . . . They need help. Why not ours?" Furthermore, observed McAndrew, "We do not have the same limitations in our charter as CRIA; we have hardly any. We hope we can learn from CRIA, and try to emulate its virtues while avoiding its few perhaps unnecessary limitations."[87] As implied by McAndrew, CRIA and other organizations often restricted their contributions to the restoration of art belonging to public institutions, churches, or the like.[88] Unsurprisingly, Gray did not agree with McAndrew's perspective.[89]

Matters came to a head in December 1970. Frustrated by Gray's unwillingness to compromise and holding a different vision than the colonel about the best path to protect Venice, the two professors broke away to establish their own organization.[90] A lawsuit and mutual recriminations would follow in subsequent months, as the two organizations sought to distinguish themselves from each other and to woo supporters to their respective causes. McAndrew and his allies always maintained their singular focus on Venice. The IFM's Venice Committee performed another decade's worth of important restoration projects in Venice until Gray's retirement, at which point the organization shifted its mandate to a broader perspective around the globe.

FIGURE 7. Michele Giambono, *Saint Chrysogonus on Horseback*, ca. 1444, tempera on wood, Church of San Trovaso. An outstanding example of the international gothic style of the mid-fifteenth century, Saint Chrysogonus appears as an elegant Christian knight in armor. The persistent humidity and salinity of the Venetian climate required the restoration of the panel in 1974 by Antonio Lazzarin and again in 2016 by Milena Dean, both with the support of the Boston chapter.

—Photo by Matteo De Fina, courtesy Save Venice Photo Archives

Chapter 2

NASCITA

Birth and Early Years of Save Venice (1970-1974)

Venice is a museum resting on the sea. Its misfortune … by a cruel paradox, is to contain in the very definition of its beauty and unique character, the principle of its own destruction: that intrinsic intimacy with water which from the architect's and conservator's point of view signifies permanent immersion, the continuous assault upon the lagoon city, in its vitals and works of art, by the salt, sea air, and humidity.

—UNESCO Report (1969)

THE SPLIT between John McAndrew and James Gray about the future of the Venice Committee was one of several disagreements among different stakeholders in the early 1970s over how best to assist Venice. In an effort to provide additional information, between 1969 and 1973 UNESCO issued reports and recommendations regarding how to respond to the devastation of the flood; these became part of a larger, more complex debate about causes of the *acqua alta* and the best methods to combat it.[1] Italia Nostra and environmentalists criticized the industrial areas at the port of Marghera and the pollutants produced by the petrochemical industry, but local politicians from multiple parties as well as some local writers defended such economic activity. Perhaps in response to this lingering uncertainty and debate, Venetian literature, cinema, and local press in the early years of this decade often evinced a theme of despair and decay, as in Giorgio Lotti's collection of photographs in the book *Venezia Muore* (Venice Is Dying) and Nantas Salvalaggio's novel *Il Campiello Sommerso* (The Submerged Square). Benjamin Britten's final opera, *Death in Venice,* and Alexander Kluge's horror short story *Mass Death in Venice,* along with *The Death of Venice* by English journalists Stephen Fay and Phillip Knightley (1975), adopted an equally pessimistic perspective.[2] The somber funerals of cultural icons Igor Stravinsky (1971) and Ezra Pound (1972), both occurring in Venice around the time of Visconti's melancholy film *Death in Venice* (1971), reinforced the idea of Venetian mortality. Beyond the flood, Venetians and Italians

more generally faced additional difficulties, instilling a sense that the country was spiraling out of control: the Red Brigades brought their terrorism to Padua and Venice beginning in 1974, and Italian inflation that year reached 19.6 percent. The Italian government did pass the Special Law for the Safeguarding of Venice in 1973, recognizing the unique nature of the Venetian lagoon and promising substantial assistance, but it was ineffective. In the face of all this dispiriting news about the "death of Venice," foreigners took action. A number of private committees were founded in 1970–71 to provide assistance for damaged works of art, including Venice in Peril, the Comité Français, and Save Venice, with still others (e.g., the Stichting Nederlands) instituted shortly thereafter. These new nonprofits complemented, and in some cases replaced, those that already existed in the late 1960s.

For the Venice Committee (VC), the official break with Gray began on the morning of 12 December 1970. That morning, John McAndrew and Sydney Freedberg, together with their spouses, met with Peter and Kathleen Wick, Eleanor Garvey, and Stuart Johnson at Harvard's Houghton Library to draft the "Agreement of Association" that outlined the key elements of a new organization to benefit the art and architecture of Venice.[3] The name was "Venice Committee (USA Corporation)," and the parenthetical designation was important to distinguish this new corporation (VC-USA) from the one sponsored by the IFM (VC-IFM). The name "Save Venice Inc." was adopted about a year later to further distinguish the new group and in response to a lawsuit from Gray. The agreement determined that morning declared VC-USA's purpose in clear terms: "To solicit and receive gifts, grants, contributions and bequests, and to perform services and engage in activities (such as the exhibition of works of art) which are designed to raise funds, all such receipts and funds to be used for conservation and restoration of works of art including paintings, buildings, sculptures, and decorative arts, in Venice, Italy, and for research and study pertaining to conservation and restoration of such works of art."[4] Subsequent paragraphs outlined the standard powers and limitations of a nonprofit 501(c)(3) corporation under Massachusetts and federal tax law. The minutes of that first meeting record the election of John McAndrew as president, Kathleen Wick as treasurer, Betty McAndrew and Eleanor Garvey as assistant treasurers, and Stuart Johnson as clerk. The new organization also established a corporate seal, appointed all eight signatories as directors, and resolved to open a checking account with Commonwealth Bank of Boston.[5] With the legal and financial preliminaries squared away, it was time to break the news to Colonel Gray.

Four days later, on 16 December John McAndrew and Walter Bareiss met with

Gray over lunch to declare the independence of their new Venice Committee.[6] McAndrew and Bareiss proposed a largely autonomous VC-USA with the right to elect its own chairperson, secretary, and treasurer, as well as the ability to set up chapters across the United States. McAndrew and Bareiss requested that the VC-USA should have its own office, as well as "all books, records, correspondence files, [and] addresses of contributors and potential contributors." They also asked for three seats on the executive committee within the IFM board and for the IFM to desist from raising money for Venice except through the new VC-USA. Most importantly, the VC-USA declared that it would have sole discretion to "set the policy for chapters on how to raise money, and together with the Venetian authorities will also decide which buildings, art works, etc. shall be restored."[7] Although McAndrew and Bareiss promised to transfer to the IFM at regular intervals all funds raised on behalf of Venice, it was clearly an audacious and intentional break. McAndrew and Bareiss must have suspected that their multiple stipulations would be unacceptable to the IFM.

Not surprisingly, Gray rejected the demands and declared that the new group had no "legal standing."[8] In early January Gray wrote to Bareiss that he would discuss the matter with the IFM executive committee but offered his "thumb nail, immediate reaction" that the VC was shirking its duty.[9] In a final paragraph, Gray observed that much thought had gone into the preparation of Bareiss's proposal and that equal thought would be expended by the IFM to reply—time that would have been much better spent on a program of raising funds for Venice. Four days later Gray informed Bareiss in polite but firm language that the IFM had denied the proposal of the VC-USA.[10] A meeting between Gray and Bareiss in late March only provoked further misunderstandings, with the IFM claiming that the VC-USA's proposal "was based upon emotional rather than logical considerations," and Bareiss declaring that they were only present to work out the details for a complete separation of the VC-USA from the IFM.[11] Shortly after that, the IFM board chair, Charles M. Grace, chastised McAndrew and the VC-USA for surreptitiously creating a new organization while simultaneously pursuing negotiations with the IFM, and declared they would accept the implied resignations of McAndrew and Bareiss.[12]

The members of the VC-USA quickly separated themselves from the IFM and declared allegiance to McAndrew. As Freedberg put it, "I regard him as the proper founder of the organization, and consider that its impetus and its character are very much involved with him, and that its destiny be left essentially to him to guide."[13] Later that month the VC-USA met again at Harvard's Houghton Library, voting

to add Bareiss as a vice president and to establish a new chapter in the state of New York to compete directly with the VC-IFM. In a nod to the awkward relations between the IFM and VC-USA, the breakaway group "decided that John McAndrew and Walter Bareiss should take whatever action they deem or either of them deems necessary or desirable in order to (i) maintain the separate existences of the corporation and the IFM, and (ii) preserve, if possible, harmonious relationships with the IFM so that this corporation can exert its efforts toward accomplishing the purposes and goals for which it has been formed."[14] The IFM was equally quick, with Gray pointing out in his newsletter of 27 April 1971 that two new chairs had been appointed to the VC-IFM because of "policy differences."[15]

The sour relations continued through the spring and summer of 1971. Gray and Grace maintained that the IFM had sole authority over restorations and fundraising for Venice and continued to vigorously promote its activities there. McAndrew and his allies worked closely with the Boston chapter headed by Muriel Howells, as well as with the emerging New York chapter, to ensure that those chapters remained with the VC-USA. Both sides lobbied for the support of the influential superintendencies in Venice as well as deep-pocketed donors in the United States and especially for the loyalty of other chapters of the VC-IFM.[16]

Vigorous correspondence ensued between McAndrew and his supporters as they sought to advise each other and to plan their next steps. Howells wrote to McAndrew from her summer house in Kittery Point, Maine, opining that the replacement trustees were merely figureheads, and that Gray was likely still in charge.[17] McAndrew responded with a frank assessment of how to ensure that the Boston chapter transferred its allegiance and reiterated his intention to move ahead.[18] In a follow-up letter to his close friend Eleanor Garvey in July 1971, McAndrew dismissed Gray's plans for a benefit dinner in New York.[19] In that same month the Boston chapter of the VC-IFM voted to join the VC-USA; it also elected as chair Rollin Hadley, director of Boston's Isabella Stewart Gardner Museum.[20]

On 24 July McAndrew, Bareiss, and Thomas Hess called an emergency meeting of the VC-USA at the Hotel Gritti in Venice, in order to formally establish new chapters in Boston, Los Angeles, and Washington, DC.[21] The minutes of that meeting record a similar declaration for each of the proposed chapters, specifying the members of the local executive committees and granting McAndrew broad authority:

Upon motion duly made and seconded, it was unanimously voted that this corporation [VC-USA] establish a new chapter in the Commonwealth of Massachusetts under the name of the corporation; that said chapter be operated under the supervision of an Executive Committee constituted by Rollin Van N. Hadley, Mrs. William White Howells, Mrs. Mason Hammond, Alice M. Pierce, each of whom shall hold office at the pleasure of the Board of Directors; that John McAndrew, the President, and Stuart R. Johnson, the Clerk, be authorized . . . to issue a Charter to such chapter in accordance with the provisions of the By-Laws; and to take any and all action which they deem necessary or desirable in order to carry out the purposes of this vote.[22]

Two days later McAndrew wrote again to Garvey, noting that the Washington, DC, chapter "has already left Gray and joined us, returning to the IFM funds already sent over by them, and breaking completely."[23] McAndrew added that Atlanta and New Orleans were likely to form chapters as well as North Carolina, and that he was in the process of issuing a charter to the New York chapter too "despite the Colonel's group there."[24] Thus it appeared that McAndrew and the VC-USA had managed to sway most of their Venice supporters away from the IFM and had generated significant interest in more than half a dozen major American cities. Whether the reason was due to the widespread desire to help Venice or to the persuasive powers of McAndrew, the VC-USA was on the rise.

New Name, New Logo, New By-Laws

Recognizing the need for some corporate structure, McAndrew and his colleagues drafted a set of by-laws for the VC-USA in the spring or summer of 1971. This seventeen-page typescript was subdivided into eight articles dealing with members, officers, directors, meetings, chapters, liability, miscellaneous, and amendments.[25] The by-laws called for three to fifteen directors, among whom there must be a president, a treasurer, and a clerk, all elected for renewable one-year terms. An annual meeting was to be held on the first Monday of December—a requirement often overlooked in the early years. The VC-USA board authorized itself to establish or dissolve chapters in other cities as necessary. The board also included a conflict-of-interest clause that allowed the VC-USA to have business dealings and contracts with outside firms in which one or more directors had a pecuniary

interest.[26] All of these issues were couched in standard legal language; nowhere in the text was there any mention of Venice or art restoration.

In September 1971 attorney Stuart Johnson mailed a set of "Rules and Regulations" to Hadley, designed to govern the new Boston chapter of VC-USA. Similar in structure, tone, and font to the by-laws of the parent corporation, the Boston regulations included five articles over eleven pages, outlining membership, meetings, amendments, officers, and the formation of a local executive committee.[27] In an accompanying letter, Johnson explained his methodology and purpose in drafting the by-laws for the chapter:

> This is a follow-up to our meeting at the Harvard Faculty Club about Venice Committee (USA) Corporation. As I promised, I have drafted a set of rules and regulations to govern the operation of the Boston Chapter of Venice Committee (USA) Corporation, and I am enclosing a copy herewith for your careful review. The basic objective of these rules and regulations is to furnish a structure or bureaucracy to the Chapter (beginning with the Executive Committee and running down to the lowliest officer) and to set certain basic rules as to how each level in the bureaucracy will operate within itself and vis-à-vis other levels. For the most part, these rules and regulations are a part of my own inventiveness and, under the circumstances, I invite your open criticism of them. I would not be surprised if you would like to make certain dramatic changes, and, if so, I would gladly make them.[28]

Johnson's letter implies that this was the first effort to draft regulations for a VC-USA chapter; presumably this document (like the founding charters) was to be replicated for chapters in Los Angeles, New Orleans, New York, and Washington, DC.

If the new corporation was indeed going to be independent, it was important that it be readily distinguished from the VC-IFM in logo and in name. This was all the more urgent as the IFM filed suit against the VC-USA in the summer of 1971 for appropriating its name and likeness.[29] Garvey provided the first of two crucial solutions for the young corporation: a new logo. On 7 May 1971 Garvey wrote to McAndrew that "there may be a 'problem' if we continue to use the same device and how strongly do we feel about it? If we find a good one, it seems to me it could be explained in the letter on which it first appears."[30] With her deep background in graphic arts, and the resources of Houghton Library at her fingertips, Garvey was well-placed to identify a new image. On 23 July 1971 Garvey wrote to McAndrew

in Venice: "Will a lion do? These are shaky polaroids, but you can get the idea. . . . No. 1 is my 1st choice silhouetted without background and perhaps without piece of left wing to left of head. Nos. 1–3 are woodcuts and would reproduce well. No. 4 is an etching-engraving (Visentini) with much fine detail. All were published for the victory of Lepanto."[31] Five days later she informed McAndrew that Hadley and Howells (both in Boston) had approved of the new leonine mascot, and McAndrew quickly agreed.[32] This particular representation of the winged lion of Saint Mark, first printed in Brescia in 1571, appeared exactly four hundred years later on the masthead of the initial Save Venice newsletter dated 1971.[33]

After a summer of squabbling with the VC-IFM, and buoyed by Garvey's new logo, McAndrew offered a new name for the young corporation. In a letter of 21 September 1971 McAndrew wrote from Venice to Garvey in Cambridge:

> Yours of the 16th just arrived, having crossed one of mine somewhere in the Atlantic. As by now you presumably know, all will be settled with the IFM people when we send out a letter saying that we are quite separate, and announce a change in name. Had things gone to court, we could have won every point, but both sides would have lost. Consequently, we are giving in on the matter of the name, which we think is a good idea anyway since so many people are just now confused. When we send out this letter (from NY) there will be a list of names down the side, and an executive committee at the top, both of which will show who we are. . . .
>
> The new name proposed was Friends of Venice, Inc.—but "Duke" Pini di San Miniato started something with this name a couple of years ago, and the British Venice in Peril Fund is about to start a sub-group of members called by the same. I have cabled suggesting "Save Venice Inc." and a couple of other names.[34]

On 30 September 1971 McAndrew wrote to Howells to share the news of the new corporate name. In response to a prior concern about exactly which form of corporate structure Save Venice should adopt, McAndrew gently poked fun at her, writing "Inc or Corp, Corp or Inc, makes no difference I should think (you can set that to some jingly tune). The great thing is that we are not nameless. Our old name confused plenty of people and the new one is better from every point of view." In order to emphasize his point, across the top of his letter McAndrew typed, in capital letters: "SAVE VENICE INC + CORP + LTD + GMBH + SOC. ANONYME."[35]

```
S A V E    V E N I C E    I N C + C O R P + L T D + G M B H + S O C   A N O N Y M E
                                          30  IX  71

Dear Muriel,
        Thank you ever and ever so much for your letter, containing, as it did,
the first real news I have had in weeks.  Inc or Copr, Corp or Inc, makes no
difference I should think.  (you can set last to some jungly tune).  The great
thing is that we are not nameless.  Our old name confused plenty of people,
and I am sure new one is better from every point of view.  Thank goodness my
cables arrived in time and took effect to prevent Friends of Venice, for the
```

FIGURE 8. John McAndrew to Muriel Howells, 30 September 1971 (detail). Dated just one day prior to the founding of Save Venice Inc. on 1 October 1971, McAndrew explained the new name of the organization, including—in jest—various corporate abbreviations in the heading and in the body of the letter.

—Photo courtesy Peter Fergusson

The directors of the VC-USA met at Houghton Library on 1 October 1971 and approved the new name of Save Venice Inc., thus making a clean break with the past.[36] On the same day Freedberg filed a corporate name change with the Massachusetts secretary of state, and a week later McAndrew and Bareiss announced the change to the public.[37] By the end of 1971, then, Save Venice Inc. had officially been established in name and deed. In November and December of that year the minutes of the board of directors bear the title "Save Venice Inc.," as do checking accounts, letterhead, and other paperwork.[38] The initial newsletter featured the name "Save Venice" and the logo of the winged lion.[39] SV had an official address at Bareiss's office inside the Lincoln Building at 60 East 42nd Street in New York.[40] The directors appointed Elena Drake Vandervoort as secretary-treasurer and Stuart Johnson as counsel.[41] The General Committee included a mix of American professors and curators (James Ackerman, Agnes Mongan, Sydney Freedberg) as well as Italian curators and academics (Francesco Valcanover, Terisio Pignatti, Renato Padoan). British luminaries included Sir John Pope-Hennessy, Viscount John Julius Norwich, and Sir Ashley Clarke, each of whom brought scholarly expertise and titles to the General Committee. On the American side, art collector and heiress Peggy Guggenheim, architectural historian and curator Edgar Kaufmann Jr., and philanthropist Terry Stanfill were important components of the General Committee.

The disagreements between McAndrew and Gray were now a thing of the past, and the new organization was ready to move forward. While sore feelings would remain for some years to come, the two founders would forever be joined in the

minds of Venetians. For example, in *Venice Restored, 1966–1986*, historian Alvise Zorzi saluted the two at the very start of a list of the most important individuals and organizations who had helped Venice over the previous twenty years: John McAndrew, "sensitive expert of Venetian architecture," and James Gray, "inexhaustible animator of what is now called the World Monuments Fund, Venice Committee."[42] Although great differences in personality and methods had driven them apart, their shared love of Venice kept them together.

SV itself was changing. One can see—despite McAndrew and Hadley being based in Boston—the center of gravity starting to shift from Boston to New York. Several important directors, including Hedy Giusti-Lanham, Walter Bareiss, and Thomas Hess, lived and worked in New York. This transition is evident also in the decision in May 1972 to transfer all SV funds from Commonwealth Bank of Boston to Chase Manhattan Bank of New York and to appoint a New York–based treasurer, Harry Halpern.[43] The development of a New York chapter (see below) further contributed to this gradual transfer to New York. Beginning in October 1972 attorney Thomas J. Kelly of the firm Herrick, Smith in Boston handled routine legal work for SV such as recording board minutes or submitting annual reports to the Massachusetts secretary of state but was not involved with international tax issues or the signing of contracts in Venice.[44] Thus the intellectual and corporate center of SV may well have been in Massachusetts but the economic and administrative nexus was effectively in New York. This slow and largely unnoticed recentering from Boston to New York foreshadowed the eventual relocation of SV headquarters from the Hub to the Big Apple.

Art Restoration and Conservation

The fledgling corporation of Save Venice was fortunate to have multiple partners for its restoration and conservation projects, including the local chapters, the Venetian superintendencies, and the various donors. John McAndrew and his allies had, of course, been deeply engaged in such partnerships as part of the IFM's Venice Committee, beginning with conservation of the Ca' d'Oro in 1968–69. Despite McAndrew's occasional dismissive remarks in 1971 and thereafter, the VC-IFM did sponsor a significant number of important projects in Venice under the leadership of James Gray.[45] The VC-IFM had further supported, together with a Chicago-based chapter, the restoration of the Scuola Canton, a 1532 synagogue built by Ashkenazi Jews from France. As previously noted, the Boston chapter of VC-IFM

had underwritten the ceiling paintings by Giambattista Tiepolo in the Scuola di Santa Maria dei Carmini, just as the Washington chapter of VC-IFM had funded cleaning of works by Giuseppe Sardi and structural repairs at the church of Santa Maria del Giglio.[46]

Now affiliated with SV, the local chapters continued to raise funds and to select projects. After joining SV in autumn 1971, the Boston chapter selected Mauro Codussi's church of San Giovanni Crisostomo as its principal project. The chapter immediately raised $10,000 from the local premiere of Vittorio De Sica's film *Garden of the Finzi-Continis* at the Exeter Street Theater in February 1972, and from a glamorous ball in May at Harvard's Busch-Reisinger Museum preceded by more than forty private dinner parties for over seven hundred guests.[47] Also in 1971 the Washington chapter raised more than $40,000 with its own premiere of Visconti's film *Death in Venice*. Then the DC group organized a November tour of Sicily and Venice, with all funds intended for the Giglio church. The New York chapter, under chair Joseph V. Noble, hosted another showing of the Finzi-Contini film, allocating the $23,000 raised for a new project: the Scuola Levantina, a baroque synagogue in the Jewish Ghetto in desperate need of a new heating system.[48] In each case, the local chapter had the right to choose its own restoration from the list provided by the superintendency, subject to the routine approval of the SV board. Beyond these specific restorations, in 1971–72 SV promised $3,500 annually toward running a stone conservation laboratory in the former *scuola* of the Misericordia and $2,000 for an emergency fund for the Superintendent of Monuments (Padoan) when lightning or leaks necessitated immediate interventions.[49]

By fall 1973 SV could boast of having $330,000 on hand, gathered from individual donors, gala events, and foundation grants, thus positioning the organization to launch a number of significant projects simultaneously.[50] In that year it completed refurbishment of the church of San Giovanni Crisostomo and of Donatello's sculpture *Saint John the Baptist* in the Frari.[51] The latter was sponsored confidentially as a "top-secret" donation by Betty and John McAndrew.[52] As with some later SV projects, the conservation of Donatello's sculpture permitted an art historical breakthrough, in this case a dramatic revision of a work's place within an artist's oeuvre. Giorgio Vasari's *Life of Donatello* (1550) had claimed that the Florentine sculptor delivered the wooden statue to the chapel of the Florentines in the church of the Frari right after concluding his decade-long sojourn (1443–53) in Padua, the university town near Venice. Ever since Vasari, the *Saint John the Baptist* had been regarded as Donatello's "earliest 'late work'" and dated to 1452–53,

FIGURE 9. Donatello, *Saint John the Baptist*, 1438, polychromed wood, Church of Santa Maria Gloriosa dei Frari, after 1973 conservation treatment. Sponsored by John and Betty McAndrew, the conservation of Donatello's statue revealed the artist's signature and date of 1438, prompting a major art historical reevaluation of the sculptor's development. Photo by Matteo De Fina, courtesy Save Venice Photo Archives

not long before the similarly haggard and intense *Saint Mary Magdalene* (Museo dell'Opera del Duomo, Florence), assigned to about 1454–55.[53] The conservation sponsored by SV uncovered a signature and the date of 1438, astonishing art historians because this date meant that the sculpture was not only made some fifteen years earlier than assumed but that it was completed when he was still based in his hometown of Florence.[54] Thus the work was not a consequence of Donatello's residency in Padua but from well before; equally important, it demonstrated that a certain strand of Donatello's emotional expressiveness had commenced at an earlier moment in his chronology.

Befitting its full coffers, the Boston chapter took the lead on a more ambitious restoration: the church of the Gesuiti (Santa Maria Assunta) in the northern edge of Cannaregio. Beginning in 1973, the three-year project focused on the elaborate inlaid stone decoration of the interior as well as restoration of paintings and furniture.[55] In 1974 the Boston chapter restored Michele Giambono's painting *Saint Chrysogonus on Horseback* in the church of San Trovaso. This large wooden panel was removed from the church and treated to remove yellowed varnish, thus revealing the white horse, gleaming armor, and damask cape that mark this dashing warrior.[56] In 1973–74 SV supported structural reinforcement at the Scuola Levantina in the Ghetto and restoration of the unusual ceramic dome of the Martini chapel in the church of San Giobbe.[57] The New Orleans chapter, under the leadership of Carlo Capomazza de Campolattaro, committed to raising $10,000 to restore the mid-fifteenth-century altarpiece of an enthroned Madonna by Fra Antonio da Negroponte in the church of San Francesco della Vigna.[58] In short, John McAndrew and his allies were extremely busy—and successful—in identifying projects all across the city and obtaining the necessary funds, just as they had been while working under the aegis of the IFM.

In all of these ventures, McAndrew and SV worked closely with the two Venice-based bureaucracies responsible for upkeep of monuments and cultural patrimony: the Superintendency of Monuments (under Renato Padoan) and the Superintendency of Fine Arts (under Francesco Valcanover). In a practice that continued for decades, the superintendents would prepare a list of endangered works of art and estimated costs, and SV would choose those it wished to sponsor. SV also made clear from its earliest days that it wished to make payment to conservators, not to the government ministry in Rome. Beginning in 1977, SV would turn to UNESCO as paymaster, but until then it endeavored to make payments directly

to local restorers and suppliers whenever possible. Owing to its good relationships with locals, SV was willing and able to provide expeditious funding for critical repairs and to allow Venetian authorities the necessary flexibility to make independent, timely decisions.[59] McAndrew wrote to Hadley in 1972 that "as of now, I am inclined to push Save Venice into saving pictures and contributing to Valcanover's laboratory for the study of stone preservation, and not buildings, even though the last are in the most danger."[60] Although McAndrew sometimes faulted the Superintendency of Monuments, SV still committed significant resources to structural repairs and cleaning of facades and interiors for dozens of structures.

Raising Funds

The fundraising techniques adopted by SV in its early years embraced the traditional and the innovative. Like most nonprofits, SV expected its board members and chapter members to donate annually and to purchase tickets to fundraising events. Newsletters, donation requests, annual appeals, and event announcements arrived regularly via post.[61] In the initial newsletter, for example, McAndrew noted that "minor gifts of pictures, furniture, china and a miscellany of objects were slipped into a sale at Parke-Bernet last winter and brought close to $3,000."[62] Encouraging donors to contribute such items again, he joked (in rhyme), "We can make cash of your high-class trash."[63] SV experimented with a variety of approaches to raising funds between 1971 and 1974, chiefly in New York and Boston; its actions inspired gratitude and occasional criticism.

At a December 1971 meeting, the board discussed a possible benefit two months hence on the second night of *Otello* at the Metropolitan Opera for two hundred people.[64] In July 1972 the directors approved a proposal for a thirty-person tour of Venice, to be held jointly with Venice in Peril.[65] In the spring of 1973 the board agreed to use the uptown New York galleries of Leo Castelli to recreate the Venice Biennale for one week; the gala opening on 18 October 1973 raised approximately $3,000.[66] One of the more unusual methods used at the Castelli galleries was the sale of 250 impressions of a silkscreen print designed by American artist Robert Rauschenberg, controversial star of the 1964 Biennale and winner of the Golden Lion; in addition to selling these prints at the event, SV offered them to the various chapters.[67] The Missoni Fashion Show at Saks Fifth Avenue in November 1973 brought in $2,415, which the board described as "hugely successful" (in large part because no expenses

were incurred).[68] In this same year Save Venice experimented with the sale of one hundred copies of a cookbook, *Venetian Cooking*, by H. F. Bruning Jr. and Umberto Bullo, and with the sale of notecards reproducing an engraving of Piazza San Marco by the eighteenth-century Italian artist Lodovico Ughi.[69] At the same time the board discussed a possible exhibition of jewelry of Miguel de la Cueva and opened negotiations with the Franklin Mint for a series of monthly medals with Venetian subjects.[70] In 1974 the board discussed (and subsequently declined) a proposal from West Coast Cinematografica of Rome to share in the expenses and proceeds from a book and film by Nicola Fiore entitled *Splendid Love*.[71] More traditional (and more successful) was a preview and reception at the Metropolitan Museum of Art on 1 May 1974 for the exhibition *Venetian Paintings at the Met*.[72] It is worth noting the preponderance of New York–based events in the description above; while some of these events were held in conjunction with the New York chapter, most of them were run by the SV board. This plethora of Manhattan events underscores the importance of New York to the organization.

The Boston chapter continued to hold fundraisers and other events by leveraging its connections to local museums. For example, a party dubbed "A Night in Venice" at the Fogg Art Museum in March 1971 raised money for the Scuola Grande dei Carmini and was covered extensively in the local press.[73] A dinner-dance at the Busch-Reisinger Museum in May 1972 titled "Viva Venezia" featured pennants sent from Venice itself; in her column "Social Chatter," Alison Arnold dryly described how "the Proper Bostonians and the distinguished Cantabridgians welcomed each other sedately with reserved nods."[74] A similar costume ball at the Busch-Reisinger in May 1973, followed by a 1974 spring benefit at the Loeb Drama Center featuring a performance by the Royal Shakespeare Company (and bartenders in Renaissance costume), raised funds for the church of the Gesuiti.[75] In 1973 alone the Boston chapter raised $36,640 from the costume ball, the annual appeal, and a cocktail party at the Gardner Museum in honor of Superintendent Francesco Valcanover, with similar results in other years.

In keeping with past practice, John and Betty McAndrew regularly donated artwork from their own collection. In May 1974, for example, they sold an unspecified work by Kandinsky for $34,000 in New York, and in October 1974 they consigned an aquatint by Henri Matisse ($1,800) and an etching by G. B. Piranesi ($600) to Robert M. Light of Boston, all for the benefit of SV.[76] The following month John McAndrew indicated his intention to donate proceeds from the sale of oriental furniture and of a painting by Picasso, again to the benefit of SV.

How did Italians and Italian Americans respond to the early efforts of SV? The superintendencies were glad to receive the financial donations and the expertise of American scholars; Valcanover's gratitude for the McAndrews' sponsorship of the *Madonna Nicopeia*, cited above, is just one example among many. The mayors and elected officials of Venice also routinely expressed their thanks to SV for the energetic fundraising of its American donors. John Pope-Hennessey (who was not Italian but who was a non-American observer) noted in a letter to Rollin Hadley in fall 1974 that SV was making a positive difference: "I saw John McAndrew in Venice in July. Speaking for myself, for the first time I left the UNESCO meeting with a ray of hope."[77] A dissenting view was expressed in a 1974 letter to the editor, in which New York resident Elmo de Paolo criticized Venetians for their passivity and hypocrisy, allowing Americans to fill the vacuum: "I think that Venetians and Italians in general should be ashamed of having people going around begging for funds to save Venice. No real Italian, no real Venetian, should allow this begging to go on. It is humiliating, and it would not be necessary if the Italians who make—and made—piles [of money] out of Venice would decide once and for all to see to it that Venice, their Venice, should be saved."[78]

This issue of who should bear responsibility for "saving" Venice would recur regularly, with strong views on both sides. In the late 1960s and early 1970s Venice was experiencing significant physical problems with its monuments; some were on the verge of falling into the canal (e.g., the church of the Gesuiti). Describing Venice as a "city of falling angels" was not just a literary turn of phrase: Venetian buildings were shedding roof tiles and statuary at an alarming rate. SV and the other private committees were instrumental in contributing to the physical maintenance of many important monuments that the Italian state or private citizens were unable to repair.

Italian government efforts to allocate money toward restoration and conservation in Venice complemented the funds raised by SV in the early 1970s. The most consequential of these efforts was doubtless the "Special Law" of 1973, which recognized the "preeminent national interest" in rescuing Venice and preserving its lagoon, and provided the Italian national government with the authority and financing to safeguard the city.[79] This *Legge Speciale* intended to defend the environment by regulating rivers, tide levels, coastal defenses, and pollution in order to protect "the historical, archaeological, and artistic environment of the city of Venice and its lagoon." More specifically, the Special Law envisioned floodgates between the Adriatic Sea and the lagoon, filters and a sewer system to reduce industrial

effluents, limitations on air pollution and fresh-water extraction in Marghera, and preservation of wetlands. The law divided responsibilities for these tasks among various administrative levels, including the national government, the regional government, the provincial government, and the cities of Venice and Chioggia. All these efforts were in theory to be coordinated by the Venice Water Authority (Magistrato alle Acque).[80] The authorized loan was substantial, to the tune of nearly half a billion dollars, but in practice there were administrative gaps, overlapping responsibilities, and political rivalries that hindered an effective response. As UNESCO noted in its 1993 review, much of the allocated money was not spent in a timely fashion, further delaying repairs.[81] The most noteworthy consequence of the 1973 Special Law was the proposal to create floodgates at the three entrances to the lagoon (Lido, Malamocco, Chioggia) from the Adriatic. In 1975 the Italian Ministry of Public Works asked for bids on a sea defense system, but none met the requirements. Later nicknamed Project MOSE after the prophet Moses who parted the waters, this ambitious project languished for decades as Venetians (and others) squabbled about how to build it, whether it would be effective, and what the environmental consequences might be. Four decades and billions of dollars later, the gates became operational for the first time in 2020.[82]

Some Venetians objected to the entire concept of the Special Law of 1973, viewing it as simultaneously authoritarian and overly deferential to environmentalists. The most vocal proponent of this view was the Venetian Wladimiro Dorigo, whose 1973 work *Una legge contro Venezia* (A Law against Venice) declared that Marghera and industrial modernization were not to blame for subsidence, flooding, and pollution. He pointed to depopulation as the preeminent cause of a dying Venice and correctly forecast that residents of Venice would continue to flee to the mainland.[83] It is true that the Special Law of 1973, along with UNESCO, did not address "human" issues such as housing, jobs, and depopulation but instead focused on environmental and physical problems.

Against this backdrop of slow government responses to both the 1966 flood and the problems facing Venice in the early 1970s, SV identified an important niche where it could take immediate action. In a 1973 newsletter that featured the Special Law as its lead story, the SV editors wrote, "Save Venice cannot, of course, help in the vast technical works promised by the new law, but we can help preserve those threatened treasures that may not hold together for 4 or 5 years until some of what is left of the $500,000,000 can go toward rescuing them."[84] Here we see more clearly than ever the focus on preservation and restoration of Venice's cultural patrimony,

specifically individual works of art and architecture, and an equally ardent desire to avoid (for the moment) entanglement in the larger political and environmental issues that afflicted Venice. Thus SV sought to raise funds through a variety of means but always with an explicit and narrow focus on art conservation.

Board Governance

During the early years of Save Venice, its leaders sought to expand across the United States and to solidify their presence in Venice. One initial step was to establish an office in Venice to implement financial transfers and provide up-to-the-minute news about conservation priorities and progress. John McAndrew was often in Venice for up to six months of the year, but a consistent presence was needed all year. In 1973 the board agreed to retain an office at the address of Interax in Venice, in order to "adjust to the needs of our expanding operations."[85] Interax provided public relations assistance, office space, telephone answering, mail collection, and special secretarial assistance when necessary for fundraising events, for a fee of two hundred dollars (later three hundred) per month.[86] In addition to standard secretarial services, SV decided at the same time to hire a Venetian, Marialuisa Weston, who could serve as local representative and translator. Weston already had a position as the private secretary of Countess Anna-Maria Cicogna; she accepted the position with SV as a supplementary one in 1973–74, and then from 1975 to 1991 worked part-time for SV.[87] Weston's fluency in Italian, Venetian, and English, along with her deep understanding of Venetian mores, made her a vital presence for Save Venice.

A second crucial step was to elect Countess Anna-Maria Cicogna to the board— the first high-profile Venetian to join the leadership of SV and a precursor of the eminent names added under the presidency of Larry Lovett in the late 1980s.[88] SV continued to add more people to its General Committee; by 1974 there were forty members and ten directors.[89] Third, SV looked for the establishment of additional chapters, including one in Cincinnati with James E. Poole III and one in St. Louis with Emily Rauh Pulitzer.[90] Existing chapters in Washington, DC; Los Angeles; and New York continued to be active, as noted above. Boston was clearly the most dynamic and successful, owing to the energy of McAndrew, Freedberg, and Hadley.

A final important step in governance was the appointment of Bruce Duff Hooton as executive director in May 1973 to oversee day-to-day operations and to relieve the burden on McAndrew. Hooton's background in the New York art world, as

well as his experience working for the IFM, made him a strong candidate for the new position of executive director.[91] However, his tenure with SV lasted only two years, and the position of executive director would remain vacant for another decade until Bea Guthrie was appointed in 1986. Thus, by April 1974 SV had a full administrative structure: president (McAndrew), two vice presidents (Bareiss, Giusti-Lanham), a secretary (Vandervoort), a treasurer (Halpern), and an executive director (Hooton), as well as an official set of by-laws and a representative in Venice. The ad-hoc nature that had sometimes defined the group in its infancy was now being transformed into something more official and permanent.

This appearance of corporate hierarchy can, however, be somewhat deceiving. As Peter Fergusson has observed, the organization was largely a volunteer operation in its early years and was often "disarmingly amateur." As Fergusson wrote (in reference to members in Boston but his comments are broadly applicable elsewhere), "All mailings were hand-addressed by volunteers in mammoth sessions gathered around someone's dining room table. For refreshments for special events, individuals cut sandwiches and baked cookies at home, while others brought wine. Fund-raising efforts included sales of paintings and works on paper, many plucked from the walls of the McAndrews' or their friends' houses."[92] Nevertheless, this corporate structure was important, particularly when John McAndrew announced his intention to step down as president in the spring of 1974. His colleagues reluctantly agreed and then offered him a courtesy appointment as chair of the organization. Rollin Hadley, who had chaired the Boston chapter, agreed to replace McAndrew as president of SV effective 1 May 1974.[93] Despite the change in title, John McAndrew did not really remove himself from the daily business of the organization. He remained deeply involved in his capacity as chair, sending detailed letters to Hadley and others about restorations, potential board members, fundraising activities, and so on. In his correspondence, he joked repeatedly about his difficulty with retirement; clearly his restless mind needed stimulation. He was gratified to receive the Pietro Torta Prize in 1976 from the Ateneo Veneto, in recognition of his service to Venice.[94]

Save Venice did not fold after the retirement of its charismatic founder; the board continued to meet regularly, to organize events to raise funds, and to honor its obligations. Yet no champion stepped forth to replace McAndrew, and the board seemed reluctant to take on ambitious new projects. The amounts raised each year were certainly respectable, and SV continued to present educational programs and advocate for historic preservation. But without McAndrew at the helm, it lacked

urgency and drive. The documents from the mid-1970s suggest an organization treading water rather than making brisk progress. McAndrew's successor, Rollin Hadley, captured the essence of the dilemma in a letter to Walter Bareiss in 1975: "Finally, we desperately need another John McAndrew who has time, money, and qualifications to devote to the cause, preferably someone in or near New York. From a quick look at the list of directors and officers one quickly realizes that we are all less than part time. . . . Any long range plan depends on either hiring someone or finding a person of leisure to take it."[95] Venice was no less compelling a cause than it had been several years earlier. Rather, common to many nonprofits, success was linked to the dedication and personality of the head. By December 1975 it had become clear to Hadley that the scale and complexity of the organization and its work could be an all-encompassing task. This meant that even those deeply devoted to Venice were reluctant to take over as its champion.

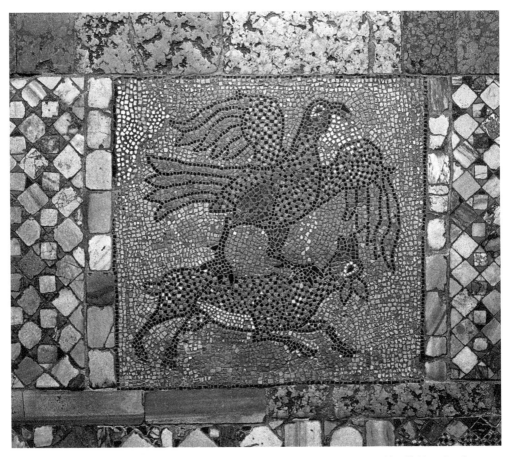

FIGURE 10. Mosaic Pavement, Church of Santi Maria e Donato, Murano (detail). Venetian floors are particularly vulnerable to water damage and human wear. Restored in 1974–78, 2012–15, and most recently in 2020, the twelfth-century mosaic floor of Santi Maria e Donato measures over five hundred square meters and includes figurative and geometric imagery, including the fanciful image here of a bird riding on the back of a fox.

—Photo by Matteo De Fina, courtesy Save Venice Photo Archives

Chapter 3

STABILITÀ

Staying the Course (1974–1986)

I saw Venice, which yieldeth the most glorious and heavenly shew upon water
that ever any mortal eye beheld, such a shew as did even ravish me both with
delight and admiration. . . . This incomparable citie, this most beautiful Queene,
this unstained vergine, this Paradise, this rich Diademe and most flourishing
garland of Christendome.

—Thomas Coryat, *Coryat's Crudities* (1611)

Rollin Hadley's plea to identify another person to lead Save Venice, ide-
ally "another John McAndrew," went unanswered, and he continued to serve as
president from 1974 until 1986. Hadley received critical assistance for more than
a decade from vice presidents Walter Bareiss and Hedy Giusti-Lanham (later
Hedy Allen); Sydney Freedberg, Elena Vandervoort, and Anna-Maria Cicogna
provided continuity and counsel on the board too. Rollin Hadley's spouse, Shelagh
Hadley, an instructor of Italian at Boston University, labored behind the scenes to
coordinate events and provide advice. President Hadley's significant contributions
to SV are sometimes overshadowed by those of his predecessor and successors,
whose strong personalities earned more attention. Yet Hadley served longer than
anyone else as the president, and he steered the organization on a steady course
for more than a decade.[1] His position as director of the Isabella Stewart Gard-
ner Museum—regarded as an outpost of historic Venice in Boston—combined
with his numerous contacts in Venice and in the art world, served SV well.[2] The
chapters in Boston and New York remained active in this period while those in
New Orleans and Washington, DC, faded away. Substantial conservation proj-
ects included the basilica of Santa Maria Assunta on Torcello, the church of Santi
Maria e Donato on Murano, the church of San Giovanni Crisostomo, and a slew
of paintings by Tintoretto in the Palazzo Ducale, including the massive *Paradise*
in the Sala del Maggior Consiglio. Partnerships with UNESCO, the International

FIGURE 11. Rollin (Bump) van Nostrand Hadley, 1988. Gelatin silver print. Photograph by Greg Heins (1945–). Longtime director of the Isabella Stewart Gardner Museum in Boston (1970–88), Hadley personifies the special connection between that museum and Venice. Born in 1927, he served Save Venice as Boston chapter chair (1971–74) and then as Save Venice president (1974–86) and chair (1986–88). Photo courtesy Isabella Stewart Gardner Museum, Boston

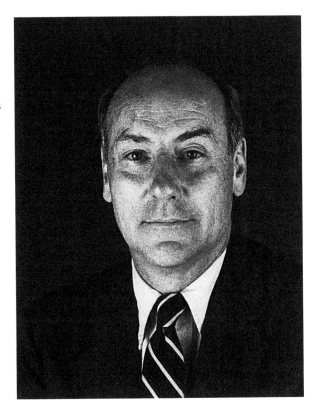

Fund for Monuments (IFM), prominent donors, and other private committees were crucial for SV in this period, particularly as Venice approached the twentieth anniversary of the 1966 flood.

Hadley at the Helm: 1974–1978

The conservation projects in the mid-1970s were largely continuations of those already underway. The Scuola Levantina heating system, the Negroponte altar-piece, and the walls of the Gesuiti church were each finished by the end of 1976; the records consistently list higher-than-expected costs, but SV was able to absorb these without difficulty.[3] With a leadership gift by Countess Elsie Gozzi, in 1977–78 SV helped to launch the Fortuny Museum in the Palazzo Pesaro degli Orfei, a spectacular gothic building near Campo Sant'Angelo that had previously served as a photography, textile-design, and painting atelier for designer Mariano Fortuny

(1871–1949).[4] Spurred in part by rivalry with the IFM, SV agreed to restore paintings from a suite of rooms in the Palazzo Ducale, including a cycle of four allegorical Tintoretto paintings in the room known as the Antecollegio and additional works celebrating Venetian diplomacy from the room of the Quattro Porte (Four Doorways).[5] The San Pietro di Castello project, sponsored by the Los Angeles chapter of VC-IFM and Virginia Scott, was finally finished in 1982 (with the separate restoration of the Lando Chapel completed in 2001–3).[6]

One major project initiated in the mid-1970s was the restoration of the cathedral of Santa Maria Assunta on the island of Torcello. An isolated building in serious disrepair but with great historical significance, this venerable structure became the first joint project of SV, the IFM, and Venice in Peril. SV board minutes indicate considerable unease among the directors about this project, as well as a strong desire that SV's own financial commitment should never exceed that of the IFM. Two board members, Sir John Pope-Hennessy and Walter Bareiss, objected to the project as ill-conceived, but John McAndrew responded that the Torcello cathedral was in worse shape than other comparable buildings, and that lack of information about costs or time to completion "is small reason to let the mosaics fall off the walls."[7] Technical difficulties resulted in a slow start, but by March 1978 SV had contributed the substantial sum of $60,000.[8] The principal focus was on stabilizing the building, which suffered from infiltration of rainwater as well as substantial humidity and condensation, resulting in the loosening of mosaics from the wall. Extensive technical studies ensued, as did continued negotiations with the Ministry of Culture, which eventually promised to match any contributions raised by the private committees. Coordinated by the International Torcello Commission under Ashley Clarke, the wall reinforcement, roof replacement, and restoration of mosaics would be completed in 1985.[9]

Similar to Torcello in materials and structural concerns, a second major project of the 1970s was the church of Santi Maria e Donato at Murano, funded completely by Gladys Krieble Delmas and her husband, Jean. Work began in 1974 and proceeded slowly but with important discoveries of Carolingian sarcophagi, late antique reliefs, and the original seventh-century foundation. A radical intervention to create a waterproof subfloor there was able to conserve most of the twelfth-century floor tiles, made of porphyry, serpentine, and other Mediterranean stones. To preserve those tiles, which were corroded by previous flooding and foot traffic, restorers cut the mosaic flooring into pieces like a jigsaw puzzle. Supported by the application of glue and cotton cloth, the pieces were coded and stacked until

they could be reinstalled on the new floor. With over five hundred square meters of mosaics, this represented the most ambitious project that SV had undertaken to date. Complicated and expensive, the cost more than tripled from the original estimate of $100,000. In January 1976 Delmas sent a firm letter to Hadley, agreeing to the increased cost of $60,000 above the $259,000 already pledged, and recognizing that inflation and "inevitable surprises in a work of this magnitude" were to be expected, but she also noted that the cost overrun "has been aggravated by the willingness of Save Venice Inc. to defer to the subsequent demands of the Soprintendenza without stipulating that the latter contribute to the added costs."[10] Frustrated, in January 1977 she stopped all payments for this project.[11] Nevertheless, the project on Murano was completed in 1978, with subsequent maintenance by SV in 2012 and again in 2020.[12]

FIGURE 12. Mosaic pavement, Church of Santi Maria e Donato, Murano, during the 1974–78 conservation treatment. With significant support from Gladys and Jean Delmas, Save Venice sponsored removal of the entire badly damaged mosaic floor, waterproofing of a new subfloor and adjacent areas, and restoration of the floor in the mid-1970s. Photo courtesy Save Venice Photo Archives

A third significant project of this period was the conservation of Titian's *Madonna di Ca' Pesaro* altarpiece in the church of the Frari. Disfigured by a layer of darkened varnish and eighteenth-century repainting, restorer Antonio Lazzarin cleaned it in 1978.[13] Financed by John McAndrew in memory of art historian Erwin Panofsky, the treatment revealed anew the vibrant colors favored by Titian. The Pesaro altarpiece served as a votive painting for the family of Jacopo Pesaro and simultaneously emphasized his valor in war as commander of the papal fleet. The unusual composition of the painting, with the Madonna and child off-center, challenged the conventional approach and represented yet another way in which Titian upended Venetian painting.

Arranging payment for these and other conservation projects required flexibility and a keen eye to expenditures. During the mid- to late 1970s, SV maintained assets of about $150,000, with half of that invested in certificates of deposit and the other half in cash to pay bills.[14] Board meetings always began with a review of recent expenses and income; here the careful eye of businessman Walter Bareiss is evident.[15] An account at American Express Bank in Venice allowed Marialuisa Weston to pay the irregular bills at the San Gregorio laboratory as well as other minor invoices.[16] Currency fluctuations and transatlantic miscommunications occasionally hampered the process of paying all bills on time, but in general the process worked smoothly.

In 1973 Italy had introduced a value-added tax, known in Italian as the Imposta sul Valore Aggiunto (IVA), which imposed an additional 19 percent on the price of products and services, including the conservation of paintings (architectural restoration of buildings and immovable artworks was taxed at 4 percent). In a legal effort to circumvent the IVA, by 1977 SV and some other private committees had partnered with UNESCO, which as an international agency was exempt from the tax. Under this arrangement, UNESCO adopted SV projects as its own and consequently signed the contracts and paid the bills on condition that SV undertook to provide the money, to be paid on presentation of the firms' invoices to UNESCO, countersigned by the director of works at the Superintendency of Fine Arts. Even when UNESCO introduced a handling charge of 2 percent in 1989 and increased it to 5 percent in 1992, Save Venice and its fellow committees could still do more projects for the same amount of money. This arrangement continued, albeit with some changes, well into the twenty-first century.

In December 1975 the board received an unusual offer from Robert Maccoun, who offered to donate his farm property in Vinalhaven, Maine; he estimated a

value of around $200,000.[17] An American marine engineer who trained in Atlantic shipyards, Maccoun moved to Oxford, England, after World War II to restore the Corpus Christi barge there, and in November 1966 founded the Trust for the Preservation of Oxford College Barges.[18] SV recommended to sell the Maine property with half of the proceeds to purchase an annuity for the benefit of Maccoun, but in the end Maccoun sold the property to a local realtor.[19] Maccoun remained a devotee of SV, and at his request in 1983 the organization contributed to restoration of an early twentieth-century harbor pinnace, a fourteen-meter ship intended for display at the Museo Storico Navale (Naval History Museum).[20] Eventually Maccoun's estate would give more than $100,000 to SV for projects "to benefit the restoration and preservation of Venice's ships and naval heritage."[21]

Although SV deliberately avoided direct involvement in larger issues like water management, pollution, and urban decay, these topics could not be entirely separated from art conservation. The organization's newsletters regularly included information about the interminable discussions to stem the *acqua alta*, as well as updates on the Special Law of 1973.[22] Improvements in the levels of air and water pollution, as well as a dramatic slowing of subsidence, were already evident by the late 1970s. SV participated regularly in the annual UNESCO meetings in Paris and Venice, along with the other private committees. Bareiss negotiated on a host of issues at these meetings, including the stone and painting laboratories, IVA payments, and joint projects like that at Torcello.

Several SV chapters withered in the mid- to late 1970s but those in New York and Boston remained vibrant. The Washington chapter, for example, disputed with the SV board in spring 1975 about the degree of cleaning needed for the facade of the church of Santa Maria del Giglio, and the chair, Virginia Murray Bacon, threatened to resign with her committee if she did not get her way.[23] Soon after she stepped aside in favor of Lilian Reinhardt, and the Washington chapter adopted a new project but then disappeared from SV records.[24] The New Orleans chapter cosponsored an exhibition there in 1977 about restoration work carried out in Venice by American firms and raised nearly $10,000 for the Negroponte altarpiece but accomplished little after that.[25] The promised chapters in St. Louis, Miami, and elsewhere did not materialize.

In April 1978 Muriel Howells in Boston observed that in comparison to any other chapter, "New York appears to be the most important."[26] Led by architect Walker O. Cain and Hedy Giusti-Lanham, the New York chapter was indeed

active.[27] For example, the partnership with artist Robert Rauschenberg to issue a print continued; in this case, selling impressions of *Watermark* netted $7,921 in 1974 and $7,436 in 1975.[28] In 1975, with the assistance of Ashley and Frances Clarke, the New York chapter organized a showing of the BBC film *The Great Gondola Race*.[29] In 1977 Giusti-Lanham brought an exhibition about Andrea Palladio, organized by Professor Mario di Valmarana of the University of Virginia, to the Cooper-Hewitt Museum in New York in honor of the American Bicentennial.[30] (Subsequent activities of the New York chapter are discussed in the next section of this chapter.)

The Boston chapter was equally active under the leadership of chairs Henry S. Lodge (1975–76) and Rodney Armstrong (1977–81). In addition to its own screening of *The Great Gondola Race*, the Boston chapter sponsored a traveling exhibition entitled *Venice Restored* at the Boston Museum of Science in the fall of 1976 that juxtaposed images of Venice from the sixteenth century with those taken before and after the 1966 flood.[31] The intention of the exhibition was to demonstrate the recent restorations by the various private committees, among them Save Venice. By November 1976 the Boston chapter had raised $76,000 to continue the restoration of the church of the Gesuiti.[32] In May 1977 Countess Aloisia Rucellai of Florence donated 25 percent of the sales of her unusual jewelry at a cocktail party in Cambridge.[33] The annual appeals of 1976, 1977, and 1978 each raised an average of about $10,000.[34] The Boston chapter benefited from the energy of Eleanor Garvey, who kept exemplary records in her roles as secretary and treasurer for the Boston chapter, and who was frequently tasked with investigating event venues, possible speakers, and additional activities.

With regard to staffing, we have already seen the appointment of Marialuisa Weston as a translator beginning in 1974–75. She wrote or cabled frequently to New York and to Boston, conveying not only amounts of invoices and the necessary contexts of projects but also her own opinions about the craftspeople with whom she worked and the worthiness of various projects. She was extremely detail-oriented and worked hard for Save Venice; her letters make clear that she adored the McAndrews and Vandervoort, and tolerated Bareiss and treasurer Harry Halpern.[35] In a letter of 3 September 1975 Vandervoort asked Weston to send a report to New York every two weeks about the latest updates and to number the letters so that it would be evident if one had gone missing (as had happened several times in 1973–75, especially with a prolonged Italian postal strike).[36] In New York the SV directors voted in April 1975 "to release Bruce Hooton from his responsibilities as

Executive Director and [instead] add his name to the General Committee."[37] The extant sources are silent on the rationale for this decision. Given the difficulty that SV occasionally experienced in transferring money to pay contractors in Venice, Hooton's dismissal was perhaps a cost-cutting measure to ensure that Weston's position could be preserved.

1978–1986

The death of John McAndrew in 1978 was a sad milestone for Save Venice. He passed away on 18 February that year and was buried in the city that he loved so well; the epitaph on his gravestone promised that he would never again leave Venice.[38] A tribute by his longtime colleague Sydney Freedberg described McAndrew as a "brilliant and influential teacher" and "an amazingly successful ambassador for his adopted city."[39] Freedberg estimated that despite the all-volunteer nature of SV, McAndrew had raised close to a million dollars between 1971 and 1978, all of it destined for Venice. Nor did McAndrew's ability to coax funds cease with his passing; a memorial concert at Santa Maria del Giglio in Venice on 13 September 1978 raised additional funds, and that autumn the board embarked on a campaign in his memory for a restoration at Torcello.[40] The tributes poured in by post and telegram; memorial concerts were held in Wellesley and in Venice, and Francesco Valcanover dedicated to McAndrew a bilingual collection of technical studies on Venetian paintings restored through SV.[41] Even Cardinal Albino Luciani, the former patriarch of Venice and briefly Pope John Paul I later that year, sent a message of appreciation to Betty McAndrew recognizing her husband's efforts on behalf of the Serenissima.[42] Indicative of a defining characteristic of the organization, namely honoring its predecessors, twenty years later Randolph (Bob) and Beatrice Guthrie restored the Badoer-Giustinian chapel in the church of San Francesco della Vigna in memory of John and Betty McAndrew.[43] The same edition of the 1978 newsletter that announced John McAndrew's death also reported the deaths of Thomas Hess and Henry Seldis, both of whom had been directors of SV in the early years, making 1978 an important milestone in the history of the organization.

Despite the loss of its beloved leader and two of his lieutenants, the organization actively pursued its goals in Venice and in the United States after 1978. The Boston chapter held regular meetings and fundraising events under the leadership of Rodney Armstrong and Peter Fergusson; its periodic donations of $25,000–$30,000

allowed crucial restoration work to go forward through the mid-1980s.[44] The New York chapter was vibrant too, under Walker O. Cain and Gabriella Lorenzotti, with a steady array of balls, receptions, and exhibitions. The Los Angeles group was largely quiet, maintaining its primary affiliation to the IFM. SV letterhead in this period lists two offices, suggesting their equality: one at 2 Palace Road in Boston (Hadley's office at the Gardner Museum) and the other at 60 East 42nd Street in New York (Bareiss's office in the Lincoln Building). The growing influence of New York remains evident in the documents, as most SV activities—banking, fundraising, publicity mailings, directors' meetings—took place in New York. In terms of restoration and conservation, SV continued to fund a range of modest projects in Venice, but one can begin to see glimmers of wider ambition in the 1980s, as in the decision in 1983 to fund Tintoretto's massive *Paradise* painting in the Palazzo Ducale for $100,000. Far grander in scope and more urgent in need was the decision in 1986 to take on restoration of an entire church for $1 million (discussed in the next chapter). The remainder of this chapter describes SV operations from 1978 to 1986, including governance, conservation, partnerships, chapter activities, and the twentieth anniversary in 1986.

Immediately after the death of John McAndrew in February 1978, the board asked his widow, Betty McAndrew, to become a director, and she remained in that position until her own death in 1986. Thomas S. Buechner, the president of Steuben Glass and a trustee of the Brooklyn Museum, was also nominated as a director in 1978, while Priscilla Barker took over as secretary in that year.[45] Other important appointments included those of Berlin professor and art historian Wolfgang Wolters (1980), Los Angeles philanthropist and novelist Terry Stanfill (1981), and supermarket heir Lawrence (Larry) Lovett (1981).[46] They were soon joined as directors by Danielle Gardner, wife of the U.S. ambassador to Italy (1982), New York art collector and philanthropist Lily Auchincloss (1983), and British art historian and museum director Sir John Pope-Hennessy (1983).[47] After many years of service, Elena Vandervoort and Harry Halpern stepped down from the board in 1984. Lovett assumed the position of treasurer in 1984, while Wolters served as project director, in effect the point person on the board for selecting and monitoring restorations. One year later surgeon Randolph (Bob) Guthrie joined as a director.[48] Within a few years these directors would usher in a dramatic change in the scope of SV activities; from 1978 to 1986 they would oversee several important conservation projects as well as the creation of a Junior Committee in New York.

FIGURE 13. Leadership of Save Venice in early 1986 (clockwise, from upper left): Treasurer Randolph H. Guthrie Jr.; President Lawrence D. Lovett; Chair Rollin van N. Hadley; Directors Lily Auchincloss, Hedy Giusti-Lanham Allen, Terry Stanfill. Together with fellow board members and staff, these six individuals led the dramatic growth of Save Venice over several decades, in New York, Boston, and Los Angeles.
—Photo courtesy Save Venice Photo Archives

Restorations from 1978 to 1986 included an array of paintings, sculptures, windows, floors, well-heads, and the bronze flagpole bases in Piazza San Marco. Much work was done in 1980–81 in the church of San Francesco della Vigna, including canvases by Francesco Fontebasso, Francesco Maggiotto, Jacopo Marieschi, and Paolo Veronese.[49] Tullio Lombardo's large marble relief altarpiece, the *Coronation of the Virgin,* in the church of San Giovanni Crisostomo was completed in 1981.[50] SV gave $10,000 in 1982 to facilitate flood-proofing in Palazzo Venier dei Leoni, housing the collection of Peggy Guggenheim, followed by additional donations to clean bronze statutes in the Zen chapel and the bronze cover of the baptismal font, both inside the southwest corner of the basilica di San Marco.[51] In 1986 funds were appropriated for repairs to Mauro Codussi's beautiful church of San Michele in Isola, which had been one of the churches carefully studied by John McAndrew in his book on early Venetian architecture.[52]

The work of Jacopo Tintoretto was a favorite of SV in the mid-1980s; as the SV newsletter of autumn 1984 noted, "It may seem that a disproportionate amount of the attention of Save Venice is going to the restoration of works by Tintoretto, but it must be remembered that Tintoretto was not only one of the greatest painters of the greatest age of Venetian painting, but also most prolific of all the Venetians. He has just a greater quantity of masterpieces than any other Venetian to restore!"[53]

The most dramatic of these conservations was Tintoretto's massive *Paradise* of the late sixteenth century, reputed to be the largest old master canvas painting in the world at 189 square meters. Restored for $100,000 between 1982 and 1985 by Serafino and Ferruccio Volpin under the direction of Francesco Valcanover and Ettore Merkel, the painting dominates the Sala del Maggior Consiglio. At the age of seventy, Tintoretto completed this enormous painting with workshop assistance led by his son Domenico. Nearly five hundred individual holy figures crowd the scene, interacting with each other or staring up toward the Virgin Mary and her son, who dominate the top of the canvas. The Archangel Gabriel hovers to the left of Mary while the Archangel Michael is on the right of Christ. The figure of Christ wears a ducal robe and is situated almost exactly above the doge's throne, thus clearly conveying the link between them.[54]

In keeping with past practice, the selection of projects was made jointly by the directors, each of whom had significant experience with art and Venice, often after in-person evaluations and site visits. There were sufficient authorities on the board that there was no need to defer to a committee of experts beyond those already serving. The minutes and correspondence suggest that Rollin Hadley, Walter Bareiss, and Sydney Freedberg usually had prominent roles in determining projects.

Beyond restoration of art and architecture, SV invested in training restorers and augmenting technical knowledge about historic preservation. For example, in 1980 Save Venice contributed to a six-month typological survey of Venice's historic center, directed by Ennio Concina of the University of Venice, with the resultant publication (in French) in 1981 underwritten too.[55] Also in 1981 SV funded the research of Emanuele Armani to determine the original formulas and colors in plaster used on the exteriors of buildings in Venice. Dubbed the "Venetian Plaster Project," it was an important example of rigorous scientific testing, used to guide the conservation of buildings throughout Venice.[56] From 1981 to 1987 SV supported Helmut Reichwald's compilation of a conservation report on the interior of Palazzo Grimani at Campo Santa Maria Formosa, including translation from German to Italian.[57] As noted previously, SV contributed regularly to the Misericordia stone conservation lab with the purchase of equipment and computers from 1971 through 1991; SV offered similar material support over two decades to the Superintendency of Monuments, the Superintendency of Fine Arts, and the San Gregorio restoration laboratory.[58] Taken together, these contributions underscore the desire of SV not merely to clean and conserve paintings or sculpture for aesthetic purposes but to promote scientific research and testing in order to improve best practices in conservation.

A significant *acqua alta* just before Christmas in 1979, with a high-water mark of 166 centimeters—below the 194 centimeters of November 1966 but still alarming—reawakened concerns about flooding. In 1981 the Ministry of Public Works brought together a group of experts informally to devise a comprehensive plan (*Progettone* or "Big Project") to preserve the hydraulic balance of the lagoon. In late November 1984 the Italian government passed a second iteration of the Special Law (no. 798), allocating $330 million over three years to revitalize the lagoon barrier project as well as to reduce pollution and restore monuments and public works in Venice and Chioggia. To facilitate cooperation, a new entity—the Consorzio Venezia Nuova—was formed as a consortium of major Italian construction firms to conduct research and coordinate implementation. It was hoped that this version of the law would spur the resumption of dredging and repair in Venice's 174 canals, to increase the flow of water and tidal cleansing. In a report published about the Special Law in the autumn 1985 SV newsletter, Philip Rylands lauded the "present climate of experiment and flexibility" as well as the "generally optimistic mood" in Rome and Venice.[59]

Perhaps inspired by that mood of optimism and flexibility, in the mid-1980s SV and the IFM explored a possible merger. The impetus was the retirement of Colonel James Gray in 1984 and the relocation of the IFM from Washington, DC, to offices within the Kress Foundation in New York City. Art historian Marilyn Perry, who was the president of the Kress Foundation and a trustee of the IFM, explained to the SV board that the IFM was going through a major self-study about its mission and scope, and thus was open to all possibilities. Not surprisingly, the SV board immediately raised questions about autonomy, board structure, overhead costs, and whether a name change would be necessary. Extensive discussions ensued.[60] Tentative efforts at collaboration included joint publicity for a Christmas calendar featuring Venetian scenes and cost-sharing for a course on stone preservation at the Misericordia laboratory for twenty students in Venice.[61] Despite the support of Freedberg for a merger, other directors were uncomfortable with the idea of returning to be an "arm" of the IFM and losing their identity. In the end, the proposed merger did not occur; the IFM changed its name to World Monuments Fund (WMF) in 1985, codifying its global mission, while Save Venice maintained its focus on the Serenissima. Three years later Bea Guthrie announced that the WMF was terminating its Venice Committee, noting that the WMF hoped SV would take up its work in Venice and collaborate with the WMF's new Italy committee and the Kress Foundation's European Preservation Program.[62]

One legacy of these discussions with the IMF/WMF, however, was renewed interest by SV in having a permanent office of its own in Venice. The IFM had offered in 1984 to share space at the church of the Pietà with SV and with Venice in Peril, an idea the SV board had found "very favorable."[63] Three years later WMF executive director Bonnie Burnham again offered to share its Venetian secretary, Donatella Asta, with Save Venice; once again the board expressed cautious interest.[64] Three months after that on 1 August 1987, SV obtained its own office at Palazzo Marcello, located in campiello San Vidal at the foot of the Accademia Bridge and adjacent to the Grand Canal.[65]

Chapters: Boston, New York, and Los Angeles

In keeping with the example set by McAndrew and Freedberg, leadership of the Boston chapter was dominated by academics. Rodney Armstrong was chair of the Boston chapter from 1977 to 1981 and served simultaneously as president of the New England Historic Genealogical Society. He had previously been the librarian at Phillips Exeter Academy (1950–73) and then director of the Boston Athenæum (1973–97). Armstrong was succeeded by Professor Peter Fergusson of Wellesley College, who served half a dozen years as Boston chapter chair (1981–86).[66] A British expatriate who specialized in medieval architecture and loved all things Italian, Fergusson was not only McAndrew's colleague at Wellesley in the late 1960s but in 1971 purchased the McAndrews' house at 107 Dover Road. During his tenure as chapter chair, Fergusson wrote dozens of elegant letters to current, prospective, and lapsed members, encouraging all of them to give to Venice in whatever ways they could. On 30 May 1986, for example, Fergusson authored a cover letter for the annual newsletter making his case for Venice: "While the needs of Venice remain acute, there is much to be proud of in the international effort to protect what we believe is the most beautiful city in Europe. Its thousand-year history as a Republic, and the extraordinary artistic patrimony which it called into being and which remains its most enduring hallmark are unique—and worth safeguarding."[67] Fergusson passed the baton to Watson (Watty or Dicky) B. Dickerman later that year.[68] Deeply interested in historic conservation, Dickerman had been the secretary and treasurer of the IFM from 1978 to 1985 and would later cofound the Katmandu Valley Preservation Trust from his home in Cambridge. Dickerman studied art history under Sydney Freedberg at Harvard in the late 1960s and always credited Freedberg for kindling his interest in art and architecture.[69]

With such strong leadership, the Boston chapter was active through the mid-1980s, organizing one major party each year as well as an annual general meeting and occasional educational activities. For example, in 1979, 1981, and 1982 the chapter sponsored a spring ball at Harvard's Busch-Reisinger Museum. In 1983 it organized three dozen dinner parties and a preview screening of *Le Cadeau*, a French-Italian farce set in Venice; in 1984 it held a dinner dance at the Copley Plaza Hotel with Venetian singers and Italian wines transported by Alitalia; and in 1985 it organized yet another party at Bloomingdale's department store in Chestnut Hill, featuring jugglers, gondoliers, and a fortune teller.[70] Janice Hunt played a leading role in organizing these events; she had been a student of John McAndrew at Wellesley College and later served the college as trustee and president of the alumnae association. The Boston chapter also sponsored Italian wine tastings, film premiers, and a reception for the traveling exhibition *Americans in Venice, 1879–1913*, featuring works by John Singer Sargent and James Abbott McNeill Whistler.[71] In May 1981 over three hundred people gathered to watch James Ackerman's film *Palladio the Architect* at the Busch-Reisinger Museum and to meet the Italian consul general of Boston, Vittorio Fumo.[72]

A summary financial statement prepared by the Boston chapter in November 1986 provides a snapshot of the previous five years of fundraising and confirms its steady contribution of about $40,000 annually.[73] Such a statement also provides insight into the number of contributors and attendees over time, with approximately 140 donors to the annual appeal and about 240 guests for each benefit gala. It confirms the importance of the annual appeal as a low-cost, high-return activity netting about $15,000 annually, as well as steady growth in the amounts raised by the galas, culminating in $36,000 raised in 1985.

The lack of a similar table for the New York chapter makes a direct comparison difficult, but it is clear from other sources that the New York chapter was similarly active from the late 1970s to the mid-1980s. Unlike the Boston chapter, which maintained a vigorous and independent executive committee to organize its activities, the New York chapter was more reliant on the chapter chair. In 1981 Hedy Giusti-Lanham became vice president of SV (together with Walter Bareiss) and passed the chair of the New York chapter to Gabriella Lorenzotti. The events organized in New York by both women reflected the interests and location of the New York chapter.

In 1979, for example, the New York chapter organized a supper dance at Bloomingdale's featuring a long line of Fiat cars stretched all around the block on Third Avenue, with the cars arranged red, white, and green in succession. One lucky couple went home with a golden Tiffany keychain containing the keys to a Fiat La

Strada; another won a pair of round-trip airline tickets to Rome and a dinner at the American embassy with Ambassador Richard Gardner and his wife, Danielle.[74] In November of the same year the New York chapter brought the photographic exhibition *Venice Restored* to the Banco di Napoli building on Park Avenue. The chapter also hosted the president of the Veneto region, Angelo Tomelleri, to learn more about current relations between UNESCO and the private committees.[75]

In the spring of 1981 the chapter held a benefit dinner at the historic Barbetta restaurant, featuring a line of clothes by Koos van der Akker entitled "Love for Venice."[76] In subsequent years Barbetta and its owner, board member Laura Maioglio Blobel, regularly hosted Save Venice donors for special meals, particularly after lectures. The New York chapter also worked closely with other organizations to raise money for Venice: for example, it partnered with the Decorators Club to arrange a tour of the Veneto and a fancy-dress ball in Venice in September 1981, and with a Mrs. Joseph Montaldo of Long Island to sponsor a benefit concert with the title "Dollar Offering Venetian Endeavor (D.O.V.E.)."[77] In February 1982 the Venetian artist Esmeralda Ruspoli exhibited her collages at a New York gallery; according to the SV newsletter, "the ladies of the New York committee addressed, telephoned, cooked, and showed up in force" with the result that "the evening's proceeds swelled the N.Y. Chapter's coffers."[78] The New York chapter organized other receptions and parties in response to important events in Italy, such as the cleaning of Tintoretto's *Paradise* in 1986. Traveling exhibitions—about Andrea Palladio, John Singer Sargent, or other historical figures with Venetian connections— were regularly held at the Metropolitan Museum, the Cooper-Hewitt Museum, and the Coe-Kerr Gallery throughout the 1980s.[79] In short, the New York chapter exhibited enthusiasm and achieved success with a wide variety of events.

One distinct feature of the New York chapter was the presence of a "Junior Committee" designed to attract young professionals in Manhattan. The group was formed in spring 1983 by Mark Fehrs Haukohl and Alexandra Stafford at the suggestion of Hedy Allen.[80] A kickoff event at the home of Mimi Stafford that summer led to a series of events, both independently and in conjunction with the full chapter. One of those events was a benefit dinner at the Carlyle Hotel in late fall of 1983, featuring Guy de Rothschild and the daughter of the Count of Paris. Somehow the guest list had grown to 362, even when the Carlyle had clearly stipulated a limit of 250. With a combination of buffet stations and creative seating, Lorenzotti and her committee were able to satisfy all the SV guests at this black-tie event.[81] In July 1986 the Junior Committee organized a dinner dance in honor of the cadets of the *Amerigo Vespucci*, an Italian "Tall Ship" docked in New York Harbor for the

July 4 festivities. The event was held at the Italian consul general's office at 690 Park Avenue, with attire to be "black tie or Venetian fantasy." In his new role as SV president, Larry Lovett was named an honorary co-chair, along with the Italian ambassador Rinaldo Petrignani. The proceeds were to benefit Pietro Lombardo's marble pilasters in the church of San Giobbe.[82]

The significance of the Junior Committee in New York was threefold. First, it developed a robust approach to fundraising that engaged young professionals and integrated them into the organization. According to cofounder Haukohl, "The Save Venice Junior Committee was the first major gathering of juniors interested in the arts in New York. . . . Junior Committees obviously blossomed in the 1990s, [but] they were simply not around prior to [that of] Save Venice. Even major museums like the Metropolitan Museum of Art did not focus on this genre."[83] Second, the Junior Committee laid the foundation for the extraordinary success of later "Young Friends" committees. In New York and Boston, masked Carnevale parties organized by the Young Friends would in some years become the top-grossing annual events for their respective chapters. Third, the Junior Committee provided a pipeline for younger members to hone their fundraising and organizational skills. For example, Tia (Fuhrmann) Chapman, Beatrice Rossi-Landi, and Allison Drescher would each assume major leadership roles for SV after serving in the Young Friends; Haukohl leveraged his experience with the Junior Committee to be a charter member of the Medici Archive Project in Florence and would eventually be recognized by the president of Italy for his contributions to Italian culture.[84]

Even if not yet formally a chapter of SV, the Los Angeles group was fortunate to have the dynamic figure of Terry Stanfill as chair. Married to the head of Twentieth Century Fox, Dennis Stanfill, she was at the center of Los Angeles and Hollywood society and deeply engaged in philanthropy with the Huntington Library and the Norton Simon Museum. She had joined the Committee to Rescue Italian Art (CRIA) and the Venice Committee of the IFM in the late 1960s and led the campaign to restore the cathedral at San Pietro di Castello in the 1970s. She also oversaw events for Venice in Peril and for the International Torcello Commission (ITC) in Los Angeles and in Venice. For example, in October 1979 Stanfill organized a dinner at the Getty Museum in Malibu that featured Venetian scholars Francesco Valcanover and Terisio Pignatti to mark the exhibition *The Golden Century of Venetian Painting* at the LA County Museum.[85] That event primarily benefited the ITC but also supported SV. Stanfill sat for many years on SV's General Committee and was appointed a director in 1981.[86]

The year 1986 marked the twentieth anniversary of the 1966 flood and thus provided both Venice and SV the opportunity to reflect on what had been accomplished in two decades. In the autumn 1986 newsletter—the first to feature color photographs—outgoing President Hadley wrote an essay describing the flood and the response of SV as a "miraculous" success that "transformed crumbling structures, damaged sculpture, and neglected paintings into the priceless treasures that they once were." He praised the concrete results of the two Special Laws, including a new aqueduct, a sewer system, and the restriction of heating fuel pollution in the city center, with the lagoon gates still to come. Hadley briefly described more than a dozen of the major projects sponsored by SV over twenty years and closed with an appeal to his readers: "Save Venice is proud of the breadth and depth of the noble projects we have undertaken. . . . You can be sure that virtually all of your contribution to Save Venice goes directly to the restoration and preservation of the city we love."[87]

In sum, the period of 1974–86 was one marked by continuity for Save Venice. Hadley offered thoughtful and consistent leadership for a dozen years, perpetuating the vision of John McAndrew and other early founders who had gradually stepped down from their roles. SV organized myriad fundraising activities, from traditional dinner dances and cocktail receptions to film premieres and gallery exhibitions. The chapters in Boston and New York each developed their own identities and procedures, selecting their restorations and raising the necessary funds. The two chapters cooperated with the parent group in preparation of newsletters and occasional shared speakers. The New York Junior Committee represented an important step forward in broadening the donor base and in proposing new ideas. A failure by SV leadership to file the required annual reports with the Massachusetts secretary of state in 1983, 1984, and 1986 went unnoticed at the time but would have consequences later, as discussed in the next chapter.

By the mid-1980s, then, Save Venice had firmly established itself in Venice as one of the private committees focused on historic conservation. It met regularly with the other private committees, and it boasted an active roster of conservation projects across the city. When Peter Fergusson stepped down as Boston chapter chair, he estimated that in fifteen years (1971–86) SV had raised $1.5 million dollars for restoration.[88] The rejected merger with IFM underscored SV's desire to remain independent and focused solely on Venice. As it approached the twentieth anniversary of the 1966 floods, however, Save Venice would appoint a troika of new leadership, leading to a remarkable transformation in its size, scope, and ambition.

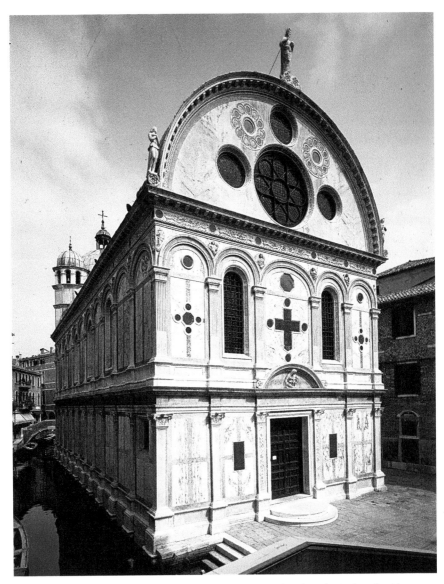

FIGURE 14. Church of Santa Maria dei Miracoli, main facade and exterior, after the 1988–97 conservation treatment. Sheathed in marble inside and out, built alongside a canal, and thus particularly vulnerable to infiltration of saltwater, the church of the Miracoli underwent a comprehensive restoration lasting a decade. Easily Save Venice's most expensive project to date, preserving the Miracoli refined conservation methods used in subsequent projects in Venice and elsewhere and proved that the organization could complete extremely ambitious restorations.

—Photo by Matteo De Fina, courtesy Save Venice Photo Archives

Chapter 4

CRESCITA

New Leadership and Expansion (1986-1996)

With Watson Dickerman taking over from me, and Larry Lovett from Bump [Hadley], and with Betty McAndrew's death, Save Venice is changing. One should see it as renewal, I think. Both Dicky and Larry know the City well, they have apartments in it, they are visible and at hand. They know the eastern seaboard equally well and I think will be extremely effective. So Venice is in good hands.

—Peter Fergusson (1986)

PETER FERGUSSON's optimistic view of the position of Save Venice in 1986 mirrored a broader sense in Venice in the 1980s that things were finally looking up.[1] Twenty years after the flood there was demonstrable progress in restoring public monuments and important paintings. Prime Minister Bettino Craxi in 1986 heralded the *Progetta Venezia* [Venetian Project] as "the first of a new generation of public works."[2] In 1985–86 the Peggy Guggenheim Collection (PGC) and the Palazzo Grassi both opened full-time to visitors; while the two institutions differed in size and purpose, they broadened opportunities to exhibit art in Venice.[3] Several years earlier the Architecture Biennale had repurposed the old rope-making building (*Corderie*) of the Arsenale to create an extensive new space for exhibitions, showcasing how to convert a former industrial building to display contemporary art and inspiring subsequent examples such as the Tate Modern in London. The resurgence of Carnevale in Venice—eloquently expressed in the photographs of Fulvio Roiter—brought tourists, and thus jobs, during the winter months. Increased awareness of the complex lagoon ecosystem, coupled with additional funds from the Special Law of 1984, promised that environmental risks would be addressed more competently. A new *Atlas of Venice* in 1989 used hundreds of aerial photographs to create an updated, color version of Jacopo de Barbari's famous woodcut view of the city; this map was intended to help with urban planning but also showed Venice at its best.[4] Historians have looked back on the 1980s as an era of successful architectural experimentation, particularly at the edges of the

historic center and on the islands of the lagoon.[5] All of these examples suggested that Venice was identifying ways to reinvent itself yet again, to rise like a phoenix from the decay and depression of the 1970s.

Success within Venice was matched by economic expansion more broadly across the Veneto and much of Italy, in what economists and the press described as *il sorpasso* (literally "the overtaking"). This Italian term referred to the fact that by 1987 Italy had overtaken Great Britain in nominal GDP, and by 1989 Italian per capita income ($15,120) exceeded that of Britain ($14,160). This made Italy the sixth-largest economy in the world, and by 1991 it had also surpassed France and the dissolved USSR to become the fourth-largest economy.[6] With hundreds of small- to medium-sized family businesses, the Veneto was one of the economic engines that powered this revival. These gains were not permanent, however—a large public debt, stubbornly high unemployment in the south of Italy, and the introduction of the euro at the end of the 1990s would hobble the Italian and Venetian economy.

The ebullient optimism of the 1980s was tempered by several specific setbacks within Venice itself. The Pink Floyd rock concert of 15 July 1989 crystallized concerns about mega-tourism as 200,000 people crammed into the area around Piazza San Marco to hear the band perform on a barge in the *bacino* (bay). Contemporary accounts agree that the concertgoers were relatively well-behaved and that only one sculpture (*The Judgment of Solomon* on the northwest corner of Palazzo Ducale) was damaged, but the images of trash strewn across the piazza and the criticism from Italia Nostra were powerful; a few days later Mayor Antonio Casellati and the entire city council were forced to resign.[7] Concern about over-tourism also resulted in popular agitation against hosting EXPO 2000 in Venice; that proposal was scuttled in 1989. In that same year the road into Venice was temporarily closed when the parking area at Tronchetto filled with visitors. Likewise, 1989 witnessed rejection of a referendum to separate historic Venice from Mestre and the mainland, demonstrating a lack of political unanimity among Venetians as they struggled to define issues crucial to the survival of their city. Journalist Sandro Meccoli wrote in early 1990 in *Il Gazzettino* about a "spiral of decadence . . . [that] threatens to crush the city."[8] Extensive debate and planning over a new future for the vast space of the Arsenale in the early 1990s yielded little result. Steady depopulation of native Venetians meant that there were fewer and fewer permanent residents: the population declined from 123,000 (1966) to 84,000 (1986) to 69,000 (1996). Tax evasion, cronyism, and an Italy-wide economic slump in the later 1990s slowed the economic growth that had boosted Venice and the Veneto a decade earlier.[9] The

tragic fire that destroyed the Teatro La Fenice opera house in 1996 was the most visible sign of things gone wrong in the 1990s. Thus, the optimism of the mid-1980s gradually gave way to depressing failures and discord by the mid-1990s.

Returning to the story of Save Venice and the ebullience of the mid-1980s, in 1986 SV president Rollin Hadley relinquished the office to his Harvard classmate Lawrence (Larry) Lovett, accepting instead the honorary title of chair. Lovett had risen quickly through the organization as director (1981), treasurer (1984), and now president. A cultured man who traveled widely, Lovett (born 1930) had begun his career in the steamship business and later oversaw a trio of family companies, including Eastern Steamship Lines. His deep love for classical music and the pleasure he derived from social events drew him to a second career of nonprofit service.[10] Lovett tapped Dr. Randolph (Bob) Guthrie to replace him as treasurer in 1986; several months later, Bob's wife, Beatrice H. Guthrie, assumed the post of executive director for SV. Five years younger than Lovett, Bob Guthrie was the chief of reconstructive and plastic surgery at New York Downtown Hospital, widely recognized for his talent in the operating room, and a professor at Cornell Medical School. He would serve as treasurer (1986–89), president (1989–97), and chair (1998–2006) of SV, as well as organize and lead multiple cruises and trips.[11] Bea Guthrie had previously served for five years on the board of the Metropolitan Opera and for two years on its executive committee, where she had honed her skills at raising funds with high-net-worth individuals, and where she had met Larry Lovett. She served twice as executive director of Save Venice (1987–99, 2003–6) as well as on its board of directors in between and following her executive appointments.[12] With the ascension of Lovett and the Guthries, the retirement of Rollin Hadley, and the passing of Betty McAndrew, Save Venice underwent a substantial transformation.

This troika of Larry Lovett, Bea Guthrie, and Bob Guthrie would revolutionize the activities of SV in almost every way from 1986 to 1996. Utilizing modern technology as well as a strong social network, they vastly expanded its donor list and increased the efficiency of its fundraising. They established a biennial gala in Venice featuring, over four days, an elaborate dinner dance, a custom treasure hunt, expert lecturers, and a guest list replete with nobility and celebrities. They introduced luxury educational travel for SV donors, with the Guthries organizing eighteen trips around the world between 1992 and 2013, offering access to private palaces and other behind-the-scenes opportunities. To expand revenue and enhance its public profile, they launched a Save Venice licensing program and partnered with an array of companies and individuals to cross-promote products. Lovett and

FIGURE 15. Lawrence (Larry) Lovett, 1993. Lovett was Save Venice's treasurer (1984–86), president (1986–89), and chair (1989–97); together with Bob and Bea Guthrie, he ushered in a transformation of the organization, enabling the conservation of the entire church of Santa Maria dei Miracoli.
—Photo courtesy Save Venice Photo Archives

FIGURE 16. Randolph (Bob) Guthrie and Beatrice Guthrie, 1987, on the *rio* (small canal) adjacent to the *Casetta Rossa* and the Save Venice office in Palazzo Marcello. Bob Guthrie served Save Venice as treasurer (1986–89), president (1989–97), and chair (1998–2006), while Bea Guthrie was executive director twice (1987–99, 2003–6); they significantly expanded the size and scope of Save Venice activities through innovative fundraising, strong leadership, and personal generosity.
—Photo courtesy Bea Guthrie

the Guthries proposed categories of sponsorship for restorations and offered additional fellowships to Italians (and later Americans) in order to increase technical and scholarly expertise. They opened a permanent office in Venice at 2888A San Marco and visited the city frequently. The hard work and creative flair of this trio catapulted SV to greater prominence and expanded activities, beginning in 1986–87 and continuing for a decade.

1986–1988: Broader Ambitions

The initial steps taken by Lovett and the Guthries in 1986 were quite modest but set the stage for later success. For example, at the May 1986 board meeting Bob Guthrie "explained the benefits of having the [mailing] list in a computer" instead of a typescript.[13] In the next meeting of October 1986, "The Treasurer [Bob Guthrie] then reported on the results of the computer analysis of giving which showed a dismal lack of repeat giving. It was generally agreed that the organization is missing a great many donations by not following up on gifts and by not expanding our lists."[14] The minutes noted dryly that "the president and the treasurer are looking into ways of reorganizing the fundraising."[15]

Such changes were in fact already underway. In the meeting of May 1986 the board had considered (but ultimately declined) a partnership with the charter airline Pilgrim Air; it then accepted an offer from Caffè Bristot of Venice to donate to SV a percentage of the profit of every bag of coffee sold by the Caffè, estimated at 100 lire (14 cents) per bag. The funds raised by such a scheme were negligible, but the proposal signified a willingness to look beyond the conventional receptions and parties that had characterized much of SV's fundraising to date. Furthermore, partnering with a local business conferred a sense of authenticity and suggested a commitment to the city beyond art restoration. SV's leadership might have been familiar with the lucrative partnership established ten years earlier between Venice in Peril and a British pizza chain; although vastly different in scale, the British example represented a similar creativity toward the raising of funds.[16] The reports and memos prepared by Bob and Bea Guthrie in fall 1986 and 1987 display a new professionalism, as well as increased use of computerized spreadsheets and word-processing programs.[17]

The willingness to challenge the status quo was also evident at the board meeting of October 1986, when Lovett made the audacious proposal to restore an entire church (Santa Maria dei Miracoli) at an estimated cost of $1 million.[18] The other directors were intrigued. In order to raise the necessary funds, Lovett suggested

holding a dinner-dance in Venice the following September and invited other direc-tors to confer on the details.[19] One month later on 7 November the board met at Lovett's residence in Venice, the Palazzetto Pisani.[20] After a morning visit to view a possible conservation project at the church of San Salvador, during an afternoon board meeting Lovett raised the issue of the Miracoli restoration and received con-siderable support.[21] In the same meeting Lovett arranged for Marchioness Maria Barbara Berlingieri to join the board so that she could "establish contacts with prominent Venetian and Italian people."[22] Inspired by these actions, the board of directors asked Bea Guthrie, identified as "expert on how to proceed," to formulate a strategy to raise the monies needed to restore the church. One month later she returned with a plan outlining the nascent ball in Venice:

> Mrs. Guthrie then gave a detailed report on the *Ball in Venice* which would be held on Labor Day weekend [1987] in benefit of Save Venice. The Palazzo Pisani Moretta, where the ball for 350 persons will take place, has been reserved for the evening of Thursday, 3 September. She envisions a dinner dance, begin-ning at 8:00 p.m. The cost of the evening, $130,000, has been underwritten by Miguel Cruz, the Italian fashion house owned by Roberto Polo [whose] spring collection would be presented at the ball. . . . She described the various events planned for the next two days, luncheons and dinners at private palazzi and villas, perhaps a trip out to the Veneto, and finally, the Regatta on Sunday, 6 September.[23]

The concept of a multievent gala spread over several days was inspired by the inauguration of the Domaine Michel winery in Sonoma County, California. Bea Guthrie had learned that the vineyard's owners encouraged their neighbors to host events on previous and subsequent days, creating an extended program and thus inspiring guests to make the trip.[24] She adapted that idea and made it a centerpiece of her vision for the event in Venice. In this manner Bea Guthrie established the tradition of the Regatta Week Gala, which would become a signature event for SV, boosting the organization's public profile and increasing its revenue stream by an order of magnitude.[25]

The Regatta Week Gala of September 1987 was the event that most clearly marked the change of leadership at Save Venice. It was audacious, ambitious, and wildly successful: "a party worthy of a doge," according to the *New York Times*.[26] Six months prior to the event, four hundred tickets had already sold out.[27] Another

hundred complimentary tickets, underwritten by corporate sponsors, were provided to politicians, performers, and important Venetians. Bandleader Peter Duchin and his orchestra, as well as cabaret star Bobby Short and his combo, were brought over from New York, forgoing their usual fees. Events included a fashion show at the Fenice theater, a lunch at Palazzo Volpi, a concert by I Solisti Veneti at the church of Santi Giovanni e Paolo, another concert at the church of the Pietà by mezzo-soprano Margarita Zimmerman, and tours of Venice given by authors John Julius Norwich, Erica Jong, and Gore Vidal. A special commemorative magazine (the *Gala Journal*) was printed. This publication was designed to seek donations, in the form of full-page advertisements, from individuals and corporations. It contained maps, schedules, and articles about history and restoration projects in Venice to orient guests and provide a keepsake. Guests could drink, dine, and dance in private Venetian palazzi as well as mingle with European aristocracy and wealthy Americans. The corporate sponsors (Tiffany, Moet & Chandon, Bottega Veneta) reflected the socially prominent individuals who were in attendance, including Prince Amyn Aga Khan, Prince and Princess Michael of Kent, Hubert de Givenchy, and Countess Christiana Brandolini d'Adda. Lovett and Berlingieri used their social connections to obtain access to lavish private homes; according to Bob and Bea Guthrie, the Venetians were proud to show off the interiors and eager to support Americans raising money on behalf of Venice.[28] The culmination of the four-day gala was the evening ball at Palazzo Pisani Moretta, which featured dozens of chandeliers with lit candles, imposing topiary arrangements of fresh fruit and flowers, and an elegant seated dinner for all.

The Regatta Week Gala recorded a profit of $402,168, five times more than any other SV event had ever raised. The gala became a milestone in the annals of nonprofit fundraising and a model for future events. Bea Guthrie informed the board that the Regatta Week Gala "had greatly increased Save Venice's visibility to the general public" and substantially increased the number of names on the mailing list.[29] The glowing account in the *New York Times*, and the well-documented participation of important social figures from England, Italy, and the United States, presaged continuing success for this formula.

The amount of money raised by the 1987 gala was impressive. Bob Guthrie announced to the board that SV now had three bank accounts at Chemical Bank in New York as well as additional accounts at Manufacturers Hanover and the Banca Commerciale Italiana in Venice. The group also held a ten-year Treasury note worth over $500,000, projected to generate an annual income of approximately $45,000 to be used for restorations.[30] A detailed spreadsheet prepared by Bob

Guthrie one month after the Regatta Week Gala provided details: corporate and individual sponsors had donated a total of $256,600, the journal had raised $13,674, and ball tickets had generated an astonishing $335,302.[31] Beyond the Regatta Week Gala, SV in 1987 collected $63,424 in annual giving, $6,000 donated by a pair of foundations, and $45,000 from the Boston chapter. The net gain for the year was a prodigious $538,529, and the year-end balance was $738,430.[32] Lovett noted for the minutes that it was clearly "the best report Save Venice has ever had."[33]

The directors were eager to capitalize on the success of the Regatta Week Gala, and they readily agreed to Bea Guthrie's proposal to create a special events committee. Staffed by Lily Auchincloss, Priscilla Barker, Bea Guthrie, Gabriella Lorenzotti, and Elizabeth Peabody, this group immediately began to consider a range of other projects for 1988, including a concert at Avery Fisher Hall, a visit to the Palladian villas of the Veneto, and a deluxe cruise.[34]

Lovett and the Guthries did not achieve all this success by themselves; several staff played key support roles. Karen Marshall joined SV as Bea Guthrie's assistant in New York in January 1987, and together they created an SV office in the lower level of Guthrie's Manhattan townhouse.[35] Among many other projects, they licensed a "Venice Collection" of furniture, tableware, silverware, glassware, jewelry, linens, garden implements, Christmas ornaments, and so forth, available through Bloomingdale's. A professional photographer, Marshall contributed numerous images to SV and served as the director of the New York office from 1995 to 1998 and again from 2002 to 2011. She continued to work part-time in 2012 and into 2013 to ensure a smooth transition for the next phase of leadership in the office. Marshall's calm demeanor and extensive network of friends and professional relationships made her indispensable. She was particularly skilled at remembering the names, faces, and personalities of the whole SV community, from board members to occasional donors. Executive director Liz Makrauer, who worked closely with Marshall after Bea Guthrie's retirement, described Marshall as SV's "institutional memory."[36]

The second important staff member was Marialuisa Weston, who continued to serve in Venice as she had in the past, albeit with mixed reviews from some directors. In April 1987 the board held (unsuccessful) discussions with the WMF about sharing the secretary Donatella Asta in Venice. Despite some directors' hesitation about Weston's executive abilities, she moved into SV's new office in Palazzo Marcello in August 1987 and continued to run the Venice office until her retirement in 1991, when she was succeeded by Maria Teresa (Lesa) Marcello.[37] Melissa Conn joined the Venice office in 1989 initially to assist Weston and then later Marcello.[38]

Weston, Marcello, and Conn were crucial in effectively managing the Venice office. Each contributed different skills, but their combined knowledge of American business practices and Venetian cultural traditions allowed them to execute the complicated financial transactions and supervise the many restorations.

Five new board members joined in 1986–88, bringing experience in the arts, philanthropy, and Venetian matters. As noted above, Maria Barbara Berlingieri was the first to join the board at the invitation of Lovett. Count Girolamo Marcello, a native Venetian who was the director of the Ateneo Veneto (and husband of Lesa Marcello), also offered insight into Venetian culture. Elizabeth Peabody, a longtime resident of Venice who had been a vice president of Bottega Veneta, and John F. Saladino, a noted American interior designer, both joined the board.[39] The fifth director was Everett Fahy, one of the world's top specialists in Italian Renaissance painting. Formerly director of the Frick Collection (1973–86) and then chair of the Department of European Paintings at the Metropolitan Museum (1986–2009), Fahy contributed a connoisseur's eye as well as extensive connections in the art world.[40] Equally momentous for the board was the death of Betty McAndrew in February 1986 and the retirement of Rollin Hadley as chair in June 1988, each of whom represented a direct connection to John McAndrew. Their absence, combined with the introduction of the Regatta Week Gala, the large-scale restoration of the Miracoli church, and an increased number of directors, signified that by the later 1980s SV was moving in new directions under new leadership.[41]

Along with dramatically increased revenue, Lovett and the Guthries upgraded the external and internal communications of Save Venice. The 1988 newsletter, for example, with fourteen color photos and twelve typeset pages, was significantly more sophisticated than the six-page, black-and-white version common in the McAndrew and Hadley eras. The board minutes had always been well-organized under McAndrew and Hadley but beginning early in 1987 they consistently included an agenda and supporting documentation as well as a more standardized format.[42] Reflecting technological changes, beginning in October 1987 the minutes were composed on a word-processor rather than a typewriter. The detailed budget projections and financial summaries prepared on a computer by Bob Guthrie brought greater clarity and detail to Save Venice's financial position. The dates for quarterly board meetings were now set a year or more in advance and on a regular schedule, with the fall meeting typically in Venice and the others in New York. Such developments reflected the greater professionalism that Lovett and the Guthries were introducing to other areas of SV, such as event planning, fundraising, and restoration project management.

FIGURE 17. Save Venice Board of Directors at the church of Santa Maria dei Miracoli, 1988, prior to restoration. The dilapidated condition of the church is evident in the discolored marble and stained pilasters. Top row from left: Everett Fahy, Elizabeth Peabody, Lily Auchincloss, Watson Dickerman, and Girolamo Marcello; second row: Beatrice Guthrie, Anna-Maria Cicogna, Barbara Berlingieri, Terry Stanfill, Priscilla Miller, John Pope-Hennessy, and Wolfgang Wolters; seated: Laurence Lovett, Rollin Hadley, and Bob Guthrie. From the Superintendency of Fine Arts, Adriana Ruggieri.
—Photo courtesy Save Venice Photo Archives

The restorations of 1986–88 included Tullio Lombardo's bas-relief *Pietà* in the church of San Lio, Jacopo Sansovino's enormous funeral monument of Doge Francesco Venier at the church of San Salvador, and an exterior sculpture of Saint Paul at the church of San Polo.[43] The Boston chapter donated $30,000 to conserve the *Pillars of Acre* (*Pilastri Acritani*), two carved square pillars originally from sixth-century Constantinople that were looted by Venetians in 1204 as part of the Fourth Crusade.[44] Even as it pointedly declined a merger, SV agreed to share a new project with the WMF: Cima da Conegliano's high altarpiece *Baptism of Christ*, in the church of San Giovanni in Bragora.[45]

Preliminary work continued on the church of Santa Maria dei Miracoli, primarily investigations of the previous efforts by the German committee and extensive study of the microclimates inside the church. Ironically, John McAndrew had written about the poor condition of the church in his earlier study of Venetian architecture.[46] SV was fortunate to have the doctoral dissertation of Ralph Lieberman, who had analyzed the church in detail in 1971 and whose thesis was published as a book in 1986.[47] In the preface to the book, Lieberman presciently described the challenges faced by SV for the conservation of the Miracoli church:

> Its already deplorable condition worsens yearly, and at a startling rate. Even in the interior there are places where whole areas of sculpted detail have corroded and fallen away. Hasty and unwise schemes to dry out the church have aggravated its condition. In 1977 Kenneth Hempel of the V&A Museum, one of the best-informed stone restorers at work in Italy, suggested to me that probably the only way to save the building would be to dismantle it, throw away the brick walls, treat all the marble in the lab, and then put the church back together again with entirely new walls. If something of this magnitude were not attempted soon, the building would be beyond hope in a decade or so. It is clear that such an intervention would cost several million dollars, assuming that permission for so radical a scheme would even be granted.[48]

Lieberman was correct that some of the brick within the church had become unstable and would need to be replaced. He was also correct about the necessity of cleaning the marble and about the eventual price tag. For SV, scaffolding, scientific instruments, and a stainless steel bath to wash the marble in order to reduce its salinity were some initial expenses for this large project.[49] Ultimately, three years of scientific studies would be required before the restoration itself could get underway; that process is described later in this chapter.

In a meeting of September 1988 the board minutes noted that SV had made a formal commitment only for the research phase at the Miracoli. However, noted the directors, "the Board feels it is morally committed to completing restoration of the Miracoli."[50] The treasurer's report at that 1988 meeting indicated $600,000 in uncommitted assets available for restoration projects.[51] Given that the ultimate cost of the restoration would balloon far beyond the $1 million Lovett had initially estimated, the board was wise to limit its financial promises at the beginning.

SAVE VENICE CHAPTERS

McAndrew's vision of SV chapters scattered across the United States, each raising money in its individual city for the benefit of Venice, had not come to pass. The chapters in Boston and New York, however, remained vibrant and did regularly contribute tens of thousands of dollars per year. In 1988 the board was faced with the surprising problem of a revived chapter in Chicago that wished greater independence. Hadley opined that he thought the Chicago chapter had long since disappeared and that any remaining funds ought to be contributed directly to SV. Lovett cautioned against the dangers of having groups use SV's name and tax-exempt number. Therefore, the board instructed that "Dr. Guthrie should explain to Chicago that becoming an official chapter of Save Venice is a lengthy and formalized process."[52] Apparently the board was nervous about the potential for a "rogue" chapter acting on its own. Such apprehension of course ignored that McAndrew's Venice Committee had been born in a similar fashion when it revolted against the strict terms of its mother organization, the IFM.[53]

The New York chapter continued to function under Gabriella Lorenzotti but appears to have been overshadowed or even partially absorbed into the activities overseen by Lovett and the Guthries. Lorenzotti was a longstanding member of the SV General Committee, and she also joined the board's special events committee; it can be difficult to sort out just which hat she was wearing at times. One event clearly organized by the New York chapter was "On Location in Venice," a private screening of clips from feature films set in Venice, followed by dinner and dancing at the Pierre Hotel. Held on Italy's Liberation Day, 25 April, in 1988, this event included junior co-chairs Martha Fuhrmann and Mark Fehrs Haukohl, who successfully brought "younger contributors to keep the dance floor lively."[54] In October 1988 Martha Fuhrmann again coordinated a Junior Committee event as part of the New York chapter, this time a "Night in Venice" at Au Bar for a fashion show by Marc Bouwer.[55] Lorenzotti also initiated a lecture series in New York in 1988,

with a lecture on 25 January by Wolfgang Wolters about SV restorations to date, another on 10 May by David Rosand about the aesthetics of Venetian painting, and a viewing of Gore Vidal's film *Vidal in Venice*. In late fall 1988, SV partnered with Gucci America to host a cocktail party at Gucci's store on Fifth Avenue, raising $10,000 for restoration of the stage curtain at the Fenice theater. One week later SV hosted the Venetian chamber orchestra I Solisti Veneti at the former Fabbri Mansion in New York for the group's first American tour since 1972.[56]

In the mid-1980s the Boston chapter remained similarly vigorous. In autumn 1985 it announced a tour of Venice and the Veneto to take place in October 1986. Designed by Peter Fergusson to commemorate the twentieth anniversary of the flood, it was to include "visits to Palladian villas, private parties, lectures, and luxurious accommodations."[57] Despite a mailing to 1,700 people in Boston, New York, and Los Angeles, the trip was canceled due to the triple threat of Chernobyl, terrorism, and the fall of the dollar.[58] Under the new leadership of Watson Dickerman, the 1986 Boston annual appeal mailing brought in $19,000 and that of 1987 raised $12,000 for the Miracoli church. A masked ball in April 1987 at the Copley Plaza Hotel raised $22,000, all destined for the restoration of the *Pillars of Acre*.[59] The 1987 ball included the sale of masks imported from artisan Giano Lovato of Venice, a fashion show coordinated by Priscilla Juvelis, and an invitation drawn by Venetian artist Sally Spector.[60] In May 1988 the Boston chapter hosted a benefit at Michela's restaurant in Cambridge in honor of Ascension Day (when Venice annually celebrates the city's mythic wedding to the sea) and of the Italian consul general Giuseppe Zaccagnino of Boston, raising more than $7,000, and attracting many Bostonians who had attended a Gardner Museum–sponsored trip with Dickerman the year before.[61] On 30 November 1988 an all-Vivaldi performance at Old South Church by I Solisti Veneti raised funds for the Miracoli church.[62] This pattern and scope of fundraising was consistent with what the Boston chapter had been doing for the previous fifteen years; it regularly held a masked ball in the spring as well as a cocktail reception in the fall along with other diverse events. The Boston chapter typically selected its own projects, but it sometimes worked together with the SV board on larger projects such as the Miracoli church.[63]

In anticipation of Hadley's retirement from the Gardner Museum in 1988, the Boston chapter changed its mailing address from 2 Palace Road to Nichols House at 55 Mount Vernon Street in Boston. A number of other local nonprofits used this prestigious Beacon Hill address to collect mail and telephone messages.[64] Four months later Peter Fergusson broached the idea of hiring a part-time staff member

who "would be helpful in assisting the chairman in development and in helping with the various benefits. She could also put our records on a word-processor for immediate access."[65] In making this proposal, Fergusson noted that Boston "would be following in the footsteps of the New York Chapter, for a long time moribund, but now very active, [as] they have hired a professional (Bea Guthrie)."The Boston chapter minutes acknowledge that "this is a big step," and opinion was divided between remaining with an all-volunteer model or switching to a new system with paid staff.

In the midst of this progress and cooperation, one administrative error would later propel a squabble about the identity of the organization. From 1983 to 1986 SV neglected to file three annual reports with the Massachusetts secretary of state.[66] As a result, in November 1986 the corporate status of Save Venice Inc. was revoked.[67] Within a year SV's new treasurer, Bob Guthrie, notified attorney Thomas Kelly to file the requisite documentation to rectify this oversight.[68] In June 1990 the secretary of state's office responded that Save Venice Inc., a Massachusetts 501(c)(3) corporation, was "revived for all purposes and without limitation of time with the same powers, duties and obligations as if the charter had not been revoked."[69]

However, during the interval of 1986–87 when the Massachusetts corporation was (temporarily) dissolved, the SV board of directors moved to reincorporate it in New York State. At the end of a meeting chaired by President Lovett in his New York house in April 1987, the directors approved a brief statement about the rationale(s) behind this decision to reincorporate: "The President reported that the auditors have urged for reincorporation of Save Venice Inc. in New York State; they feel that the present situation is cumbersome. The move would make it necessary for Save Venice to hire New York counsel and to form a new set of by-laws. Upon motion made and seconded, reincorporation was approved. There being no further business, the meeting was adjourned."[70] The reference to being "cumbersome" presumably refers to the fact that the officers of SV were chiefly based in New York and that they would find it easier to work with the New York attorney general's office than with the Massachusetts secretary of state.[71] This interpretation is confirmed by a letter from attorney and SV director Jack Wasserman in New York to Donna Hoffman in Boston about a decade later in which Wasserman wrote, "By the late 1980s virtually all of the original directors of the original Massachusetts corporation had died or retired and there were no longer any Boston-based directors. With minor exceptions, the succeeding directors were based in New York, and they caused the formation of a New York corporation."[72] On 23 March 1988 Save Venice of New York Inc. (SV/NY) was created as a 501(c)(3) corporation.[73]

The SV board minutes of April 1987 do not indicate any dissent from this rein-corporation effort nor did the directors resident in Boston (Hadley, Dickerman) resign in protest. The board minutes do not specify whether the directors were aware of the dissolution of the Massachusetts corporation by the secretary of state. It appears that from 1988 to 1997 the Massachusetts corporation and the New York corporation operated in parallel. It is not clear when the Boston-based members of the Massachusetts corporation first realized the existence of SV/NY as an inde-pendent entity; Boston's lawyer Emily Livingston told Paul Wallace in late 1998, "We became aware of these actions only after they were taken by Jack [Wasser-man] or others in New York," implying that nearly a decade passed without notice from the Boston group.[74]

The 1988 SV newsletter—for the first time—listed the New York and Venetian addresses separately and indicated that the address at 2 Palace Road in the Fen-way (the Gardner Museum) belonged to the Boston "chapter." Since 1971 there had always been a separate chapter in Boston, as there was in New York. The real change, then, was about the corporate heart of Save Venice Inc. and whether it was a Massachusetts corporation or a New York one. This disagreement between Boston and New York would eventually swell in the late 1990s into a disagreement about who "owned" Save Venice—or at least who had claim to that name.

1989-1992: The Perils of Politics

Following the great success of the new business model based on the Venice gala, SV leadership rotated again. In 1989 Lovett transitioned from president to chair, Bob Guthrie took over as president, and Berlingieri was promoted to vice president.[75] At this time the president of the organization held the greatest authority, while the chair was more honorific. Together with Bea Guthrie as executive director, Lovett and Bob Guthrie would continue to oversee steady growth in the organization and to take on ambitious new challenges. In 1991 Marialuisa Weston retired after nearly two decades as SV's local agent in Venice; she was replaced by Lesa Marcello.[76] The group's income and assets rose steadily in the early 1990s, buoyed by generous donations and myriad fundraisers, including the continuation of Regatta Week and the first Guthrie-led excursion. However, SV also encountered a number of obstacles in this period, from political backlash and personnel squabbles to techni-cal difficulties and financial challenges. To some extent these headwinds were to be expected as a natural consequence of a rapidly growing organization. Yet it is also

possible to see the roots of disagreements that would engulf the organization in the later 1990s, including the dispute between Boston and New York and a split on the board between the Guthries and Lovett.

In the board meeting of January 1989, hosted by Berlingieri in her home of Palazzo Treves, Bob Guthrie reported that the organization had expanded to nearly one thousand contributors, in contrast to the paltry two hundred of just three years earlier.[77] Income topped half a million dollars, and the directors continued to review and approve restoration projects at a steady rate while demonstrating appropriate concern for spiraling costs and administrative fees.[78] Mindful of the need to earn revenue and promote Venetian culture in a variety of ways, the board experimented with several new approaches in 1989–90. For example, John Saladino proposed that SV organize a showhouse of Venetian-inspired rooms in New York as a fundraiser, noting that he had garnered $750,000 from a similar project the year before. Danielle Gardner reported that $11,000 had already been raised to support publication of a book of photographs by Driscoll Devons about the Jewish cemetery on the Lido. SV participated with the Consorzio Venezia Nuova in the publication of a book on the efforts to protect Venice's shoreline.[79] The board approved an April 1989 dinner at Tiffany & Co. to celebrate the eightieth birthday of Archimede Seguso, the Venetian glassmaker, and—on a much larger scale—an October 1990 ball for four hundred guests at the Plaza Hotel called "Vignettes of Venice," which included a reading of literary excerpts and poems pertaining to Venice.[80]

The major event of 1989, however, was the Regatta Week Gala in Venice. Chaired by Patricia S. Patterson of New York and with guests of honor Prince Andrew and Sarah Ferguson, the Duchess of York, the late summer spectacular raised a total of about $450,000 to finance restoration of the Miracoli church as well as lunettes, paintings, and marble statuary in three other Venetian churches.[81] This version of the gala introduced the Save Venice treasure hunt, where participants searched for clues in each of the six *sestieri* (districts) of Venice before competing in a final hunt for the grand prize—a diamond lion brooch designed by Bulgari.[82] SV printed ten thousand copies of the treasure hunt booklet, selling the surplus copies in Venetian bookstores. The treasure hunt would become an essential element of the Regatta Week Gala and in future years would serve as a vehicle to introduce families and casual visitors to SV's work. Another innovation was a day trip on the *terrafirma*, comprising a trio of events in Vicenza: a concert at the Teatro Olimpico, a visit with Count Ludovico Valmarana at Palladio's villa La Rotonda, and a dinner hosted by Count Paolo Marzotto at the family villa perched above Vicenza.

Although fashion reporters noted the quantity of luggage brought by the Duke and Duchess of York or speculated on the best kinds of dress for a summer ball, Bea Guthrie and the gala organizers emphasized the intellectual substance of the weekend.[83] For example, they pointed to the concerts, tours, and lectures, as well as the substantive articles printed in the *Gala Journal.* They encouraged gala guests to explore the lesser-known parts of Venice and to visit conservation projects past and present; the treasure hunt was an effective means of enticing guests to do both, as well as to appreciate the visual texture of the city.[84]

Two months after the successful conclusion of the 1989 gala, SV for the first time stepped beyond simple conservation and fundraising and into the controversial shoals of politics. Expressing opinions about local politics risked alienating the Venetians who had enthusiastically supported the first two galas. On 7 November 1989 Larry Lovett and Bob Guthrie wrote to William McKee Tappe, the American representative to the International Bureau of Expositions, to voice their concerns about the Italian government's proposal to locate Expo 2000, a kind of world's fair, in Venice. They cited the concerns of Mayor Casellati about the influx of 150,000 extra daily visitors, as well as the impact of increased boat traffic and the public facilities necessary to support so many guests. Lovett and Guthrie pointed to the infamous Pink Floyd concert of the previous summer as evidence of how a large crowd could wreak havoc on the delicate ecology and fragile buildings of Venice's historic city center. Guthrie sent a copy of the letter to all board members, noting, "We felt we had to speak up against Expo 2000, although we know it's dangerous."[85] In January 1990 the entire board registered its disapproval of Venice as an exposition site and conveyed that sentiment to UNESCO. In May Berlingieri reported that many Venetian businesses were now opposed to the Expo, and she described a recent publication titled *Venice or Expo: It Is Up to You.* The board agreed to help distribute this report and to hold a joint press conference with the WMF to object to the expo in Venice.[86] The UNESCO liaison officer Maria Teresa Rubin disregarded guidelines from her Paris headquarters and indicated that her office was also opposed to Venice as a site for the expo. In the face of such opposition, one month later Expo 2000 was awarded to Hanover, Germany.

Earlier leaders of SV such as McAndrew or Hadley had not hesitated to express their views about what was best for Venice, of course, but they had largely limited their criticism to matters of restoration or conservation. Lovett and Bob Guthrie took a broader view, seeing Italy as "a museum of the masterworks which we claim as the common heritage of Western civilization," and asking rhetorically, "How can

the Italians be expected to be the sole curators of that museum? When we teach our children about the painting, sculpture, and architecture of the Renaissance, how can we say that these works do not concern us? . . . For every dollar spent by Save Venice in Venice, the Italian government and numerous Italian private individuals and organizations spend thousands."[87] Lovett and the Guthries believed that it was important for them, and for the other private committees, to speak out in defense of Venice's historic city center.

A third iteration of the Regatta Week Gala occurred in September 1991, with Oscar de la Renta as the honorary chair. The ticket price was now set at $2,000 per person. Even at a higher price, 90 percent of the 250 tickets were sold before the invitations had even been mailed, indicative of repeat guests and favorable word of mouth.[88] The board noted that it would have to devise some type of priority system to distribute the few remaining tickets, and it looked for ways to increase the capacity of the event while retaining its exclusivity. A partial solution was to hold a very large ball on the final evening—in 1991 the ball included 300 guests plus 150 Venetians.[89] Attendees again included European nobility such as Lord Rothschild, Count Frederick Chandon, Princess Michael of Kent, and Archduke Dominic Habsburg. A buffet lunch in the gardens of the Cipriani Hotel featuring regional menus from Tuscany, Liguria, and Venice was followed by a vocal baroque music performance by Regina Resnik. A reprise of the treasure hunt and a trio of lectures provided intellectual fodder for guests to deepen their understanding of Venice. The 1991 regatta netted $506,000 for the Miracoli church, a staggering success that eclipsed the previous records of 1989.[90]

A dissenting opinion to this luxury was voiced in the newspaper *La Nuova Venezia* by art history professor Lionello Puppi. He objected to the ways in which the city was being "consumed" by elites who flew in and out without really understanding how Venice functioned.[91] Puppi recognized that the participants contributed sizeable donations to benefit the city, but he criticized them for focusing more on banquets and dances than on lectures and site visits. According to one Italian journalist, Puppi characterized the treasure hunt and fancy balls as a "macabre feast" that showed "disrespect to the dignity and historic role of the city." In response, Bob Guthrie stressed the conservation work that SV was doing and declared that the organization was in Venice to provide "friendship and support, but certainly not to become involved in the political issues that affect the city."[92] In this Guthrie offered a subtle distinction between SV's apolitical stance and Puppi's own political activity as a representative of the Communist Party in the Italian Senate.

Just days later Bob Guthrie reflected on the role of SV and challenged the board to clarify its stance vis-à-vis political involvement. He noted that engaging in political issues put the restoration mission of SV at risk, even as he acknowledged that cleaning pictures and restoring frames was only a partial solution to a larger problem: "The board needs to decide to what extent it wishes to be involved in political as well as restoration activities. The Chairman of the Private Committees, Alvise Zorzi, says 'it does not make much sense to preserve the monuments when the container is sinking.' . . . Others are reluctant to involve Save Venice in the internal affairs of Italy feeling that they are no more our business than the affairs of New York are the business of Italians."[93] Guthrie pointed out some consequences of SV's objection to the expo, citing the cancellation of a gala in San Francisco earlier that year after the Italian consulate withdrew its support and the characterization of SV as "neo-colonialists" by local Venetian newspapers. Guthrie also informed the board of UNESCO's position that it could not support any organization that interfered in the internal affairs of a member state and emphasized that "it is self-evident that this is a serious matter in UN affairs." Guthrie concluded his remarks by laying out the stark choice faced by Save Venice:

> In summation, on the one hand, we have very definite ideas about how things should be done, and we would like to effect them. We feel that we could immeasurably improve this city, and it is frustrating not to be able to do so. On the other hand, we must recognize that feeling that we have the answers to everyone's problems is the incurable American disease which tends to alienate large numbers. Equally important is that we have to live and work here, and it is not pleasant or productive to be in conflict with anyone. It interferes with our real job of restoration and fund-raising and it reduces the quality of life.[94]

Guthrie's analysis was exactly right, particularly about this being a "serious matter" for the United Nations. Months earlier UNESCO had announced its intention to close its office in Piazza San Marco and to conclude its twenty-five-year Campaign for Venice.[95] Given that the UNESCO office was the liaison with the private committees, and that the link to UNESCO provided significant financial advantages such as exemption from the value-added tax, the shutting of the office was a crucial announcement. That closure was motivated by several reasons, including pressure from nation-state members of UNESCO concerned that the campaign required UNESCO to use its human and financial resources to support a

city in one of the wealthiest countries in the world, in contrast to its stated mission to assist the most vulnerable. Equally important was political pressure by Italian authorities in response to perceived "meddling" by the private committees in Italy's internal, local affairs.[96] The Italian government therefore declined to renew its commitment to support the office in Piazza San Marco, including the position of liaison officer. UNESCO offered to continue processing payments on behalf of SV and the other private committees. But this came at a (literal) cost: the private committees would have to substantially increase their joint contributions from \$15,000 to more than \$50,000 annually in order to support the staff. Save Venice and Venice in Peril proposed various solutions to this thorny problem, including a two-tiered "membership fee" for the private committees and an increase in the service fee paid to UNESCO on all projects from 2 to 5 percent.[97]

In the midst of this debate, the private committees held their annual meeting in Venice in October 1991 to review recent events and plan for next steps. One day later, a roundtable meeting was held at the Ateneo Veneto to examine different options for protecting Venice; it included Italian politicians, engineers, and city planners as well as representatives from SV and other private committees.[98] Some advocated putting additional pressure on the Italian state (and indeed a general strike was called on 22 October to protest government cutbacks) while others called for a radical restructuring to form a kind of private-public partnership that included municipal, provincial, regional, national, European Union (EU), and international stakeholders. The context here was that the Italian economy was in poor shape, and Italy was not expected to be able to join the EU nor to follow through on its promised half-billion lire grant to aid Venice.

In concert with the other private committees, SV had previously agreed to jointly form a new entity, the Association of International Private Committees for the Safeguarding of Venice (APC), so that UNESCO would have one partner rather than multiple organizations. That agreement—which gave rise to the UNESCO–Private Committees Joint Programme for the Safeguarding of Venice (and thus distinct from the UNESCO International Campaign of prior years)—continued the fruitful partnership of prior years, with John Millerchip in the role of liaison between UNESCO and the APC.[99]

RESTORATIONS, FELLOWSHIPS, EDUCATION, AND CRUISES

Save Venice continued to support an array of restorations in the early 1990s, with conservation of the Miracoli church at the head of the list. Typically, the board

would vote on restoration projects at its fall meeting in Venice, when directors could visit the sites and meet with restorers in person; emergency repairs were also discussed at the other two meetings in New York each year. One can see the board becoming savvier in its judgments about how to select restorations and specifically when to decline opportunities. For example, in early 1990 SV decided it could not pay for restoration of the privately owned Palazzo Barbaro, despite the building's historic ties to American culture and specifically to Boston.[100] This decision confirmed SV's position that its restorations had to be accessible to the public. A year later the board declared that before approving payment for an altarpiece painting it wished to know whether the altar itself would require restoration.[101] In early 1992 the directors declined to pay for transportation of the civic hospital's archival records because the request lay outside its core mission.[102] SV also declined a request from the PGC to help acquire a gothic building and garden next door in order to expand its exhibition space, citing fears that the renovation of the building might not be approved by the Superintendency of Monuments.[103] Such denials represented the exception rather than the rule for SV, which was generally eager to embrace new opportunities in historic conservation.

The project at Santa Maria dei Miracoli remained by far the group's most significant but progress was painfully slow. In January 1990 the architect Mario Piana estimated needing $516,000 to restore the right wall of the church (alongside the street), and the board agreed to add this amount to the $115,000 already expended for staff assistants, drawings, and laboratory tests. SV had received $35,000 in July 1989 from the Getty grant program but its request for a larger project implementation grant of $250,000 had been initially denied.[104] Wolfgang Wolters reminded the board in May 1990 that "we need to be patient. . . . It is impossible for us—and quite dangerous politically—to interfere officially in the decisions of a Superintendent."[105] At its October 1990 meeting the board discussed the Miracoli restoration at length, hearing from Bob Guthrie about a solution to the salinization and condensation that had damaged the marble, and from Wolters about preparation of architectural drawings. A detailed fifteen-page report summarized restoration activities from spring 1988 to January 1990.[106] The aptly named Ottorino Nonfarmale ("Do no harm") and his firm from Bologna were selected to execute the church restoration under Piana's direction.[107] By early 1992 large marble slabs were being desalinated in specially designed tubs, the scaffolding was in place, and new details about the history of the church had emerged from the architectural drawings commissioned by Professor Manfred Schuller and his students from the

University of Bamberg. The board debated—without a clear resolution—whether to commit itself to a restoration of the entire building or only section by section.[108] In September 1992 the Getty Foundation offered $250,000 if SV would match this on a two-for-one basis; the board agreed and began to make plans to restore both the facade of the church and the canal side wall.[109] By the end of 1992 the commitment to the Miracoli was approaching a million dollars. Bea Guthrie in New York and Lesa Marcello in Venice were each commended by the board for the "enormous amount of time and effort" expended on obtaining the Getty grant and on effective collaboration with Venetian authorities.[110]

What specific steps were necessary to preserve and restore the church of the Miracoli? The conservations required a variety of different approaches to solve a litany of problems inside and outside. Tests revealed that rain leakage had saturated the upper walls of the church through the roof and windows.[111] The brick and stone walls of the church had to be isolated from the rising saltwater of the adjacent canal too; this was accomplished by sealing the base of the walls to prevent the capillary action of water being absorbed from the canal. The rose window was totally rebuilt, and the marble frames of doorways were extensively repaired. The decorative marble slabs were stripped of the corrosive cement that had been used to attach them in the nineteenth century and rehung on the original copper hooks used by the Lombardo family of sculptors to guarantee an airspace between the panels and the church's brick walls. The bricks were desalinated by cleaning them with mud packs. Both interior and exterior statues were cleaned, preserved, and reattached. In the course of the decade-long project, restorers invented new techniques, such as a harmonic hammer to search for cracks within the marble slabs, or a twenty-four-hour monitor to record the fluctuations of moisture and salt within the slabs.[112]

Despite the substantial expense of the Miracoli church, SV continued to support other projects too: the sixteenth-century fresco attributed to Battista Franco in the Sottoportego della Pasina, estimated $10,000, the majolica tile floor in the Lando Chapel at the church of San Sebastiano, for $21,000, Lorenzo Lotto's altarpiece of Saint Nicholas of Bari in the church of Santa Maria dei Carmini, and—in memory of Hedy Allen—the altarpiece of Saint Barbara by Jacopo Palma il Vecchio in the church of Santa Maria Formosa. In addition, SV expanded its conservation umbrella to include musical instruments, gardens, and books. For example, the organization agreed to donate $91,000 to restore a 1740 organ created by Pietro Nacchini in the church of San Giorgio Maggiore and to restore painted organ shutters in the church of San Salvador.[113] It partnered with the WMF on several

attempts to restore the Biennale gardens in Castello.[114] SV likewise underwrote a video and photographic inventory of liturgical vestments and religious treasures in Venetian church sacristies carried out by German experts in 1992–93, for $41,600.[115]

Closely related to the restoration projects was a series of fellowships in the early 1990s. SV had previously granted a "scholarship" of $650 per month in 1982–83 to Venetian architect Emmanuele Armani to investigate sixteenth-century paint samples; a year later it gave another $1,000 to Venetian architect Mario Piana (later a superintendency official at the Miracoli church) to conduct research for a book on the history of building techniques in Venice.[116] But these were isolated, one-time contributions. Recognizing that it needed more expertise, and more labor, for Santa Maria dei Miracoli, SV established several multiyear fellowships for young restorers. The first was a "Scientific Research Fellowship" to assist Vasco Fassina at the Misericordia stone laboratory and to study decay of the stonework at the Miracoli church.[117] The second was a "Miracoli Fellowship" of $960 per month, from 1991 to 1998, to provide assistance to the Superintendency of Monuments; the recipient was Francesco Piegari.[118] A third fellowship, also from 1991 to 1998, was granted to support Professor Schuller's detailed *Bauforschung* drawings to survey construction techniques used at the Miracoli church.[119] Each of these fellowships ranged from half a million to one million lire per month (roughly $500–900), and all of them were granted to Europeans.

Beyond the fellowships linked to the Miracoli church, SV created a "Pigment Analysis Fellowship" from 1991 to 2002, designed to allow a scientist to research the physical and chemical makeup of paintings on a microscopic level prior to restoration. Stefano Volpin received this fellowship for nearly a decade.[120] In 1991 the board further agreed to offer up to $10,000 to each superintendent for needed equipment and future fellowships.[121] In 1993 Save Venice agreed to renew a scholarship of $775 per month for Marica Petrkovic to restore a polyptych in the Gallerie dell'Accademia.[122] In September 1994, as the work on the Miracoli church increased, the board made explicit its desire to provide two or three multiyear fellowships to "learn everything to do with wood restoration and painting in the early 16th century—if they are good [Ottorino] Nonfarmale hires them, but they can be sent home if they do not work out."[123] The early 1990s thus represented a watershed moment for SV in terms of its commitment to fellowships focused on technical expertise, and in terms of supporting Italian restorers. This tradition of fellowships for Europeans would continue for many years and be augmented in the late 1990s by additional fellowships for American recipients.

Educational activities also came to the fore in this period. In 1990 Save Venice reintroduced a lecture series in New York, accompanied by dinner at the Knickerbocker Club, featuring talks by Desmond Guinness on the eccentric collector and decorator Charles de Beistegui, by John Dixon Hunt on Venetian gardens, and by Olivier Bernier on medieval mosaics and gold.[124] The following year there were lectures by Colin Eisler of New York University's Institute of Fine Arts on fifteenth-century Venice, by Bernier again on eighteenth-century Venice, and by Mario di Valmarana of the University of Virginia on the Palladian villa, raising a total of $6,200. The next year featured historian Patricia Labalme of Princeton's Institute for Advanced Study speaking about women in Renaissance Venice, as well as return appearances by Bernier and di Valmarana respectively.[125] In May 1991 SV helped to organize a two-day seminar called "Humanities West" in San Francisco that sold 850 tickets.[126] A four-day Titian seminar was offered in Venice in June 1990 to take advantage of the huge Titian exhibition at the Palazzo Ducale. The seminar featured lectures by John Pope-Hennessey and Terisio Pignatti, tours of the PGC by Philip Rylands, and a concert at the Fenice Theater by Slovak soprano Edita Guberova.[127]

The introduction of a biennial (later annual) excursion for SV friends in the early 1990s served educational and financial purposes.[128] The brainchild of Bob and Bea Guthrie, these trips brought in additional revenue and cemented long-term friendships among those most devoted to SV. The early cruises stopped in Venice and other Italian ports but soon the destinations included the broader Mediterranean (Istanbul, Bodrum, Greek islands), and eventually came to include northern Europe, Asia, and Latin America. The excursions were initially conceived to complement the Regatta Week Gala; they occurred at the same time of year (i.e., early September) but in even-numbered years only. The first was a benefit cruise on the *Sea Goddess* with Cunard Line in early September 1992. The itinerary for 120 guests included stops in Civitavecchia, Salerno, Palermo, Bari, Dubrovnik, and finally Venice, and included visits to historic sites like Paestum and Cefalù.[129] At $5,700 per person, plus airfare and hotel costs, it was a high-end trip and expected to raise $1,700 per passage sold. This and subsequent excursions always included onboard lectures in addition to local guides; the emphasis in talks and site visits was on the history, art, and culture of the locations being visited.

THE BOSTON CHAPTER, 1989-1992

The Boston chapter maintained an active social and fundraising schedule from 1989 to 1992, emulating the New York group in some ways and diverging in others.

In April 1989 nearly three hundred people attended a masked ball at the Copley Plaza Hotel featuring the Lou Allegro orchestra and a film by Paula Scully. Among the attendees were two journalists from Venice.[130] Chapter chair Watson Dickerman noted in his report to the board that year that "the popularity of this kind of 'dinner dance' indicates that repetition of this theme is highly welcomed and could be considered for future fund-raising."[131] The $23,000 raised at the dinner dance was used to support the conservation of the high altarpiece by Cima da Conegliano and a *Madonna and Child* by Bartolomeo Vivarini, both in the church of San Giovanni in Bragora.[132]

Recognizing the advantages of better organization and following the example of the Guthries in New York, in 1989 the Boston chapter hired Elizabeth (Betsy) Waters on a part-time basis "to organize and put on computer our mailing lists, a task we expect when completed [that] will greatly streamline our operations."[133] The Boston executive committee specified that "Betsy's responsibility is not only to be in charge of the records, the mailings, and to play a large role in the benefits, but also to seek corporate support." The Boston committee agreed to a trial period of two years, after which it would evaluate whether to return to an all-volunteer operation.[134] The chapter also recognized that closer cooperation with New York was desirable because "in seeking corporate assistance in the form of prizes or favors for an event, the Boston Chapter has sometimes failed because New York has already solicited the same companies."[135] In his handwritten report to the board in September 1989, Dickerman concluded that the Boston chapter had enjoyed a "healthy and profitable year."[136]

The following years were equally busy in Boston. A spring 1990 talk by John Dixon Hunt on the topic of Venetian gardens at the Academy of Arts and Sciences in Cambridge raised $10,000, a raffle brought in $6,200, the annual appeal that year collected $13,000, and an event at the American Wine Institute in the fall was similarly successful.[137] In 1991 the Boston chapter netted a profit of $18,400 from its Ballo in Maschera (Masked Ball) benefit and raised $16,800 from its annual appeal.[138] At the annual meeting that year, held in the Harvard Club in the Back Bay, Bob Guthrie gave a slide presentation on the history of Venice and Bea Guthrie described the current restoration projects. In 1992 the Boston chapter planned a very ambitious schedule: a February wine-tasting dinner and talk by art historian Barry Hannegan at the Ritz-Carlton; a May performance of Goldoni's *The Servant with Two Masters* with supper to follow; a September reception and tour of the Boston Museum of Fine Arts' exhibition on *The Lure of Italy: American Artists*

and the Italian Experience, 1760–1914; and finally an illustrated talk on Venice by Elizabeth Gordon, followed by dinner at the Harvard Club, in October.[139]

For SV as a whole, the period from 1989 to 1992 was thus marked by significant growth and notable achievements, especially in funds raised, visibility, and professionalization. Lovett and the Guthries expanded the biannual Regatta Week Gala to four full days and laid the foundation for a regular series of luxury excursions in the off-years. The balance sheet was healthy, with multiple bank accounts and innovative methods to increase the amount and impact of its assets. The increased number of directors (now twenty-five) provided both wider expertise and a larger pool of potential donors, some of whom contributed six-figure gifts. The Miracoli restoration was firmly underway with a clear sense of what needed to be done and the will to see it through. Additional conservation projects were proceeding as well, even if they took a back seat to the Miracoli. SV increased its impact in the educational sphere by founding a lecture series in New York, financing fellowships, and subsidizing publications. It was not all good news, of course—the negative publicity about Expo 2000 and the sense that SV was "meddling" in Venetian affairs temporarily damaged the organization's reputation. There were minor personnel issues and disagreements about policy, the chapters in Los Angeles and New York were less visible, and the revenue from Boston declined. Lovett and Bob Guthrie worked well together, as did the respective branches in Boston and New York. Nevertheless, there were underlying tensions, and glimmers of this stress appeared in the period from 1993 to 1997.

1993–1997: Success and Stress

Completing the restoration of Santa Maria dei Miracoli in 1997 was one of the great achievements of Save Venice and a triumph for a private committee in Venice. It proved that SV could sustain the ambitious fundraising, executive planning, and technical expertise needed to manage such a large and complex project, as well as coordinate with civic authorities. That signal accomplishment was complemented in the mid-1990s by the introduction of a licensing program, a vibrant Young Friends (YF) group, and increasingly sophisticated accounting and governance practices, all of which vaulted SV into prosperity and acclaim around its twenty-fifth anniversary. An important new member of the SV leadership team in this period was the talented and tenacious attorney Jack G. Wasserman, appointed to the board in April 1992 and promoted to treasurer in February 1994.[140] In

Boston, Ronald Lee Fleming replaced Dickerman as chapter chair in 1993, and then in 1996 he was followed by Donna Hoffman, who led Boston through negotiations with Jack Wasserman and Bob Guthrie over Boston's autonomy. The most dramatic event of this period in Venice, and one that directly impacted SV, was the catastrophic fire of 29 January 1996 at the historic La Fenice theater.[141] It underscored how fragile the city could be, even if in this case the threat came from fire rather than water. Save Venice lost the $100,000 that it had recently invested in a restored stage curtain at the Fenice, but the city lost one of its most beloved monuments, and the accusations of negligence and corruption that emerged afterward only added salt to the wound.

GOVERNANCE, YOUNG FRIENDS, AND EXCURSIONS

Several senior members of Save Venice passed away in the mid-1990s, including John Pope-Hennessy and Lily Auchincloss, each of whom were memorialized with resolutions recalling their contributions.[142] New members of the board included Isabella Eich and Beatrice Santo Domingo (1992); Roger Rearick (1993); J. Winston Fowlkes and Paul F. Wallace (1995); Elizabeth (Betsy) Lovett, Robert Duke, David Bull, Beatrice Rossi-Landi, Richard Oldenburg, Alexis Gregory, and Prince Pierre d'Arenberg (1996); Donna Hoffman (1997); and Charles Ryskamp and David Rosand (1998).[143]

In recognition of the increasing number of Italians who were participating in its events, in spring 1993 SV began the process of registering itself as a foreign foundation in Italy. As Jack Wasserman reported to the board, this step would entitle Italian nationals to receive certain tax benefits. In due course Maria Barbara Berlingieri was appointed as SV's official Italian representative, and the application was formally approved by the board. In January 1995 the Italian government acknowledged SV as a nonprofit and provided a tax identification number (*codice fiscale*). Three years later, however, SV decided to *not* register formally in Italy as a nonprofit organization.[144] SV was concerned about providing detailed financial information to the Italian government and about the possible loss of tax exemption if the IRS perceived that the charity had too much foreign leadership.

Wasserman soon became a strong ally of the Guthries and an important figure on the board for his legal and financial acumen. It was Wasserman who insisted that SV hire a major accounting firm to review and audit the accounts each year.[145] As Wasserman remembers it, Bob Guthrie said that this decision was a seminal moment because the organization now knew exactly how much it had available to

spend on projects.[146] Of course Guthrie himself had been responsible for initially standardizing the recordkeeping of SV's accounts, so it is little surprise that he and Wasserman would agree on the importance of well-kept account books. By September 1996 agreement had been reached: Ernst & Young would prepare a detailed audit of the year 1995 and would review the accounts for the past ten years at no charge.[147] The contract specified that Ernst & Young would prepare annual tax filings, present recommendations on internal accounting and operational efficiencies, advise on compensation issues, and assist with administrative controls. With Wasserman as chair, the finance committee decided to do an audit every year.[148] By early 1997 the finance committee had commenced a review of New York State's new requirements for nonprofit fundraising and had accepted Ernst & Young's recommendation to hire a part-time controller, Denise Lewis, to assist with both the year-end audit and the budgeting process. A subcommittee with Wasserman, Duke, and Fowlkes presented a ten-year study (1986–96) of SV's fundraising and internal operations; combined with the complete audit conducted by Ernst & Young, it gave the board a clearer overview of how much was available for projects and how much should be invested in long-term accounts.[149]

Wasserman led the board to evaluate the organization's investment advisors more critically, as in February 1995 when the board decided that "in light of the modest appreciation generated at U.S. Trust Company since 1990, Save Venice should explore the possibility of using additional or other investment advisors."[150] In 1997–98 Wasserman's legal background would play a critical role in determining how proxies could (or could not) be counted from absent board members, and would help tip the balance of power away from Lovett. Lastly, Wasserman was a driving force in the effort to clarify the corporate status of SV in the late 1990s, including the relationship of the Boston group to the rest of the organization.

In an effort to professionalize board service, Bob Guthrie made a number of administrative changes between 1993 and 1996. Along with providing detailed agendas and bank balances at each meeting, as he had since the late 1980s, Guthrie worked with Wasserman to prepare an annual operating budget and to develop investment strategies for the short- and long-term.[151] At Guthrie's suggestion, the board formally agreed to meet in Venice every fall and to hold additional meetings by telephone when necessary.[152] Guthrie developed a protocol for the board "regarding the procedures which Save Venice will follow in granting funds for future projects, except in emergency or special situations."[153] The number of directors was increased to thirty, and individual directors were provided liability

insurance of up to $1,000,000.[154] All directors were elected to three-year terms on a staggered basis, thus ensuring overlap of board terms and a schedule for new and retiring members. Each director was assigned to serve on one (or more) specific committee(s). A list of board committee members, and a list of all directors' contact information, was included annually in the minutes.[155] All of these changes helped to make SV more transparent and more effective as an organization; they also demonstrate the increasing influence of the Guthries.

Their energy and resulting success occasionally led to disagreements with Lovett and others as SV defined its emerging and increasingly important role in Venice. John Berendt alleged various disagreements and perceived slights between Bob Guthrie and Larry Lovett about the respective responsibilities of the president and chair.[156] Nevertheless, they managed to work together and keep any disagreement largely private until early 1997. A couple of years earlier, the formerly close relationship between the PGC and SV showed signs of strain as well. The two institutions were important American outposts in Venice, and the Guggenheim director, Philip Rylands, had contributed to the SV newsletter. SV held a seat on the PGC Advisory Board, and the two organizations occasionally assisted each other with restorations or fundraising events. Both organizations utilized American undergraduates as summer interns, although the PGC's program was far larger and established earlier. In 1993–94 an apparent misunderstanding about a request for financial support led Rylands to write to the Guthries: "We have talked about the importance of Save Venice and the Peggy Guggenheim Collection—as two American institutions working in different ways for the present and future of Venice—in working together, and this should, I hope, continue to be the mainstay of our friendship and of the continuity of Save Venice on the [PGC] Board."[157] As SV expanded during the 1990s, it was to be expected that there might be discord within its ranks, or with other organizations, about strategic and financial priorities, as we saw with the clash over Expo 2000. Such differences of opinion became more significant only when SV began to occupy a more prominent role in Venice and thus can be viewed as a reflection of its increased success and impact.

The creation of a Young Friends (YF) subcommittee was an important step in SV's continuing expansion, for grooming future leaders as well as expanding the pool of donors. As noted in chapter 3, a New York Junior Committee had been founded in 1983 and was still active at the end of that decade but then faded away. In 1993 Alexandra Stafford reorganized and renamed the group, and coordinated a February masked ball at Doubles, a private club in the basement of the

Sherry-Netherland Hotel on the Upper East Side, which raised $4,000. In May of that year the New York YF held a wine-tasting and lecture at the Mayfair Baglioni Hotel.[158] Three more events in the autumn of 1993 netted a total profit of $15,000, at which point Tia Chapman reported the group's intention to underwrite a conservation project.[159] By 1995 the YF had created a "memorandum of association" listing Lindsay Brooks as chair, Beatrice Rossi-Landi as president, and Dayssi Olarte de Kanavos as secretary, with a standing committee of twenty members.[160] YF members created their own schedule of events at the 1995 Regatta Week Gala and raised an additional $10,000 at their 1995 ball in New York.[161] The YF voted to finance restoration of an exterior lunette sculpture of the *Madonna della Misericordia* at the church of San Tomà, as well as of Alvise Vivarini's painting *Christ Carrying the Cross* inside Santi Giovanni e Paolo, and two altarpieces by Luca Giordano in the church of Santa Maria della Salute.[162] They carried out a series of cocktail parties, lectures, dinner dances, and Carnevale-themed events through the later 1990s. In 1997, for example, the YF held their fifth annual Carnevale Ball at the Metropolitan Club for 350 guests; at that time they also sought cooperation with the Boston-based YF group run by Cristina Coletta.[163] Dayssi Olarte de Kanavos assumed the YF presidency in 1997 while Rossi-Landi became the YF chair. Young Friends events were crucial in broadening the pool of donors and in introducing alternate, less-expensive events for a younger crowd. The YF emphasized their desire to work closely with the SV directors and expressed the hope that the younger members would eventually "graduate" to the main organization, as indeed happened—both Olarte de Kanavos and Rossi-Landi joined the board, and Rossi-Landi later served multiple terms as SV president.

The inaugural cruise of 1992 was sufficiently successful that Bob Guthrie immediately booked a second one on the *Sea Goddess* for September 1994, visiting Athens, the Greek islands, and Istanbul. This cruise sold out seven months in advance and raised approximately $150,000 for Save Venice.[164] That was followed in the early fall of 1996 by a fourteen-day Adriatic excursion from Rome to Venice, with a net profit of $247,000.[165] In September 1998 Guthrie organized another cruise from Athens to Jerusalem on the *Sea Goddess II*. The cruise included stops at the island of Mykonos, southern Turkey, eastern Turkey (Antioch), Syria (Krak des Chevaliers), and Israel. A three-day prelude in Athens and a six-day post-cruise land excursion to Jericho, Jerusalem, Petra, and the Red Sea meant a total length of more than two weeks. In a written description of the trip circulated to SV directors, Bob Guthrie described the "marvelous" ship, the "unparalleled" guides, and the

"extraordinary" sites of antiquity that would make it their "best cruise ever."[166] As we will see, these trips would become a hallmark of the Guthries and an important component of financial success for the organization.

LICENSING AND PUBLIC RELATIONS

Licensing the Save Venice name became another way for the organization to raise its profile and its profits. Bea Guthrie introduced this concept early in 1996 and brought in two licensing consultants to make a presentation to the board.[167] The goal was to use the organization's name and cachet—and in effect the name of Venice—to market various household products. The other directors were initially skeptical, pointing out that the cost for legal representation and creative design had to be considered along with other startup costs, and that the implementation of a full licensing program could take up to three years. Oscar de la Renta shared his experience with more than seventy-five licensing arrangements of his own and recommended a series of best practices. The board asked Guthrie to investigate licensing arrangements with other firms and individuals and subsequently formed a new licensing and merchandise subcommittee, chaired by Winston Fowlkes.[168] Fowlkes and Guthrie then presented their recommendations in May 1996, stipulating that any licensing program should have the twin aims of "raising funds and broadening awareness of Save Venice's goals."[169] Fowlkes and Guthrie acknowledged that SV would need professional help to launch and carry out a licensing program, and described the details regarding an initial retainer, a sliding scale of royalties, responsibility for creative design, and a three-year contract with an early termination clause. Anthony Manning and Carl Levine were selected as the primary licensing agents with patent lawyer Bradley Geist and independent counsel Bruce Bordelon hired for "contractual work and general advice."[170] Fowlkes promised that the program would conform to IRS rules to ensure that SV retained its tax-exempt status.

Moving quickly to identify possible candidates for the licensing program, the board acknowledged the work of its own director John Saladino in formulating this agreement, and thanked him for agreeing to design a tabletop collection. Saladino's work was intended to be the first contribution to the new "Save Venice Home Collection." The board agreed to provide publicity at events in cooperation with the companies that would manufacture the actual products. A second contribution offered by Peter Kraus, owner of Ursus Books, was to publish in October 1996 a catalogue of Venetian rare books. In return for using SV's mailing list, Ursus Books

promised to assume all costs of publication and to donate a percentage of catalogue sales to SV.[171]

At the next board meeting of September 1996, Fowlkes announced the official inauguration of what was now called "The Venice Collection." The products included painted furniture (designed by Mark Hampton and produced by Hickory Chair), bedding and linens (designed by John Loring and produced by West Point/Stevens), table settings (designed by Oscar de la Renta and produced by Sasaki), and outdoor furniture (designed by Piero Pinto). The goal was for each product line to be inspired by Venice in some way; for example, the bedding and linens were to be woven cotton, based on Venetian lace and Fortuny designs.[172] In early 1997 Fowlkes reported that SV had filed an application to trademark both the name "The Venice Collection" and the use of the lion of Saint Mark as its logo.[173] Furthermore, licensing agreements had been signed with two additional companies.[174] In May 1997 a number of manufacturers sent representatives to Venice to learn about Venetian style and be inspired by visiting palaces, furniture factories, antique dealers, and even the archives of the Venetian silk manufacturer Rubelli.[175] The Venice Collection planned to launch at Bloomingdale's in New York in February 1998.

In addition to marketing these products at SV events, Bea Guthrie met with Jonathan Marder at the *New Yorker* magazine to discuss advertising supplements to promote the Venice Collection. Given the high cost of running an advertisement to all 900,000 subscribers, it was agreed to place the advertising only in magazines mailed to the main markets where department stores would carry the collection.[176]

Beyond purchasing print ads and hiring two licensing consultants to promote the Venice Collection, SV invested resources in crafting its public image in other ways too. In September 1996 the board hired Eleanor Lambert, a celebrated publicist who over the course of more than seven decades promoted the "patriotic voice of American style" and who devised the initial "Best-Dressed" list. She promoted American fashion and American designers, including Oscar de la Renta. Lambert was particularly fond of Venice, and for many years was a stalwart supporter of SV's galas and annual appeals.[177] Although initially hired on a monthly basis, in recognition of Lambert's international perspective and extensive list of supporters in New York and Europe, the board established an annual retainer for her.[178] Additional public relations efforts included the 1993 decision to publish the newsletter annually in autumn, and actions taken by Bea Guthrie and Tia Chapman to prepare "a complete, illustrated list of projects for use with press and others."[179]

Concern over a possible oil tanker spill in Venice prompted the board to consider the implications of making a statement on environmental and economic matters, and the potential impact on SV's reputation. In September 1993 the board had been advised that "there is an immediate risk of the spillage or leakage of crude or refined oil from the increasing number of oil-carrying vessels passing into and through the Venetian Lagoon, and the cruise ships and freighters passing through the Giudecca Canal, and that such spillage or leakage would have a disastrous and irreparable impact on the historic center of the City of Venice."[180] The board immediately voted to appoint a special subcommittee to contact the other private committees and UNESCO, as well as other national and international governmental agencies, to formulate a joint declaration of intent. In its formal resolution, the board noted that "the stated purposes for which Save Venice was incorporated included the responsibilities to 'disseminate information' and to 'sponsor [and] coordinate meetings which will aid and assist in the rehabilitation and restoration of the city of Venice.'"[181] Three years later, however, the directors adopted a more cautious tone. In July 1996 Bob Guthrie outlined for the board his concerns about oil tankers as well as about mass tourism and flooding. In its next meeting, the board again advocated for further discussion of such issues at the annual meeting of the private committees, but "it was the view of several Board members that any proposals to solve the problems should be offered in the form of questions rather than specific proposals."[182] It appears that some directors had become more cautious after the prior charges of meddling in Venetian affairs and now preferred to proceed more carefully on public policy issues.

RESTORATIONS

Restorations from 1993 to 1996 included a number of smaller projects and, of course, the eventual conclusion of the extensive work on the church of Santa Maria dei Miracoli. Given the complexity of its most important project, the board minutes contain surprisingly little detail about the Miracoli in this period. Still, the directors visited the Miracoli church every autumn as part of the annual board meeting in Venice, and the minutes certainly do document the regular transfer of funds to Ottorino Nonfarmale and his team of restorers. By early 1993 the treatment on the street side of the church had been completed and the scaffolding was moved to the front facade.[183] In early 1994 SV agreed to contribute $350,000 to finance restoration of the apse; in 1995 it pledged $438,709 to restore the ceiling, which had been blackened by centuries of grime and candle smoke.[184] The board was also willing

to allocate funds for a series of smaller related projects at the church: $16,000 for Vasco Fassina to continue his research on the church stones, $5,900 to Manfred Schuller for isometric drawings, $9,675 to Max Leuthenmayr to restore wooden pews inside the church, $19,300 to replace the two bells in the church tower, and $10,000 toward a 1994 conference on "the conservation of monuments in the Mediterranean basin" featuring the Miracoli church as a successful case study. Finally, in February 1995 the board "expressed its intent to approve all restoration projects inside the church."[185] In spring 1996 Bea Guthrie edited and translated from Italian a summary report of the restorations completed on the facade and canal sides.[186] In spring 1997 the scaffolding was removed from the church and planning began for a commemorative book; *Santa Maria dei Miracoli a Venezia: La storia, la fabbrica, i restauri* was published six years later in Italian, edited by Mario Piana and Wolfgang Wolters under the auspices of the Istituto Veneto as part of the "Monuments of Venice" series.[187]

Restorations elsewhere included a marble altar frame by Pietro Lombardo and a wooden equestrian monument of Leonardo da Prato attributed to Antonio Minello, both in the church of Santi Giovanni e Paolo.[188] SV supported the conservation of the floor in the church of San Sebastiano as well as the decorative *pietradura* floor near the choir of the church of the Frari.[189] Also at the Frari, the board approved funding for cleaning the funeral monument of Alvise Pasqualino and investigated restoration of the monument to Federico Corner and its frescoed surround, attributed to the circle of Andrea Mantegna.[190] The church of San Giovanni in Bragora was the site of several conservations, including Jacopo Marieschi's altarpiece and its marble frame, eight Istrian stone columns, a holy water basin, and a pair of doors.[191]

Outside of churches, SV approved a dendrochronology study of the main beams and underwater pilings of twenty-five Venetian palaces in order to determine their age.[192] In cooperation with the Museo Storico Navale at the Arsenale, the Maccoun bequest was used to restore three Venetian boats and to restore gondoliers' costumes to be included in an exhibition of gondolas at the Palazzo Ducale in the fall of 1996.[193] In Piazza San Marco, the board approved financing for the restoration and protection of the bronze bases of the three flagpoles in front of the basilica.[194] The restoration of the Jewish cemetery at San Nicolo del Lido, overgrown with weeds and in danger of flooding, was proposed in 1993 and eventually finished in 1999.[195] SV also contributed to various book-related projects, including the cost of translating a text about the significance of Palazzo Grimani, the restoration of

books in the Fava Library, and a possible partnership with the publisher Arsenale to promote books about Venice.[196]

Earlier we saw the unusual generosity of Gladys Krieble Delmas and Robert Maccoun, each of whom donated as individuals and whose respective estates later made substantial donations to SV. An equally noteworthy example of individual giving was the $300,000 bequest made in the early 1990s by New York schoolteacher Carmela (Millie) Gennaro, which was applied to restoration of the facade and canal side of the Miracoli church. Growing up in Manhattan as the daughter of Sicilian American parents, Gennaro's only direct experience with Venice occurred during a "grand tour" of Europe in 1950, but the Serenissima clearly made a powerful impression on her.[197] Board members routinely sponsored projects too, including a substantial leadership gift by Paul Wallace for the Miracoli ceiling. Lily Auchincloss, Larry Lovett, Winston Fowlkes, Alexis Gregory, Walter Bareiss, Wolfgang Wolters, and the Guthries (to name just a few) each sponsored at least one restoration.

THE BOSTON CHAPTER, 1993-1997

During the mid-1990s, the Boston chapter faced questions about its identity and structure, both from within its own ranks and from the New York board. Historically the Boston group had operated quite independently, choosing its own restorations and selecting its own executive committee. Yet at times it also followed the lead of New York, as when it hired a professional executive director or founded a Junior Committee. The thorny issue of SV's corporate status, and whether it was based in Boston or New York, further complicated discussions about Boston's autonomy.

These issues came to the fore in the summer and fall of 1993 when the Boston executive committee debated how to respond to disappointing attendance and lower revenue from its most recent party in 1992. Betsy Waters pointed out that the annual appeal giving in 1992–93 had also declined substantially and expressed concern that the Boston chapter was hosting too many events. The executive committee discussed the option of becoming a satellite of the New York office but ultimately decided that "there was consensus that the Boston Chapter should retain its own identity and remain autonomous."[198] In that same meeting the chapter decided to return to an all-volunteer model. Waters stepped down as executive director effective September 1993, after which Ronald Fleming was elected chair, Donna Hoffman became secretary, and Emily Livingston assumed the role of legal counselor. Several couples joined the executive committee, most of whom would remain directly involved for more than two decades.[199] At the November 1993 annual meeting,

perhaps to acquaint newer members with earlier events, Peter Fergusson gave a brief illustrated lecture on the history of SV. Bob and Bea Guthrie were not directly involved in these events, but they did regularly attend the Boston annual meeting and sometimes presented information about SV activities and restorations. Boston's desire to remain autonomous was repeated in the September 1994 minutes when the secretary recorded that "we all affirmed Peter [Fergusson's] reminder that Boston is the original incorporator of Save Venice Inc. and thus the parent organization."[200] Such a statement, combined with other references to the "chapter" in New York, imply that the Boston chapter was unaware of the reincorporation in New York. It also seemed to ignore the substantial differences in scale of operation.

Events in Boston frequently drew from the academic and cultural institutions within the city. Despite the warning from Betsy Waters about a surfeit of events, the Boston chapter continued to host lectures, parties, and even a tour of the nation's capital. For example, in the spring of 1994 Professor Michael Jacoff gave a lecture at the Chilton Club about the four gilded horses of San Marco, which the executive committee deemed to be "a social and financial success."[201] The fall 1994 annual meeting at the Boston Athenæum featured professor Edward Merrill of MIT, a specialist in the materials of restoration. Meeting regularly every other month, the executive committee affirmed its all-volunteer status and planned two major events for 1995: an April tour of the National Gallery of Art's exhibition *The Glory of Venice: Art in the Eighteenth Century* in Washington, DC, and a May fundraiser in Wellesley. The exhibition tour included a visit to the Italianate gardens at Dumbarton Oaks and a reception at the residence of the Italian ambassador.[202] Later that spring Janice Hunt and Octavia Porter Randolph organized "Una Serata nel Giardino" (An Evening in the Garden), with a Venetian buffet in the Italian garden of the Hunnewell Estate on Lake Waban in Wellesley for two hundred people, featuring a strolling lute player and dancers in vintage costumes.[203] An article in the *Boston Globe* noted that "the setting for the party is as close to Venice as the Boston area comes."[204] In March 1996 Mario di Valmarana gave a lecture at the Chilton Club on "The Palaces of Venice," with the aim of raising money for the recently destroyed Fenice theater.[205]

Inspired by the success of the YF of New York, and with direction from Tia Chapman, Francesco di Valmarana (the son of architectural historian Mario di Valmarana) founded a new "Junior Committee" in Boston.[206] From December 1994 to August 1995 he organized four events and drummed up significant interest among young members.[207] None of these events netted much money, but they

were important in generating visibility and attracting a new generation. In October 1995 Christina Coletta assumed the chair of Boston's Junior Committee, and at the annual general meeting that month declared her group's intention to develop programs with real content. One month later she carried out a successful chamber orchestra concert at Ivan's Club of Boston.[208] In a sign of its success and independence, the Boston Junior Committee printed its own stationery and opened its own checking account at the Private Bank of Boston.[209] Coletta and her committee continued to organize additional events, such as a sunset cruise on the Charles River in June 1996 and a lecture at the Somerset Club by Sotheby's vice president Christopher Apostle on eighteenth-century Venetian paintings. Subsequent activities included a showing of the 1955 film *Summertime* at the Museum of Fine Arts in May 1997, a lecture by Bruce Redford on "Venice and the Grand Tour" in November 1997, and planning for a Saint Mark's Day benefit gala in April 1998.[210] It is clear that the Junior Committee was becoming a more significant element of the Boston chapter, and the minutes reflect regular commendations by the executive committee for the good work of the "juniors."

Recognizing the importance of communication, in 1996 Coletta suggested using the internet to promote the activities of Save Venice. The Boston executive committee expressed caution about this new technology: "Cristina showed us samples of a Web site, designed by an architect friend, who has offered to design one for Save Venice without charge. Although we recognize the importance of the Web in future communications, questions arose about its maintenance cost and purpose for us. Watty [Dickerman] will be in New York for the May 2nd meeting of the Directors, and he will bring this up with Bea Guthrie."[211] The board in New York also declined to participate in the creation of a website at that time. Three years later, with funding from the Cynthia Hazen Polsky Foundation, the New York board launched its site with the domain name of savevenice.org. The Boston group would launch its own website in spring 2001.[212]

Boston chapter activities directly supported a number of restorations in this period, beginning with the organ doors by Francesco Vecellio (Titian's brother) in the church of San Salvador.[213] Titian's *Transfiguration*, also in the church of San Salvador, was completed in 1996.[214] Three additional projects adopted by Boston were Antonio Vivarini's polyptych in the church of San Pantalon ($14,200), the seventeenth-century equestrian monument commemorating the *condottiere* (mercenary general) Orazio Baglioni in the church of Santi Giovanni e Paolo ($51,200), and a 1790 organ by Gaetano Callido, also in Santi Giovanni e Paolo ($29,100).[215]

The annual appeal in Boston from 1994 to 1996 collected between $8,000 and $16,000 each year; by the end of 1995 the chapter's balance stood at $64,000, nearly all of which was sent to New York to fund specific restorations.[216]

To judge from the minutes kept by the Boston committee, the group was well-organized and focused on its mission. It provided regular updates on restorations and a treasurer's report at each meeting. Despite the frequent turnover of officers in the period 1992–96, the "old guard" of Peter Fergusson, Eleanor Garvey, and others kept the group moving forward. Lilian Armstrong steered the nominating committee, while Janice Hunt and Octavia Randolph devoted many hours to fundraising events. The anticipated turmoil around the resignation of Betsy Waters three years earlier never materialized. In his final remarks as chapter chair before ceding the gavel to Donna Hoffman, Ron Fleming "called attention to the growth of the Boston Chapter and the role of the volunteers, who have developed and refined the donor list and planned and executed all the activities, with no paid assistance."[217]

Nevertheless, perhaps nervous that the Boston group was becoming overextended, Bob Guthrie sought a deeper understanding of operations in Boston. Early in 1996 he requested a year-end financial statement and copies of Boston's meeting minutes.[218] It should be remembered that the SV finance committee, headed by Jack Wasserman, was at the same time developing short- and long-term investment strategies and had recommended that SV hire a part-time bookkeeper to keep abreast of all financial statements.[219] We have also seen that Wasserman and Guthrie hired Ernst & Young to review the financial accounts of Save Venice, so it was sensible to include Boston's figures in the audit. In September 1996 Guthrie expressed his concern about the lack of leadership in Boston.[220] Although it is true that the Boston chapter was not operating at the scale of the New York group, it was efficient and organized with its educational, fundraising, and membership activities.

At the next board meeting in New York in January 1997, the new chair of the Boston chapter, Donna Hoffman, reported "on both recent and proposed future activities."[221] She announced that the group had sufficient funds to pay off the Baglioni equestrian monument, and furthermore that the YF group in Boston planned to restore the sculpture known as the "Hunchback of the Rialto" (*Gobbo di Rialto*). She noted that the Boston chapter had formed several standing committees (e.g., membership, strategic planning, programs, publicity) in order to share the workload and to ensure long-term stability. Later that spring the Boston chapter held a benefit event to celebrate the Feast of Saint Mark on 25 April at Harvard

University's Fly Club that included soloists from the New England Conservatory of Music and a traditional Venetian menu featuring fresh *sarde in saor* (sardines and pickled onions) flown in that morning from Europe.[222]

Despite Hoffman's report, Wasserman and the finance committee directed Ernst & Young "to review the financial operations and statements of the Boston Committee to ensure that they are in compliance with federal and state requirements."[223] Two months later Wasserman sent a pointed letter to the Boston chapter's attorney, Emily Livingston, asking whether the "Boston Committee" was acting as an unincorporated association, a not-for-profit corporation, or something else.[224]

Wasserman's 1997 letter would touch off discord between Boston and New York over who owned the right to the name of Save Venice Inc.—an issue that simmered in exchanges between the two cities before finally being resolved in 2008–9. A second disagreement, between Lovett and the Guthries over who would lead the national organization, would play out in public view in 1997–98 and then be resolved relatively quickly.

Together, these two conflicts had the potential to tarnish SV's brand and undermine its success. In the end, neither did, but they exemplify how differences of personality and competition between components of an organization can arise within nonprofits.

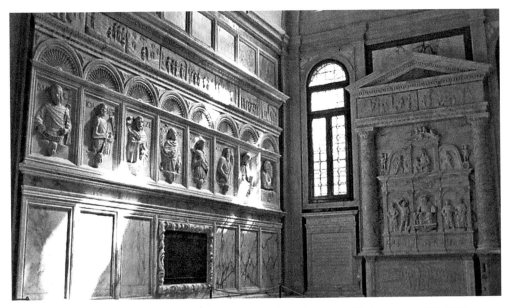

FIGURE 18. Badoer-Giustinian chapel, Church of San Francesco della Vigna, ca. 1491–1553, here after the 1999 conservation treatment (detail). Venetian buildings have long recycled precious materials. In 1534 architect Jacopo Sansovino rebuilt this Franciscan church in up-to -date Renaissance style, repurposing the marble carvings of the earlier choir screen and family chapel of the Badoer family into a new chapel for the same patrons.

—Photo Courtesy Save Venice Photo Archives

Chapter 5

SCISMA

Save Venice Splinters (1997–1998)

Their armored car proved to be no more than a farm tractor draped in sheet metal, and their sole accomplishment was to unfurl the flag of the long-defunct Republic of Venice, but the separatists who stormed the Campanile in St. Mark's Square early this morning were carrying real automatic weapons and the police mounted an assault to recapture the landmark tower.

—*New York Times* (1997)

THE BICENTENNIAL of the fall of the Venetian Republic in 1997 triggered a variety of commemorations. Surely the most dramatic occurred early on the morning of 9 May, when a band of radical separatists in ski masks and green jumpsuits stormed the *campanile* of Piazza San Marco and draped a large red-and-gold pennant from the top of the tower. The pennant, with the winged lion of Saint Mark, represented the historic Republic of Venice. Those bearing it sought to proclaim the "independence of Veneto," but were quickly arrested by the police and disavowed by Umberto Bossi and his political party, the Lega Nord.[1] Although the purported insurrection was largely symbolic, and the "tank" driven through the piazza was only a dressed-up tractor, the event underscored some of the political and cultural tensions that existed in Venice as it commemorated its past and pondered its present.

Scholars, artists, and Venetian citizens also marked the two hundredth anniversary, albeit in more peaceful fashion. Professors John Martin and Dennis Romano penned a brief article for the *Christian Science Monitor* about the lessons of Venetian political history and subsequently edited a volume of conference proceedings (*Venice Reconsidered*) that examined the Venetian legacy up to Napoleon's conquest in 1797. Italian scholars gathered to assess Venice's role in the nineteenth century under French and Austrian rule, pointing to administrative reforms and cultural activity even as they acknowledged the decline of Venetian autonomy. Margaret Plant used the events of 1997 as an opportunity to reflect on the city's past two

hundred years and to conclude her own volume *Venice: Fragile City*. Venetian psychiatrist Antonio Alberto Semi offered a bleak memoir about Venice as a necropolis in his *Venezia in fumo* [Venice Up in Smoke], *1797–1997*. Exhibitions at the Fondazione Cini and Palazzo Ducale emphasized the theme of transition and change in arts and politics as Venice adjusted to the modern world.[2] These commemorations and analyses chronicled the slow decline of Venice from an early modern maritime superpower to a second-tier city, far behind Rome and Milan. The Biennale that year reflected this sense of decay too, with the *New York Times* describing it as "one of the weakest Biennales in recent memory, plagued by bureaucratic procrastination and a late start."[3] Unlike the American bicentennial of 1976, which celebrated American success and continued world hegemony, the fall of Venice was, not surprisingly, a somber occasion.

The year 1997 began inauspiciously for Save Venice too, and the triumphant restoration of the church of the Miracoli that autumn offered only partial reprieve from a period of unrest. Disagreements at the board of directors meeting in New York in January 1997 caused elections there to be postponed until September.[4] Nominally about staff expenses and reimbursements, that dispute seemed to reflect broader disagreements between the Guthrie and Lovett factions on the board. The question over corporate control of SV was also evident in this January meeting as New York continued to request "certain records and figures" from Boston.[5] In response, Donna Hoffman in Boston appointed a subcommittee of Emily Livingston, Peter Fergusson, and Eleanor Garvey to serve as a liaison with the leadership in New York, while the board appointed Jack Wasserman, Bob Guthrie, and Paul Wallace as representatives to Boston.[6] These two disagreements would dominate the agenda in New York, Boston, and Venice for much of 1997 and 1998. While the two episodes certainly overlap, they need to be examined separately, beginning with the Lovett-Guthrie dispute and then returning to the New York–Boston disagreement.[7]

Lovett versus Guthrie

At the May 1997 board meeting, the directors adopted various tactics to promote the candidates of their choice for leadership positions and committee assignments. In an attempt to dilute Bob Guthrie's authority, for example, Barbara Berlingieri successfully called for "broader participation" by limiting to four the number

of committees on which any single individual could serve. Larry Lovett's other main ally, Alexis Gregory, introduced a resolution to thank Lovett "for his leadership, financial support, and the continued contribution to the international prestige he has brought to the organization."[8] In response, Wasserman and his supporters authorized a resolution to acknowledge and thank Bea Guthrie "for her commitment and dedication to Save Venice," noting that "her enthusiasm and untiring efforts on behalf of Save Venice have played a major role in creating the success and recognition that Save Venice receives today."[9] The passage of these two resolutions reflected contending camps on the board.

During the next few weeks both sides jockeyed to gain the upper hand with competing proposals of executive leadership. Under Bob Guthrie's proposal, Winston Fowlkes would become president, Lovett would take up the new role of "international chairman," Bob Guthrie would remain as chair, and Bea Guthrie would stay as executive director.[10] Berlingieri spurned that slate, claiming that she and many others on the board could not accept what she described as a Guthrie-dominated organization.[11] She offered a pair of alternate proposals in which Lovett would be international chair and the Guthries would hold non-board positions. Bea Guthrie expressed skepticism that major changes of leadership would be to the benefit of an increasingly complex and successful organization like SV.[12] Both sides campaigned for support among board members during the summer, with an eye toward the board meeting in early fall.

Amid these dialogues about SV's future, the organization pushed forward with its regular programming. In September 1997 SV held its sixth Regatta Week Gala, attracting more than three hundred people at $3,000 per person. Vineyard tours, a treasure hunt, stimulating lectures, elegant dinners, and behind-the-scenes access: all of these were once again available to the guests of Save Venice on this late summer long weekend. That year's *Gala Journal* included half a dozen short essays by European and American scholars, describing and illustrating the most recent restorations. The Miracoli church—completed that year after a decade of conservation—received the most coverage. Beyond the Miracoli, W. R. Rearick wrote about *The Coronation of the Virgin* by Giovanni d'Alemagna and Antonio Vivarini in the church of San Pantalon, Claudia Kryza-Gersch analyzed the equestrian monument of Orazio Baglioni in the basilica of Santi Giovanni e Paolo, and Wendy Stedman Sheard considered three sculptures by Pietro Lombardo in the church of Santo Stefano. The *Gala Journal* also included forty full-page color

advertisements, photos of donors and guests, and welcoming letters from the mayor and superintendents of Venice.[13]

The board members, however, anticipated that the real action might be at the Hotel Monaco. Bob Guthrie and Larry Lovett each showed up at the meeting with a handful of proxies in an effort to shift the votes in their favor, but the board managed to deflect the crisis in several ways. First, they unanimously reelected seven sitting directors and three new directors, roughly preserving the balance of power and displaying some unanimity. Second, several board members abstained on other critical votes, thus denying either Lovett or Guthrie an outright victory. Third, Paul Wallace (serving as a neutral chair of the meeting) presented a slate of officers that did not include a "president" but instead nominated Lovett as international chair and Bob Guthrie as chair.[14] Lastly, Wallace proposed the creation of a "Management Committee" composed of nine members of the board "to study all aspects of Save Venice's operations and governance, [including] (1) the role and responsibility of the officers, (2) the function and authority of the various board committees, (3) the operations and functions of all aspects of Save Venice."[15] In a nod to the fracture within the board, Guthrie and Lovett were each appointed to the committee, and each was allowed to select three additional members, with Wallace to serve as subcommittee chair. The essential result was to kick the can down the road in terms of defining management structure and who should populate it. The resignation of experienced directors Walter Bareiss and Watson Dickerman, tendered ahead of this meeting, made the selection of the next president even more important.

Instead, the discussion at this September board meeting revolved around fundraising strategies and executive compensation. The draft audit prepared by Ernst & Young for the year ending 31 December 1996 concluded that SV had a higher-than-average ratio of fundraising expenses compared to monies raised. The high rent for the Venice office certainly contributed to that ratio; the auditors also noted the strong reliance on event-based fundraising rather than a more varied revenue stream (e.g., licensing royalties, individual donations).[16] It must be remembered that the dramatic growth of Save Venice during the previous decade had occurred thanks to events like the Regatta Week Gala, so it is understandable the organization had come to rely on this model. After considerable discussion, the board voted to accept the audit.

The issue of executive compensation and reimbursement had been debated at

a previous board meeting in May and surfaced again in this September meeting. In a prepared statement, Bea Guthrie briefly summarized the criticism against her and then recounted her salary level from 1987 to 1997, contending that in light of what executives at other similarly sized nonprofits in New York were paid, she was not overcompensated.[17] She concluded with a plea to move beyond disagreements to date:

> The fact that this gala was perhaps the most successful ever is proof that in spite of our differences, we can all still work effectively together. The difficult task of raising money for Venice requires all of our combined talents. We complement each other and are an unusually varied and talented group of people, and we all bring different strengths. The board needs us all. We must all put this behind us and to go forward to do what we can, individually and collectively, to preserve our great heritage that is Venice.

According to the same board minutes, "Apologies were tendered and Mrs. Guthrie said that, so far as she was concerned, the matter was closed."[18] Her eloquence had smoothed the waters, averting a possible crisis.

During the remainder of this two-day meeting, the board discussed renewal of fellowships, the status of the licensing program, upcoming concerts and lectures, a UNESCO project to create a CD-ROM, and relations with Boston. The directors learned that fundraising to restore the burned La Fenice theater in Venice had been wildly successful, with an expected donation of about $588,000. As Bea Guthrie had noted, the 1997 Regatta Week Gala set another record, with a preliminary net profit of $705,000.[19] By year's end, SV had a total of more than $1.6 million in its various bank accounts, with a Plaza Hotel dinner dance ("Winter Crystal Carnival") and another Cunard cruise on the *Sea Goddess II*, both planned for the fall of 1998. The board may have felt distracted by its own divisions, but that did not stop it from conducting business and achieving enviable financial success.

In December 1997 Paul Wallace reported that the Management Committee had not succeeded in identifying an appropriate candidate for president. The board agreed to a ninety-day extension to consider all candidates again. The absence of a single leader was said to be demoralizing for the staff (and some donors) who were unsure whom to follow.[20] Recognizing that the situation was not tenable, Bob Guthrie organized a telephone meeting of the board and nominated Wallace to

serve as SV president, which was unanimously accepted.²¹ Given Wallace's even-handed approach in recent meetings, and his generosity in underwriting the ceiling of the Miracoli church, this was a positive step.

Unfortunately, the new year provided little respite. In early January 1998 Wallace terminated Lesa Marcello as director of the Venice office, ostensibly to reduce costs there and presumably reflecting the concern about the ratio of expenses incurred to funds raised. A fax from Bea Guthrie to Marcello in mid-January offered additional rationales for consolidating the Venice office from two staff members to one and for keeping Melissa Conn.²² That fax also offered specific praise for Marcello's perfor-mance on many fronts, including successful completion of the Miracoli church and a well-organized gala the previous year.²³ Marcello seems to have been caught in the midst of a larger controversy between Lovett and Guthrie over the Pietro Torta Prize for architectural restoration, specifically whether it should be awarded to an individual (Lovett) or to the organization (Save Venice).²⁴ Since its founding in 1974, the Torta Prize had been given to individuals and to organizations, sometimes in the same year. One of the prior recipients of the Torta Prize, Wolfgang Wolters, the widely respected art historian and SV project director, stepped down from SV's board in response to these disagreements about the prize and about Lesa Marcello.

More dramatically, on 7 May 1998 Count Girolamo Marcello, Lesa's husband and a board member, made his first-ever appearance at a New York board meeting. He came to read a prepared statement objecting to the termination of his wife's employment.²⁵ Count Marcello claimed that Venetian tradition had been compro-mised by questioning the decision of the Torta Prize committee and by firing Lesa Marcello without notice. The count conceded that SV had the right to terminate an employee at will but pointed out the implications of such action for her reputa-tion and for that of SV. He concluded by asking for new leadership. Not surpris-ingly, the board was split in its response. Bob Guthrie and Paul Wallace stood behind their decision and reiterated their appreciation for Lesa Marcello's "many years of effective service and her loyalty and dedication to Save Venice."²⁶ Presum-ably in solidarity with the Marcellos, Berlingieri asked to cease being SV's legal representative in Italy, and the board appointed Lovett in her place. By the end of the meeting, the board had declined to take any action to reinstate Lesa Marcello.

Two months later in July 1998 Wasserman wrote to Wallace commenting on the IRS treatment of grants to foreign organizations and the tax-exempt status of SV. At issue was the amount of authority that the board of a U.S. domestic charity pos-sesses when earmarking funds for a foreign project. Wasserman's interpretation was

that a substantial number of foreign directors could compromise the board's ability to refuse or cancel a grant to another country. In order to avoid a potential IRS problem, Wasserman wrote, "it would be best for Save Venice to reduce the number of non-American directors."[27] Such a position may well have been logical, but it exacerbated the tension between Guthrie's allies (largely resident in the United States) and Lovett's allies (largely resident in Europe). Wasserman's interpretation presumably reinforced the desire of some board members to reduce the number of Europeans that Lovett had brought on to the board.[28]

After more than two years of skirmishes, the stage was now set for a showdown in September 1998. Appropriately, it occurred in Venice. President Wallace opened the meeting with the hope that "issues relating to the governance and management of Save Venice . . . could be addressed and resolved at today's meeting."[29] Slightly more than half of the board was physically present for this meeting; therefore both sides arrived at the Hotel Monaco bearing proxies.[30] The board deadlocked on the first two items placed on the agenda, which concerned the status of the Boston chapter and the passage of new by-laws. It was clear that neither side had a majority. The next agenda item was to fill ten positions on the board. David Bull offered a slate of nine names, most of whom were allies of Bob Guthrie. Alexis Gregory offered three alternative candidates, but Wasserman ruled that the proxies held by the Guthries were valid and that the slate of nine should be considered first.[31] Gregory objected to the election and the overall nominating process.[32]

In the vote for new directors, Guthrie amassed seventeen votes to Lovett's twelve and thus carried the day. The supporters of Lovett were livid.[33] Realizing that they had lost the battle, Gregory, Lovett, and several others (including all four Venetians) announced their resignations, effective immediately, and walked out of the room.[34] Wallace called for nominations to replace those who had just left the room, and four new names were approved.[35] The new majority then went about conducting business, successfully passing the new by-laws and a resolution about the Boston chapter that had failed earlier in the morning. The board also appointed the members of six committees, with Wallace chairing the executive and nominating committees as well as retaining the presidency. Bob Guthrie and Wasserman were the other two members of the executive committee, meaning they would have a firm handle on the agenda of Save Venice for at least the next year.[36]

The victory of the Guthries was evident, although it came at some cost. Local papers in Venice and the *New York Times* featured stories about the split, with the *Times* headline reading, "Send the Gondolas: 'Save Venice' Is Sinking."[37] *Il*

Gazzettino of Venice framed the story as a melee between Venetians and Americans, quoting the outcasts' criticism of "excessive Americanization" as causing SV to lose sight of its original mission.[38] When the dust settled, about one-third of the board had resigned. Each side accused the other of focusing on social prominence to the detriment of art restoration.[39]

Lovett wasted no time in founding his own organization, Venetian Heritage, to compete with Save Venice. In some ways, the new group followed the example of the older one. Venetian Heritage also recruited generous individuals and raised funds through ticketed events. It sponsored specific restoration projects to preserve art and architecture, and it maintained the successful formula of playing up the glamor of Venice in its parties. Within three years Venetian Heritage had established the tradition of an every-other-year gala in June to coincide with the Venice Biennale.[40] Some Venetian Heritage supporters had been previously affiliated with SV, and many were from Lovett's international circle.

In other crucial ways, however, the emphasis of Venetian Heritage was different. First, the organization was explicitly more Venetian in outlook, with a separate corporation in the United States and a linked one in Italy, the latter configured as an ONLUS, equivalent to a 501(c)3 association. SV had been leery of obtaining ONLUS status but Venetian Heritage forged ahead. Second, Venetian Heritage embraced the cultural patrimony of the Venetian Empire conceived broadly, not only in the city of Venice but in Croatia, Turkey, and Crete. This wider perspective on the geography of Venetian influence throughout the Mediterranean was, and remains, unique to Venetian Heritage. Third, Lovett defined glamor through the titled individuals from across Europe who populated the committees, served as officers, and attended the group's events. Finally, the leadership made a splash with the sponsorship of exhibitions, far more than SV had previously undertaken.

Like SV, Venetian Heritage promoted its publications, public events, and—above all—restoration projects. A forty-seven-page booklet printed by Venetian Heritage around 2001–2 summarized its early activities, listed the members of its board and international committee, and illuminated its mission to restore art in "those areas of the Adriatic and Mediterranean that were once part of the Serenissima."[41] As noted above, a large percentage of the board came from Europe, with nearly half (20 of 45) bearing a title, including international chairwoman Countess Cristiana Brandolini d'Adda. By contrast, when Bob and Bea Guthrie rebuilt the SV board in 1999–2000, they prioritized American citizens.[42]

It is a testament to Venetian Heritage and SV that each prospered impressively in the twenty-first century. The enduring appeal of these groups underscores the emotional hold that Venice and its artistic treasures have on people across the globe. The two organizations spurred each other to success and had similar missions, thus acknowledging that the course charted by the McAndrews and Sydney Freedberg in 1971 was still a valid one three decades later. By contrast, the visions held by their respective leadership about how best to achieve their goals were clearly incompatible. The disagreements were surely aggravated by the special complexities of operating in two countries, with different languages, currencies, and customs.

As we will see in the next chapter, Save Venice marched ahead, continuing to raise prodigious amounts of money and to fund a wide variety of restoration projects in the first two decades of the twenty-first century. Before following that story, however, we must return to the disagreement between Boston and New York over control of the organization's corporate identity.

Boston versus New York

From its earliest days, Save Venice had a well-established presence in Boston and in New York. The organization founded a chapter in each city in the early 1970s; in subsequent years there were directors resident in both cities, and board meetings were held in each. As noted in chapter 4, the directors had created a New York–based corporation in 1987, which operated in parallel with the Massachusetts-based corporation for about a decade, each with its own tax identification number. In 1996 and early 1997 Bob Guthrie and Jack Wasserman introduced a series of administrative and accounting changes designed to professionalize SV and to clarify its financial position. Among those reforms were efforts to better understand the finances and activities in Boston and to clarify Boston's corporate status.[43] One of their objectives was greater uniformity and consistency in tracking revenue and expenses across the whole organization, as evidenced in the appointment of accountants Ernst & Young and in other efforts to keep the books in order. Another factor was the significant growth of the New York–based group from the mid-1980s to the mid-1990s, with increasingly ambitious goals for raising funds and conserving larger and more complex works of art and architecture. In contrast, the Boston-based group had remained more or less the same size and was again deficient in its reports to the Commonwealth of Massachusetts. The parable of the student

outperforming the teacher may be a cliché, but by 1997 the New York group had outstripped Boston on nearly all metrics.

In response to requests from New York, by August 1997 the Boston group had submitted all of its recent financial figures.[44] At the SV board meeting in Venice one week later, Wasserman informed the board of the confusing situation: the original Massachusetts corporation had neglected to file its annual reports for 1993–96, while the New York corporation had filed in Massachusetts but not in New York.[45] Ernst & Young had studied the situation and concluded just prior to the board meeting that "SV is an independent not-for-profit institution incorporated in 1971 under the laws of the State of Massachusetts. SV operates an administrative office in New York City and a project office in Venice."[46] Wasserman was eager to correct the situation, and he proposed a straightforward—if unprecedented—solution to the board: "Mr. Wasserman has contacted Boston concerning a proposal to dissolve the Massachusetts incorporation. The Boston Committee would come under the New York corporation and would function as an autonomous committee or chapter as provided in Save Venice's New York by-laws. Save Venice would receive and deposit all of Boston's checks and pay all of their bills. It is hoped that this change will be enacted in the coming year."[47] The proposal of dissolution, rather than a merger, represented a change in emphasis and reflected Wasserman's goal to have all activities occur under the aegis of the New York corporation.[48] The SV board took no action on this proposal but instead waited to see what Guthrie and Wasserman could achieve through negotiation with Boston.

In mid-November 1997 Guthrie and Wasserman traveled to Boston's Harvard Club for a meeting with the leadership of the Boston chapter. In her report to the Boston executive committee, Eleanor Garvey summarized the two essential points of their proposal: (1) the Boston chapter should send its income and its invoices to New York, so that Ernst & Young could more easily track the flow of money, and (2) the Boston chapter should dissolve its present form and reorganize with whatever by-laws it chose. In suggesting that New York should be responsible for all finances, it was noted that in the previous year, SV had grossed $1.5 million of which Boston had contributed only $50,000.[49] Thus all agreed that while Boston had been a fixture of SV activities since its earliest days, its financial contributions were now greatly overshadowed by the money raised by New York.

The initial response from Donna Hoffman in Boston was that of cautious approval; she wrote to Wasserman on 25 November later that "the proposals that

Bob and you made have much merit, and I think all of us at our meeting of November 17 want to move expeditiously to conclude on matters."[50] In order to follow correct legal procedure, on 13 November Hoffman had filed annual reports with the Massachusetts secretary of state for the missing years, declaring that the directors of SV were all resident in Massachusetts.[51] On virtually the same day, Wasserman had filed an annual report for 1996 with the attorney general of Massachusetts, the State of New York, and the IRS, claiming that the "final responsibility for the charity's custody of contributions" rested with the directors in New York, including Lovett, Wasserman, and both Guthries.[52] Thus each side was trying to establish its credibility with the relevant state authorities.

Bob Guthrie immediately informed all of the New York directors of the situation, correctly stating that "the legal relationship between us [New York] and them [Boston] has become murky and needs resolution. SV is still both a Massachusetts and New York corporate entity, and the filing and tax reporting has been confused between the two."[53] Guthrie acknowledged that Hoffman and her colleagues were "receptive" but had "expressed concern about preserving autonomy on certain matters, e.g., designating the projects for which SV Boston funds would be spent."[54] In January 1988, the Boston executive committee asked for details of the proposed reorganization and of the by-laws that would govern the new entity.[55] Additional correspondence and another meeting in Boston in mid-May 1998 indicated that all sides agreed to a merger of some kind as the best way to resolve the confused identities.[56]

It did not work out that way, however. In June 1998 the Boston subcommittee sent a letter to Paul Wallace, requesting a "special status" and the right to retain a separate corporate existence.[57] Wasserman dismissed the letter in mid-July and did not address the concerns of the Boston group when he sent a draft of proposed by-laws to all directors in late August. Hoffman wrote her own letter to the directors, asking them to refrain from voting on the proposed by-laws until there was greater clarity on which were being amended and for whom.[58] As we have seen, the tumultuous Venice board meeting of September 1998 resulted in the simultaneous resignation of multiple directors, and thus Hoffman's request could not be addressed. Correspondence ensued between Wasserman and Hoffman in fall 1998.[59] A final effort to broker a deal in person in December 1998 failed when each side refused to budge.

In January 1999 Boston's executive committee met to settle the issue. After

extensive discussion, two motions were proposed. The first was that the Boston chapter "should decline the invitation to dissolve itself, merge with SV/NY, or otherwise assume the position of a chapter under the by-laws of SV/NY," and instead "should continue to go about doing its work as it has in the past."[60] A counterproposal declared that "Save Venice Boston should continue as a chapter of SV/NY, on condition that we retain our autonomy according to conditions approved by us." The vote was in favor of the first proposal, eleven to one, with the second proposal defeated by an identical margin.

On the very next day, Fergusson and Garvey wrote to Bob Guthrie to convey the results of that vote and the reasoning behind it.[61] They emphasized that the Boston chapter had no quarrel with SV/NY but for various reasons did not welcome a merger, noting that some were uneasy about what had transpired at the Venice meeting the previous September. Guthrie responded with a conciliatory and friendly letter two weeks later, emphasizing his desire to resolve these issues amicably.[62]

Later in the year the Boston chapter sent its minutes and financial reports to Ernst & Young in New York and informed its guests at the annual general meeting in October of the vote for continued independence. Donna Hoffman stepped down as chair, replaced by Peter Fergusson, and the Boston chapter continued to organize fundraisers and select restorations as it had for the previous thirty years.[63] From the perspective of Boston, then, the issue of a merger with New York was now closed. But the story of the tangled relationship between Save Venice Boston and Save Venice New York was not yet concluded. To those in Boston, it may have seemed still too early to concede that its historic leadership in preserving the art of Venice had waned. To those in New York, it was essential to maintain the dynamic growth of the organization, and that meant rebuilding its board and asserting its leadership as well as establishing greater coherence in its financial records.

The divisive events of 1997–98 challenged Save Venice at home and abroad. Yet the organization demonstrated resilience by continuing to meet its fundraising and restoration goals. Looking ahead to the twenty-first century, a revitalized SV could consider taking on even greater responsibilities for the benefit of the city. Embarking on a restoration of another entire building, along the lines of restoring the church of the Miracoli, would have been an obvious follow-up, given that ambitious projects galvanized American donors and were embraced by grateful Venetians. In a sign that perhaps grander aspirations might be possible, Venetian resident John Millerchip, a trustee of Venice in Peril and liaison to UNESCO,

expressed the hope in October 2000 that SV might seek a leading role in the comprehensive development of the Arsenale, the vast complex of former shipyards owned by the Italian navy and partially activated for Biennale exhibitions.[64] Such an assessment underscored SV's track record after three decades of success, and a sense that deeper involvement in urban planning, and indeed the future of the city, might be a logical next step. Although this prediction did not come to pass, the turn of the millennium provided an occasion for everyone in the organization to take stock of where Save Venice had been and where it was headed.

FIGURE 19. Scuola Grande di San Marco facade, 1488–95, after the 2001–4 conservation treatment. Designed and carved by Pietro, Tullio, and Antonio Lombardo, with Giovanni Buora and later Mauro Codussi, this is one of the grandest Renaissance facades in the city. Restoration drew from techniques of stone conservation developed during the earlier treatment of the Miracoli church.
—Photo by Matteo De Fina, courtesy Save Venice Photo Archives

Chapter 6

RICOSTRUZIONE

Rebuilding and Rebranding (1999–2006)

The California chapter of Save Venice was considered by some to be more
flamboyant and spectacular than the other chapters. Its proximity to Hollywood
and its affiliations with the film and theater industry resulted in sumptuous and
beautiful events. Our chapter was the cilantro in the salad.

 —Matthew White (2019)

THE TURN of the millennium appeared promising for Italy, as a key player in the
European Union and its third-largest economy. Although the actual introduction
of euro notes and coins would not happen until January 2002, the new currency
became official at the start of 1999. For several years before that, the euro had
already been listed on price tags and menus to acclimatize Italian customers as well
as foreigners in Italy. The potential of the euro to make Venice once again a world
city, and not just an Italian one, was enticing. However, businesses by and large did
not cooperate with the guidelines in the transition to the new currency. A price
of 20,000 lire was supposed to convert to 10 euros, but in practice the new price
became 20 euros. The abrupt pickup in inflation following the introduction of the
euro was particularly pronounced for frequently purchased products and services
(e.g., groceries, coffee, haircuts, car insurance), especially for those workers in lower
income brackets.[1] This meant that Venice, already an expensive city, became less
and less affordable to its inhabitants—and to many visitors. The high prices exac-
erbated the tourist phenomenon of *mordi e fuggi* (hit and run), in which tourists
disembarked from cruise ships or motor coaches to whiz past a couple of major
sights rather than taking the time to explore the city's hidden corners or patronize
local businesses.

 Moreover, currency fluctuations under the euro made life more difficult for any
American company or organization operating in Italy. Many Americans assumed
that the weak lira throughout the late 1990s, which meant bargain prices for people

spending U.S. dollars, whether for conservation treatments in Venice or gala cater-ing, would continue for another decade under the new currency. At first this proved true. In January 1999 the euro began to sink against the dollar and then fell pre-cipitously, reaching a low in November 2000. But by the summer of 2003 the euro had climbed substantially and would be strong against the dollar for ten more years. Considering these major economic shifts, as well as its own recent internal struggles, Save Venice needed to reinvent itself as an organization, in the United States and in Italy.

For SV, the conflicts of 1997–98 had necessitated a reckoning. A depleted board in New York, an independent-minded chapter in Boston, and negative public-ity in Venice could have crushed the organization. Instead, it bounced back and reestablished itself at the turn of the millennium, maintaining its focus on restora-tion projects and event-based fundraising to pay for them. Strong leadership from Bob Guthrie and his executive team (both board and staff) was essential to this resurgence. These leaders prioritized SV's signature events—the Regatta Week Gala, elegant cruises, and masked black-tie balls—and recruited their friends to become supporters. Such ticketed events burgeoned in the new century, with record-breaking attendance and revenues almost every year. The number of res-torations also continued to climb, reaching a peak of fifty-five projects per year by 2003–4, with the enormous facade of the Scuola Grande di San Marco as the lead project. Nor were these the only outlet for SV's energy: the group also supported fellowships, workshops, and publication subventions. This rebuilding phase of the organization was tested in 2002–3 by the U.S. invasion of Iraq and a "job-less recovery" in the aftermath of the dot-com bubble. These circumstances kept the U.S. economy and the confidence of American consumers in the doldrums. The recession reduced revenue for SV at precisely the same time its commitments were expanding, resulting in a financial squeeze that briefly threatened a deficit. Administrative turnover was a concern too, with three executive directors and three presidents in less than five years, as well as the resignation of Roger Rearick from the board after more than two decades of service. On the positive side, the establishment of a flourishing chapter in Los Angeles (with Matthew White) and some interest in Chicago indicated that SV could broaden its base.[2] The Boston group continued to pursue its own path, raising money and selecting restorations as it saw fit.

Turnover at the Top

The first step for SV was to rebuild the board of directors, which had shrunk to just seventeen people. In addition to the half-dozen board members who had walked out of the September 1998 meeting in Venice, and several of their allies who had resigned in the following months, other directors stepped down in late 1998.[3] In response, in January 1999 the board approved eleven new candidates and appointed a new nominating committee consisting of Winston Fowlkes (chair), Bea Guthrie, Beatrice Rossi-Landi, Terry Stanfill, and Richard Oldenburg.[4] In May 1999 the board elected an additional nine candidates, bringing the total number to thirty-two of a possible thirty-five.[5] Concerned that even this number might not be sufficient, Bea Guthrie asked the board to propose additional candidates, particularly with greater representation from the West Coast.[6] Five months later, the board nominated four more candidates, bringing the total to the maximum of thirty-five.[7] Satisfied for the moment with a fully constituted board of directors, Bob Guthrie commended its members and early in 2000 declared that SV was now a "financially secure organization" whose record of ongoing and completed projects had surpassed that of any previous year.[8]

In accordance with past practice and to ensure an orderly rotation, Guthrie reassigned the directors into three class years, with overlapping terms to expire in 2001, 2002, and 2003. He also provided a list of suggested committees (executive, nominating, projects, licensing) and asked for formal adoption of the revised by-laws; both requests passed unanimously.[9] The new by-laws permitted further expansion of the board, to a maximum of forty-five directors. Robert (Bob) Duke, the new chair of the nominating committee, presented a successful motion to nominate an additional six candidates in 2001.[10] Given the large number of new members, and reflecting the practice of many nonprofits to specify the obligations of trustees, Bob Guthrie drafted a brief document entitled "Board Membership: Commitments and Expectations." This memorandum stipulated attendance at meetings, financial support, committee work, help in raising funds, and recruitment of new supporters.[11] Among their multiple responsibilities, directors were required to attend at least one board meeting per year and encouraged to purchase tickets, adopt restoration projects, and advocate enthusiastically on behalf of Save Venice. This vision of board service required wholehearted participation by each member. As such, it echoed Bea Guthrie's observation in 1997 that "the board needs us all."[12]

In addition to repopulating the board, SV identified a new executive director. Bea Guthrie had indicated her intention to step down from that role in May 1998, but she agreed to stay on for an additional year when the board did not immediately identify a successor. But whom to choose? Should her successor be someone with deep knowledge of Venice or of the visual arts? Or should a track record in raising funds be the main criterion? The challenge of maintaining offices in two countries and of a board with many new members suggested that casting a wide net might be wise, yet there also existed a desire to find someone already familiar with the organization. In January 1999 Paul Wallace initiated conversations with Rosemarie Morse, an experienced book editor, to be the new executive director.[13] Those conversations came to naught, however, and by May 1999 the board tapped a familiar face, Tia Fuhrmann Chapman, to be the new executive director effective October 1999.[14] The directors then drafted a resolution recognizing Guthrie's thirteen years of service as executive director; it noted that she had "labored tirelessly during days, nights, and weekends" and among her achievements enumerated the Regatta Week Galas, with their treasure hunts and *Gala Journals*, the Cunard cruises, and more. The resolution further praised Guthrie for expanding the database of donors from 100 to 4,500, and for increasing annual income from $30,000 to more than $700,000. It particularly singled out her "good humor and equanimity to maintain the success of Save Venice in the face of extraordinary adverse pressure during a most difficult period when its future was threatened."[15] These qualities of energy, poise, and perseverance underpinned her thriving tenure.

Tia Chapman had first met the Guthries in 1989 when she was an intern at the Peggy Guggenheim Collection and had volunteered to help guide guests through Venice. She worked off and on at the SV office in New York through the 1990s while a graduate student and an employee at Christie's auction house, and she was an early proponent of the Young Friends (YF) in 1993. Familiar with New York cultural institutions and the recipient of an MBA in 1999, she knew Bea Guthrie well and the transition was a smooth one.[16] Chapman would remain as executive director for three years (1999–2002), during which time she sought additional support from foundations and increased the number of restricted gifts to SV, whereby supporters would assign donations to specific projects, often "adopting" a work outright. Together with Rossi-Landi, Chapman produced pamphlets for each restoration project that clearly outlined the opportunities for sponsorship and for recognition of the donor in SV publications. In 2002 she stepped down to take a

development position elsewhere in New York, and the board issued a resolution praising her work and her generous donations.[17]

In autumn 2002 Michael John Dagon was selected as the new executive director.[18] Although just thirty-two years old, he spoke fluent Italian, had earned a graduate degree from Syracuse University's program in Florence, and had previously run a student exchange program in Venice. Dagon had also worked for the Getty Museum in Los Angeles and, most recently, as associate director of major gifts at Barnard College in New York.[19] His initial charge from the board was to perform an in-depth review of SV's overhead and operating expenses.[20] He worked closely with the staff of the Venice office to enhance fundraising opportunities, as well as to increase advertising revenues in New York, and tried to establish a chapter in Chicago. He also corresponded with the Boston chapter about its status, organized lectures in New York, and attended the private committees meetings in Venice.[21] Dagon expressed a desire to work especially with younger donors and to encourage the next generation of leaders in the organization. Despite these achievements, apprehension about excessive operating costs within the office, coupled with concerns about lack of a long-term plan and a disagreement with the board leadership, led to his departure after about a year.[22] By fall 2003 Bea Guthrie had agreed to return as interim executive director.[23] She would remain in that role until May 2006 when she was succeeded by Elizabeth Makrauer. Guthrie's second act as executive director is discussed in more detail below; not surprisingly, her management style and achievements closely mirrored her previous tenure.

The turnover of executive directors was echoed in the role of president, which rotated from Paul Wallace (1998–2001) to John Dobkin (2001–2) to Beatrice Rossi-Landi (2003–6) to Sarah Schulte (2007–9). The position of president had recently evolved to be a strong second-in-command, for which it was important to possess skills that complemented those of the chair. Having two leaders at the top made sense given the large size of the board and the busy event calendar. A business background was important in the years immediately after the schism. With extensive experience as a director and CEO in the hospitality, manufacturing, and real estate businesses, Paul Wallace provided continuity and admirable neutrality through the conflicts of the late 1990s and subsequent rebuilding process.[24] He chaired important subcommittees and worked hard behind the scenes to keep the board united. His generous donations and his firm but gentle hand in guiding board discussions were much admired. His successor, John Dobkin, had been

the director of the National Academy of Design in New York City (1978–88) and then president of Historic Hudson Valley (1989–99), before being elected to the SV board in October 2001. Unlike nearly all his predecessors as president (who had previously served one or more terms as a director), Dobkin was immediately elevated to board president. His lack of prior experience with the organization, or perhaps a different vision from that of Dagon, the new executive director, may have precipitated Dobkin's abrupt resignation from the board just a year later.[25]

Looking for a different set of skills and someone with experience within SV, the board elected Beatrice Rossi-Landi to be president in 2003. A graduate of the Parsons School of Design and a graphic designer at Christie's and later at her own firm, Rossi-Landi had joined the YF in 1993, and along with Tia Chapman was a key part of its expansion in those years. Her Italian American heritage (she quipped that she was "half Texan and half Roman") gave her familiarity with Italian culture and society as well as fluency in the language. In agreeing to serve as president, Rossi-Landi specified that the by-laws should be amended so that the president would "not be primarily responsible for the efficient, harmonious and effective day-to-day administration of Save Venice . . . or . . . have primary authority over the hiring and discharge of staff personnel and the procedures and operations of Save Venice."[26] Her view was that Bob Guthrie's regular presence in the New York office (which was located in the basement of his townhouse) meant that he was better positioned to determine personnel. This change in the by-laws further strengthened the authority of the chair relative to the president. Despite some financial headwinds in 2003, Rossi-Landi served three successful years as president, regularly representing SV at meetings in Venice of the private committees and leading by example in contributing to multiple restorations. She also sought to foster a better relationship between the YF and the board of directors in order to "improve communication and to help establish greater continuity, interest, and loyalty to Save Venice."[27] Her success in securing donations from the James R. Dougherty, Jr. Foundation provided regular contributions to underwrite individual projects. In a resolution acknowledging Rossi-Landi's contributions, Bob Guthrie pointed to her expertise as a graphic designer, her generosity and "avid interest" in restoring works of art, and her fifteen years of combined service as president of YF and as president of the entire organization.[28]

Throughout this period, Bob Guthrie remained firmly ensconced as chair (1997–2006). The revised by-laws limited officers to five-year terms, and Guthrie's

tenure as chair was expected to end in January 2004. In anticipation of that event, in May 2003 the board asked Guthrie to stay on for another five-year term and offered to amend the by-laws. Guthrie demurred, citing the intent of the by-laws as "specifically made to prevent any one person from dominating the organization." In support of his decision, Guthrie cited the example of extended leadership by John and Betty McAndrew in the 1970s and pointed to how SV had "nearly foundered" after John McAndrew's death because the organization had nobody waiting in the wings. Guthrie added that of course he would assist a new chair, and the nominating committee agreed to identify a candidate.[29] At its next board meeting in October 2003, however, the executive committee reiterated its request that Guthrie stand for election again when his term expired—and this time he agreed.[30] Whereas in previous decades it was the president that represented the ultimate authority, Guthrie transformed the position of chair into the most powerful position within SV. In this same meeting of fall 2003, Bea Guthrie was asked to return as executive director, and Beatrice Rossi-Landi was nominated for president.

Thus, the Guthrie duo returned to the helm of SV for an additional three years.[31] Despite their popularity and record of success, the Guthries' reappointment was questioned by a few on the board, who agreed with Bob Guthrie's earlier point that it was time for a fresh viewpoint at the top. This inclination was seen most clearly in the person of Roger Rearick, an eminent art historian who had served SV onsite as a member of the Projects Committee as well as liaison to the private committees from 1993 to 2003.[32] Rearick's preference for new leadership was principally motivated by concern about personnel and financial matters rather than any personal animus.

Rearick was not the only one feeling anxious about the future of the organization. Early in 2003 Bob Guthrie became alarmed that overall operating expenses were outpacing revenue in an unsustainable fashion, and he responded promptly by communicating with the staff and board leaders about possible solutions. Guthrie's proposal to reduce office staffing levels in Venice by 50 percent in response to a budget shortfall kindled opposition from Rearick and his colleagues. Rearick wrote to fellow members of the Projects Committee to raise concerns both to the substance of Guthrie's cost-cutting proposal and to the way in which it was introduced:

> Bob Guthrie recently called an Executive Committee meeting where it was decided, without consulting the full Board or the Projects Committee, that

effective July 1st, 2003, the Venice office will be reduced to part time (from 9
to 1 daily), and [staff] cut to half salary. . . . It is obvious that our restoration
programs, not to mention our other activities in Venice, cannot be maintained
on this basis. The staff here has a full schedule of work every day and such a
cut in working time would mean a moratorium on all new restorations, and an
elimination of many current ones.[33]

Rearick's unease reflected the family ethos so central to Save Venice. He was moti-
vated not just by his sense that two staff members were needed to handle the vol-
ume of tasks in Venice but also by his respect and affection for those employees. As
is evident from his memo, Rearick also felt that broader consultation should have
been sought prior to making such a momentous proposal.

Buoyed by support from the Projects Committee, two days later Rearick laid
out his views in detail, concluding, "If we cannot continue on any level beyond
'holding the fort' why should we continue at all?"[34] Matters came to a head at
the next board meeting in May 2003, held at the Hotel Bauer in Venice. Citing
the Sarbanes-Oxley Act of 2002, which applied primarily to U.S. corporations
but which influenced financial reporting for nonprofits such as SV, Rearick and
a half-dozen directors circulated a memo calling for financial information to be
presented at each board meeting, including all revenue, expenditures, and indi-
vidual salaries, as well as an independent annual audit and accountability stan-
dards for executive officers.[35] As articulated in the memo, this subset of directors
was concerned about personal liability and wished to be aware of relevant financial
information in discharging their responsibilities. Clearly Rearick's worries now
extended beyond staffing the Venice office; he was preoccupied with the larger
financial picture.

In essence, Rearick wanted a smaller, more efficient board where everyone was
directly involved in all activities. Guthrie and his allies, on the other hand, felt that it
was important to have a larger board, to ensure strong attendance at ticketed events
and to share the burden of tasks among directors. Although this difference of opinion
was ostensibly about board governance, as it had been in the fateful arguments of
1998, the underlying issues were different and, thankfully, less consequential for the
organization as a whole. In hindsight, Rearick and his allies seem to have overreacted
to the proposed reduction in staffing, and their concerns about transparency appear
to have been misplaced. In the end, the board declared that it "did not feel that there

was any need for change in present governance with the exception of establishing an Audit Committee."[36] Thus, the efforts to question board leadership fizzled quickly, and a significant majority of the board remained firmly behind Bob Guthrie.

Although Rearick resigned, there is no evidence that any board member joined him, and there were no lasting repercussions. Indeed, soon after a reconciliation was evident. In making his final donation in fall 2003, Rearick asked that his gift be directed toward the maintenance of the present staff of the Venice office with its current number of employees and salary. In a gesture of goodwill, he added, "It is my fervent wish that all past differences can now be set aside in order to achieve what we all so firmly wish to accomplish for Venice."[37] These sentiments were reciprocated by the board leadership; two years later the organization dedicated one of its most significant restorations, the facade of the Scuola Grande di San Marco, to Rearick's memory. The shared commitment to the mission of the organization, and a fundamental respect for fellow board members, had mended the discord.

Finance, Fundraising, and Fellowships

The disagreements among board members in 2003 about financial and personnel issues were rooted in very real concerns that unsustainable spending might drive SV out of business. The origins of that problem are clear in hindsight but were not immediately obvious in the early days of the new millennium. After all, the late 1990s had been a time of expansion for SV and for the U.S. economy in general, with a strong dollar and a buoyant stock market. However, in 2001 a combination of events—the September 11 terrorist attacks, the dollar's decline against the euro, and increased overhead costs—put pressure on SV's coffers. An analysis of its financial challenges in 2003–4, and of its responses, illuminates how the organization weathered this storm. Such analysis provides further insight into its rationales for financial prudence (e.g., the desire to maintain a three-year reserve of operating expenses) as well as the leadership strategies employed by Guthrie and others.

At the turn of the millennium, Save Venice had roughly $2.6 million in assets, with about half of that amount earmarked toward specific projects.[38] Those obligations included more than three dozen ongoing restorations, as well as three fellowships, contributions to brochures and publications, underwriting of exhibitions, and more. The list of restoration projects presented to the board early in 2000 ran

to more than five single-spaced pages and reflects an eagerness to identify and fund a broad range of activities. Save Venice also enjoyed strong participation from supporters with its annual appeal (c. $150,000 per year) and with its lectures and smaller fundraising events in New York, Boston, and now California.

Fowlkes was an active treasurer, coordinating with U.S. Trust and with the finance committee to ensure that sufficient funds were available in the operating account and that a sensible balance was maintained between equities and fixed income funds in the investment account.[39] Save Venice's assets fluctuated between $2.5 and $3 million from 1999 to 2002, but by October 2002 Fowlkes was concerned enough that he advised the board to be "extra conservative" when committing to future spending.[40] He pointed to the general downturn in the U.S. economy after the terror attacks of 9/11, which had lowered the market value of SV investments to about $2.3 million and led to a substantial decrease in donations to most charities, including SV. He explained that the trip to Turkey in 2002 had been postponed because of safety concerns over terrorism, and thus not only did the organization lose the expected income that year but ship charter fees still had to be paid. (The 2003 Venice gala was also postponed, further depleting the anticipated revenues.) Fowlkes reminded the board of the many restoration commitments it had undertaken, totaling $1.96 million, versus estimated assets of just under $2.3 million. He added that the dollar had dropped in value against the euro from 1.124 to 0.918 by the end of 2002.[41] The licensing program revenue had also dipped sharply in 2002, from $350,000 the year before to less than $100,000. In sum, SV faced a large deficit, and potentially insolvency, in the near future.

Bob Guthrie was very much aware of these looming financial problems. During the October 2002 board meeting in Venice, he told Melissa Conn that she might lose her office assistant, to which Conn replied that she and her assistant (Jill Weinrich) would rather work half-time than have one of them laid off.[42] In January 2003 Guthrie met with the executive committee, which (according to Guthrie) unanimously decided that overhead needed to be significantly reduced but came to no specific decisions at that time.[43] Guthrie thus notified the Venice office that staff reductions were now likely, and this triggered Rearick's protests in late January 2003. At the same time, the board met in New York and discovered that its commitments and assets were almost exactly equal. Fowlkes again reminded the board to be extremely careful about future commitments until new sources of funding could be found.[44]

By April 2003 Save Venice faced a predicament. In a letter to the board, Guthrie did not mince words: "Since the Executive Committee meeting several months ago, our situation has worsened. Our overhead is now reaching levels that our accountants tell us is in violation of the guidelines of the New York State Bureau of Charities. Beyond that, they tell us that if we dip into restricted funds for operating costs, each board member is individually liable. While I am chairman, that is not going to happen. The doors will be shut first."[45] Guthrie was referring to a letter from CPA Sidney D. Wexler summarizing the 2002 audit of SV's books. Wexler acknowledged that 2002 had been a difficult time for most nonprofit entities, but he warned SV that its unrestricted income had decreased by approximately $500,000 from 2001 to 2002 while its operating expenses remained the same, resulting in a shortfall of $160,000.[46] Wexler recommended a reduction in operating expenses as soon as possible.

Looking for a solution, on 1 May 2003 Guthrie distributed a detailed memo and attachments to the board about the troubled financial situation, in order to give the directors "a chance to digest them, develop ideas and make tentative decisions" in advance of that month's meeting.[47] In referring to the fact that SV's operating costs exceeded its annual unrestricted income and represented more than half of total income, Guthrie stated, "The first is unsustainable, and the second is an embarrassment." He included Wexler's letter and two spreadsheets demonstrating that the operating expenses of the two offices totaled around half a million dollars. Guthrie pointed out, as Fowlkes had done previously, that SV's reserves had fallen $1.1 million during the past year due to the decline of the dollar, the market slump, and the absence of income from a cruise and a Venice gala. Guthrie offered projections and options for reducing expenses in New York and Venice but declined to take a position on which solution would be best, believing that was the responsibility of the board. Guthrie's memo judiciously refrained from mentioning the lower rate of giving by the board in the previous two years.

Given the financial dilemmas, the May 2003 board meeting required much discussion, with varying solutions proposed for the financial and personnel problems facing the organization. Fowlkes announced that he would transfer $300,000 into euros to cover the organization's obligations to restore the Fenice theater. To cut expenses, he replaced Ernst & Young with a less expensive firm and won approval for an in-house audit committee. It was at this point that Rearick and others called for greater transparency and more complete accounting, but to little avail. In a

lengthy report, Guthrie reviewed all the financial documents and declared that immediate reductions in expenses were necessary.[48]

The board debated additional solutions to the high overhead. Fowlkes recommended a $50,000 reduction in the New York and Venice offices, as well as a campaign to raise $200,000 from the directors themselves. Others objected, claiming that the Venice office could not function with fewer than two people, and that it seemed unfair to leave Conn alone in the office in her second trimester of pregnancy. In the end, the board adopted a compromise:

> The Venice staff would remain at two full-time people but move to a less expensive location;
>
> The New York office would eliminate the paid position of executive director;
>
> The board committed itself to raise $200,000 in unrestricted funds by June 2003.[49]

Skeptical that the measures would be sufficient, Fowlkes and Guthrie warned the board that this plan was not a long-term solution.[50]

Happily, none of these concerns came to pass. By October 2003 the financial situation had brightened dramatically with revenue coming from several sources. The board raised $115,000 in emergency funds, the trip to Turkey in summer 2003 netted approximately $110,000, and the New York YF's backgammon tournament collected $8,000.[51] Under the leadership of Hutton Wilkinson, Matthew White, and Terry Stanfill, the energetic California chapter raised an additional $150,000 in unrestricted money and began organizing a lecture, champagne reception, film screening, and weekend in Las Vegas. Treasurer Fowlkes reported in autumn of 2003 that Save Venice was "more financially sound" than at the beginning of the year, with $238,000 fewer commitments and $514,000 additional uncommitted funds. In a memo to the board just before that meeting, board member Bob Duke noted that "an improved stock market and a stronger dollar exchange rate with the euro greatly enhances the Save Venice financial situation, [while] a successful Gala in Venice next fall will surely take Save Venice to a state of financial health."[52] In September 2004, with J. Robert (Bob) Lovejoy now serving as treasurer, the board engaged in extensive discussion about its economic objectives, the appropriate ratio for overhead costs versus projects, the proportion of monies held in dollars versus

euros, and so forth.[53] This discussion demonstrated the board's resolve to maintain a sound fiscal footing. In early 2005 an external audit indicated that ratios of fundraising expenses to funds raised, and of program expenses to total expenses, were comfortably within the appropriate ranges.[54] Subsequent board meetings in 2005 and 2006 continued with careful attention to SV's financial position, but the danger of collapse had passed. Justifying once again the large size of the board, many individuals had pulled together to surmount the crisis.

A busy schedule of fundraising events between 1999 and 2006 kept SV in the black. Tapping into donors at different levels across the country, these ranged from the modest cocktail parties and trunk shows organized by local committees to the elaborate galas in Venice and week-long cruises led by the Guthries. In New York, the YF had previously established the tradition of a midwinter masked ball, and that continued in 1999 with the Winter Crystal Carnival, raising $160,000 for the facade of the Scuola Grande di San Marco. Collaboration with fashion and jewelry companies brought creative flair to these parties in addition to cash donations. For the Winter Crystal Carnival, the Italian jewelry firm Bulgari invited more than three dozen fashion designers to create a collection of fantasy masks and headdresses, which were then sold at a silent auction to partygoers. For the same event, Escada lent evening dresses and Swarovski offered prizes as well as provided overall sponsorship.[55] In 2000 the Marco Polo Ball, again chaired by Nadja Swarovski and Adelina Wong Ettelson, brought 350 guests to the Metropolitan Club and netted more than $100,000 to restore the Marco Polo arch in Cannaregio.[56] With the exception of the futuristic Carnevale-in-3000-A.D. dinner dance in 2001, subsequent masquerade balls linked their themes to Venetian history, rotating from one historical reference to another each year: the Byzantine Ball (2002), the Doges and Dogaressas Ball (2003), Casanova's Court: Masks, Romance, and Lovers Ball (2004), and the Bellini Ball (2005).[57] Increasingly these events in New York were run by the YF while the more senior members concentrated on the Venetian galas and international excursions. Already important, the Carnevale ball in New York would become a crucial foundation of SV's financial success and indeed the central event in the calendar in subsequent years.

Other New York social events included gallery receptions, private shopping in retail boutiques, cocktail hours, and dinners with guest speakers from Italy, such as glassmaker Gianluca Seguso.[58] A March 2005 party for six hundred guests at

Cipriani 42nd Street, with the theme "Dolce Vita a Venezia: Celebrating Italian Glamour of the 1950s," netted \$260,000 and honored Terry Stanfill for her many contributions.[59] A juried exhibition of contemporary art of Venice was held at the Salander-O'Reilly Gallery on the Upper East Side in November 2005; half of the artists' sales was donated to SV.[60]

Beyond New York, Save Venice organized exhibitions and parties to raise awareness of its mission and to recruit new supporters. For example, in Dallas a "Salute to Venice" event was held at the luxury department store Stanley Korshak in October 2000. Sponsored by the Hotel Bauer (Venice) and Italian menswear manufacturer Belvest, the store agreed to make a contribution to SV, provide a list of names and addresses of clients, and distribute SV newsletters and restoration brochures.[61] In Chicago Michael Dagon attracted more than forty people to a sold-out lecture and reception in spring 2003.[62] Taking advantage of exhibitions already on museum calendars in Washington, DC's National Gallery of Art, a 2006 tour of the exhibition *Bellini, Giorgione, Titian, and the Renaissance of Venetian Painting* with curator David Alan Brown, and a corresponding dinner at Teatro Goldoni restaurant, helped to raise money for a restoration in the Museo Correr.[63] Under the leadership of Allison (Alli) Drescher and Juan Prieto, the YF in Boston organized a series of very profitable Carnevale-themed parties in the early years of the millennium.

Innovative methods of raising funds sometimes came up short. In January 2004 the licensing program was curtailed "for various reasons including the [U.S.] economy and the unwillingness of the Licensee to create new designs for the Corporation."[64] In the same meeting, it was acknowledged that a previously launched project (the Serenissima Society) to reward generous donors with discounts in Venice would have to be canceled: "The Serenissima Society was not working as envisioned in creating new donors and increasing unrestricted giving. Printing the various elements required to promote and fulfill membership is expensive. Maintaining membership rolls is cumbersome and time-consuming, and not all participating merchants honor the card."[65] Despite these two mishaps, the extant documents make clear that SV had rebounded from the financial distress of 2003 and was once again enjoying financial success and a sense of forward momentum.

Even when SV was facing financial difficulty, the directors recognized that fellowships for young art historians and restorers represented an investment to increase expertise and encourage the next generation. Whereas previous fellowships had been given largely to Italian nationals for technical expertise, in 2000 the

board instituted a requirement for new recipients "whereby they will either give a lecture or write an article about a particular project upon their return to this country." This signaled the board's intention to award more fellowships to U.S. residents. The initial recipient of this largesse was graduate student Frederick Ilchman to continue his studies on the early career of the painter Tintoretto.[66] Presaging his future involvement with SV, Ilchman gave tours for guests and prospective donors as well as assisting with research and writing for newsletters while in Venice. A second recipient of this art history fellowship in 2001–3 was Johanna Fassl, for her study of altarpieces by Giambattista Tiepolo.[67]

In concert with this art history fellowship, in 1999 Paul Wallace offered a gift of $25,000 per year for three years from his family foundation.[68] Wallace's "restoration fellowship" was designed to support "an American restorer to work and study with restorers in Venice" for a period of six to eight months. Recipients included Serena Urry, a paintings conservator (1999–2000) and Jeffrey Wirsing, a sculpture conservator (2000–2001).[69] In 2002 Rearick attempted a new tack for the organization, that of musical training, when he donated funds to establish a fellowship in his name to allow "promising young singers to study and gain first-hand experience in smaller roles in the repertory and a chance to learn and practice."[70] Remembering the importance of assisting Italian restorers, from 2001 to 2004 SV funded Giovanna dall'Aquila on a grant to assist the Superintendency of Monuments with work on the facade of the Scuola Grande di San Marco, the next major project after the Miracoli church. The board was also willing to support external organizations with similar goals in restoration; for example, in May 2002 it renewed for the fifth time a $10,000 grant to underwrite seminars sponsored by the International Centre for the Study of the Preservation and Restoration of Cultural Property (ICCROM).[71] The tradition of SV-sponsored fellowships was now firmly established; while the funding, focus, and frequency of such fellowships fluctuated, they would remain an important element of the core mission.

Special Events: Galas, Cruises, Trips, and Lectures

The Regatta Week Galas in Venice continued to be critical for SV in terms of fundraising, membership, and its public identity from 1999 thru 2004. Nothing else generated as much money or required as much attention. For the 1999 gala the theme of "Americans in Venice" embraced lectures on Peggy Guggenheim, John

Singer Sargent, and the members of the Palazzo Barbaro circle, complemented by a cabaret night of 1920s songs at the Hotel des Bains made famous by Cole Porter and Elsa Maxwell. Peter Duchin and his orchestra played more American music on the following evening at the grand Palazzo Volpi. Given the turmoil on the board in 1998, the 1999 gala was—not surprisingly—the least successful in financial terms, even as it gained rave reviews from the guests.[72] The 2001 gala with the theme of "Music in Venice" initially seemed to be plagued by similar problems.[73] It was to be preceded by a six-day Aegean cruise aboard the *M/Y Harmony* from Corfu to Venice in late August, which sold out in just four days but was then canceled "due to contractual discrepancies and extremely unsatisfactory reports from recent passengers."[74] Despite this cruise cancellation, the 2001 gala raised a prodigious amount of money ($644,868), largely due to strong attendance and significant sponsorship of all major elements. This gala was notable for the sizeable contingent from the California chapter, led by Los Angeles designers Matthew White and Hutton Wilkinson.[75] It also had the good fortune to conclude just days before the terrorist attacks of 9/11 suspended air travel and radically disrupted life in the United States and elsewhere.

The 2003 gala was postponed to 2004 amid concerns that Americans would be reluctant to travel internationally in the aftermath of 9/11. The absence of revenue led to painful discussions about staff cutbacks and belt-tightening all around. In assessing whether the galas should be continued or substituted with something new, Fowlkes cautioned that SV should not risk a proven major fundraising event for an unknown entity so long as the finances were tight. Bob Guthrie noted in May 2003 that with a bit of luck, "the Board felt that we would make it through to our next fundraiser—the Gala in Venice in the fall of 2004."[76] In the event, the 2004 gala was a success with a net profit of $445,000, buoyed in part by the lively enthusiasm of thirty-four Young Friends from New York.[77] In addition to the usual receptions, lectures, and evening balls, the 2004 gala included a day trip to Udine and Aquileia to view Tiepolo frescoes and Byzantine mosaics, respectively.[78] The 2004 treasure hunt, designed for the first time by artist and graphic designer Michael LaPlaca, featured a fold-out map (instead of a booklet) with visual clues arranged around the edges of the map. Entitled "A Mosaic of Venice," it included both photographs and illustrations to guide guests through the lesser-known corners of Venice.[79]

Despite the concerns expressed by Fowlkes about abandoning the traditional end-of-August slot, the board felt sufficiently confident to plan a February 2006

Carnevale gala in Venice. Doubtless, the tremendous success of the Young Friends' Carnevale parties in New York and Boston influenced this decision. In addition, Venice possessed a long tradition of masking, and the practice of celebrating Carnevale in Venice (and across Catholic Europe) extended back to the late Middle Ages.[80] That tradition had been largely dormant, however, from Napoleon's conquest in 1797 until the mid-1970s when youths from Padua staged an impromptu event in costume in and around the Piazza San Marco. The Venetian Carnevale grew rapidly in popularity, even without much municipal support, and by the 1980s thousands of tourists were streaming into Venice in midwinter, revivifying the restaurants, hotels, and shops that had often closed for several months in the low season. It was in this context that SV decided to hold an event linked directly to Venetian Carnevale. In preparation for the 2006 Carnevale gala, SV partnered with the Italian Cultural Institute in New York for a cocktail party at the Rainbow Room in Manhattan, promoting Virginio Favale's book *Venice Carnival*.[81] Next, with Venice's Hotel Bauer as a base, the 2006 gala guests enjoyed evening events in turn at Palazzo Papadopoli, Palazzo Mocenigo, and finally Palazzo Pisani Moretta, including a torchlit procession through the streets. Activities included a treasure hunt, cocktail parties, onsite lectures, and a Renaissance country luncheon at Castello di Roncade.[82] For the latter, designer Matteo Corvino recruited the townspeople to prepare traditional breads, cheeses, and meats as in a sixteenth-century village fair. The 2006 Carnevale party in Venice netted more than $350,000 from 180 attendees. Although the number of guests and the net profit were less than previous galas, the Carnevale gala proved that a midwinter event in Venice was feasible and that careful planning could work around the crowds in the center of the city.[83] Furthermore, the good results from the gala prompted SV to consider Venice-based events at other times of the year (e.g., Biennale in June, Redentore in July).

Another distinguishing element of SV were the luxury cruises and trips organized by the Guthries for board members and friends. As discussed in chapter 4, the trips initially were offered only in even-numbered years but soon proved so popular that they came to be scheduled every year. Moving beyond the Mediterranean, SV expanded its horizons to Russia, Germany, and even Brazil. From 2000 to 2006 SV organized half a dozen successful trips; most were sea-based cruises, but there was also a land trip to St. Petersburg (2003–4) as well as a river cruise on the Elbe to see Prague, Dresden, and Berlin (2005). The size of each trip varied according to the destination and the capacity of the ship (or bus), ranging from an intimate group of

thirty for a trip down the Amazon River in May 2004 to a massive group of nearly one hundred participants for a June 2000 "White Nights" trip to Russia. The price per person varied widely too, depending on the length of the trip, the quality of accommodations selected by the traveler, and the inclusion of airfare. The board minutes generally record the amount of money raised by each trip, which ranged from $110,000 for a trip to Turkey (2003), to more than $300,000 each for an Elbe River cruise (2005) and a cruise around Sicily (2006). The trips were not without financial risk, as the ships often had to be booked years in advance and required substantial deposits.[84] The minutes contain numerous detailed reports from the Guthries about their negotiations with Cunard and other cruise lines, and demonstrate shrewd assessments of the risk-return ratio. Several trips had to be canceled or postponed owing to unexpected events (e.g., the 9/11 attacks, the financial downturns of 2003 and 2008, or determinations that the ship was not of sufficient quality) but such trips were usually rescheduled for a following year.

The trips reflected Bob and Bea Guthrie's preference for upscale accommodations, interesting locales, and expert guides. In his letters extolling the trips and recruiting participants, Bob Guthrie emphasized the difference between an exclusive, "boutique" trip like his on the Amazon and a package tour organized by a tour operator for the masses:

> There are first-class cruise ships that ply the Amazon, but they don't stop to explore. They don't go out on trips along the trails at night. They don't hear the birds singing or the monkeys chattering. They don't stick their toes in the water to test for piranhas. They pass by, fifty feet in the air, seeing the world go by on the other side of [a] picture window. . . . We, on the other hand, will be right down in the midst of everything, and before we are done, my guess is that we will wish that we had gone for two weeks instead of one.[85]

Guthrie also highlighted the high quality of the hand-picked guides and lecturers who would accompany the trip; for the Amazon trip, the leader was Gilberto Castro, whom Guthrie described as "an enthusiastic, serious, and talented professional."[86] Guides for other trips included experienced speakers such as John Julius Norwich, Oliver Bernier, and Suzanne Massie. The detailed reconnaissance and extensive advance planning Bob Guthrie did also meant that if something had to be changed at the last minute, there was a vetted alternative available.

Participants on these trips frequently spoke of the opportunity to go beyond a conventional tour; they valued the opportunity to visit private homes and art collections, to examine restorations *in situ*, and to speak with experts on different topics. For example, Beatrice Esteve of Brazil, a board member who helped to organize the Amazon trip and who attended nearly a dozen other excursions with the Guthries, described the opportunity to meet Crown Prince Hassan, the intended future king of Jordan, at breakfast, as well as the chance to visit several private castles along the Rhine on another voyage.[87] Another board member, Martha Stires Wright, recalled how her father, Sidney Stires (who had joined the board in 1999), would sign up for virtually any destination as long as the Guthries were leading the trip.[88] These participants valued the combination of academic learning, camaraderie, and private access. Perhaps the most convincing metrics of success were the high number of repeat travelers and the rapidity with which these trips sold out. In essence, the Guthries managed to replicate the success of the Venetian galas—founded on access to private homes and villas, behind-the-scenes learning opportunities, and consistently elegant meals and receptions—in other locations around the world. These trips substantially increased both targeted restoration gifts and annual unrestricted revenue. Above all, they cemented the loyalty of board members and top donors.

If trips and cruises attracted SV's most affluent supporters, an expanding array of lectures provided an opportunity to draw in a different and broader group. Lectures—in New York, Venice, California, and Boston—rarely contributed to the bottom line, but they constituted an important element of educational mission and outreach. We have already seen that SV introduced a consistent lecture series in New York in 1990, and that the Boston chapter regularly drew from local scholars to provide single lectures and gallery talks. Although the original charter drawn up by John McAndrew and colleagues in 1971 did not explicitly cite education as a core goal of the organization, SV embraced lectures and educational events, making them part of the calendar.

In the fall of 2000 SV offered three lectures in New York, including David Rosand on Rembrandt's indebtedness to Venetian art ("Titian's Dutch Disciple"), Debra Pincus on "Ducal Tombs," and Helen Fioratti on "The Lagoon: Its Society and Furnishings, from Necessity to Splendor."[89] Inspired by this success, SV organized three more lectures in spring 2001, including Bob Guthrie and Theodore Rabb speaking on the topic "Can Venice Be Saved? Acqua Alta and the Lagoon,"

followed by Eric Denker on "Whistler and His Circle in Venice" and William Griswold on "Venetian Drawings in New York City."[90] Four more lectures followed in fall 2001 by Gianluca Seguso (of the Venetian glass company), architectural historian Deborah Howard, Byron scholar and former board member Jack Wasserman, and garden historian John Dixon Hunt.[91] Spring 2002 featured lectures on Tintoretto (by Frederick Ilchman), on Ruskin (by John Julius Norwich), and on the novel-in-progress *Venice for Lovers* by the Polish American author Louis Begley.[92] In the fall of 2002 two nationally recognized authors spoke about their experiences with Venice: Garry Wills and Erica Jong.[93] A sponsored dinner often followed each of the lectures. Venues included the Colony Club, the Knickerbocker Club, the Lotos Club, and Sotheby's. This successful tradition of half a dozen lectures annually continued in New York for years.[94]

Also in 2001 the Venice office began to organize a lecture series in Venice itself entitled "Venezia Restaurata" (Venice Restored), featuring conservation projects by each of the private committees in turn.[95] Francesca Bortolotto Possati, owner of the Hotel Bauer, typically hosted these lectures by providing the venue and an elegant reception. Free of charge, these lectures were held about every two months and offered good public relations for SV.[96] The California chapter followed suit, inviting Frederick Ilchman to lecture in Los Angeles in 2002 to 175 people, followed by Mary Ann Bonino on music in Venice. The next year the California chapter hosted Sonia Evers speaking about "Americans in Venice" and then Alberto Nardi on "The History of Jewelry Making in Venice."[97] The Boston chapter already had an annual spring lecture, and in 2004 followed New York in establishing a three-part series each spring. In short, SV's educational portfolio grew significantly in the early part of the new millennium.

Restorations

The leaders of Save Venice have generally preferred to think big. Easily the most important restoration in this period 1999–2006 was the facade of the Scuola Grande di San Marco. Adjacent to the church of Santi Giovanni e Paolo, this building had been the original seat of the major confraternity of San Marco, founded in 1260. Architects Pietro Lombardo and later Mauro Codussi completely rebuilt it after a fire in the late fifteenth century. In the nineteenth and twentieth centuries it served as a military and then a public hospital and remains the main hospital of

Venice today. In addition to a museum dedicated to medical history, it retains the only emergency room entrance in the world served by water taxi or motorboat ambulance. The facade displays multiple pilasters and arches of polished marble, demonstrating Renaissance classicism and a bit of Byzantine style. The methods of stone restoration developed during the conservation of the nearby Miracoli church proved to be crucial for the work on the Scuola Grande di San Marco. By 2002 SV had committed more than half a million dollars to cleaning that facade.[98] The complex scaffolding and its decorative cover slowed progress, but by 2004 the project was on its fourth and final phase of cleaning. The inauguration ceremony occurred on 13 May 2005 in memory of Roger Rearick, who had championed this project but died the previous year.[99] In the following month, the European Commission awarded the E.U. Prize for Cultural Heritage to Save Venice for restoration of San Marco's facade.[100] SV would return to projects in or related to the Scuola in subsequent years, including restoration of several paintings decorating the interior, such as the *Apparition of Saint Mark* by Domenico Tintoretto and most recently the illuminated paper registers of the confraternity of San Marco for the period 1448–1556, now held in the Venetian State Archive.

Restoration of the theater La Fenice, a landmark in the history of opera, was important to SV but perhaps even more crucial to Venetians. In 1990 SV had restored the stage curtain, which depicted the celebrations for the Venetian victory against the Ottomans at the Battle of Lepanto in 1571, but the entire theater (including the curtain) was gutted by fire in January 1996 in an act of arson by two Italian electricians. Significant delays in construction slowed the rebuilding, yet by 2002 SV had donated $250,000 for the painted and stuccoed ceiling of the auditorium.[101] The theater reopened in January 2004 and quickly established a tradition of a major annual New Year's concert. In New York in November 2005 SV hosted a film, *Return of the Fenice*, to celebrate the new theater.[102] To support the Fenice, SV has occasionally rented the space in order to host performances and meals associated with its galas.

If SV's leaders liked large, ambitious restorations, often donors preferred to sponsor individual works. This resulted in many smaller conservations at any one time, such as the dozens accomplished from 1999 to 2006. Indeed, this period was the apogee to date for the number of projects sponsored by Save Venice. For example, the 2000 newsletter listed eighteen separate projects, including paintings by Pordenone, sculpture by Domenico Gagni, frescoes in the church of San Samuele, the Lando chapel in the cathedral of San Pietro di Castello, and structural

consolidation of the Scuola Grande Tedesca, the oldest of the five synagogues in the Venetian Ghetto.[103] The 2002 newsletter described fifteen additional projects, such as Tintoretto's *Birth of Saint John the Baptist* in San Zaccaria, the funeral monument for the painter Palma il Giovane in the church of Santi Giovanni e Paolo, and that of the late fifteenth-century military commander Melchiore Trevisan in the church of the Frari; further mentioned were the majolica tiles in the church of San Sebastiano (for another Lando chapel) and a rare twelfth-century Greek manuscript brought from Constantinople to Venice around 1453.[104] In January 2003 David Rosand announced to the board that SV was currently administering fifty-five projects, with seventeen completed the prior year and twenty-three expected to be done before the end of that year.[105] The cost of individual projects varied widely, from $1,500 for a door in the bell tower of S. Giovanni in Bragora to hundreds of thousands of dollars for an entire floor or for an ensemble of paintings and frames. It was around this time that the voluminous information from the Projects Committee began to be added as attachments rather than incorporated into the text of the board minutes—yet one more sign of the unprecedented volume at which SV was working.

For these and other restorations in subsequent years, the Projects Committee had adopted a new procedure in fall 1999, intended to streamline the process of selecting projects. As explained by art conservator and committee chair David Bull, the committee would review all projects prior to a full board meeting and prepare two lists: (1) projects to be funded directly by SV, and (2) projects for which an additional sponsor must be found (i.e., conditional approval with no commitment of general funds).[106] The color brochures created by Beatrice Rossi-Landi were essential in obtaining external support for the second group of projects. Gone were the days when just one or two individuals, such as John McAndrew or Rollin Hadley, could identify, select, and raise funds themselves for most conservation projects. SV was now juggling dozens of simultaneous projects and thus established an effective process for managing that caseload, including expansion of the Projects Committee from five to ten members and regular communication between the Projects Committee, nearly all based in the United States, and Melissa Conn in Venice.[107]

David Rosand succeeded Bull as Projects Committee chair in 2004 and held that job for nearly a decade, ushering in several important developments. He introduced the use of bar graph reports for each project so that board members could gauge progress at a glance. He required a Projects Committee review and a site visit by the board prior to project approval (an exception was created for emergency

repairs of less than $10,000). Committee members had to evaluate and monitor projects; stay abreast of policy changes from government, church, and museum officials; and balance the desire of donors and corporations to be publicly recognized on scaffolding and signage—general practice in the United States—against Italian practice and a broad concern about excessive commercialization.[108] Lastly, the Projects Committee managed the selection of fellowship recipients as well as grants related to conservation activities (e.g., ICCROM).

Public Relations

In order to promote its mission and recruit additional members, SV pursued a multipronged strategy that included print and electronic communication, licensing arrangements, and partnerships. As we have just seen, signage at a conservation site represented one (albeit limited) method to advertise its work. In 1999 SV hired Patrick Robertson, "a well-known London-based public relations expert," with the goal to "generate a great deal of positive exposure for Save Venice."[109] Initially engaged for an eight-month trial period, Robertson worked closely with the executive committee and Bob Guthrie to increase the group's visibility through published articles and paid advertisements. Robertson also collaborated with treasurer Winston Fowlkes and Guthrie on the Licensing Committee, which Fowlkes had characterized early in 1999 as "losing momentum."[110] By the following meeting of May 1999, however, the Licensing Committee reported a net profit of $135,000 from total revenues of $267,000. In that same meeting Bea Guthrie described new licensing arrangements with Century Furniture, Deruta Ceramics Company, and a wholesale distributor of garden ornaments called Hen Feathers.[111] Eighteen months later she informed the board of an astonishing $225,000 in royalties from Venetian-inspired painted furniture pieces.[112] Recognizing both the financial and public relations windfall from these licensing agreements, other directors suggested additional affiliations, such as an Illy coffee cup or vendors from the New York Gift Show.[113] By May 2003, however, the drop in the U.S. economy had substantially curtailed profits from licensors, at which point Bea Guthrie warned the board that several licenses had not been renewed and that the licensing program might not produce any income in the future.[114]

Another initiative discussed at length but ultimately discarded was a partnership with the new Venetian casino in Las Vegas. In January 2000 Paul Wallace met with the president of The Venetian Las Vegas, which had held its grand opening

the previous year. To recover from a poorly handled launch campaign, The Venetian resort asked SV to be involved in the one-year anniversary celebration of the casino. Wallace informed the board that he was surprisingly impressed with the casino but cautioned that "involvement with The Venetian would be a critical decision for Save Venice." He was particularly concerned with the exact nature of the deal as well as the expected duration of the agreement. Another board member proposed that in return for lending its name to The Venetian, SV could ask the casino to underwrite the New York ball in February 2001. After subsequent discussion, the directors concluded that "dealing with a gambling casino, if not handled properly, could taint [their] reputation. . . . It was therefore the opinion of the directors that Save Venice should not enter into this proposed affiliation at the present time, although exploratory discussions with The Venetian could be continued."[115] SV apparently never reopened those discussions with The Venetian, even as the context around legalized gambling changed dramatically in the first two decades of the twenty-first century, with an increasing number of states (including New York and Massachusetts) permitting legalized gambling and creating lucrative partnerships with local Native American tribes.

The creation and launch of a website represented an additional important step to broadening the public reach of Save Venice. As noted previously, leadership in both Boston and New York had been slow to embrace the concept of a website, but by May 1999 the organization had established a domain name.[116] In October 2000 the executive committee signed a contract with the company Kintera to update and maintain the website. Kintera specialized in nonprofit organizations and promised to develop new ways for SV to use the website to raise funds.[117] In addition to receiving online donations and promoting the annual appeal, the website advertised galas, lectures, and other events. Gradually it also became a way for SV to document and promote the restorations carried out in Italy. The website would become increasingly important, and increasingly sophisticated, as the internet gained prominence in daily use.

The most traditional form of public relations and donor stewardship remained the annual hardcopy newsletter. John McAndrew had started this tradition in 1971–72 with a four-page, black-and-white newsletter devoted primarily to updates about recent restorations, along with occasional reports about fundraising events or important news from Venice. Rollin Hadley continued that format throughout the 1970s and early 1980s, with occasional biennial issues and expansion to six or eight pages. The Guthries modernized the look of the newsletter in several important

ways beginning in 1986: printing it on glossy paper, doubling the number of pages, inserting color photographs, and including more news about and photographs of board members and donors. By 1999 and thereafter the newsletter was averaging sixteen pages in length, with the majority of it devoted to short articles about individual conservation projects. The last several pages were reserved for chapter news; biographies of incoming directors; and description of trips, balls, and other events, thus recognizing contributors and underscoring the social aspect of the cause. At least several thousand copies were printed each year. The Boston chapter produced its own modest newsletter under the direction of Wellesley professor Peter Fergusson. Consciously following the example set by John McAndrew, the Boston newsletter in this period was considerably simpler in style and size than the New York one. In addition to updates about recent restorations and a summary of Boston-area events, the Boston newsletter included a "News from Venice" section as McAndrew had always done. Both newsletters were traditionally mailed in November as part of the annual appeal.

California and Boston Chapters

From its inception in 1971, SV had always been centered along the Atlantic seaboard with most activities in Boston, New York, and (to a more limited extent) Washington, DC. In the early years of the twenty-first century, however, SV witnessed a spike of activity on the West Coast. The indefatigable Terry Stanfill had been a champion of restorations in Venice from her initial participation with the IFM's Venice Committee, utilizing her connections with Hollywood and Los Angeles society to raise money for the cathedral of San Pietro di Castello through the 1970s. She later served many years as a vice president of SV, and it was in this capacity that she partnered with Matthew White and Hutton Wilkinson to found a California chapter in the winter of 2000.[118] Within three months the group had held several gatherings, planned a "kickoff" event to announce the formation of the chapter, and chosen the Lando Chapel of San Pietro di Castello as its initial restoration.[119] The 2000 newsletter of SV included a full page about the founding and activities of the California chapter, including its intent to restore the monument to Palma il Giovane in the church of Santi Giovanni e Paolo, as well as a monumental arch attributed to architect Michele Sanmichele near the gardens of the Biennale.[120] In late September 2000 the California chapter raised $85,000 from 140 guests attending "Un Ballo in Maschera," organized by Thomas Schumacher

FIGURE 20. Matthew White, Terry Stanfill, and Hutton Wilkinson, 2000. Under a handful of dedicated supporters, including this trio, the California chapter of Save Venice blossomed in the early twenty-first century with spectacular parties around Los Angeles, expanding the presence of Save Venice to the West Coast and raising substantial sums to undertake major projects.
—Photo by Alan Berliner, Berliner Photography, courtesy Save Venice Photo Archives

and Matthew White at their home in San Marino, the Italian Renaissance revival Villa delle Favole (House of Fairy Tales).[121] White wrote a short article about the event for the *San Marino Tribune*, describing the elaborate costumes, luxurious decorations, and extravagant menu, as well as the presence of musician Elton John, theater director Julie Taymor, and UN undersecretary general Joseph Connor.[122] The event was sponsored in part by Christie's auction house, which six months later auctioned off a "harlequin brooch" by the Venetian jewelry firm Nardi Gioelleria, with the $8,000 proceeds to benefit the California chapter of Save Venice.[123]

The trio of Stanfill, White, and Wilkinson continued to organize ambitious events, including a September 2001 garden party featuring vintage Fortuny gowns and textiles (reflecting the organizers' expertise with interior decoration and fabrics), and a "Casanova in California" ball in April 2002 at the California Club.[124] The latter included 350 guests and raised at least $150,000; it was followed in 2004 by a "Casanova Goes Casual" weekend that included a lecture, a film screening of *Summertime* at Disney Studios, and a barbecue at Wilkinson's Malibu ranch.[125] As noted previously, the California chapter sent numerous members to the Venice galas and instituted a lecture series of its own in beginning in 2000. A report to the board in October 2003 described a series of other smaller events, some still in the planning stages: a picnic lunch at the Regatta Week Gala, a film screening, a champagne reception, a Las Vegas event, and so forth.[126]

It is clear from these reports, newspaper articles, and other sources that the California chapter was flourishing in terms of the money it raised and the interest it spawned in SV's activities.[127] The revenue generated by Los Angeles–area supporters in these early years of the millennium was on a par with that of major events in New York. The California chapter was considered by some to be more glamorous, in keeping with its proximity to Hollywood and the theatrical tradition of Los Angeles. Matthew White later described the California chapter as "the cilantro in the salad."[128] It also reflected the creative talents of Stanfill, White, and Wilkinson, each of whom would serve on the SV board for many years.

With the exception of its Young Friends group, the Boston chapter was more staid in the early years of the new century, continuing with its traditional activities and steering clear of the New York office as much as possible. The Boston group had declared its intention to be an independent entity in 1999 and thus saw little reason to coordinate with New York, hence the near-total absence of Boston events in the SV minutes for 1999–2004.[129] At least in the eyes of the Boston chapter, the two groups were distinct and separate.

After Donna Hoffman's term as chair concluded in 1999, the Boston chapter was led by Peter Fergusson (2000–2001), Lucille Spagnuolo (2001–3), and Juan Prieto (2003–9). Fergusson's long relationship with SV, dating back to his days with John McAndrew at Wellesley, encouraged him to defend the sovereignty of the Boston chapter. Spagnuolo was a collector of contemporary prints and photographs who loved Venice (both of her daughters were married there) and who was praised for her "wise, affectionate, and strong leadership" as she oversaw an internal reorganization of the Boston chapter.[130] Prieto, a commercial real estate developer, served three consecutive terms as Boston chapter chair. He established Boston's spring lecture series, brought a businessperson's perspective to the group, and—most importantly—guided a rapprochement of the Boston and New York groups.[131] Architect and professor Donald Freeman was the long-term treasurer.[132] Allison Drescher had become the chair of the Boston YF in the late 1990s and quickly emerged as an effective fundraiser and advocate.

In its December 2002 meeting Boston's executive committee summarized its traditional cycle of events: "In a general discussion of the number of events [that] Save Venice Boston can sensibly manage during a given year, it was agreed that the 'old' friends would undertake: the Annual General Meeting, a Fall event, the Annual Appeal, and a Spring Lecture. The Young Friends would plan: a Fall event,

Carnevale, and a Summer event."[133] The annual general meeting (AGM) served as a kickoff each fall, with a slate of officers presented to the membership, a greeting from the Italian consul general in Boston (traditionally the honorary chair of the Boston chapter), and a short lecture. In keeping with the original by-laws drafted by John McAndrew, the AGM was always free and open to the public. AGM topics in the early 2000s emphasized presentations by local scholars about flooding and water engineering in Venice.[134]

The "Fall event" demonstrated considerable variety, from culinary arts and fashion to art history. For example, in the fall of 2000 the Boston group gathered at Harvard's Loeb House with chefs Julia Child and Lydia Shire, raising $22,000 toward restoration of Giandomenico Tiepolo frescoes from the Villa Zianigo now at Ca' Rezzonico.[135] In subsequent years the focus turned to fashion and jewelry, with sponsored events at Tiffany's, Neiman Marcus, and other high-end retailers.[136] A similar event, organized by Barbara Lloyd at the Boston Design Center and emphasizing the fabrics of Fortuny, raised $17,000 and was deemed "a huge success."[137] In 2004 the Boston chapter partnered with the Gardner Museum during its exhibition *Gondola Days—Isabella Stewart Gardner and the Palazzo Barbaro Circle* to host a reception and celebrate the significant contributions of late nineteenth-century Bostonian artists, writers, and philanthropists in Palazzo Barbaro.[138] The annual appeal, coordinated for many years by Fergusson, usually raised about $15,000 per annum.

Boston's spring lecture traditionally featured one professor on a topic related to Venice; speakers in the early years of the millennium included John Dixon Hunt on Venetian gardens, Mario di Valmarana on Palladio's architecture, and Garry Wills on Venetian history. In January 2004 Prieto established a series that imitated the tripartite structure of New York. At forty dollars per lecture or one hundred dollars for the series, and with venues like the Chilton Club in Back Bay or the Country Club in Brookline, the spring lecture series was an immediate success. Prieto reported that the first lecture attracted only 40 guests but that attendance grew to 125 for the final lecture. The series has continued to be a critical part of the chapter's identity.[139]

One of the most important developments in these years was the dynamism of the Boston Young Friends. We have already seen the strong foundation created by Cristina Coletta from 1995 to 1998 with her Boston Junior Committee, at which point she handed the reins to Allison Drescher. In February 2000 Drescher organized the first Boston Young Friends Carnevale party, at Locke-Ober restaurant,

FIGURE 21. Carnevale party hosted by Boston Young Friends at the Algonquin Club, Boston, 2002.
During the early years of the new millennium, Allison Drescher and Juan Prieto (pictured far left)
organized annual costume parties through the Young Friends of the Boston chapter, often around
the theme of Carnevale, and dedicated the proceeds of each event to a specific restoration project.
—Photo copyright Roger Farrington

followed by Carnevale 2001 the next year at the Gamble mansion on Common-
wealth Avenue. A magic show, face-painting, and dancing to the eight-piece band
"Horns in the House" attracted nearly two hundred guests, and a tradition was
born. With a background in real estate and event planning, Drescher leveraged
her enthusiasm, social contacts, and abundant creativity to make the Boston YF
a major force. Boston's treasurer noted in 2002 the "substantial increase in monies
raised" and declared that "these were in large part due to the outstandingly success-
ful Carnevale events," which allowed SV Boston to double the number of restora-
tions sponsored each year.[140]

The 2002 Carnevale party brought 250 revelers to the Algonquin Club while in
2003 the Young Friends celebrated "Carnevale 1771" in eighteenth-century costumes
and hand-painted masks.[141] In 2004, anticipating the exhibition at the Gardner

Museum later that year about the Palazzo Barbaro circle in Venice, Boston YF chose the theme of "Carnevale 1904" and invited guests to recreate the Edwardian era. A copious silent auction each year provided much of the revenue, and the Carnevale party soon became the largest fundraiser of the year for the Boston chapter.[142] In the fall of 2003 Drescher printed a small booklet for potential donors in which she described how the Carnevale gala was "a costume party with Venetian flair, that has raised significant funds for art restoration and [that] has become a hot ticket on the Boston social scene."[143] The success of these parties meant that a number of major restorations in Venice from this period were credited solely to the Boston YF and chosen by them.[144]

Recognizing the difficulty of consistently turning out a crowd in Boston in February, in 2005 Drescher transitioned to a spring costume party honoring Saint Mark, patron saint of Venice, on his day, 25 April. The Saint Mark's Day party brought two hundred Bostonians in black-tie and masks, this time raising funds to restore Michele di Matteo's fifteenth-century polyptych from the church of Sant' Elena (Castello), now in the Academia.[145] One year later, co-chairs Meredith Roy and Frederick Ilchman took the Venice Film Festival of 1959 as the theme for a 2006 dinner-dance at the Ritz-Carlton Hotel. In an important sign that Boston and New York were drawing closer, Bob Guthrie flew up from New York, as did multiple members from Venice and from California.[146] Beyond these major benefits, Drescher also arranged for pre-parties to advertise the balls; in-store events at La Perla or Armani; an *al fresco* cocktail party in Newport, Rhode Island; a visit to the Italian ship *Amerigo Vespucci;* and even a Boston YF trip to Venice itself.[147] Such events not only doubled the amount that the Boston chapter could contribute to restorations in the early 2000s (e.g., the 2003 Carnevale party netted $45,000 and the 2004 Carnevale event exceeded $50,000) but also sparked interest among an entirely new demographic.[148] By 2005 the YF in Boston and New York were coordinating so that they could attend each other's events, including preparations for a joint party in Newport in July 2006 to celebrate the Venetian feast of the Redentore.[149]

The vast majority of the funds raised in Boston went to traditional restoration projects, such as the *Supper at Emmaus* attributed to Carpaccio in the church of San Salvador (a project in memory of Sydney Freedberg), the Callisto organ restoration in Santi Giovanni e Paolo, the marble frame of Titian's *Madonna di Ca' Pesaro* altarpiece in the church of the Frari, and a marble relief of a Madonna with saints

on the outside wall of the Arsenale shipyard. It was not all fine art; the chapter agreed to fund conservation of *portolani* maps and nautical papers in the Museo Correr as well as the cleaning of tombstones in the Lido's Jewish Cemetery.[150]

In choosing its own restorations (albeit in consultation with New York), the Boston chapter continued to maintain some of its desired independence. The creation of Boston's own website in 2001 provided further evidence of its search for autonomy.[151] Similarly, the chapter's proposal to support an international conference at Cambridge University in 2003, intended to gather and disseminate scientific advice about managing the Venetian lagoon, represented an effort to move in its own direction. Boston chapter chair Lucille Spagnuolo had proposed a donation of $15,000 to the conference in 2002 but executive director Michael Dagon objected that "such a donation does not fall within the charter parameters of Save Venice, which hold us to cultural and/or artistic projects."[152] Provided with additional information by Peter Fergusson, the board eventually approved the payment.[153] This minor disagreement illuminates the appeal to the Boston group of broader academic and environmental issues, whereas the larger contingent in New York hewed more closely to the SV charter that emphasized art restorations. The amicable resolution about the Cambridge conference provided hope that the more fundamental disagreements between Boston and New York might be resolved too, but that would take more time.

During the process of revising its by-laws between 2000 and 2002, the Boston chapter discovered that a notice of change of officers for the Massachusetts corporation Save Venice Inc. had been filed with the Massachusetts attorney general's office around 1999.[154] The chapter's new attorney, Hal Carroll, wrote to Bob Guthrie in 2003 for clarification about the corporation's "line of authority." Four days later Guthrie sent a detailed response in which he reviewed the various iterations of SV from 1966 to date, asserting that "SV and SVNY exist concurrently and have the same Board of Directors; BC [Boston chapter] is a chapter of both."[155] In Guthrie's view, the Boston chapter was the heir of the original New England chapter of VC-IFM from 1970, while the corporate version of SV had simply moved from Massachusetts to New York. Thus, Guthrie explained, the office in New York was the "mother organization" and not a chapter. He concluded with a conciliatory statement that reiterated his desire for Boston and New York to work together.[156] Two years later the Boston chapter produced a proposal for a "Joint Venture Agreement" but it did not gain sufficient support in either city.[157]

It is at this time that one can begin to detect a softening of Boston's objections to

New York and the gradual acceptance that some sort of negotiated settlement was inevitable and frankly desirable. The executive committee in Boston recognized the difficulty in 2005, admitting that "currently all of Boston's fund-raising efforts and accounting are consolidated into New York's tax filings and annual reports, [and] both organizations share one tax identification number."[158] Some long-term supporters in Boston who prized their independence and their decades of activity resisted this path to union. Prieto, however, patiently made arguments about the financial, legal, and administrative benefits of an alliance with New York. He was elected to a second term as Boston chapter chair in October 2005, but the nature of the relationship between Boston and New York would not be resolved for several more years.

In conclusion, the rebuilding of SV from 1999 to 2006 was broadly successful even as it had to surmount economic, legal, and personnel issues. In order to increase financial support and involve more individual donors, the New York–based board expanded significantly under the Guthries' twin leadership, nearly tripling in size to forty-five members. The record-setting revenue and high numbers of restorations in the early years of the century are a testament to the larger board and its dedicated leaders. Despite the scare of a financial downturn in 2003 and a couple of unsuccessful fundraising efforts in 2004, SV emerged healthier and wealthier by 2006. Notwithstanding the challenges inherent in a winter gala (and the reluctance of some regular supporters to consider transatlantic travel in that season), the 2006 Carnevale party proved that SV could reinvent its fundraising formula. As 2006 progressed, it seemed that Italy was fully up to speed again as well, with a well-run winter Olympics in Turin in February and the spectacular victory of the national men's soccer team in the World Cup that summer. Event-based fundraising—including the Regatta Week Galas, excursions, Carnevale parties, and in-store events—provided the foundation of SV's financial success. The robust growth of the California chapter was particularly good news. The Boston chapter, while raising much smaller amounts, maintained its momentum and displayed high energy from its YF group. The slow rapprochement between Boston and New York was a delicate process that would ultimately benefit both sides, albeit only after overcoming deficits of trust. The looming question for SV toward the end of 2006 was how the organization would fare after the retirement of the Guthries. Who would take on the myriad responsibilities that the Guthries had assumed, from board cultivation and budget planning to project management and trip organization? Would the leadership vacuum after the death of John McAndrew be repeated?

Mindful of the past, the board (and the Guthries) began planning nearly eighteen months in advance. In October 2005 Bea Guthrie signaled her intention to resign as executive director effective May 2006, to be followed by Bob Guthrie's resignation in December 2006.[159] Graphic designer and longtime supporter Michael LaPlaca offered to prepare a proposal to study the future of Save Venice; instead, the directors voted in October 2005 to establish their own planning committee to "help prepare for the retirements of the Executive Director and Chairman."[160] Over the course of more than a year, that committee spoke with staff and board members to hear their advice on charting the future of the organization. The committee expressed confidence in Karen Marshall, Liz Makrauer, and Melissa Conn in their current administrative roles in the two offices and promised recommendations in spring 2006. Those recommendations would be critical in determining the future of Save Venice, from 2007 to present, as discussed in the next two chapters.

FIGURE 22. Sala dell'Albergo (detail), Gallerie dell'Accademia, after 2012 conservation treatment. Originally the boardroom of a powerful confraternity and now part of the Accademia Galleries, the Sala dell'Albergo offers another instance of recycling works into a new setting. The fifteenth-century wooden ceiling complements sixteenth-century paintings of the life of the Virgin, including Titian's *Presentation of the Virgin at the Temple* (1534–38), conserved by Giulio Bono and his team between 2010 and 2012 and dedicated to Professor David Rosand.
—Photo by Matteo De Fina, courtesy Save Venice Photo Archives

Chapter 7

UNITÀ

Integration (2007-2014)

San Sebastiano is for Veronese what the Sistine Chapel is for Michelangelo, the Scuola Grande di San Rocco for Tintoretto: a monumental demonstration of and tribute to his art.

 —David Rosand (2009)

VENICE HAS long been one of the world's favorite cities to visit. How much more popular could it become? The first decade of the new millennium witnessed an ever-increasing number of tourists arriving by land, sea, and air. In its *Venice Report* (2009), the Venice in Peril Fund estimated that from 2000 to 2007 the number of rooms to rent in hotels and bed-and-breakfasts had climbed by more than 1,000 percent, and the number of cruise ship dockings per year more than doubled from 200 to 510.[1] A 2013 report by Sylvia Poggioli of National Public Radio reported 650 cruise ships in Venice annually, holding 1.8 million passengers, often with 40,000–50,000 disgorged in a single day.[2] Following yet another expansion in 2002, the Marco Polo Airport increased its visitors year over year, becoming the fifth-busiest in Italy and reaching capacity by 2009. Platitudes about Venice and its culture belonging to the entire world were coming true in a worrisome way. More visitors and many more cruise ships had elevated congestion in the city center and raised concerns about air pollution, propeller wash (*moto ondoso*), and the impact of vibrations on the foundations of Venetian buildings.[3] The movement No Grandi Navi (No Big Ships) organized blockades, flotillas, and press conferences but was unable to meaningfully influence legislation prior to 2020. Save Venice remained mum on the issue of cruise ships, reflecting not only its desire to avoid political issues in general but also an acknowledgment that some on the board believed that the economic benefits for the city outweighed the drawbacks. Mayors Massimo Cacciari (1993–2000, 2005–10), Paolo Costa (2000–5), and Giorgio Orsoni (2010–14) each found themselves in a difficult spot vis-à-vis the cruise ship industry, caught between the shopkeepers and gondoliers that depended

on the flood of daily tourist traffic and those who bemoaned the increasing crowds and environmental impact on air and water. Hoteliers complained that the cruise ships acted as floating hotels and thus deprived them of business. Further complicating the issue were the competing entities that controlled different parts of the port and the city, frustrating decision-making.[4]

Efforts to alleviate crowding and support the influx of visitors met with mixed results. For example, the 2008 installation of a new bridge spanning the Grand Canal (the Ponte della Costituzione, more commonly known as the Calatrava Bridge after its architect) spawned recriminations. Despite offering a useful shortcut between the Piazzale Roma bus depot and the Santa Lucia train station, the new bridge was lambasted for its lack of wheelchair access, slippery steps when damp, and starkly contemporary design that seemed in opposition to nearby buildings. Of course, linking these transport hubs provided great convenience for commuters and tourists alike, and even those who grumbled soon adopted this expediency. Similarly, the installation in 2010 of the Venice People Mover, an automated elevated shuttle train connecting Piazzale Roma, the Tronchetto parking garage, and the cruise ship port, permitted the easy transfer of up to three thousand people per hour. Another bright spot was the founding in 2008 of the Fondazione Musei Civici (MUVE), forging a nonprofit alliance of a dozen museums and historic buildings owned by the city, most prominently the Palazzo Ducale and the Museo Correr. This network helps to support the preservation of these museums' large permanent collections and funds exhibitions big and small.[5] Adopting such a fiscal structure and an American-style approach to cultivating donations from private individuals and corporations marked a major shift from the assumption that governments—whether local or national—were largely responsible for cultural funding in Italy. It seems logical that the attitudes and examples of the many successful U.S. nonprofits operating in Venice, from the Peggy Guggenheim Collection to the various university study-abroad programs to Save Venice, had encouraged the choice of the U.S. nonprofit model.

In January 2007 SV simultaneously welcomed a new chairperson, president, treasurer, and executive director; these officers promoted new activities while still preserving some traditional ones. Given that most of these positions were filled by experienced members of the board, however, the turnover was not as great as it might initially appear. In addition, both Guthries remained as directors, with Bea Guthrie serving as co-chair of the events committee and Bob Guthrie continuing to organize excursions. The change was more a passing of the torch than a wholesale changing of the guard. The new leadership was quickly tested by the Great

Recession of 2008–9 and a steep, if temporary, drop in the value of the corporation's portfolio as well as repeated concerns about inefficient annual giving by the directors. Nevertheless, on the strength of earnings from events and excursions, SV emerged largely unscathed. Major restorations from 2007 to 2014 included launching a comprehensive treatment of the church of San Sebastiano—the masterpiece of painter Paolo Veronese—as well as the Sala dell'Albergo within the Accademia, famous for Titian's mural *The Presentation of the Virgin.* The New York office moved from the basement of the Guthries' townhouse to rented space on the Upper East Side in 2010 and then again within Manhattan in 2014. The Boston and California groups continued to be active and to send regular contributions from galas, lectures, and local events while each retaining their own identities. After years of negotiations over which entity was heir to the organization founded by the McAndrews and Sydney Freedberg, a truce was brokered in 2009 between New York and Boston; the Boston group agreed to be a "chapter" in return for two seats on the board and the right to retain its own executive committee. Melissa Conn remained a steadfast presence in the Venice office, with assistance from new staff member Leslie Contarini and a series of interns and fellows, while Liz Makrauer ran the New York office beginning in 2006 and was succeeded by Amy Gross in 2013.

The theme of "unity" captures the most significant developments of SV in this period. The rupture with Larry Lovett was firmly in the past; soon Boston and New York would find common ground. Moreover, the board began to see itself as more cohesive than it had in the past. The introduction of a membership program and a planned-giving initiative unified and reinforced the loyalty of many longtime supporters. Relocating the New York office (and later the Venice office) outside Guthrie residences was intended to foster a more professional identity, where the staff was independent from the influence of individual board members and thus identified more with the organization itself. This chapter describes leadership, excursions and events, restorations, and the final rapprochement between Boston and New York, as well as the activities of supporters outside New York. The events of these years indicated that growth and unification could happen simultaneously.

Leadership

Because the turnover in leadership in early 2007 had been anticipated for more than a year, the transitions occurred without incident. Bob Guthrie took up the new position of chair emeritus. Former treasurer J. Robert (Bob) Lovejoy became

chair, former secretary Sarah Schulte took over as president from Beatrice Rossi-Landi, and staff member Elizabeth (Liz) Makrauer was promoted to executive director in place of Beatrice Guthrie. John Staelin agreed to serve as treasurer, while John Fiorilla moved up from Young Friends to become board secretary. Each of these individuals had prior experience serving on the SV board or as a staff member; there was no consideration this time of going outside the organization.[6]

In his role as chair from 2007 to 2010, Bob Lovejoy sought to continue the fiscal responsibility of Bob Guthrie and to transition to a more "institutional" form of management. With significant experience in the legal, corporate, and nonprofit worlds, Lovejoy distributed responsibilities to a broader range of board members and staff and tapped their respective visions for the organization.[7] He established a more active committee process and recruited board members to adopt more dynamic roles as committee chairs. He asked Makrauer and the staff to take over most of the office operations that had previously been handled by the Guthries. At Lovejoy's urging, Staelin compiled a set of "Financial Management Principles" designed to collect and codify all financial policies in one place. Many of those policies, such as having sufficient assets to cover three years of operating expenses (i.e., salaries, rent, and other overhead costs) plus all project commitments, had frequently been stated by Bob Guthrie at board meetings but never written down.[8] Lovejoy's prior experience as treasurer and chair of the finance committee led him to implement policies about how to cover (and avoid) cost overruns while also reminding board members of their obligation to support various fundraising activities.[9] This attention to the bottom line was especially important as SV embarked on the large, multiyear restoration of San Sebastiano.[10] Continuing the work of the Guthries, Lovejoy sought to professionalize the organization and convert it from something resembling a family-style business to a modern, independent nonprofit. He agreed with Bob Guthrie's view that for many board members, SV was a "second charity" that came after greater financial commitments to cultural institutions, schools and universities, religious organizations, and so forth. Thus Lovejoy, along with Guthrie, believed that events run by and for the board should incorporate fun and friend-raising as well as collecting funds.

Lovejoy worked closely with his friend Sarah Schulte, a painter who had joined the SV General Committee in 1992 and the board in 1999; she served as board secretary until 2008 and then as president from 2007 to 2009. It was no exaggeration to say, as the board did in its resolution when she stepped down after one term as president, that Schulte had engaged in "tireless effort on behalf of Save Venice for so many years."[11] She performed many of the thankless tasks that make a

FIGURE 23. Robert (Bob) and Pat Lovejoy, 2002. With experience in the corporate, legal, and nonprofit worlds, Bob Lovejoy served as Save Venice treasurer (2004–6) and chair (2006–10). He helped to professionalize the organization and ensure its financial stability.
—Photo courtesy Save Venice Photo Archives

nonprofit run smoothly; Lovejoy described her as a "head cheerleader" for SV who kept everyone excited and engaged and was always on the lookout to recruit new supporters.[12] When Schulte stepped down, Matthew White—who had moved some years before from Los Angeles to New York—became president for one year before moving up to the role of chair to succeed Lovejoy.[13]

Charismatic and elegant, Matthew White came from a career in dance and interior design.[14] In 2003 White moved to New York to create a new interior design firm and became increasingly involved with the SV board, becoming president (2010) and then chair (2011–16). His background was firmly in the arts, and his enthusiasm for matters aesthetic, particularly Italian-inspired, came across in all his interactions.[15] Yet White was also a conscientious businessman, always attentive to the bottom line of the organization. Described as a "graceful diplomat" who encouraged board members and staff to collaborate and pool their expertise, White continued the work of his predecessor in promoting the important work of subcommittees, redistributing tasks more broadly, and implementing a further professionalization of the staff. White led the search that selected Amy Gross as executive director. He also identified some of the priorities that she would subsequently pursue (e.g., reducing reliance on cruises to raise funds, identifying and relocating to new office space, reimagining

the New York lecture series). White envisioned a stronger role for the New York office and endorsed changes to the staffing structure and organizational chart that would allow the office to flourish and continue its focus on raising funds. One of his greatest contributions was to plan and successfully execute glamorous and successful fundraising events in New York and in Venice that contributed to SV's increasing visibility, especially with younger audiences. White demonstrated a willingness to think ambitiously about the organization's role and potential, and many on the board give him credit for his courage in taking on multiple large projects simultaneously. More specifically, White's sense that restoring the Sala dell'Albergo inside the Gallerie dell'Accademia was too good an opportunity to pass up—even with the ongoing commitment to San Sebastiano—provided the template for the next decade's embrace of several major projects at once.

The range of new board members reflected efforts to recruit successful people with relevant experience, often from the New York social orbit. In 2008 John Staelin, who would later become treasurer, joined his wife, the jeweler Elizabeth Locke, on the board. Art historian Patricia Fortini Brown of Princeton University linked with her colleague, historian Theodore Rabb, while Irina Tolstoy and Frederick Ilchman, both doctoral students of David Rosand, represented the next generation of scholars. Theater director Manfred Flynn Kuhnert, marketing executive Adelina Wong Ettelson, and art historian Sonia Evers also came to the board in 2008–9, while Venetian jeweler Alberto Nardi added an Italian perspective beginning in 2010. Business executive and nonprofit leader Tina Walls was the first of several Denver-area supporters.[16] Later additions included executive Richard Almeida, artist Anne Fitzpatrick, Sotheby's senior vice president Christopher Apostle, painter Roger de Montebello, businesswoman Lauren Santo Domingo, photographer Charles Thompson, opera aficionado Cat Jagger Pollon, and designer Alexandra Lind Rose.[17] From 2010 to 2014 the board added an advisory committee consisting of half a dozen people who were knowledgeable about Venice and who could provide suggestions from a distance.[18]

Working closely with new and returning board members alike, Liz Makrauer served seven years as executive director (2006–12), demonstrating "boundless energy" as she helped steer the organization through a national recession and then steady expansion.[19] Mentored by longtime director of the New York office Karen Marshall, Makrauer noted that she "did a little bit of everything" as the office slowly adjusted to the absence of the Guthries in day-to-day activities. She helped to allocate operational responsibilities (e.g., operations, publicity, development) and to hire additional staff, as well as to oversee relocation of the office into an

apartment building at 1104 Lexington Avenue. Commended for her dedication, she worked closely with the board to increase donations of all sizes.

Amy Gross became the new executive director in September 2013, chosen by a search committee composed of board members and with the guidance of a search firm. Unlike Chapman or Makrauer, Gross had no background with SV but she was familiar with New York and with the nonprofit world. She had worked as director of development at Young Concert Artists and as director of individual giving at the New York City Opera.[20] Her years of experience with performing arts organizations brought a valuable perspective, particularly around the pursuit of multiyear pledges from top donors and long-term cultivation of supporters. As a parallel to the professionalization espoused by Lovejoy and later White as chairs, and working with board member Martha Stires Wright, Gross created a human resources manual and introduced performance reviews for staff. Gross helped give greater coherence and consistent branding to the fundraising timetable, the membership program, and the major ticketed events. For the two most lucrative events on the calendar, the New York "Ballo in Maschera" and the Venice gala, she persuaded the board that the proceeds must be considered unrestricted funds and be used to maintain the three-year minimum of operating expenses, rather than being earmarked for a specific restoration. She continued White's goal of obtaining underwriting, either corporate or private, for every element of these ticketed events, and restructured the New York office with new positions and staffing changes. She and her team successfully managed suggestions and recommendations coming from the directors and the broader pool of donors: for example, a thorough upgrade (both technical and aesthetic) of the website and the creation of the Conservation Patron Council to galvanize pockets of support outside of the Northeast.[21]

With all of the changes on the American side, Melissa Conn provided continuity and expertise in the Venice office. By now she was a familiar face in Venice, respected for her judgment by Venetian restorers, government officials, and American donors alike. At the initial stage of a restoration, Conn took over much of the work in devising project plans that had up through the 1990s generally fallen to officials of the superintendency. In later stages of conservation treatment, she displayed a knack for keeping projects under budget and on time. Conn's deep understanding of Venetian tradition and American commercial culture permitted her to serve as a bridge between the two. Board member Alida Brill-Scheuer recognized this when she praised Conn's "tactful expertise in resolving difficulties" associated with planning a conference in March 2009 to announce completion of the exterior restoration of the Scuola Tedesca.[22] Frederick Ilchman confirmed that

Conn's mediation skills were valuable not just on matters pertaining to SV but throughout the broader community in Venice of conservators, church officials, the private committees, and museums.[23] In Spring 2022 she was elected an honorary member (*consorella d'onore*) of the confraternity San Giorgio degli Schiavoni. The Ohio native had earned the admiration of the locals.

One of the most active board members in these years was Mary Frank. She joined the board in 2003 and served in multiple roles, combining scholarly zeal as a doctoral student of Patricia Fortini Brown and nonprofit experience as a trustee of the American Academy in Rome. Frank often looked for ways to make SV a more responsive and energetic organization. Inspired in 2009 by a casual conversation with an associate, who inquired why he had not received a renewal notice from SV after he had donated to the annual appeal the previous year, Frank realized the advantages of retaining donors through a formal membership program.[24] She had to overcome the anxiety of other directors that such a program might cannibalize the annual appeal and field questions about what kinds of benefits a member might expect. Unlike an art museum or theater company, where membership comes with obvious benefits such as free admission or discounted parking, Venice was free to visit.[25] In October 2010, in her role as development committee chair, she launched the new membership program. One goal was to guarantee a steady stream of income to support fixed costs such as the office rent, website, and annual newsletter. Such income was intended to be independent of event-based and project-sponsorship fundraising, which could fluctuate substantially from year to year and was often earmarked for specific restorations. Distributing membership brochures at museums or libraries permitted SV to cast a wider net for supporters. Most importantly, the membership program encouraged current supporters to identify more closely with the organization and to benefit from the tangible rewards of membership. In some sense the membership program was an effort to extend to all supporters (albeit at a reduced level) the sense of belonging that the Guthries had instilled through the galas and cruises.

In his capacity as chair, White declared that all events and trips sponsored by Save Venice should be open to all members, rather than by personal invitation. The membership program came to include personalized letters and specific mention of member-only activities; a later tiered membership program offered special benefits (e.g., private tours, gallery talks, early sign-up for ticketed events) to higher-level members. The Boston chapter agreed to participate in the membership program provided that project sponsorships from Boston were not subject to a percentage fee to cover administrative expenses and currency fluctuations, as was the case for

individuals who adopted restorations.[26] In 2014 the membership program generated in excess of $150,000 from more than two hundred households, nearly double the amount from the annual appeal.[27] That was an unusually good year for membership income (and a nadir for the annual appeal) but the membership program consistently produced close to $100,000 per year; coupled with project sponsorships, it remains a reason behind SV's success in recent years.

Excursions and Events

The bulk of SV revenue continued to come from excursions, gala weekends, and masked balls, supplemented by smaller cocktail parties and receptions. Educational events, primarily lectures in New York and Boston, provided academic enrichment and a relatively inexpensive way for members and guests to learn more about SV's mission and accomplishments, even if they did not contribute much financially. Trips continued to be popular; indeed, rather than just being linked to biannual galas in Venice, these trips began to occur on an annual basis (or even more frequently). The Boston chapter scheduled its own trips, and the California chapter regularly joined these opportunities. Between 2000 and 2013 trips led by Bob Guthrie netted nearly $2 million for Save Venice.[28]

The previous chapter described the Guthries' penchant for upscale accommodations, historically significant sites, and top-notch guides, as well as their ability to recruit friends and fellow board members to sign up. Those characteristics remained essential components of SV trips from 2007 to 2014 too. The tone was set by a June 2006 cruise through the Adriatic Sea to Sicily, departing from Venice and stopping to visit mosaics in Ravenna, castles along the Dalmatian Coast, temples in Agrigento, and the cathedral in Cefalù. Historian John Julius Norwich lectured onboard and onsite, along with museum curator Carlos Picòn. The trip netted nearly $350,000.[29] Six months later the Guthries and Oliver Bernier led a New Year's trip to Moscow and St. Petersburg, taking in the Pushkin Museum, the Kremlin, the Hermitage, and the imperial palace in Tsarskoe Selo (now called Pushkin).[30] A return trip to Sicily in June 2007, again with Lord Norwich, brought ninety-two guests on the *Corinthian II* from Venice to Ravenna, Split (Croatia), and a final stop in Palermo.[31] In most cases SV rented the entire ship rather than sharing with other groups; while this entailed greater risk, the payoff was an increased sense of fellowship on board and greater control over the itinerary. The decision to charter entire ships had its roots in the earlier trips of the 1990s and continued to pay dividends in later years.

On a smaller scale but also in 2007, Juan Prieto and Frederick Ilchman organized a trip for thirty-six guests to Madrid, in conjunction with the first major Tintoretto exhibition in seventy years. In addition to a tour of the exhibit when the Museo del Prado was closed to the public, participants enjoyed the royal palace of El Escorial and traveled to Toledo to learn about artistic connections between El Greco and Tintoretto, where they were treated to a private lunch by the Duke and Duchess of Segorbe.[32] This tour represented the first time that the Boston chapter had organized an excursion; guests came from Brazil, New York, and California. In late 2007 the directors suggested that such trips were occurring too frequently, so Bob Guthrie agreed to a hiatus and there were no trips in 2008.[33]

Despite the Great Recession of 2008–9, demand for such trips continued to be high. The organization responded with a steady schedule of excursions following the brief break. In the winter of 2009 Bob Guthrie chartered the *Oberoi Philae* to cruise the Nile River from Aswan to Luxor, followed by five days in Cairo. Egyptologist Lanny Bell was the scholar of the trip, which included visits to Abu Simbel temple, the Luxor temple, and Nefertari's tomb, as well as a camel ride and an outing on a traditional sail boat (*felucca*).[34] This trip netted $185,000 and according to Guthrie the feedback from participants was "overwhelmingly positive."[35] The next trip to Turin was originally planned as a "Truffle Excursion" to take advantage of the gourmet offerings of the Piedmont region in October 2010. But the proximity to treasures in the visual arts relatively unknown to Americans initiated a change in plans to accommodate much more history, art, and architecture. The result was a feast for all the senses: it included a truffle hunt, a tasting tour at the Ferrero chocolate factory in Alba, dinner at Turin's Whist Club, and a private visit to the Pinacoteca Agnelli (art collection). Frederick Ilchman and Theodore Rabb brought the group to see numerous examples of baroque architecture in Turin and its environs.[36] In late August 2011 SV chartered the boat *Le Levant* for ninety guests to visit major ports of the Black Sea, including Istanbul, Odessa, Sevastopol, and Yalta, with a post-trip excursion to Cappadocia.[37]

A Rhine River cruise in late August 2013 on the ship *Avalon Artistry II* sailed from Basel to Amsterdam with a diversion on the Mosel River and stops including Heidelberg and Cologne before concluding with a visit to the Rijksmuseum.[38] Travelers were given the option of adding extensions before and after, with time in Franconia and Bavaria beforehand (with dinner in a Fugger castle in Augsburg) and visits in the Netherlands post-cruise. During that particular cruise, a short slide update on current SV restorations inspired Beatrice Santo Domingo to underwrite the entire treatment of the organ and its shutters painted by Veronese

in the church of San Sebastiano.[39] This episode exemplifies how a gala or a trip might not only generate funds through tickets sold but also prompt larger donations. Specific trip policies developed by the Guthries helped the bottom line: for example, the pre- and post-excursions were only available to those who registered for the main trip, and the deposit was nonrefundable, thus ensuring a contribution. While some of the cruises boasted only a tenuous connection to Venetian or even Italian culture, they were central to the organization's business model and reinforced travelers' loyalty to SV.

The Boston chapter organized a second trip in February 2013, this time to Sarasota, in order to view a Paolo Veronese exhibition at the Ringling Museum. That excursion included a visit to the Circus Museum and a 1920s costumed cocktail party at Ca' d'Zan, the fantastical Venetian Gothic palazzo on the Ringling estate that overlooks Sarasota Bay.[40] As chair of the Boston chapter and as co-curator of the Veronese exhibition, Ilchman organized and led this midwinter tour. In June of the following year Ilchman and Melissa Conn took a group of participants on an excursion called "Following in the Footsteps of Titian," which began with the artist's masterpieces in the Frari and Accademia and ended at his home in the neighborhood of Cannaregio; in between it included a visit to Pieve di Cadore for Titian's birthplace as well as a stay in the Dolomites to enjoy mountain views, cuisine, and wine.[41] The Titian trip was scheduled to immediately follow a board meeting in Venice and thus benefited from the presence of many directors who signed up. Unlike the *viaggioni* (big trips) organized by the Guthries in prior years, the 2013–14 trips were designed for thirty to forty guests, essentially the capacity of a single bus. While they raised less money overall, they required less staff and board time to plan, and served a similar purpose of fundraising and friend-raising. In sum, the excursions arranged by SV were successful in almost every way. Perhaps the lone drawback was the risk in laying out substantial deposits a full year or two in advance of the largest trips.

The Venice galas remained the signature events of the organization. The tradition of an early September gala in Venice had been successfully modified in 2006 when it was linked to Carnevale at midwinter, and in 2008 SV experimented again with a Palladian Gala in mid-July, designed to coincide with the five hundredth anniversary of the birth of architect Andrea Palladio and with the annual Redentore festival.[42] Visits to Palladian villas on the mainland and a dinner in the cloisters of San Giorgio Maggiore (also designed by Palladio), which featured tabletop models of still other examples of Palladian architecture, were combined with the usual treasure hunt, fashion previews, concerts, and cocktail parties.[43] SV president Sarah Schulte noted that the Palladian Gala had attracted a contingent of "new,

young supporters."[44] In the same meeting, however, Lovejoy cautioned that profits from the galas in 2006 and 2008 had not met expectations: "Mr. Lovejoy referred Board members to the Gala Profit Spreadsheet (Attachment L). He pointed out that the last two Galas did not meet the net profit goals achieved at previous galas and that in order to sustain Save Venice's level of restoration activity and operating costs, Gala proceeds must increase in the future. He stressed that the following needed to be achieved for future Galas: more underwriting, increased attendance, and ticket prices that reflected true cost."[45] The timing of the 2008 gala was unfortunate. The Great Recession caused by the subprime mortgage crisis had begun in December 2007 and thus by summer 2008 the U.S. economy was teetering, with the Dow Jones on the way to losing more than half its value in the following year. Bear Stearns collapsed two months prior to the 2008 gala, while Lehmann Brothers declared bankruptcy two months afterward. In the treasurer's report of July 2008, John Staelin confirmed that SV assets were off by 11 percent for the year, although the annual audit confirmed that the ratio of program spending per dollar raised (75/25) was in the appropriate range. Thus, Lovejoy was correct that SV had to raise more money if it wished to maintain its current pace of restoration. Fortunately, Staelin (in line with previous treasurers) had recommended the board adopt fiscal policies to maintain three years of operating expenses in reserve, so the organization was able to ride out the recession.[46] This incident also underscores Lovejoy's role as a financial watchdog, assisted by a treasurer who helped execute this vision.

Two years later in February 2010 SV hosted another Carnevale gala, featuring splendid costumes as well as participation in the Cavalchina Ball at the Fenice theater.[47] Matthew White and Thomas Schumacher hosted lunch and a lecture at the Scuola Grande di San Giovanni Evangelista. On the following evening at the *ridotto* (casino) of the Hotel Monaco, the "Lovers of Opera" ball featured eighteenth-century gambling games and a quartet of opera singers during dinner.[48] Per Lovejoy's recommendation, ticket prices increased to $4,500 for adults, and virtually all of the events were sponsored (often by board members), thus significantly lowering costs to the organization.[49] In 2012 SV returned to its traditional slot in late August with a "Summertime Gala" in Venice. The usual lectures, treasure hunt, cocktails, concerts, and dinners were offered this time too; it is noticeable that the newsletter that year made a point of mentioning each individual sponsor.[50] The centerpiece of the program was a black-tie ball at Palazzo Barbaro, which has a special resonance for Americans in Venice. This palazzo had been purchased in the 1880s by wealthy Boston expatriates Daniel and Ariana Curtis and became a

haven for Americans (especially those with Boston connections) like John Singer Sargent, Bernard Berenson, Henry James, and Isabella Stewart Gardner.[51]

While Venice galas unfolded over several days and excursions could last more than a week, easily the most lucrative single-evening event was the late winter ball in New York each year. This was typically organized by the YF with a theme defining costumes and decor, as in their Red and White Ball (2007), the Iridescent Ball (2008), and the Primavera a Venezia Ball (2009). For the fortieth anniversary of the organization in 2011, the YF combined with new chair Matthew White to launch "Un Ballo in Maschera," which set a new standard by netting $650,000 and bringing on major corporate sponsors.[52] From this point forward the New York ball would employ a consistent Italianate title and be held at the same time of year, in order to improve its branding and marketability. A deliberate push to achieve coverage beyond the social press was successful, with the *Wall Street Journal* and other outlets providing stories about SV's broader mission.[53] The idea of an annual masked ball was not new, even for SV, and the black-tie dinner dance is of course a staple of charities across North America, but the emphasis on sumptuous costumes and masks helped to separate this ball from many others in New York. A ball in 2012 around the theme of the Lido was equally successful, as was the 2013 reprise of "Un Ballo in Maschera," raising $550,000 from more than 450 guests.[54] George Rudenauer was president of YF from 2004 to 2011 and worked closely with Adelina Wong Ettelson, Alexandra Lind Rose, and Dayssi Olarte de Kanavos as they meticulously designed and executed a series of masked balls. The organization and planning of these lucrative balls gradually transitioned from being YF events (with a lower ticket price) to serving as the major fundraiser for the entire organization with participation by the broader board. In subsequent years Lauren Santo Domingo would take a leadership role as ball chair in attracting corporate support and establishing long-term partnerships with luxury brands, increasingly those in jewelry and fashion, such as Bulgari, Dolce and Gabbana, and Oscar da la Renta.

One special event—for a different reason and a different audience—was held on 28 October 2014 to honor the important contributions of Bob Guthrie, Bea Guthrie, and (posthumously) David Rosand. This luncheon at New York's University Club netted $90,000 and included presentation of a new award (Il Doge d'Oro, the Golden Doge) to recognize the monumental service provided by each recipient during the preceding decades.[55] The daytime event was intended to attract supporters who no longer—or had never—attended the masked balls. More importantly, it celebrated the Guthries, who had led such a robust comeback, and acknowledged Rosand's academic contributions and learned presence.

Beyond the international and domestic excursions, gala balls, and honoree luncheon—all of which raised substantial sums—the New York office supported additional activities that promoted SV in other ways. In order to stay close to many donors and generate enthusiasm for its mission, the New York office regularly programmed six lectures per year at Manhattan venues. The speakers were generally professors or curators with expertise in Venetian art or history, but the range of topics was impressively broad, incorporating literature, music, architecture, and more. Not surprisingly, the church of San Sebastiano and its artist Paolo Veronese was a frequent topic, with lectures by David Rosand (2008), Mary Frank (2008), and Xavier Salomon (2011). Kathryn Calley Galitz explored J. M. W. Turner's work in Venice (2007) and Debra Pincus analyzed the signatures of artist Giovanni Bellini and his involvement with the active book market in Renaissance Venice (2008), while Nancy Mowell Mathews considered Maurice Prendergast (2009) and Eric Denker probed the relationships between Canaletto and his rivals in eighteenth-century Venice (2010).[56]

Many of these subjects were small slices of Venetian art history, while other lectures took on larger and broader topics. Based on his decades of experience with Venice and SV, Bob Guthrie mused on the provocative question "Will Venice Drown?" in 2008, while Matthew White spoke about how foreigners had long learned from Italian art (just as it had informed his own design practice) in his 2009 lecture "Bringing Italy Home: The Grand Tour Today." Additional lectures about modern Venice included Philip Rylands's memories of Peggy Guggenheim (2011) and Laurie Zapalac's thoughts on entrepreneurship in twenty-first-century Venice as crucial to increasing the city's resident population (2013). Elizabeth Horodowich (2009) and Joanne Ferraro (2013) drew from their respective histories of Venice, while Margaret Rosenthal opined on film and theatrical interpretations of the "honest courtesan" and poet of sixteenth-century Venice Veronica Franco (2011). Part of the appeal of these talks was learning about aspects of Venice that were unknown to most tourists. Some of the organization's ticketed events, such as the Venetian galas or the "Ballo in Maschera," were intended to be expensive, whereas attending lectures was more economical. The venue was part of the appeal too. Often held at the Colony Club on the Upper East Side, the lectures provided a gracious setting for intellectual sustenance and camaraderie.

The establishment of the Educational Resources Committee (ERC) in 2012 and the arrival of Amy Gross in 2013 led to reimagining the lecture series and rebranding it as the "Education and Enrichment" series in subsequent years. For example, the costs of running lectures in a private club encouraged Gross and others to consider

alternate spaces for some presentations, including gallery talks in art museums and studio visits. Gross partnered with New York University's Casa Italiana to host two lectures per year in Greenwich Village, and later did so with the Italian Cultural Institute on Park Avenue, thus offering free lectures while appealing to new audiences in new locations. Early registration and preferred seating were introduced, encouraging members to join or renew at a higher level. Talks more frequently discussed current conservation projects, such as those by Melissa Conn, who began to visit the United States almost annually to bring the latest conservation updates from Venice. The founding of SV's own library and study center in Venice in 2015, with its program of "Research and Restoration Roundtables," and the increased role of the ERC demonstrated additional emphasis on SV's educational mission.

The Boston chapter's nascent lecture series continued to thrive in this period of 2007–14 and is discussed later in this chapter in the context of other Boston-based activities. With regard to significant fundraising events, Boston linked its own black-tie or costumed parties to cultural institutions such as the Museum of Fine Arts (MFA), Gardner Museum, and Boston Public Library, as well as to specific Venetian themes. For instance, in 2007 Boston's spring benefit celebrated Venetian explorer Marco Polo and the Silk Road with a costumed ball at the Taj Hotel overlooking Boston's Public Garden.[57] In spring 2009 the benefit expanded to a four-day event known as "Serenissima on the Charles," using Ilchman's exhibition *Titian, Tintoretto, Veronese: Rivals in Renaissance Venice* at the MFA as a fixed point to celebrate the many connections between Boston and Venice. The goal of organizers Francesca Piper Koss and Frederick Ilchman was to replicate in Boston the format and success of the Venice gala. A kickoff evening lecture at the Chilton Club by Mary Frank was followed by a day-trip to Newport to view two mansions with significant Venetian paintings (Marble House, The Elms) as well as a luncheon and concert at Ronald Fleming's "cottage," Bellevue House. The highlight of the weekend was a guided tour of the MFA exhibit with the curator before public hours and a dinner at the Isabella Stewart Gardner Museum, the Venetian gothic revival palazzo built from 1899 to 1902. It was on this occasion that longtime SV member Peter Fergusson compiled a short history of SV, produced for guests of that weekend.[58]

Using an exhibition about Venetian art as the impetus for a multievent weekend, as happened with this Boston show in 2009 or two years prior with the Prado exhibition in Madrid, became yet another way for the Boston chapter to raise funds and would be replicated in future years.[59] The following year saw an autumn weekend entitled "Boston Dreams of Italy," which took its inspiration from the recently published book by SV president Matthew White, *Italy of My Dreams*. With White

and other New York guests in town, everyone congregated in the Back Bay at the historic Ames-Webster Mansion for dinner, dancing, an opera singer, and a "gondola" pedi-cab up and down Commonwealth Avenue. The following morning the Ames-Webster House hosted an Edwardian champagne brunch recreating Boston circa 1910, where guests had the opportunity to view Benjamin Constant's murals of 1887, depicting the Venetian doge and his ministers receiving homage from an Ottoman emissary in the Piazzetta San Marco.[60]

In November 2011 the Boston chapter again utilized an MFA exhibition of Greek and Roman art, *Aphrodite and the Gods of Love*, to explore the Venus-Venice connection and Venice's longstanding identification with the classical goddess of love and beauty. Following a lecture and the exhibition visit, the meal did not follow the usual format of a seated dinner at a hotel or club. Instead, that event experimented with a "dine-around," meaning more intimate dinners in the homes of executive committee members.[61] In April 2013 the theme "Biblioteca di Notte" (Library by Night) was the link between the Boston Public Library (the venue) and Venice's Marciana Library. A silent auction included jewelry, hotel packages, a master cooking class, cases of wine, and a Matthew Pillsbury photograph. In November 2014 nearly two hundred guests returned to the Boston Public Library, this time for a dinner dance entitled "Capriccio Veneziano." That theme was drawn from Francisco Goya's famous album of prints (*Caprichos*) and the major exhibition *Goya: Order and Disorder* at the MFA.[62]

The California (Los Angeles) chapter was equally active at the beginning of this period, sometimes on an impressively large scale. For example, in January 2008 it hosted hundreds for "Moonlight on the Lido" weekend, designed to fund the restoration of the Gentile Bellini organ shutters from the basilica of San Marco as well as frescoes in the church of San Sebastiano. Taking its cue from *Top Hat*, the 1935 musical film starring Ginger Rogers and Fred Astaire—which concludes in Venice—this gala ranged from Beverly Hills and Santa Monica to the Getty Museum and ultimately to Sophia Loren's former ranch, with extravagant costumes, designs, and cuisine, all on a grand scale.[63] In February 2012 the Stanfills and Wilkinsons partnered with Manfred Flynn Kuhnert and Peter Iacono to host a weekend entitled "La Dolce Vita." It evoked Los Angeles in the 1950s and early 1960s with a "Fellini Ball," vintage couture, and period music.[64] On a more modest scale, in 2011 Kuhnert and Iacono hosted one hundred people for "Prosecco and Puccini" at their home, featuring arias and duets from Puccini, Verdi, and Donizetti. Outside of parties, the California chapter invited a lecture by Sally and Carl Gable, owners of the Villa Cornaro, about their restoration efforts of one of

Palladio's masterpieces, as well as a reprise of Margaret Rosenthal's observations about the sixteenth-century Venetian courtesan and poet Veronica Franco.[65]

From New York and Boston to Los Angeles and Venice, SV demonstrated its fundraising prowess through a series of balls and multievent weekends. Even as the formulas were varied, these remained at the center of the organization's public identity. Initiated by the McAndrews and their friends in the 1970s, and refined by the Guthries with their colleagues in the 1980s and 1990s, these events continued in subsequent years to supply much of the annual budget and to promote SV's reputation. The excursions added additional fundraising power, all of which enabled Save Venice to increase the stream of conservation projects.

Conservation: San Sebastiano and Sala dell'Albergo

Two conservation projects dominated SV's history from 2007 to 2014: the church of San Sebastiano and the room known as the Sala dell'Albergo inside the Accademia. Each was (and is) a significant setting in the history of Venice, each boasted a pedigree of famous artists and architects, and each produced its own challenges and successes in terms of fundraising and conservation. Restoration at San Sebastiano unfolded in phases, with the board approving, and restorers treating, portions of the church in turn. The Sala dell'Albergo was more limited in scope, being a single room, but it involved more scrutiny given its prime location. The Santa Maria dei Miracoli project had proved that SV could manage a complex and expensive conservation; the challenge in this case was to juggle two such projects simultaneously.

San Sebastiano, toward the western end of Dorsoduro, was only the second project adopted by Save Venice that aimed to conserve a whole structure inside and out. Like the church of the Miracoli two decades earlier, the cost was high and the timeline long, but the opportunity to restore an entire building justified the effort and expense. Built on the site of a former hospice and dedicated in 1468 to a patron saint of the plague, Saint Sebastian, the church was substantially restructured and expanded in the early sixteenth century as part of a Hieronymite monastery. Beginning in 1555 virtually the entire church was decorated by Paolo Veronese, from floor to ceiling, utilizing oil on canvas as well as fresco (both *buon fresco* and *a secco*). Remarkably intact, the church's 400 square meters of fresco and mural paintings, and forty-four oil paintings, survive almost exactly as the artist intended. It was Veronese's own burial site and represents an exceptional opportunity to observe an artist in multiple media.

Melissa Conn first investigated this church in September 2004 in response to concerns from the superintendency about mold on the wooden ceiling that

threatened the frescoes, ceiling, decorative framing, and canvases.[66] The experi-
ence of the Miracoli church prompted SV to commission an extensive set of tests,
including a photogrammetric survey, pigment analysis, structural testing, and trial
cleaning. This analysis enabled by 2007 a five-step plan for restoration.[67] The
estimate to restore the ceiling, windows, walls, floor, facade, and chapels came to
$1.79 million. Although the board hoped to treat the entire building eventually, it
decided to begin with just the ceiling. Veronese had wished for this wooden ceiling
to resemble marble and Istrian stone, and to simultaneously house three large ceil-
ing canvases depicting the story of Old Testament heroine Esther.[68] The imagery
blends classical motifs, biblical characters, and allegorical figures and is among the
more influential ceiling paintings of the sixteenth century.

Sponsorship brochures were printed in June 2007 to inspire donations, and an
initial report in October 2008 indicated that progress had commenced under the
direction of Amalia Basso and Giovanna Nepi Scirè in the superintendency.[69] Proj-
ect Director David Rosand, himself a Veronese scholar, provided regular updates
to the board in subsequent years, and the progress on San Sebastiano was the lead
story in the SV newsletter year after year. The board enthusiastically sponsored
efforts in support of San Sebastiano, including sales of jewelry in New York by
Elizabeth Locke, YF events, and repeated festivities in New York, Boston, Ven-
ice, and Los Angeles. The initial stage of restoration—the ceiling and its three
canvases—was completed by 2011 and celebrated that summer with an exhibition
of the canvases at Palazzo Grimani at Santa Maria Formosa, allowing these mas-
terpieces to be examined at eye-level.[70]

By May 2009 the board had agreed to commence a second phase: the frescoes
around the nave for an additional $450,000, to be undertaken in 2011–12.[71] This
work included Veronese's *Annunciation* on the presbytery's triumphal arch, the bal-
ustrade panel, and four panels around the central canvas.[72] Next, from 2012 to 2015
the restorers worked on Veronese's fresco cycle of sibyls, prophets, and angels as
well as narrative scenes from the life of Saint Sebastian in the monk's loft (*barco*).
Just after completing his fresco cycle on the walls of San Sebastiano, Veronese
designed and decorated a new wooden organ loft with painted shutters; these too
were restored in 2014–15 with gifts from the Santo Domingo family.[73] In addi-
tion to paintings by Veronese, works by other artists were stabilized and cleaned,
including the tomb of the archbishop of Cyprus, Livio Podocataro, across the nave
from the organ, created by the workshop of Jacopo Sansovino (this treatment won
the Italian Heritage Award in 2013 for sculpture conservation).[74]

Rosand underscored the significance of San Sebastiano to the artist and his

reputation, likening the work of Veronese there to that of Michelangelo in the Sistine Chapel.[75] The significant expense of the San Sebastiano treatment, on top of other conservation projects and the regular cost of running two offices, meant that SV had to raise additional funds, about $1 million over three years. The organization met the challenge by asking board members to donate more, soliciting donations from friends, and continuing to host a variety of fundraisers. By the end of 2014 much progress had been made but the San Sebastiano project was still ongoing at the time of SV's fiftieth anniversary in 2021–22.

The Sala dell'Albergo, now Room XXIV of the Gallerie dell'Accademia, was the second major project in this period, commencing in 2008 and finished in 2012 at an approximate cost of $400,000.[76] Originally the boardroom and archive of a prestigious charitable confraternity, the Scuola Grande di Santa Maria della Carità, the room and other portions of the Scuola and its church became part of the Accademia in 1807 by Napoleonic decree. This ornate space included a gilded wooden ceiling of the fifteenth century featuring a relief of Christ and roundels of the four Evangelists writing the Gospels, as well as three large canvases narrating significant moments in the life of the Virgin Mary. One of the latter canvases was the well-known *Presentation of the Virgin in the Temple* (1534–38) by Titian; this massive mural, 7.75 meters wide, was rolled and transported to the Misericordia laboratory in Cannaregio for treatment, rather than being conserved on site. The two-year conservation of this canvas resulted in another Italian Heritage Award in 2013 for painting restoration and project management.[77] The restoration also permitted the reinstallation of two canvases, in storage outside of Venice for more than a century, back on their original walls.

This focus on works within the Accademia was something of a departure for Save Venice and in fact for the private committees in general. In previous decades, the Italian state supplied most of the money needed for conservation projects in national museums like the Accademia. By the early 2000s, however, newly constrained federal and provincial budgets meant that donations from groups like SV became particularly welcome. The absence of government funds was compounded by the withdrawal from the scene of large Italian banks and corporations that had traditionally been major sponsors of art restoration and related publications. Chair Matthew White deserves credit for deciding, in concert with the Projects Committee and the board, to take on the Sala dell'Albergo simultaneously with San Sebastiano. In order to fund them at the same time, White instituted a different approach: a minimum individual donation of $50,000 for the Sala dell'Albergo restoration, thus simplifying the bookkeeping and subsequently honoring those

exceptional donors. For San Sebastiano, SV split the campaign into specific opportunities that could be adopted by individual sponsors.

Beyond these two major projects, SV managed a variety of other conservations both large and small. That included restoration of Tintoretto's *Deposition of Christ* in the Accademia and a pair of processional poles from the church of San Trovaso. The Veneto-Byzantine mosaic pavement in the church of Santi Maria e Donato on the island of Murano was a technically challenging project launched in 2012 but one that reflected a longstanding commitment to the site. SV explored a range of other media too, including eleven early modern choir books from the basilica of San Marco (restored in partnership with the Swiss committee Fondazione Pro Venezia).

At the conclusion of the Sala dell'Albergo restoration in 2012, the next project at the Accademia was conservation of nine monumental canvases created by Vittore Carpaccio for the lay confraternity known as the Scuola di Sant'Orsola.[78] Begun in 2013 and lasting more than five years, conservation of this cycle would take place largely *in situ* at the Accademia. Restoring the paintings onsite was particularly important because the conservators were able to treat two at a time and side by side, thus ensuring that the results were in balance with each other. In a testament to the stature of these paintings, one canvas (*Arrival in Cologne*) was requested by the Istituto Superiore per la Conservazione ed il Restauro in Rome for treatment in 2013–14. Such masterpieces were deemed to be critical not just to Venice but to the Italian state as well.

In order to celebrate the substantial number of restorations in the Accademia and to disseminate the conservation work in which it was engaged, SV published two important books in this period. The first was *Masterpieces Restored: The Gallerie dell'Accademia and Save Venice Inc.*, timed to coincide with the opening of the newly expanded galleries and to honor the retirement of Superintendent Giovanna Nepi Scirè. Edited by curator Giulio Maniera Elia and including an essay by David Rosand as well as articles by specialists about each of the restored works, it demonstrated that the restoration of these paintings offered the opportunity to understand them better. With 330 photographs and published in Italian and English, this book bolstered SV's scholarly reputation and solidified its good relationship with the leading paintings collection in Venice.[79] In 2011 SV published its most ambitious book yet, a 472-page tome edited by David Rosand and Melissa Conn that described more than four hundred works of art conserved across forty years: *Save Venice Inc.: Four Decades of Restoration*.[80] Divided by *sestiere*, the book documents the immense scope of work that SV has engaged in and provides an overview of all conservation projects. *Four Decades* did not prioritize the conservation processes

adopted by Save Venice nor the people and events that have made it successful but instead portrayed the paintings, frescoes, architectural works, and other objects with an abundance of color photographs and narratives.

Rapprochement between New York and Boston

The presence of Bostonians Juan Prieto, Allison Drescher, and Frederick Ilchman on the New York board helped to improve cooperation between the two sides after 2004, and it may be that the Guthries' stepping down from leadership roles after 2006 allowed new voices to finalize a truce. Working with New York attorney (and SV director) Donald Fox, Juan Prieto and the Boston chapter's attorney Bob Connor drafted another resolution in 2008 that proposed a merger of SV and SV/NY.[81] This proposal specified that Boston should elect its own executive committee, maintain a separate bank account, select its own restorations, and nominate two members to sit on the board in New York. In return, the Massachusetts corporation would be dissolved, and New York would receive annual financial statements and the right to approve Boston's project selections. The Boston executive committee met early in 2009, and the minutes noted that "extensive discussion ensued, whereby some expressed that they were happy to relinquish the legal and financial reporting to New York, while others spoke of their concern that the Boston group might lose some of its distinctive identity, which has often been marked by admirable academic seriousness."[82] The executive committee concurred that representation in Venice, and the office services in New York (e.g., website, publications, financial transactions, audits, and legal matters), were essential for Boston. In addition, merging with New York would offer legal protection for officers. In May 2009 chair Bob Lovejoy publicly thanked Prieto and Fox "for their time and work to constructively restate the relationship between Save Venice Inc. and the Boston Chapter," and both sides approved the agreement.[83] With that, the long-running disagreement between Boston and New York was finally laid to rest. Subsequent correspondence and activities indicated that the two groups could work well together, with each benefiting from the other's strengths.

Boston Chapter

In addition to brokering the "constructive restatement" between Boston and New York, Prieto worked closely with Drescher and Ilchman to make the Boston chapter more profitable and efficient during and after their tenure as Boston leaders. In

early 2007 Drescher launched an events committee, designed to ensure that every event had an organizing committee, a budget, and a timeline.[84] Correspondence within the executive committee (EC) clearly shows how she imposed structural changes and a heightened seriousness on the group. Drescher's efforts to organize more ambitious and successful events coincided with the view of Prieto that fundraising events must be designed from the start to make a profit. In his role as chapter chair, Prieto introduced a number of changes: reducing the number of meetings by delegating more authority to subcommittees, maintaining a more substantial financial cushion, and clarifying the terms of an appointment to the EC.[85] Prieto was following practices in New York, which had instituted the three-year reserve fund and had for some time held just three full board meetings per year. During Prieto's time as chair, the EC generally met in the boardroom at his employer Cabot Cabot & Forbes, thus lending a corporate, professional air to the proceedings.[86] Ilchman drew on standard practices across U.S. nonprofits to professionalize the EC, for example suggesting a uniform set of expectations for all members in terms of annual minimum donations and service.[87] The trio of Prieto, Drescher, and Ilchman successfully transformed Boston's prior approach into a more focused and efficient set of procedures that would ultimately increase the number and scope of restorations sponsored by the Boston chapter.

When Prieto stepped down, architect Donald Freeman was elected to succeed him in 2009 for a two-year term. Freeman had served on the Boston EC for many years, where (among other tasks) he worked simultaneously as in-house graphic designer, lecture committee chair, and treasurer.[88] Freeman introduced the concept of lecture patrons, whose collective donations covered expenses for bringing out-of-town speakers to Boston, and he promoted a musical performance each year as part of the lecture series. He gradually transformed the annual newsletter into a more elaborate publication with color photographs, book reviews, and news from Boston and Venice. Freeman was succeeded two years later by curator Frederick Ilchman, who contributed a love of Italian art, familiarity with SV board and staff, a background in nonprofit work, and a contagious enthusiasm for all things Venetian. Executive consultant Susan Angelastro served as EC secretary and Projects Committee chair throughout this period, as well as liaison with the office of the Italian consulate in Boston; her fluency in Italian and regular trips to Italy made her effective in these roles.[89] The EC in Boston generally included about a dozen members beyond the officers listed above; in keeping with the numerous academic institutions in Boston, about half came from the university and museum world.

The financial records of SV Boston for 2007–14 indicate that the chapter's annual donation for restorations was about $60,000, generally spread between five to seven

projects per year.[90] That is roughly consistent with prior performance; during the decade from 1998 to 2009, the Boston chapter had sent a total of $448,000 to New York for specific project sponsorships.[91] The period 2012–13 was undoubtedly a high point for the chapter, with $131,000 expended, primarily on projects in the church of San Sebastiano.[92] It kept a close eye on the actual costs of restorations, noting early in 2007, for example, that the declining dollar, Italian inflation, and more elaborate treatment plans had pushed up costs of several restorations by nearly 50 percent.[93]

Financial success in this period allowed the Boston chapter to select increasingly substantial and ambitious projects. Those included Tintoretto's *Deposition of Christ* ($85,000) and Titian's *Pietà* and its gilded wooden frame ($78,000) in the Accademia, both treated in anticipation of major exhibitions in 2008–9, allowing the completed works to be seen by wider publics.[94] Another significant restoration project was Paolo Veronese's festive ceiling canvas of the *Triumph of Mordechai*

FIGURE 24. Paolo Veronese, *Triumph of Mordechai*, 1556, oil on canvas, Church of San Sebastiano, after conservation. The most festive of Veronese's three ceiling narratives depicting the Old Testament heroine Esther, the canvas was treated by the firm CBC (Conservazione Beni Culturali) in the Misericordia conservation lab between 2009 and 2011. Although the smalt pigments have discolored over the centuries, rendering the blue sky a pale gray, the other colors of Veronese's palette emerged as characteristically vibrant: pink, vermillion, lime green, and gold.
—Photo by Matteo De Fina, courtesy Save Venice Photo Archives

($65,000) in the church of San Sebastiano, followed in the same church in 2012 by conservation of a fresco of the prophet Isaiah ($15,000) and of the annunciation ($27,000) across the chancel arch.[95] The following year the Boston chapter undertook the conservation of the tomb of Livio Podocataro on the north wall of San Sebastiano. Podocataro (d. 1556) was archbishop of Nicosia in the Venetian colony of Cyprus, though he never went there, living instead in Venice in a house near the church. His massive Istrian stone monument, partially gilded, had been created by Jacopo Sansovino's workshop around the same time that Veronese was painting the frescoes behind it.[96] Of particular appeal to the Boston group was that this monument had apparently never undergone a proper conservation treatment in its four centuries of existence, and thus had been largely ignored by both scholars and the general public. As in the case of the frame and statuary of Titian's *Assumption of the Virgin* in the church of the Frari, the specific varieties of stones employed in the tomb were unknown, hidden under a thick layer of dust and grime, and much of the structure was far above the church floor. The restoration of the Podocataro tomb clarified numerous aspects of this fascinating monument.[97]

In 2014 the Boston chapter adopted Tintoretto's *Saint Martial in Glory with Saints Peter and Paul* in the church of San Marziale, last restored in 1959 and covered by disfiguring yellowed varnish. Following conservation, it would be featured in Tintoretto retrospectives at Venice's Palazzo Ducale and Washington's National Gallery of Art.[98] Smaller memorial gifts were offered too. For example, Eleanor Garvey's estate donated $10,000, subsequently used to restore a set of two dozen badly damaged drawings by Francesco Guardi in the Museo Correr; her friends in the Boston chapter added additional funds to restore a second set of drawings.[99] The Boston chapter returned to a couple of projects that it had initially supported in the 1970s, now needing maintenance: the *Pillars of Acre* near the south facade of the basilica of San Marco and Michele Giambono's *Saint Chrysogonus on Horseback*, a masterpiece of international gothic painting in the church of San Trovaso.[100]

The Boston lecture series provided a sense of continuity in the spring schedule each year with a trio of presentations on Venetian topics.[101] Members of the Boston chapter were occasionally asked to share their own research, as when James Johnson spoke about Venetian masking, Christopher Carlsmith described Venetian-inspired ceilings in American homes, and Ilchman revealed discoveries in Renaissance paintings through scientific examinations. The tradition of a musical performance with remarks, launched by Freeman and Prieto in 2004, continued most years through 2011 with performances by Daniel Stepner (baroque violin) and Laura Jeppesen (viola da gamba), and then occasionally with other performers after

FIGURE 25 a & b. Workshop of Jacopo Sansovino, *Tomb of Bishop Livio Podocataro*, 1556–58, Church of San Sebastiano, after conservation (top) and during conservation (left). Installed on the north wall of San Sebastiano and cleaned in 2012–13 for perhaps the first time in its existence, the tomb's details in gold and delicate carvings previously obscured by a thick layer of grime and smoke were revealed. The treatment won first prize for sculpture restoration from the Italian Heritage Awards.
—Photos by Matteo De Fina, courtesy Save Venice Photo Archives

that. In 2013 *Boston Globe* art critic Sebastian Smee offered a splendid discourse on Venice and its Biennale. A pair of talks that drew on extensive personal experience in Venice were Judith Martin (aka Miss Manners) in 2008 on "Venetophiles and Lagoonatics," followed by Sally and Carl Gable describing their experience restoring their Palladian villa in 2010 with "Finding a New Life in a Venetian Country House." The Boston lecture series was intended to be educational and generally broke even, rather than making a profit. It was in this period that the Chilton Club became the primary venue for the lecture series and annual general meeting (AGM), owing to its oversized slide screen, quiet elegance, and central location near Copley Square. In keeping with the tradition established by John and Betty McAndrew, the AGM was the other fixed event in the Boston calendar each year, held in early autumn.

Not all presentations were scholarly, nor were they part of the lecture series.[102] Prieto brought designer and jeweler Hutton Wilkinson to Boston for a 2008 visit that celebrated the legacy of Hollywood designer Tony Duquette. The Boston chapter invited Princeton University historian and SV board member Theodore (Ted) Rabb to Newbury Street's Pucker Gallery in February 2012 for the launch of his new book *The Artist and the Warrior: Military History through the Eyes of the Masters*. Also on Newbury Street was an October 2013 talk and mini-exhibition by New York artist Adam Van Doren, reading for SV Boston members from his new book *An Artist in Venice*. Sometimes the Boston chapter piggybacked on events organized by others and added its own twist: for example, in 2014 it brought fifty guests to a performance of Venetian composer Antonio Vivaldi at Symphony Hall by the Handel and Haydn Society, followed by a reception across the street where James Johnson described the historical context of Vivaldi and maestro Harry Christophers outlined his planning process for individual performances and an entire concert season.

The template that Drescher had instituted for the Boston YF continued to be successful, but the frequency of events and amounts raised began to decline after her departure. A Carnevale party in 2007 sold out with 175 attendees, as did a cocktail party at the Intercontinental condominiums that same year, with funds supporting restoration of Fra Antonio da Negroponte's *Madonna and Child Enthroned* at the church of San Francesco della Vigna.[103] In subsequent years there were tours of Childs Gallery, the MFA, and the Gardner Museum, as well as a 2012 "Courtesans and Casanovas" masked party at the venerable Locke-Ober restaurant.[104]

Compared to the New York YF, and to its own performance in the early 2000s, however, the Boston YF was less active and the events simply less profitable.

In conclusion, the period from 2007 to 2014 witnessed overall expansion and increased unity on a number of fronts. Despite the market downturn of 2008–9, Save Venice was able to continue raising millions of dollars per year, especially from galas and excursions, and to direct that money to the principal restorations of San Sebastiano, the Sala dell'Albergo, and the Carpaccio Saint Ursula cycle. Educational efforts, previously centered on fellowships and training courses, now encompassed publishing books and exhibition catalogues. Together with Melissa Conn, the scholars on the board organized a conference panel of symposium papers for the annual meeting of the Renaissance Society of America (including in 2010, when the entire conference occurred in Venice).[105] The success of the Boston lecture series, and the reconceptualization of the Education and Enrichment series in New York, further increased the emphasis on the educational mission. The "constructive restatement" of the relationship between Boston and New York meant that the overall organization was able to function in greater harmony and unity. It became clear that SV would carry on with new leadership, just as it had eventually rebounded after the death of John McAndrew in 1978. Behind the success in this period was a willingness to embrace new fundraising formulas, such as a membership program or the experiment of a Venice gala in midwinter or midsummer instead of Regatta Week. Active leaders in the individual cities, and above all at the organization's headquarters, resulted in Save Venice being more prepared to face challenges and take advantage of opportunities when they arose. The professionalization of procedures and policies meant that the organization was less dependent on the efforts of a single individual and could withstand even significant turnover at the top.

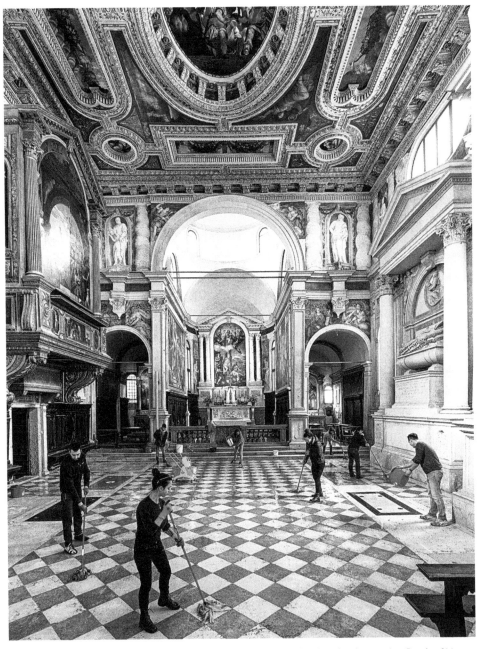

FIGURE 26. Church of San Sebastiano, interior, 2019. Right after the devastating floods of November 2019, Save Venice established the Immediate Response Fund to pay for supplies and labor to aid submerged churches and other public buildings. In this case, the floor of San Sebastiano was rinsed with fresh water and mopped to remove salt deposits from seawater.

—Photo by Matteo De Fina, courtesy Save Venice Photo Archives

Chapter 8

SERENITÀ

Save Venice Matures (2015–2021)

IN HER September 2016 report to the board, executive director Amy Gross referred to the "robust and diverse range of activities" overseen by Save Venice, noting that it was operating at an "all-time high."[1] Her report was prescient: the most recent period of the organization's history (2015–21) has been marked by unprecedented success and a growing self-confidence in its mission and operations. Despite the second-worst *acqua alta* ever in 2019 and the devastating coronavirus pandemic in 2020–21, SV improved its balance sheet, expanded its geographical reach, and completed a series of high-profile conservation projects. Early in 2015 the Venice office moved from ground-level space on one side of the Accademia bridge to a top-floor suite in the Palazzo Contarini Polignac on the Dorsoduro side of the bridge. The additional room allowed for the creation of the Rosand Library and Study Center, which with its frequent roundtables and lectures quickly became a hub for English-speaking Venetian scholars. Fundraising swung into high gear with the New York staff and a cadre of volunteers establishing a consistent rhythm of events in New York and in Venice; the increased financial success of the "Ballo in Maschera" in Manhattan each spring was particularly notable. The California chapter was mostly quiet following the resignations of Hutton Wilkinson and Manfred Flynn Kuhnert in 2015, whereas the Boston chapter organized a steady series of galas and lectures before it too became less active by 2019. New supporters in Houston, Chicago, and Charleston, South Carolina, as well as domestic excursions to Denver and Fort Worth/Dallas, led to a wider geographical base of "focus cities" across the United States.[2] Matthew White and Beatrice Rossi-Landi stepped down as chair and president respectively, to be replaced early in 2016 by Frederick Ilchman and Richard Almeida (and later Tina Walls).

Several important conservation projects overlapped between 2015 and 2021, demonstrating SV's ability and indeed determination to juggle multiple complex endeavors.

These included the multiyear conservation of San Sebastiano, the Carpaccio cycles of Saint Ursula, and that of the Scuola San Giorgio degli Schiavoni (Scuola Dalmata), along with two significant Titian altarpieces. The quincentenary of Tintoretto's birth was a major focus in 2018–19, with a coordinated series of restorations, exhibitions, publications, and fundraising events under the rubric of "Tintoretto 500." In 2019–20 the organization looked ahead to its own fiftieth anniversary in October 2021 by adopting two substantial projects: the mosaics at the high altar end of the church of Santa Maria Assunta on the island of Torcello and the Scuola Italiana (Italian synagogue) in the Ghetto. Preliminary work at Torcello revealed fragments of ninth-century frescoes covered by a later ceiling. These fragments were not in a Byzantine but in a Western European style and included an inscription honoring the French bishop Saint Martin of Tours. These traces were later hidden as the church was enlarged in the eleventh century and the famous mosaic decoration in the Byzantine manner begun. This discovery of frescoes demonstrates that ninth-century Venetians looked to northern European styles rather than Byzantium for artistic inspiration, and thus the predilection for Byzantine art and architecture throughout the lagoon may have been less uniform and begun later than previously assumed.

The capacity to embrace multiple large restorations simultaneously was due to financial success in this period. Flush with cash by 2019, SV created a special reserve fund and a Strategic Planning Committee, as well as a Fiftieth Anniversary Committee. Although the coronavirus forced delays at worksites in Venice and postponement or cancellation of various events beginning in spring 2020, SV pivoted to an online-only approach for its lectures and select fundraising events, thus preserving much of its momentum. Recognizing that it was impossible to hold the usual black-tie galas for hundreds of people, SV opted to commemorate its semi-centennial by asking supporters to host a series of dinners and cocktail parties across the United States and around the globe between June 2021 and March 2022 entitled "50 Celebrations for 50 Years."[3] By early fall of 2021 the fundraising campaigns for the two anniversary projects in Torcello and the Ghetto were successfully concluded. The Ballo in Maschera in New York returned in April 2022 to mark the fiftieth anniversary, with the gala in Venice close behind. By a fortunate coincidence, in 2021 the city of Venice celebrated its own birthday, marking the 1,600th anniversary of its legendary birth in 421. This provided still more opportunities, including a major exhibition at the Palazzo Ducale, to reflect on how Venice has been born (and reborn) during its remarkable history, and how Save Venice has contributed to its cultural heritage.[4]

Governance

The ascension of Frederick Ilchman to be chair of SV was simultaneously predictable and unexpected. Ilchman had been directly involved for nearly two decades, most recently as Boston chapter chair (2011–15) and as co–project director (2013–16). A protégé of the Guthries and of David Rosand, and the only SV chair to hold a Ph.D., Ilchman possessed an infectious enthusiasm for, and astonishing knowledge of, Venetian history, culture, and art, gleaned from years spent in Venice as well as from his extensive research on the artist Tintoretto.[5] On the other hand, he was relatively young and had never served in one of the vice presidential slots, nor did he have a business or financial background. Other candidates might have offered more experience or other strengths.[6]

After substantial discussion, in January 2016 the nominating committee selected Ilchman as chair and Almeida as president.[7] A veteran corporate executive and a former treasurer of SV with deep knowledge of finance, Almeida balanced Ilchman's expertise in the arts world. Almeida's steady, affable personality and his experience with nonprofit boards in Chicago and Charleston also complemented Ilchman's strong public persona and his networks in Boston and New York.[8] Through this effective partnership, and in collaboration with the office staff and board leadership, Almeida and Ilchman substantially increased the financial reserves of SV and its ability to take on larger projects, as well as initiating a process of strategic planning. When Almeida's term ended in February 2020 he was succeeded by Tina Walls, another experienced business executive who had a substantial history with SV as its development committee chair (2016–20) and with several nonprofits and arts organizations in Denver.[9]

Ilchman moved swiftly to outline his vision in his initial board meeting as chair, describing his wish for SV to be "a model non-profit that is nimble, effective, and fun, wherein the primary goal is restoration and the secondary is education."[10] He enumerated a dozen specific goals, among which were capitalizing on an expanded presence in Venice through the Rosand Library; completing restorations both in San Sebastiano and via Tintoretto 500; reviving the California chapter and adding a new one in Texas; reestablishing the Young Friends Committee in New York; and ensuring full board participation in membership, fundraising, and event activities. Following suggestions from Almeida and Lovejoy, he encouraged the subcommittee chairs to formulate similar visioning goals through mission statements and charters to be updated annually.[11] Ilchman also reorganized the composition of the

FIGURE 27. Frederick Ilchman, 2016, in front of Titians's *Assunta*, Church of Santa Maria Gloriosa dei Frari. An art historian and museum curator with particular expertise on Tintoretto, Ilchman served as Boston chapter chair (2011–15), co-project director (2013–16), and chair (2016–present). —Photo by Matteo De Fina, courtesy Save Venice Photo Archives

executive committee so that key subcommittee chairs would be represented, and encouraged the board to think about how to effectively market its restorations in engaging ways to attract a broader audience. At the beginning of each board meeting Ilchman made a habit of identifying specific goals to be realized. He imprinted his own style and substance on SV right from the start of his term, and he continued to play an activist role as chair. Ilchman noted that SV had enjoyed a tradition of strong leadership from John McAndrew onward; Ilchman's view was that a chair must establish a vision of ambitious goals and encourage the board to meet them.[12]

We have previously seen the efforts of Bob and Bea Guthrie in the early 2000s to rebuild the board to about thirty-five people in order to guarantee strong attendance at ticketed events and to have a range of experience from the academic,

business, art, and nonprofit worlds. The size of the board had increased to an average of about forty-five members by 2014 and expanded closer to fifty members in the period under consideration here. The motivation was consistent: to expand the pool of those who would invite friends and potential donors, and to draw from a breadth of professions and geographic areas. The practice of having four or five vice presidents (rather than simply one) had begun in 2011 and remained in place through 2021; the other customary (and single) positions of board secretary, treasurer, and project director did not change. Two innovations were the creation in 2016 of emeritus directors for those who had given "exemplary and distinguished service" to SV but were now in the twilight of their careers, and of honorary directors for those who had made "extraordinary contributions to the objectives of Save Venice" from outside the organization.[13] The board and the executive director implemented additional policies to spur professional development and observe best practices: these included a whistleblower policy, a separation-of-employment policy, and enhanced performance reviews for staff.[14] The legal committee, headed by Charles Tolbert and John Fiorilla, played an increasingly important role in scrutinizing contracts, reviewing by-laws, and managing risk.

The composition of the board remained broadly similar in terms of professional and socioeconomic background although the geographical breakdown altered a bit. Long-term academic members like Ilchman, Anne Hawley, and Patricia Fortini Brown were joined by scholars and curators such as C. D. Dickerson III, Sonia Evers, Sarah Blake McHam, Tracy Cooper, and Xavier Salomon. Lee Essex Doyle, Anne Fitzpatrick, and Tracey Roberts linked with Juan Prieto to give voice to Boston interests, while Cat Jagger Pollon was one of a very few from the West Coast. Amy Harmon joined Tina Walls from Denver, Richard Almeida came from Chicago, and Larry Davis with Claire Barry provided perspective from Texas. Andrew Jones hailed from London, while Francesca Bortolotto Possati and Alberto Nardi represented Venice. The majority of the board, however, was still from New York: Christopher Apostle, Mary Kathryn Navab, Laura Maioglio Blobel, and Mary Ellen Oldenburg, to name just a few, along with former Young Friends like Lizzie Asher, Adelina Wong Ettelson, Dayssi Olarte de Kanavos, Lauren Santo Domingo, George Rudenauer, and Alexandra Lind Rose, all of whom brought energy and a dash of glamor.[15] Martha Stires Wright became the first second-generation member of the board, following her father Sidney Stires (board member, 1999–2011) and serving as treasurer from 2016 to 2019 before being succeeded by Jeffrey Bolton.

FIGURE 28. Save Venice Board of Directors, spouses, guests, and staff, 2019, visiting the Carpaccio cycle of Saint Ursula in the Gallerie dell'Accademia. Carpaccio's cycle of the story of Saint Ursula dates to the 1490s. Moved to the Accademia around 1812, the paintings have been restored multiple times over the centuries; the most recent conservation, sponsored by Save Venice between 2010 and 2019 and carried out by Egidio Arlango and CBC (Conservazione Bene Culturali), sought to reestablish harmony and balance through cleaning followed by painstaking retouching. The contrast of this gathering with figure 17 in chapter 4 demonstrates the growth of the board over three decades and the related ambition to undertake simultaneously numerous major restorations.
—Photo by Matteo De Fina, courtesy Save Venice Photo Archives

Melissa Conn continued her long-term role as director of the Venice office with Leslie Contarini as program coordinator and eventually program director.[16] The latter was instrumental in all forms of electronic communications, particularly in creating the monthly e-news, whose articles are frequently picked up by the Venetian press. With the additional space offered by the Rosand Library, Conn and Contarini organized regular programs and instituted a more robust public presence for SV. In an effort to establish stronger connections with residents and businesses of Venice, Ilchman and Gross supported a local advisory committee, chaired by Alberto Nardi and coordinated by Conn, with members drawn from the Venetian and Veneto business community to advise on local issues and recruit Italian supporters.[17] In the previous chapter we saw that Amy Gross became executive director in 2013; together with Kimberly Tamboer Manjarres and several others, Gross led the paid staff and particularly the New York office, providing strong continuity and enhanced professionalism.[18] The New York office also moved into new office space in 2014, this time on East 58th Street.

The decade-long expansion of the U.S. economy from 2009 to 2020, combined with prudent investments and determined fundraising, meant that SV saw its total assets nearly double from 2015 to 2020. At the end of 2014, for example, SV had net assets of just under $3 million, split evenly between cash and investments. In 2015 alone SV raised nearly $2 million, including $1.5 million from just two events, and it was able to sustain that pace in the following years.[19] Toward the end of 2019 SV had net assets of just under $6 million, including $4.77 million in unrestricted net assets.[20] By 2019 SV had sufficient cash and liquid investments to create a special reserve fund, designed to cushion the organization against economic downturns.[21] Treasurer Jeffrey Bolton expressed the hope that this might represent the seed money for an eventual endowment. The surfeit of funds also resulted in the creation of a Strategic Planning Committee, chaired initially by Amy Harmon and later John Fiorilla, with the charge to plan for the long-term future and reconcile the charters and mission statements developed by each board subcommittee into a cohesive whole. At the conclusion of 2021, SV's net assets had increased yet again to $8.5 million.[22] This consistent increase in funds occurred despite the substantial outlays for projects undertaken in this period; in 2016 SV was carrying total commitments of $2.7 million, its highest ever, and that number was significantly exceeded in 2020 with project commitments in excess of $4 million.[23]

How did Save Venice manage to raise so much money? The special events and excursions narrated earlier (and described below) were primarily responsible, but so too was a more concentrated focus on attracting and retaining donors through the use of member cultivation events and personalized outreach by staff and board members. Furthermore, SV continued soliciting sizeable donations from funders like the Thompson Family Foundation, the Dougherty Foundation, and the Delmas Foundation (to name just three of those that gave consistently). Ilchman stated in 2016 that "the board should act as the primary donors to the organization," and it appears that board members followed his encouragement.[24] In her role as development committee chair, Walls monitored the effectiveness of various campaigns, increased the number of major donors, and expanded the membership program and planned giving.[25] An effective investment portfolio, with about two-thirds of assets invested in equities, resulted in SV equaling or outperforming market indices. Lastly, SV ensured that a minimum of three-quarters of its total outlay was on program spending, in keeping with nonprofit best practices, and thus reassured its donors (individual and institutional) that the bulk of the money was going directly to restorations and not to overhead, as John McAndrew had promised decades before.[26] From 2018 to 2020

the auditor reported that fundraising expenses for SV were between 10–15 percent of all spending, thus representing significant improvement in operational efficiencies.[27]

New Initiatives

One notable initiative was the formation of the Educational Resources Committee (ERC), chaired initially by Mary Frank and later by Irina Tolstoy and then Davide Gasparotto. Founded in 2012 as a temporary subcommittee at the direction of SV chair Matthew White to take over the portfolio of fellowships, publications, exhibitions, and the like from the Projects Committee, the ERC's job was to advise the larger board about educational opportunities and to seek out funding from foundations and individuals to that effect.[28] Although both committees were largely staffed by scholars, the Projects Committee always had responsibility for all of the physical aspects of a work of art, including pre-restoration analysis, conservation treatments, transport, security, and so forth. By contrast, the ERC was (and remains) in charge of initiatives related to the creation and dissemination of knowledge as well as the operations of the Rosand Library and Study Center. The ERC's purview includes the lectures, of course, and those continued on a scale consistent with prior years. In the period 2015–21, however, the ERC further supported exhibitions, conferences, fellowships, and publications. For example, it provided a subsidy for a series of volumes about Venetian churches, including that of San Pietro di Castello, a site of repeated SV conservations.[29] These books offered a solid scholarly platform for the restorations sponsored by SV and its fellow committees in Venice, by documenting and disseminating discoveries. The ERC encouraged the publication of guidebooks, such as *Tintoretto in Venice* (2018) and *Carpaccio in Venice* (2020), paying for printing costs as well as stipends for researchers and editors, and gave curatorial fellowships to Gabriele Matino and Ilaria Turri to prepare the Tintoretto exhibitions.[30] Books to mark the fiftieth anniversary and summarize the most important restorations were under consideration.[31] The ERC worked with the Kress and Delmas Foundations to digitize archival documents in the Venice office and approved an internal grant of 5,000 euros to build a photography archive in the Venice office.[32] This committee also arranged for private tours at the Frick Collection, the Metropolitan Museum, and Sotheby's, and coordinated the submission of academic panels at the annual meetings of the Renaissance Society of America.[33] Furthermore, the ERC obtained external funding from the Delmas Foundation to support exhibitions such as *Venice, the Jews, and Europe* (2016) and a

conference at the Scuola Grande di San Rocco in Venice entitled *American Writers in the Museums, 1798–1898* (2016).³⁴ A virtual reality app describing the True Cross cycle at the Scuola San Giovanni Evangelista, support for a Ca' Rezzonico exhibition catalogue, publication of the 2018 Tintoretto conference proceedings: these and many other projects were championed by the ERC at board meetings.³⁵

The most important educational initiative was the creation of the Rosand Library and Study Center (RLSC) in Venice. Established in memory of David Rosand, a professor of art history at Columbia from 1964 until his death in 2014 and the project director of SV for eleven years, the RLSC's nucleus was the collection of more than four thousand books from Rosand's own library. These books and his personal papers were complemented by the restoration files and photographic archive already present in the Venice office, covering nearly fifty years and seven hundred projects. The goal was to create an English-language library for students and scholars working in Venice, as well as a scholarly hub for conservators. The impetus for this library came from Rosand himself in the months prior to his death. With financial support from the Kress Foundation, the Frank Family Foundation, and SV, Mary Frank worked with Professor Ellen Rosand, David's widow, to supervise the counting, cataloging, and shipping of the books from New York to Venice. The process was complicated not only by the ephemera tucked inside the books (e.g., David's notes, postcards, and published reviews) but by the size of the collection. It became clear that the library would never fit inside the current office in Palazzo Marcello. Melissa Conn quickly secured an appropriate space by leasing the top floor of Palazzo Contarini Polignac from the family of Roger de Montebello, an artist resident in Venice who had joined the SV board in 2012. (This space offered the further benefits of a kitchen, air-conditioning, and an elevator.) The RLSC opened in June 2015, with windows to gaze over the Grand Canal, thus perpetuating David Rosand's affection for his "home upon the waters."³⁶ Taking advantage of the new space, SV immediately launched "Research and Restoration Roundtables" with monthly presentations by art restorers, art historians, curators, and officials from the Italian Ministry of Culture. These roundtables were an extension of the successful lecture series initiated in Venice some years before. The new space permitted other book presentations, lectures, and receptions, all of which increased SV's visibility in Venice.

The RLSC offers additional opportunities for short-term fellowships and internships, as students and postdoctoral scholars could benefit from Rosand's extensive collection on Venetian history and art. In addition to the undergraduates who had come each year from Lafayette College, Wake Forest, or Columbia University to

FIGURE 29. Rosand Library and Study Center (RLSC), Palazzo Contarini Polignac. Opened in 2015, the RLSC houses the reference library bequeathed by David Rosand and serves as a hub for students, scholars, and conservators as well as the Venetian office of Save Venice.
—Photo by Matteo De Fina, courtesy Save Venice Photo Archives

assist in the office, Ph.D. candidate Sophia D'Addio spent three months finishing her dissertation about painted organ shutters while helping update project descriptions on the website, and University of Cambridge graduate Mateusz Mayer created a finding aid for Rosand's archive of offprints, manuscripts, brochures, and scholarly essays.[37] In 2019 the ERC granted fellowships to five young scholars from Ca' Foscari, Columbia University, the University of Melbourne, and the University of Sydney.[38] The RLSC has partnered with several Italian institutions, including the Istituto N. Tommaseo in Venice for a work-study program to introduce high school students to art conservation, and the restoration school of the Instituto Veneto dei Beni Culturali to train college-age students about conservation procedures in canvas, stone, wood, and paper.[39]

The RLSC memorializes one donor to SV. The introduction of a planned-giving program, "Venezia Per Sempre / Venice Forever," offers another means for benefactors to be remembered. The impetus here was an unsolicited phone call to SV's New York office from a lawyer representing the estate of a recently deceased woman

looking to give $1 million for historic preservation in either Paris or Venice. Save Venice had no program in place to receive such a gift, so Mary Frank and the development committee quickly created one to track and accept bequests.[40] Advertised regularly in the annual newsletter and on the website, by 2019 Venezia Per Sempre had garnered nearly twenty members who included SV in their wills, including that of founding member Charlotte Hermann, whose bequest supported restoration of the Carpaccio cycle in the Scuola San Giorgio degli Schiavoni.[41] In 2019 SV suggested an IRA charitable rollover for taxpayers who were seventy years or older.[42] Both of these initiatives suggested a broader approach to seeking donations beyond ticketed events and excursions, as well as increased attention to its long-term sustainability. Yet another new initiative in 2019 was the introduction of the Conservation Patron Council, a select group of upper-level donors in focus cities across the United States and Europe who promise to host at their own expense one event per year in their city in order to introduce SV to new audiences and to generate members.[43]

To clarify its message, in 2017–18 SV launched a refreshed logo and a new slogan while overhauling its website.[44] This effort was one of the dozen goals that Ilchman had outlined at the beginning of his tenure as chair: to communicate more effectively via new and old technologies. The new motto, "Conserving Art. Celebrating History," sought to be more concise and action-oriented than the previous slogan of "Dedicated to Preserving the Artistic Heritage of Venice." The leonine mascot remained largely unchanged from the one originally chosen by Eleanor Garvey in 1971, except that for increased legibility, the phrase *Pax Tibi Marce Evangelista Meus* (Peace to You, Mark My Evangelist) was removed from the book on which the lion rests its right paw. SV developed affiliate logos for the Boston chapter as well as for specific entities such as the RLSC, Venezia Per Sempre, and the fiftieth anniversary committee. The new website features greater accessibility from mobile devices, simpler payment processing, increased speed, and a significantly expanded capability to search for projects.[45]

In concert with these efforts, the board discussed the use of traditional media and social media to advocate for Save Venice. In 2017 George Rudenauer encouraged sharing of posts using @saveveniceinc, and Christopher Apostle suggested that Instagram could be utilized to promote projects for sponsorship.[46] A new Wikipedia page was launched in 2018 and expanded in 2020 to briefly describe the history, leadership, events, and restorations of SV.[47] Lauren Santo Domingo and Francesca Bortolotto Possati recruited British actor Jeremy Irons to speak in September 2017 as an ambassador for SV in a CNN Style episode about the restorations in San

Sebastiano.[48] Richard Almeida underscored the importance of what he called "corporation branding" in his remarks to the board in September 2017, at the same time that Frederick Ilchman called for a "stronger brand management system."[49]

The membership program has continued to generate income, interest, and loyalty. The practice of differentiating levels of membership became more pronounced over time, with those at the higher levels (e.g., fellows at $1,000 per year) invited to attend exclusive gallery tours at the Frick and Metropolitan Museums, or the opportunity to travel on more intimate excursions. The establishment of the Immediate Response Fund in November 2019 generated more than two hundred new donors.[50] In 2020 Tina Walls informed the board that donations via the website had doubled year over year, reflecting both the increased digital content provided by SV during the pandemic and a new method of giving.[51] The development committee, along with Amy Gross and director of development Kim Tamboer Manjarres, tracks the membership numbers carefully and routinely updates membership brochures and benefits to reflect changes in demographics and interest.

One recent element of the membership program involved the reconstitution of the New York Young Friends, which had sputtered out after several of its leading members graduated to the board. In October 2018 Lizzie Asher relaunched the YF with a cocktail party in New York for two hundred people, and then formed a steering committee that included sons and daughters of several board members. A spring 2019 event at the James Hotel in SoHo raised initial funds to restore four paintings by Pietro Longhi in the Ca' Rezzonico Museum. A late night reception at Ca' d'Oro in Venice in June 2019 provided another opportunity to gather.[52] Both staff and board leadership made clear that the YF needed to be formally integrated into, and supported by, the SV "family" rather than operating as a pop-up group with its own identity. In July 2019 the group formed a YF executive committee and expressed the desire to create a structured calendar.[53] By February 2020 the YF had established its own nominating and education committees, organized a New York party for 150 people in honor of Prince Emanuel Filiberto of Savoy, and adopted additional Longhi paintings at the Ca' Rezzonico.[54] In 2021 the YF sponsored a party at Rice University in Houston, transforming the university's faculty club into a Venetian palazzo for one evening with the theme "Martinis and Masks."[55] Asher, who had been a full board member for several years, provided brief biographies of the YF members. In a sign of the times, Asher pointed out that communication and financial practices for her generation were substantially different than even ten

years ago, and that the YF committee practices would need to evolve to reflect the prevalence of texting and mobile payment systems.[56]

Ilchman devised the Women Artists of Venice program, launched in 2021, to combine art conservation, scientific research, and scholarly dialogue, all in the service of identifying and celebrating a neglected field in art history. The Venetian Republic was renowned for its female humanists in the fifteenth and sixteenth centuries (e.g., Laura Cereta, Cassandra Fedele, and Isotta Nogarola), and we now know that Venice had an impressive number of women artists too.[57] Tracy Cooper leads the research track and Melissa Conn is supervising restorations. The first treatments under the Women Artists of Venice umbrella were eighteenth-century paintings by Giulia Lama (San Marziale and Malamocco) and pastels by Rosalba Carriera and Marianna Carlevarjis (Musei Civici and Gallerie dell'Accademia). The long-term goal is to document and conserve as necessary all pre-nineteenth-century works by women artists and artisans in Venice. The scope may expand to include female patrons and collectors. The program quickly attracted new donors and press attention.[58]

The Education and Enrichment series in New York has continued to offer a variety of lectures and gallery visits, with an emphasis on art history.[59] Scholars often represent major research universities: Patricia Fortini Brown of Princeton, Colin Eisler of New York University, and Heather Nolin of Yale. In keeping with the broader scope that had previously been introduced by Amy Gross and the ERC, however, the series launched several elements that went beyond traditional academic lectures. For example, in 2017 Ellen Rosand and Mary Frank collaborated with Grant Herreid of the Ex Umbris early music ensemble to create an interdisciplinary presentation that included discussions of Venetian art paired with music from that period: "Music in Situ: Venetian Music in Its Artistic Context," co-presented with the Morgan Library and Museum as part of Carnegie Hall's La Serenissima Festival. Mary Frank and Francine Segan put together an evening about "Art, Food, and Wine of the Veneto." Other topics strayed from art history or Renaissance Venice but were promoted to draw new supporters and broaden the organization's appeal. For example, in 2019 Pellegrino D'Acierno of Hofstra University blended culinary arts and film studies in his talk "Delectable Venice: Desiring and Encountering La Serenissima through Cuisine and Cinema." Melissa McGill's talk "Red Regatta" in 2019 considered contemporary art and received rave reviews.

Lectures commemorated important anniversaries, beginning with the fiftieth anniversary of the flood in November 2016, when Conn and Xavier Salomon spoke

at the Italian Cultural Institute about efforts to recover from the terrible *acqua alta* of 1966. The Tintoretto 500 celebrations of 2018–19 brought Andrea Bayer of the Metropolitan Museum and John Marciari of the Morgan Library to speak about the works of Tintoretto. Conn contributed frequently, providing periodic updates about San Sebastiano, Carpaccio's Saint Ursula cycle, Titian's paintings in the church of the Frari, and the twin fiftieth-anniversary projects in Torcello and the Ghetto. The onset of the COVID-19 pandemic in March 2020 required that all events convert from in-person to virtual; the remarks of Gardner Museum curator Nathaniel Silver about the upcoming exhibition on Titian's "poesie" reunited, or the comments of *New Yorker* author Cynthia Zarin on Venice and Byzantium, for example, were offered online in fall 2020. The most significant, and successful, effort to pivot in the face of the pandemic was the "Love Letter to Venice" in October 2020, a twenty-two-minute documentary film that featured spectacular footage of Venice and interviews with curators, students, and leaders of Save Venice, all shot on location just weeks earlier.[60] Produced by Adelina Wong Ettelson and Amy Gross, and narrated by actor Jeremy Irons, this virtual showcase acknowledged donors to the 2020 Ballo in Maschera who had allowed SV to keep their contributions. The film had the added advantage of reaching far more people via the internet than could be accommodated in a hotel ballroom, and thus SV converted a potential loss into a win.

"Un Ballo in Maschera" and "Il Gran Gala a Venezia"

A biennial gala in Venice and an annual ball in New York were by now established traditions. What changed in this period was the amount of money raised by the New York ball, and the more prominent place that it has come to occupy in Manhattan's social calendar. Dubbed the "mini-Met ball," "Un Ballo in Maschera" maintained the title and the concept of a luxurious, Italianate masked ball even as the subtheme rotated each year.[61] The subtitles from 2015 to 2019 evoked Italy and provided ample inspiration for creative mask-making and decorations: they included "The Pleasure of Love," "Italian Vacation," "Dangerous Beauty," "Splendors of the Orient," and "Artists and Muses." The event was regularly featured in society magazines but also served as a bridge to serious reporting about restorations and current events in Venice.[62] Dolce and Gabbana was a leading sponsor for several years, as were Oscar de la Renta, Buccellati, Bulgari, and Pomellato. Each donated cash as well as prizes or sponsored a competition for best mask. The financial contributions from sponsors continued to increase, even reaching a peak of $100,000 from a top donor in support of the 2016 ball.[63] Lauren Santo Domingo was the driving force behind the New

York ball's continued success from 2015 to 2019; utilizing her social contacts in New York and working with designer Bronson Van Wyck, she and her colleagues consistently netted nearly a million dollars in a single evening.[64]

The New York ball was notable for the large number of committee co-chairs, vice chairs, honorary chairs, and hosts—each brought friends and thus the ball often sold out before the invitation was circulated. Buying an entire table for one's friends became a popular option: for example, four months prior to the 2018 ball there were already commitments for four tables at $50,000 each and another four tables at $30,000 each.[65] With few exceptions, the New York ball has not been tied to a specific conservation project but instead the monies remain unrestricted, available for use where needed most. From 2015 to 2019 the ball always grossed at least $1 million, even as the number of guests was deliberately lowered from a high of six hundred to somewhere between four and five hundred to prevent overcrowding.[66] The lower head count only increased the exclusivity of the event. The coronavirus forced the cancellation of the ball in 2020 and 2021 but it returned in April 2022, grossing $2.2 million.

The four-day gala in Venice had previously been linked to the Regatta Storica at the close of the summer (nine times), Carnevale in midwinter (three times), and Redentore in midsummer (once). In 2015 SV experimented with a gala soon after the June opening of the Venetian Biennale, the oldest contemporary art exhibition in the world and an event that has defined modernity in Venice since its founding in 1895. The Biennale offers a chance to view a wide array of international artists, often in atmospheric older venues, and to make the case that SV was a bridge between past and present. Save Venice's 2015 gala made this connection explicit by choosing the subtitle "Contemporary Art Meets the Old Masters." With just 150 guests, some utilizing the new half-gala ticket at a lower price point, the gala still netted in excess of $500,000, once again being sure to have all major events underwritten by an individual or corporate sponsor. In a twist, nearly fifty supporters of the Salk Institute joined the SV guests for the evening at the Palazzo Ducale, and then had their own tours of San Sebastiano, thanks to the generosity of Frederik Paulsen.[67] The SV newsletter of that year included a two-page feature utilizing photographs and text to narrate a day-by-day review of the lectures, exhibitions, concerts, receptions, and site visits.[68] Mary Hilliard reported for the *New York Social Diary* on all aspects of the 2015 gala, including the Cole Porter–themed dinner in Ca' Rezzonico (where the composer lived from 1926 to 1927) and a performance of Porter's songs by Broadway actor James Monroe Iglehart.[69]

In 2017 SV returned to a Biennale gala, this time entitled "Il Gran Gala a Venezia: A Venetian Affair." The title of this event came from Andrea di Robilant's historical

account of the same name; one evening the author narrated scenes while soprano Liesl Odenweller with her Venice Music Project performed opera selections from the period.[70] Leveraging the connections of Matthew White and his husband, the theater producer Thomas Schumacher, this gala included a concert by Broadway stars Ashley Brown and Josh Strickland performing American songs at the Palazzo Pisani Moretta. A second innovation at the 2017 gala was the introduction of "Scholar Chairs," a committee of experts in art history who made presentations and led tours; this emphasized the intellectual and cultural components.[71] Approximately 125 guests attended, 40 percent of whom had never attended a Venice gala and 25 percent of whom were entirely new—thus demonstrating that the organization was succeeding in identifying and welcoming new members.[72] Adelina Wong Ettelson served as the co-chair of the events committee for much of this period and thus shaped many of these events in New York and Venice.

Aiming to blend restoration projects, educational initiatives, and fundraising, SV took a leading role in the 2018–19 quincentennial of the birth of Jacopo Tintoretto. SV created a slate of activities, curated its own exhibition, and coordinated with a number of Venetian institutions. Unlike his rivals Titian and Veronese, Tintoretto was born in Venice and passed nearly all his career there, covering the walls of his hometown with paintings. Tintoretto's works had already been the subject of many previous restorations by SV, most notably the massive *Paradise* in the Palazzo Ducale in 1986. Given Ilchman's specialization in this painter, it was little surprise that "Tintoretto 500" became a mantra of Ilchman's time as chair, with nearly twenty works conserved by SV and three simultaneous exhibitions about the artist and his world.[73] As part of the Tintoretto festivities, Ilchman directed a three-day SV event in Venice that was less elaborate than a traditional gala (there was no black-tie event) but that included multiple activities. "Tintoretto 500: A Celebration of Renaissance Art and Human Creativity" took place in October 2018 and quickly sold out with 120 guests. During the day guests enjoyed private tours of the exhibitions about Tintoretto's youth at the Accademia, Tintoretto's mature career at the Palazzo Ducale, and the intersection of faith and medicine in Renaissance Venice (Scuola Grande di San Marco), while in the evening they dined inside the Palazzo Contarini Polignac and the ballroom of the Museo Correr.[74] The culminating visit and dinner occurred in the Scuola Grande di San Rocco, which Ilchman quipped was "Tintoretto World Headquarters" as it retains dozens of the artist's paintings. To coincide with this quincentennial, SV published a guidebook about Tintoretto, organized a follow-up excursion to the Veneto, and later coordinated a trip to Washington, DC, for the American venue of the Palazzo Ducale exhibition,

the painter's first major retrospective in North America. The activities clustered under the aegis of Tintoretto 500 thus represented a successful experiment to take the initiative to a greater degree than before. Rather than merely accept external grant proposals for conservation, or base a gala's activities on exhibitions already planned, in this case SV itself drove the schedule so that all these Tintoretto events would overlap with its three-day event. The self-confidence and strong branding of Save Venice was evident during this weekend, which featured a content-heavy program centered on one artist, even as events were scattered over two continents, two years, and multiple venues.

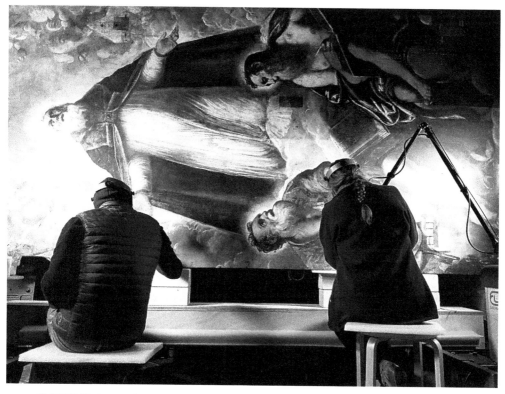

FIGURE 30. Jacopo Tintoretto, *Saint Martial in Glory with Saints Peter and Paul*, 1549, oil on canvas, Church of San Marziale, during conservation. One of nineteen paintings by the artist restored for the Tintoretto 500 celebration in 2018–19, this picture provided another art historical reevaluation. Previously considered a middling effort by the painter, removal of previous restorations and a toned varnish disclosed a powerful composition, brilliantly lit with heavenly illumination. The small brown rectangle in the middle of the painting shows an uncleaned section within a larger section that has been partially treated.
—Photo by Matteo De Fina, courtesy Save Venice Photo Archives

Given that the 2017 gala and the 2018 Tintoretto events occurred in such proximity, the board and staff wisely decided to postpone its next major event in Venice to 2020. A Carnevale gala was held in February 2020 with an opening reception to celebrate Valentine's Day at the "Glass Cathedral" (ex-church of Santa Chiara) on Murano, followed the next night by a costume ball at the Palazzo Pisani Moretta and finally a performance by Ashley Brown at the Conservatorio di Musica Benedetto Marcello.[75] Additional performances were arranged as well as an exhibition at Ca' Rezzonico, *Disegnare dal vero: Tiepolo, Longhi, Guardi*, consisting entirely of drawings restored by SV. According to an article in the fashion magazine *W*, "guests kept using the word 'family' to describe [Save Venice]."[76] The 2020 gala was the first to be held after the terrible floods of November 2019, which reduced tourism in Venice by at least 30 percent; thus, the devotion of SV's "family" was critically important to sustaining both local businesses and SV itself. The 2020 gala concluded just days before Italy declared the coronavirus epidemic, which of course reduced tourism to a much greater degree and for a much longer period.

To some degree, all these Venice galas were rehearsals for a far grander event: the fiftieth anniversary of SV, a landmark in the life of any nonprofit. Planning began early with selection of an actual date, 1 October 2021, commemorating the day that Sydney Freedberg filed the name "Save Venice Inc." with the office of the secretary of state in Massachusetts in 1971. Juan Prieto agreed to chair this semicentennial committee, with a cascade of events, excursions, and restorations in the United States and Venice in 2021 and 2022. The timetable and format of those events has repeatedly shifted owing to the unpredictable nature of the coronavirus pandemic, and events in October 2021 were dramatically scaled back or postponed. One resounding success has been "50 x 50," a series of fifty dinners across North America and around the world to celebrate SV's fifty years, hosted by board members or major donors. This decentralized approach permitted local adjustments and allowed people far beyond New York, Venice, or Boston to commemorate the organization's birthday.[77]

Beyond Venice

From 2015 to 2020 Save Venice organized eight excursions for members, following a familiar recipe but also adapting to new realities. Often linked to a major art exhibition related to Venice, these trips ranged from Cuba and Japan to Denver and Washington, DC. As noted in the previous chapter, such trips were generally modest in size (thirty or fewer guests) and of shorter duration than previous excursions

run by the Guthries. Whereas the Guthrie-organized trips had catered to a distinct audience of their friends and board members, eligibility for the more recent excursions required SV membership. Furthermore, these were planned and executed in close conjunction with the New York and Venice offices. Although smaller excursions might raise less money for the organization, they still accomplished the goals of engendering loyalty and reinforcing SV's message.

The initial excursion of this period was populated by a small group that followed Frederick Ilchman to Japan in September 2015 for the opening of the exhibition *Venice: Five Centuries of the World's Most Alluring City from the MFA Boston*. Hosted at the MFA's sister institution in Nagoya and curated by Ilchman himself, this show illustrated five hundred years of paintings, prints, textiles, glass, and photos made in Venice. The group later enjoyed the contemporary architecture of Tadao Ando and dined at a Venetian-style *osteria* in Ginza. The second trip was an outlier in that it was neither linked to a major exhibition about Venice nor organized by Ilchman. Instead, Juan Prieto took a group of sixteen intrepid adventurers to his home country of Cuba in early December 2015. Lectures on the architecture and history of Havana were complemented by a visit to the necropolis of Christopher Columbus and a tour of Finca Vigia, Ernest Hemingway's residence. The group met with the U.S. ambassador to Cuba and visited the Museo de Bellas Artes and the Museum of Decorative Arts.[78] A third trip in May 2016 played to SV's strengths: "Veronese and Vino in the Veneto" not only had an alliterative ring but focused on a Renaissance artist (Paolo Veronese) in some of the Veneto's most notable locations, including spectacular mainland villas in Verona, Vicenza, and Maser. A team of international scholars (Matteo Casini, Bernard Aikema, Paola Marini, and Allison Sherman) gave lectures to the two dozen guests who were shepherded around by Ilchman, Conn, and Contarini.[79]

Befitting new pockets of support outside the East Coast, in October 2016 Tina Walls crafted a three-day visit to her hometown of Denver to take advantage of the exhibition *Glory of Venice: Masterworks of the Renaissance* at the Denver Art Museum with curator Angelica Daneo. That exhibit was paired with visits to the Clyfford Still Museum and the Ponzio family collection of contemporary art.[80] One year later three dozen SV members traveled to Fort Worth and Dallas to view *Casanova: The Seduction of Europe* at Fort Worth's Kimbell Museum with conservator Claire Barry and curators C. D. Dickerson III and Ilchman. Trip participants also viewed the private art collections of Anne Bass and Richard Barrett, the Modern Art Museum in Fort Worth, and the Meadows Museum in Dallas.[81]

As previously noted, 2018–19 was the anniversary of Tintoretto, with the Tintoretto 500 celebration in Venice in October 2018. Immediately following the celebration, Ilchman and Xavier Salomon led a three-day excursion to the mainland featuring a guided visit to "La Malcontenta" (formally known as Villa Foscari), a Palladian villa in Mira.[82] This trip included lunch at Castello di Roncade and a tour by candlelight of the museum in Possagno honoring the Italian sculptor Antonio Canova (1757–1822). Exceeding all expectations, this excursion raised more than $100,000; this and the Venice Tintoretto celebration combined grossed more than half a million dollars. In keeping with the theme of Tintoretto, SV arranged a May 2019 excursion entitled "Tintoretto on the Potomac" when the exhibition *Tintoretto: Artist of Renaissance Venice* traveled from the Palazzo Ducale to the National Gallery of Art in Washington, DC. The exhibition, curated by Ilchman and Robert Echols, was paired with a sumptuous dinner at the residence of the Italian ambassador and then a private tour (again arranged by Tina Walls) at the National Museum of African American History and Culture on the Washington Mall. The pandemic of 2020–21 postponed other trips, such as that to Madrid from October 2020 to October 2022, but those described above make clear that the tradition of Save Venice excursions remained strong.

The Boston and California Chapters

Although SV experienced considerable success with its excursions and focus cities in Texas and Colorado, the chapters in Boston and Los Angeles were much less active than in prior years. Indeed, the Los Angeles chapter effectively ceased to exist after 2015. A number of its prominent members contributed to SV on an individual level but there was an insufficient cohort to sustain events.[83] In Boston, the chapter carried out a consistent schedule of black-tie dinner-dances, lectures, and other events from 2015 to 2018, sufficient to sponsor several conservation projects per year, before a decline in 2019–21. Art gallery owner Richard Baiano, who had co-organized with Gina Morda two gala evenings at the Boston Public Library in 2013 and 2014, was elected chair of the chapter in October 2015.[84] Juan Prieto masterminded three additional elegant and well-attended costumed balls in the Back Bay, featuring designs and decor around a special theme each year. Although he had assumed additional responsibilities as SV chair in January 2016, Ilchman continued to serve on Boston's executive committee and to be an important figure there.[85]

The annual general meeting continued to kick off the Boston calendar each

year. Each AGM included a short lecture by a local scholar, generally about Vene-
tian art.[86] The spring lecture series offered longer explorations on Venetian his-
tory, music, and art. For example, speakers such as Eric Dursteler, James Johnson,
and Caroline Bruzelius analyzed distinctive aspects of the Serenissima's past, from
Mediterranean foodways and Casanova's biography to the reconstruction of Vene-
tian buildings and space using 3-D modeling. Scott Jarrett brought colleagues from
the Handel and Haydn Society to perform masterworks by Monteverdi, MFA
curator Erica Hirshler discussed John Singer Sargent's relationship with Venice,
and Lorenzo Buonanno introduced the sculpture of Tullio Lombardo. Contem-
porary art and Venice was a popular topic too: photographer Abelardo Morell and
painter Jorge Pombo explained how they interpret Venice today, while Paul Ha
offered observations about his involvement with the Biennale. Other events—not
always directly connected to Venice nor to art conservation—rounded out the
schedule, as in October 2015 when Juan Prieto invited designer Hutton Wilkinson
and director Manfred Flynn Kuhnert from Los Angeles for a book signing for
The Walk to Elsie's, their recounting of the story of iconoclastic decorators Elsie de
Wolfe and Tony Duquette between 1932 and 1951.[87] The Boston YF, led by Gina
Morda, hosted a reception at jewelry store Lux Bond & Green featuring Roberto
Coin in November 2015, followed by a raucous costume party in April 2016 on the
theme of the "Royal Tenenbaums" at Boston's Tennis and Racquet Club.[88]

Three black-tie galas of 2016–18, planned by Juan Prieto together with Tracey
Roberts, Lee Essex Doyle, and Elizabeth Georgantas, emphasized glamor and rep-
resented a peak of activity. In 2016 the theme was "Gioelli dell'Oriente" (Jewels of
the Orient), for which guests entered the stately Algonquin Club to find a pillow-
strewn hookah lounge and red silk tablecloths along with Moroccan cuisine. The
2017 masked ball "An Enchanted Evening: Snow Falls on Venice" took over the
Harvard Club's spectacular double-height Harvard Hall, utilizing a silver-and-
white color scheme to recreate the magic of winter in the lagoon. That event was
preceded by a trunk show in which select jewelers contributed pieces at wholesale
prices with 10 percent of the proceeds to benefit SV.[89] In November 2018 "Sposal-
izio del Mare" (Wedding to the Sea) commemorated the famous ceremony wherein
the Doge threw a gold wedding ring into the Adriatic to celebrate Venice's rela-
tionship with the sea.[90] Each gala raised funds for a specific conservation project:
Tintoretto's San Marziale altarpiece; a fresco in San Sebastiano; the seventeenth-
century ceiling from Palazzo Nani, now in Ca' Rezzonico; and a Tintoretto ceil-
ing canvas, *Saint Jerome Presenting Doge Priuli to Peace and Justice* in the Palazzo

Ducale. Significantly smaller than its counterpart in New York, the Boston gala traditionally attracted about 140 guests and netted around $50,000 per evening.

Immediately following the autumn 2018 gala, however, Juan Prieto stepped down from the Boston chapter. The Boston executive committee met less frequently, and fundraising declined. No gala was held in 2019 or 2020. The lecture series, the AGM, and occasional membership events continued, but all were intended to educate rather than raise funds. The Italian consul general in Boston hosted a cocktail party in January 2020 as part of the #AmericaLovesVenice campaign following the 2019 floods, injecting some energy as well as generating good press. However, the coronavirus pandemic in 2020 forced postponements and cancellations throughout the spring and into the fall for the Boston chapter, as it did for so many other organizations, sowing doubts about how the chapter might bounce back to its historic strength. The decline of the Boston and California chapters illustrates a pitfall of all-volunteer groups. Without a paid staff or an unusually dedicated volunteer leader to keep the organization on schedule, activity can quickly come to a halt.

Conservation and Discoveries: Veronese, Tintoretto, Titian, Carpaccio, and More

As Matthew White noted in a letter on the eve of 2015, while it was not unusual for SV to restore works by the great Venetian masters, it was rare to have important projects by Veronese, Tintoretto, Titian, and Carpaccio occurring all at once.[91] This ambitious approach was continued in the philosophy of incoming chair Frederick Ilchman, who opined that modest projects inspire modest donations, while great projects impel great donations.[92] White's willingness to take on the Sala dell'Albergo restoration together with that of San Sebastiano motivated Ilchman to press for multiple high-profile projects and to push the board to find ways to finance them. Donating his expertise, energy, and charisma, Projects Director Christopher Apostle worked closely with board and staff members to identify suitable projects and target potential donors to see treatments through to completion.

The discoveries and contributions to scholarship made through these various restoration projects were often as important as the improvements in appearance or physical protection for the objects themselves. To put it another way, restoring the original beauty of a single painting or sculpture was (and is) doubtless important for aesthetic and historical purposes, but the increased knowledge about an artist's methodology or a new technique adopted by conservators offer significant

dividends. Such discoveries had been occurring since the initial conservation projects of 1968 and had become more evident in recent years. For example, attention paid to the presbytery cupola in San Sebastiano revealed the presence of two lunettes composed of two canvases each, depicting the Evangelists Matthew, Mark, Luke, and John. Long obscured owing to the difficulty of viewing them, it appears that at least one pair can be assigned with confidence for the first time to Veronese and his workshop and dated to the early 1560s. Two facing paintings of Saint Matthew and Saint John appear to be skillful works from the mid-seventeenth century whose attributions are still being debated.[93] At the same time, other frescoes by Veronese were discovered, hidden behind the San Sebastiano organ loft for five hundred years—when the instrument was removed, it was suddenly possible to see Veronese's original colors and brushwork untouched by any conservation work.[94] In the case of Tintoretto, the conservation of his *Wedding Feast at Cana* in the sacristy of Santa Maria della Salute revealed that it was not a traditional oil painting as had long been thought but actually an antiquated tempera technique for which the artist bound his color pigments in egg yolk, not oil.[95] For Carpaccio, the cleaning of the *Saint Ursula* cycle prompted new research into the lives of Venetian brides, as Patricia Fortini Brown and Sarah Blake McHam discussed at the 2018 annual meeting of the Renaissance Society of America in New Orleans, followed by additional discoveries and hypotheses from Matteo Casini, Gabriele Matino, and Valentina Piovan presented at the 2021 annual meeting.[96]

While restoration prompts fresh attention to well-known monuments, sometimes treatments bring to light works of art hiding in plain sight. For example, the tomb of Alvise della Torre, an exceptionally modest wooden coffin mounted in front of a mysterious painting, hangs high on the right nave of the church of the Frari. Examination and treatment focused attention on the backstory of the nobleman's death and prompted new consideration about the identity of the painter.[97] Patricia Fortini Brown has attributed the painting to Andrea Schiavone (1510?–1563), a Croatian who moved to Venice and worked for many private clients and whose style is often compared to that of Titian and Tintoretto. Even more interesting is the saga of vendetta and violence between the Della Torre and Savorgnan families that included multiple murders on the Grand Canal and a sentence of lifelong exile issued by the Council of Ten. Much of this history is displayed in narrative scenes painted in grisaille, along with the Della Torre coats of arms and a skull dripping blood onto the casket. None of this story would have been known if not for the cleaning and attendant research; the conservation and restoration go

beyond enhancing the object itself to immerse us in daily life, feudal traditions, and republican values in Renaissance Venice. These discoveries stand as part of the legacy of Save Venice, along with the refurbished buildings and rooms that house the artwork.

Turning from the significant discoveries to the actual restoration techniques and activities, the church of San Sebastiano was *primus inter pares* for the period 2015–21 and exemplified SV's preference to take on a whole building rather than share elements (and credit) with other private committees. Having completed the ceiling, the frescoes in the monks' loft, and the mural paintings, conservators turned to the remaining elements. Cleaning of the polychrome marble high altar, which included Veronese's altar painting of *Virgin and Child with Saint Sebastian and Saints*, as well as adjoining frescoes of hermit saints on either side of the altar, was completed by the Egidio Arlango firm in 2015–17 under the sponsorship of Richard and Nancy Riess. Flanking the altar were two huge lateral canvases depicting *Saint Sebastian Leading Marcus and Marcellinus to Martyrdom* on the left and the *Martyrdom of Saint Sebastian* on the right, both restored in 2017 thanks to the Riess family. The church's main facade, designed by Antonio Scarpagnino and carried out by 1548, was also cleaned in 2017 with a gift from the Santo Domingo family.[98] In this latter project the conservators removed the cement plaster that had been applied during a 1960s restoration and substituted a white marmorino plaster made from ground marble dust, similar to what Scarpagnino had used in the sixteenth century.[99] Sensitivity to using original materials and only making changes that are later reversible are hallmarks of current historic preservation. The loft above the main door to the church contained a long row of wooden stalls where the Hieronymite monks could observe church services in privacy. Each stall was decorated with delicate geometric patterns and vegetal designs, but these had been almost totally obscured by thick layers of dark brown shellac varnish and surface grime. Removal of those contaminants in the spring of 2020 complemented the whimsical fresco paintings, such as the trompe l'oeil of two monks on a staircase, that were only intended to ever be seen by the monks themselves. For the six side chapels in the nave, conservators removed centuries of grime from the gilt stuccowork and desalinized the marble. The chapels on either side of the high altar were treated in 2022, which should be the last major project in San Sebastiano.

The previous chapter briefly described initial conservation work on Vittore Carpaccio's cycle of the legend of Saint Ursula, in which a French fourth-century Christian princess betrothed to a pagan prince traveled to Rome and then to Germany,

where the couple and their numerous travel companions, including Pope Cyriacus, were martyred by the Huns. This series of nine large canvases, completed between 1488 and 1495 for the Scuola di Sant'Orsola near the church of Santi Giovanni e Paolo, depicted the pagan assassins as Ottoman Turks and adapted locations in Venice to create fictional settings. Scientific investigation on the Carpaccio cycle from 2015 to 2019 included the use of infrared reflectography to better understand the underdrawings and more precisely date individual works.[100] With the exception of a second painting (*Apotheosis of Saint Ursula*) also sent to Rome's Istituto Superiore per la Conservazione ed il Restauro, all of the paintings were restored onsite in the Accademia.[101] Removing discolored varnish and old repainting, combined with hundreds of hours of careful retouching, revealed Carpaccio's expertise at conveying light and shadow. The entire project cost just over $1 million and was completed by June 2019.

Two additional Carpaccio projects began in 2019. The first was restoration of the artist's imposing *Miracle of the True Cross on the Rialto Bridge*, which depicts a crowded scene on the Grand Canal in the 1490s with the wooden Rialto bridge in the background. Like the Saint Ursula cycle, this work was created for a Scuola (San Giovanni Evangelista) and resides today in the Accademia. Like much of Carpaccio's work, it employs what Patricia Fortini Brown calls the "eyewitness style," full of myriad details to convince the viewers that the miracles depicted actually happened. The final Carpaccio project, still underway, is another nine-canvas cycle for the Scuola di San Giorgio degli Schiavoni (aka Scuola Dalmata), a confraternity that catered to the community of immigrants who moved to Venice from the other side of the Adriatic in the early modern period. This cycle (1502–7) comprises two paintings from the life of Christ, three relating to the life of Saint Jerome, three depicting Saint George, and one from the life of the lesser-known Saint Tryphon.[102] The paintings remain on the walls today; conservation of them, and eventual inclusion of some in an exhibition at the National Gallery of Art in Washington, DC, and then the Palazzo Ducale, is expected in 2022 and 2023.

While the Scuola di San Giorgio is cherished for its secluded location and sense of discovery, two iconic works by Titian in the church of the Frari are among the most prominent in Venice today. Both were conserved recently, offering examples of high- and low-tech solutions to the challenges facing works of art in Venice. The first is the *Madonna di Ca' Pesaro*, a towering altarpiece on canvas painted between 1519 and 1526 for the left nave, where it remains today. The composition brilliantly combines the traditions of the vertical altarpiece in the *sacra conversazione* (sacred

dialogue of saints), the horizontal votive picture, and the group portrait, along with an unusually subtle understanding of the intended location and viewpoints of worshippers.[103] Like the Carpaccio series, Titian's Pesaro altarpiece alludes to Venetian conflict with the Ottoman Turks, and like other Renaissance altarpieces it freely mixes Christian figures from different periods with contemporary individuals.[104] The conservation of the Pesaro altarpiece required restorer Giulio Bono and his team to inject precise amounts of sturgeon glue, a byproduct of the caviar industry, into the hairline cracks in the pictorial surface so that unstable paint layers would re-adhere to the canvas below.[105] To ensure the stability of the painting's surface, and to counter fluctuations in temperature and humidity, a sophisticated tension system was added to the canvas's stretcher. The painting was also given its own "sweater," a barrier layer of organic wool attached to its back to shield the painting from moisture in the brick wall behind the altar. Even as the scientific investigations become ever more sophisticated, including pigment analysis and successive generations of infrared cameras to observe images beneath the surface of a painting, solutions often employ natural materials. The Pesaro altarpiece had previously been restored by Save Venice in 1978, yet thick varnishes and glues, as well as discolored retouching from previous nineteenth-century efforts, made this project more complex than anticipated. It was completed and the painting successfully reinstalled in the summer of 2017.[106]

A second and even more conspicuous painting in the church is Titian's *Assumption of the Virgin* or "Assunta" (1518), which the artist completed immediately before beginning work on the Pesaro altarpiece, and its attendant Istrian stone frame and marble surround. Titian's depiction of the Madonna taken up to a benevolent God the Father, rising above stupefied apostles, offered a revolutionary and heroic interpretation of a traditional subject. At more than six meters high, it is the tallest painting on wood panel in the world. It towers above the presbytery and was deliberately intended to be visible well down the nave, through the existing arch of the choir screen. Conservation has addressed far more than discolored varnish and old retouching on the paint surface. An initial task was to solve reverberations from the nearby modern organ, whose pipes had been hidden behind and attached to Titian's altarpiece. Alarmingly, notes emanating from the pipes caused the wooden panels to vibrate and potentially separate, endangering the painting. The SV board insisted that removing the organ pipes was a prerequisite to the overall restoration. Conservator Giulio Bono then used digitized radiography and infrared reflectography imaging to identify and restore overly ardent cleaning and repainting of prior decades.

The Projects Committee has often prioritized treating a famous painting or sculpture as well as its surrounding frame, altar, or niche, considering an ensemble as an aesthetic whole. This was the case with the *Assunta*'s enormous stone frame, surmounted by three statues and created by sculptors Giovanni Battista Bregno and Lorenzo Bregno contemporaneously with the painting. Cleaning of the frame in 2019 revealed yet another historical discovery: the artists' intention to make its low-relief decoration, and the three life-size statues that surmount it, bright white with painted and gilded accents, not a dull gray as was assumed for generations given the coating of dust and candle smoke. The choice of stones established a hierarchy of materials: Christ, the most important figure at center, was carved in marble; Saints Francis and Anthony, who flank him, by contrast, were in cheaper Istrian stone.[107] Determining the media of the statues had been impossible from the floor of the chapel, misleading generations of scholars; the scaffolding and hoists employed by SV permitted these art historical observations and the resulting conclusions. Furthermore, conservator Alessandra Costa used laser technology on the gilded inner frame to remove wax and grime, revealing the original azurite and indigo chosen by the artist.

Nineteen works by Tintoretto were restored in preparation for the Tintoretto 500 celebration, including the *Wedding Feast at Cana* in the sacristy of the church of Santa Maria della Salute and *Saint Martial in Glory* in the church of San Marziale. A 1580 painting of *Saint Justine with the Camerlenghi Treasurers and Secretaries* in the Museo Correr illustrates the Venetian nobility as officeholders. Given the abundance of paintings by Tintoretto in Venice, it is not surprising that several masterpieces by the artist had been largely overlooked. For example, the Ateneo Veneto's *Apparition of the Virgin to Saint Jerome*, despite having been engraved by Agostino Carracci in 1580, was not thought to be a top-tier picture. Following cleaning, however, scholars determined that the powerful figures of Mary and Jerome were by Tintoretto himself, while the beautiful mountainous landscape was probably executed by a studio assistant from northern Europe. Now considered a major work, this painting and the *Saint Martial* both played starring roles in the Palazzo Ducale and National Gallery of Art exhibitions of Tintoretto, reaching new audiences. Without the conservation work funded by SV, the quality of the two paintings would not have been apparent, nor would the pictures have been allowed to travel. SV's Tintoretto campaign embraced the Accademia's grand *Crucifixion*, Tintoretto's tomb in the church of Madonna dell'Orto, and numerous works *in situ* in the Palazzo Ducale.[108] Together with related publications and exhibition sponsorship and fellowships, SV expended well over $1 million on Tintoretto 500.[109]

One important result was the series of partnerships that SV forged with the Musei Civici di Venezia, the Scuola Grande di San Rocco, the Scuola Grande di San Marco, and the Morgan Library and Museum of New York. The investment certainly resulted in much greater attention to the artist and a wider awareness of SV. In Venice more than 100,000 people attended the exhibitions at the Accademia and the Palazzo Ducale, with an additional 195,000 visitors viewing the Tintoretto exhibition in Washington, DC.[110]

Encouraged by the progress at San Sebastiano, as well as completion of treatments of major paintings by Titian, Carpaccio, and all the restorations and activities around Tintoretto 500, the board of Save Venice adopted two major projects in June 2019. These included (1) the late medieval mosaics in the central and adjacent apse of the basilica of Santa Maria Assunta on the island of Torcello, plus the structural brickwork behind the mosaics, and (2) the 1575 Scuola Italiana, a synagogue in the Venetian Ghetto. Both were linked to earlier SV projects: in 1978 SV had agreed to give $50,000 to the International Torcello Committee to stabilize the foundation walls and reattach the mosaics, and in the same year donated $15,000 to the Scuola Levantina in the Ghetto to top up an earlier donation of $128,000.[111] Thus, neither project was new to SV but the scope of the restoration and the concomitant expenses were significantly greater, with each project totaling around $1 million.

The basilica of Santa Maria Assunta is one of the best surviving examples of monumental Byzantine art, but its remote location means that it is ignored by most visitors to Venice and even by many locals. Nevertheless, its 223 square meters of Byzantine mosaics presents a direct link to the earlier history of Venice. Moreover, the mosaics and the walls behind were in urgent need of conservation. The project focused on the *Madonna Hodegetria* and *Twelve Apostles* mosaic in the presbytery, the *Christ Pantocrator* mosaic in the diaconicon apse, and the reconstruction of the adjacent walls.[112] Completely unexpected was the discovery of ninth-century fresco fragments hidden under the roofline and in the crypt, dating from an extensive Carolingian decorative cycle that preceded the famous mosaics. Conservation had just begun in fall 2019 when half a meter of floodwater from the November *acqua alta*, followed by the coronavirus, caused months of delay. The work was completed in the fall of 2021.

The Scuola Italiana is one of five surviving synagogues in Venice. Despite its proximity to the Jewish Museum (Museo Ebraico), it has not been part of the museum's visitor route and has been open only by special appointments or for services.[113] In 2015 Venetian Heritage announced a major campaign to restore the

museum and three nearby synagogues, but those efforts came to naught.[114] Early in 2019 Save Venice received a $1.1 million donation from the Jerome Levy Foundation to restore the museum's ground floor and expand the second floor for additional exhibition space.[115] Even with the grant from the Levy Foundation and some cost savings on other projects, endorsing both projects simultaneously represented a potentially risky financial commitment of about $2 million. After extensive discussion, the board voted to pursue both restorations for the 2021 anniversary.[116] It recognized then and in subsequent meetings that adoption of other projects would need to be curtailed until these had been funded.

These six substantial restorations dominated SV's calendar for the period from 2015 into 2021. Dozens of other smaller restoration projects were completed too and were described in the annual newsletters and on the website. In its five decades SV had never adopted so many major projects in such a short amount of time.

FIGURE 31. Scuola Italiana, Jewish Ghetto, constructed in 1575, here prior to the 2021 conservation. One of five synagogues in the Venetian ghetto, this one features a small baroque dome and five large arched windows; conservation of this space will allow it to become part of a visitor route for the Jewish Museum. Along with Torcello, this restoration will also celebrate the fiftieth anniversary of Save Venice.
—Photo by Matteo De Fina, courtesy Save Venice Photo Archives

The pair of anniversary projects at Torcello and in the Ghetto appeared to signal a new approach; rather than pay for a multiyear conservation in distinct phases (as at the Miracoli or at San Sebastiano), the board voted to commit to the entire cost at once. Such a decision reflected the directors' confidence, even as it risked violating the three-year reserve rule that had previously guided SV's project spending. The organization's ambitious art conservation goals rested more than ever on the continued success of Venice galas and the New York Ballo in Maschera, as well as on sponsorships of individual restorations by donors and foundations, unrestricted funds from the membership program, and annual contributions.

Acqua Alta, Coronavirus, and the Immediate Response Fund

Many conservation projects were unexpectedly put at risk by catastrophes in 2019 and 2020. The first was the *acqua alta* of mid-November 2019. During the terrible week of 12–17 November, the waters rose nearly to the level of the historic 1966 floods and with equally severe consequences. As Melissa Conn noted one week after the flood, the situation was dire:

> Nearly a week has passed since the first devastating flood of the night of November 12/13 with waters at 6 feet above sea level, a mere three inches less than the historic flood of November 1966 which was the catalyst for the founding of Save Venice. The water has continued to rise the entire week, with exceptional tides last Friday and again yesterday, making the 2019 floods in many ways more detrimental than those 53 years ago. The situation is particularly dramatic on Torcello, where the church of Santa Maria Assunta flooded several times, and two feet of water remains in the former Baptistry area in front of the church and in our worksite behind the apse. Thankfully our team of workmen was already on the premises for our 50th anniversary apse project, and remained on site day and night for emergency interventions.
>
> The Scuola di San Giorgio degli Schiavoni had nearly two feet of water in the interior, and there is visible damage to the marble altar and the benches, but the Carpaccio paintings are safe. San Sebastiano's nave had 8 inches of water, and about 15 inches in the sacristy. The list could go on and on. Once the waters recede, the next threat comes from the salt deposits left behind from the evaporated sea water . . . eating into bricks, mortar, and

stone and creating lasting structural damage. The foundations of the buildings are now all at risk, as tidal waters have undermined their stability.[117]

The potential impact on Venice's artistic patrimony was immense, and as Conn implied, it could be months or even years before the full consequences would be apparent. But as she noted in the same letter, the aftermath for residents of Venice was immediate and severe: "Words cannot express what the Venetian community is facing. Not only the artistic patrimony has been damaged, but shopkeepers have lost their wares, cafe and restaurant equipment has been destroyed, and the local economy is at risk. Not to mention the ground floor residences. It is heartbreaking to see piles of mattresses, space heaters, personal belongings, books, and once-treasured possessions piling up on the 'high ground' of bridges so that they do not float away in the next high tide before the sanitation workers can carry them away."[118]

It is too soon to know whether the 2019 floods were an aberration and another fifty years will pass before the next historic flood, or if they are a harbinger of more frequent devastation. In this case, Save Venice took action straightaway with the creation on 20 November of an Immediate Response Fund for artistic and cultural heritage recovery.[119] The Italian ambassador to the United States, Armando Varricchio, contacted SV to establish a partnership. He activated the network of Italian consulates and cultural institutes across the United States to launch the campaign #AmericaLovesVenice, with all donations directed to SV. The board appropriated $100,000 of SV's own funds to populate the fund. Donations poured in, exceeding $600,000 within two months, many from donors new to SV. Most of the funds were quickly distributed in Venice for cleaning equipment and emergency interventions in public buildings.[120] Venetian officials suspended certain procedural requirements in order that floors could be washed with freshwater to remove salt deposits and vulnerable materials moved to higher levels and carefully dried without delay. A dinner at the ambassador's residence in Washington in December 2019 raised more than $40,000 and was complemented by a cocktail party in Boston in late January 2020, sponsored by Boston consul general Federica Sereni, which raised an additional $15,000.[121] Acknowledging the wisdom in being able to make quickly many small-level grants, the board has allowed the Immediate Response Fund to remain active and be ready to counter the next unexpected catastrophe.[122] The board and staff also recognized that numerous potential donors to SV may not be interested in art per se but merely wish to do something to help Venice. The fund sparked more than six hundred individual donations and boosted the organization's reputation and

recognition.[123] If there is a silver lining to the terrible floods of 2019, it would be the outpouring of international concern as well as the impetus provided to complete the Project MOSE sea gates, which were operated successfully for the first time in July 2020 and then raised again in October when the water rose above 110 centimeters during an actual flood.[124] After decades of debate and protest, it is reassuring to see that the floodgates work and that they should mitigate the frequency of flooding.

The COVID-19 outbreak struck Italy just three months later with a different but equally devastating impact. It was first detected in Rome on 31 January 2020 and quickly spread to the northern provinces of Lombardy and Veneto. By 22 February Padua had witnessed its first death and the Veneto had seventeen confirmed cases. (As noted previously, SV had hosted its 2020 Carnevale gala earlier in the month, and was fortunate to have concluded its events prior to widespread infections.) By 23 February the last two days of Carnevale were canceled, and the *New York Times* published an article entitled "The Ghost Town of Venice" in which the opening line read, "First came the flood, then came the disease."[125] On 9 March the Italian government instituted a nationwide quarantine, followed by the closure of all nonessential businesses, which lasted until early June. With 34,000 deaths as of that date, Italy suffered more from the coronavirus than any other country in Europe. Fall 2020 witnessed a worrisome rise in infection rates in Italy (as in most of Europe and in the United States) as cold weather limited opportunities to be outside and as the regular flu began to return. The Italian government declared in October 2020 that all restaurants must close at 6:00 p.m., a potential death knell for those businesses and for the hotels, shops, and others relying on the tourist trade. Despite the increasing availability of vaccines in 2021, however, such restrictions endured well into the spring and summer, diminishing the peak tourist season. By the autumn of 2021 Italy had adopted a Green Pass that was required for access to bars, restaurants, museums, concerts, sporting events, and public transportation. Italy continues to struggle with how to respond effectively to the coronavirus and its worrisome variants, particularly for the unvaccinated.

As with the floods of 2019, it is too soon to analyze the longer-term impact of the coronavirus on historic preservation specifically and the city of Venice more generally. Certainly, the epidemic decimated tourism, closed the university, and threatened human activity at all levels. An article in *La Nuova Venezia,* a local newspaper, on 1 April 2020 described the efforts of SV to restore the mosaic pavement in the church of Santi Maria e Donato on the island of Murano in light of the flooding, and how the necessity of social distancing required the temporary suspension of all work.[126]

Some conservation work was restarted in May 2020. An article published by CNN in mid-May included optimistic observations by Melissa Conn and other Venetian residents about how the coronavirus offered the opportunity to "reset" Venice's relations with tourism.[127] By September 2020 SV had recommenced nearly all of its conservation activities. A mayoral election that month returned the incumbent, Luigi Brugnaro, who has promised to restore tourism to its former level, but within months he had closed all of the city museums until April 2021 due (again) to the pandemic. In June 2021, after an absence of eighteen months, the first large cruise ships returned to the Venetian lagoon, but only temporarily as the Italian government announced that effective 1 August it would ban large vessels from Venetian waters.[128] The future of tourism in Venice remains uncertain.

Life within the lagoon has begun a halting return to normalcy, and by fall 2021 SV began to disburse funds to complete the many projects on its docket. Yet Venice already suffered from a declining population that skewed older as many of the young had previously moved to the mainland for jobs, affordable housing, green space, and the amenities of suburban life. The specter of a prolonged economic recession from the coronavirus, inflation, or conflicts abroad raises the question of whether Americans will continue to give money to support art in a foreign country when faced with their own needs at home. The coronavirus severely impacted U.S. domestic SV programming from spring 2020 to spring 2021, with all lectures, galas, and other events postponed or online only. Of course, SV has weathered recessions and national disasters before, and early indications are that it has survived this one-two punch as well. For example, in 2020 and 2021 it pivoted to virtual programming with numerous events offered via Zoom. SV retained a substantial amount of donations from the canceled New York ball in spring 2020, and it received gifts for the semicentennial, now to be celebrated as much in 2022 as in autumn 2021. Unlike so many other American charities and cultural organizations after two years of pandemic, Save Venice's financial picture was not perilous. No staff members were furloughed or laid off, and restoration work resumed relatively quickly. With plentiful donations, SV's financial picture in 2022 was in fact rosier than at any time in the preceding decades. Due to the confluence of two disasters, each described as a once-in-a-lifetime event, the fiftieth anniversary of Save Venice in 2021–22 occurred in a very different environment than the one the organization has enjoyed for most of its history. Yet its core strengths—a devoted base of supporters, highly competent board and staff, and unwavering dedication to its mission—has helped position it for success looking forward.

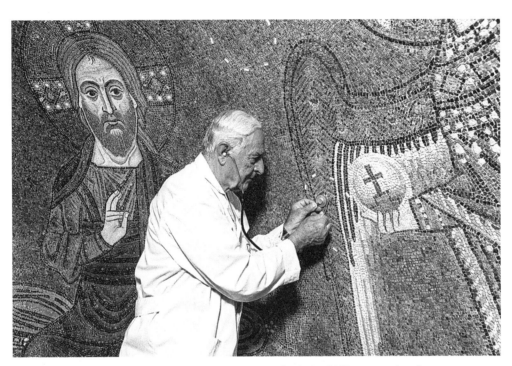

FIGURE 32. Mosaics, Santa Maria Assunta, Torcello, during 2020 conservation. Conservator Giovanni Cucco inspects the adhesion of mosaic tiles to the brick and mortar wall in the Diaconicon apse of the cathedral.

—Photo by Matteo De Fina, courtesy Save Venice Photo Archives

Chapter 9

ALLEATE

Private Committees and UNESCO (1966–2021)

I think I may say that the aim we had set ourselves has been fully achieved.…
Saving Venice has become a cause of world-wide importance.
— René Maheu, UNESCO director-general (1973)

THIS BOOK has focused on the activities of Save Venice and how it has grown to be the leading American organization of its kind in Venice, but SV was far from alone in its focus on cultural heritage and conservation. When UNESCO director-general René Maheu pleaded for help from the international community in the days after the 1966 flood, fifty-nine private committees stepped forward to assist the "Campaign for the Safeguarding of Venice."[1] Four of those early private committees were discussed briefly in the opening chapter: the Committee to Rescue Italian Art (CRIA), the Italian Art and Archives Rescue Fund (IAARF), the International Fund for Monuments (IFM), and Italia Nostra. Those groups provided funding for about four dozen Venetian projects between 1966 and 1969.[2] By 1970–71 other organizations had emerged including the Comité Français, Venice in Peril, and Save Venice Inc.[3] As of 2021, about two dozen private committees continue to engage in fundraising, education, and sponsorship of art conservation projects for Venice.[4] This chapter examines the individual and collective contributions of five private committees in Venice, as well as similar organizations inside and outside of Venice. The role of the Association of International Private Committees (APC) is briefly considered, as are the varied contributions of UNESCO. From cheerleader to paymaster, UNESCO was a visible presence in Venice from the late 1960s to the early 1990s with its Campaign for Venice, and then with the successor Joint Programme until 2015. It still maintains an office in Venice but has different priorities than in previous decades. These nonprofit and nongovernmental organizations represent important components of the efforts to preserve and restore the cultural patrimony of the Serenissima, and they testify to the international allure of Venice. Comparing the activities and structures of other

private committees with those of Save Venice allows us to more clearly identify and understand the development and growth of SV during the past five decades.

The Private Committees of Venice

These private committees were (and are) primarily national in character, representing interested citizens from twelve individual countries, seven of which are members of the European Union. Most countries have one committee, though Italy, Germany, and the United States have each had several. Each committee selects its own projects and operates independently, although collaborations have happened occasionally, such as those at Torcello (1977–85) and at the Ospedaletto (1987–91). In a 1993 report, UNESCO praised the private committees for having "consistently drawn attention to the need to deal with the restoration program in the wider context of the protection of Venice and its environment against natural and man-made dangers."[5] Many of the private committees also contributed to the painting conservation laboratory in the former church of San Gregorio, as well as to the stone conservation laboratory located in the Scuola della Misericordia.[6]

As noted previously, the private committees were primarily an informal network during the first two decades after the 1966 flood, but in 1993 they established a formal Association of International Private Committees for the Safeguarding of Venice.[7] For several decades the APC represented the interests of the private committees and coordinated with UNESCO and Italian government ministries (especially the superintendencies in Venice).[8] By 1993 UNESCO estimated that the private committees had contributed about $15 million total, which restored over eight hundred paintings and nearly one hundred monuments.[9] In 1997 UNESCO formally recognized the APC as a nongovernmental organization in operational relations with UNESCO.[10] By 2009 the APC claimed that its members had allocated in excess of 50 million euros ($70 million).[11] In June 2020 the APC noted that during 2019 its members had spent more than 8.1 million euros ($9.1 million) on restorations, research, and training, with more than 5.1 million euros ($5.8 million) already promised for 2020.[12] In short, the APC and its members have played a significant role in the conservation of Venetian art and architecture. In recent years some of the private committees have shifted their focus from art conservation to a broader scope of activities designed to support the city of Venice, and the APC itself has begun to advocate for wider actions to promote a more sustainable economy. Under the direction of chairwoman Paola Marini, the APC had drafted a new initiative

to reevaluate how best to safeguard historic town centers. The Venice Appeal will provide a rationale and framework to protect both tangible and intangible urban cultural heritage generally, and will recognize the fragility of the Venetian lagoon in particular. The APC seeks to maintain its traditional role as the steward of historic conservation in Venice while moving forward with other actions that will make the city more sustainable in the long term.[13]

For several decades SV has been the largest of the private committees in terms of total funds raised and in the number of project sponsorships. A 2011 analysis from Worcester Polytechnic Institute indicated that between 1966 and 2011, SV had completed more than three times as many projects as any other private committee.[14] That same analysis showed a sharp increase in the number of projects sponsored by the private committees in the 1990s, buoyed by the activities of SV under Lovett and the Guthries, before a sharp drop with the Great Recession of 2008–9.

In 2019 SV spent $1.9 million on restoration projects; by comparison, Venetian Heritage spent $1.2 million, and all of the other private committees were well below the million-dollar mark.[15] Equally important is the amount already committed for 2020 and beyond. While Venetian Heritage, Venice in Peril, and the Stichting Nederlands (Dutch Committee) each promised around $250,000, SV earmarked $4.93 million through 2022.[16] Thus it is clear that SV has been, and continues to be, consistently operating on a significantly larger scale than the other private committees in Venice.

Beyond the mere number of projects, how can we compare the history and activities of SV to its fellow organizations in Venice? What priorities have informed the

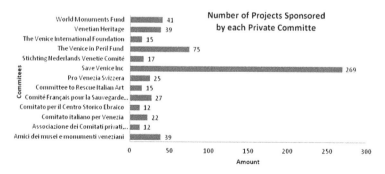

FIGURE 33. Bar graph for number of projects sponsored by each private committee, 1966–2011. Prepared by students at Worcester Polytechnic Institute, this graph demonstrates that Save Venice completed significantly more projects than its fellow committees in Venice up through 2010, a trend that has continued through 2022.

—Courtesy Fabio Carrera

private committees' work on cultural heritage? Do they favor specific artists, entire buildings, or neighborhoods? How have they responded (if at all) to depopulation, environmental risks, mass tourism, or other challenges not directly linked to art conservation? What does such a comparison reveal about the nature of nonprofit organizations engaged in historic preservation in Venice? What lessons can be applied for the future of SV and for the other members of the APC? Answers to these questions can be gleaned from analyzing the activities of the private committees, other nonprofits, and UNESCO, and by comparing their actions with those of Save Venice.

Venice in Peril Fund (Great Britain)

Venice in Peril was founded in 1971 by Sir Ashley Clarke, former British ambassador to Italy, and his wife, Lady Frances Clarke.[17] The Clarkes and the McAndrews were good friends, and their respective organizations developed on parallel paths and with remarkably similar goals. Each couple maintained an apartment in Venice; both were well-respected inside and outside of Venice for their efforts to preserve Venetian monuments; both enticed notable figures to join them and to help run their respective organizations. Historian, author, and broadcaster John Julius Norwich joined as the first chair of Venice in Peril and remained in that post for nearly three decades; he wrote and spoke extensively about Venice, a city that he visited more than two hundred times.[18]

Venice in Peril was particularly fond of stone conservation and of smaller, out-of-the-way churches and monuments that had often been overlooked, although it adopted several high-profile projects too. Early endeavors included restoration of the late gothic church Madonna dell'Orto in Cannaregio, Jacopo Sansovino's Loggetta next to the Campanile, and the Veneto-Byzantine church of San Nicolò dei Mendicoli.[19] The monumental entrance to the Palazzo Ducale, known as the Porta della Carta, was a significant project from 1976 to 1979, both because of its conspicuous location and because of subsequent disagreement about the effectiveness of a new technique to inject a silicon polymer into the marble sculptures that decorate the arch.[20] Other efforts in the 1980s included organ doors in the Gallerie dell'Accademia, an altarpiece in the church of San Pantalon, a polychrome wood crucifix in San Giorgio Maggiore, and a new roof for the church of San Trovaso. Under the leadership of Ashley Clarke, Venice in Peril partnered with Save Venice and a host of other committees to preserve the Byzantine mosaics in the basilica of Santa Maria Assunta on Torcello from 1977 to 1985, and again in 2002 to monitor

the success of the first operation.[21] Another joint venture in this period was the refurbishment of the Sala della Musica at the Ospedaletto (Santa Maria dei Dere-litti) in the later 1980s, done in concert with a dozen of the private committees.[22] Like SV, Venice in Peril was extremely active in the 1990s with more than a dozen substantial projects in various churches, palaces, and piazzas as well as two cemeteries. Also similar to SV was the range of tasks (e.g., statues, crucifixes, paintings, building repair, waterproofing).

One notable innovation by Venice in Peril in 1977 was its partnership with Peter Boizot, founder of Britain's Pizza Express chain. Boizot agreed to donate a percentage of the sale price of every "Pizza Veneziana" sold; that single agreement raised in excess of £2 million over the course of thirty years.[23] One result of this far-sighted corporate partnership was that Venice in Peril could spend less time seeking funds through auctions, galas, and similar events of the type with which SV was so involved. Venice in Peril always emphasized public talks as a core part of its educational function, with regular lectures in London, and like SV has for years published a regular newsletter, describing its conservation activities and publicizing forthcoming events.[24]

Anna Somers Cocks succeeded Norwich as chair in 1999.[25] Holding the post for more than a decade, she expanded the role of the fund to include research into environmental and socioeconomic risks facing the city. She advocated strongly in favor of a mobile sea barrier and against the presence of cruise ships. Some considered Somers Cocks to be an environmental visionary for vigorously addressing the issue of climate change at the start of the twenty-first century, while others thought of her as an interfering foreigner scolding Venice about how best to manage its infrastructure.[26] Her public activism on these and other controversial issues in Venice was clearly at odds with the more reserved stance of SV. Under her leadership, in 2001 Venice in Peril supported a three-year research project in conjunction with the University of Cambridge to study the impact of rising water levels in the Venice lagoon.[27] Subsequent publications included *The Science of Saving Venice* (2004), *Flooding and Environmental Challenges for Venice and Its Lagoon: State of Knowledge* (2005), and *The Venice Report* (2009).

In 2006 Venice in Peril introduced the Casa San Giobbe, a pilot project designed to show how to convert dilapidated housing stock into modern apartments while preserving original elements and using traditional techniques (e.g., saving the terrazzo floors and using lime mortar rather than modern concrete, or washing corrosive salts from the original brickwork rather than installing new industrial bricks).

Venice in Peril paid for detailed architectural plans and research while the city of Venice covered actual construction costs. The goals were to show that such a renovation could be done for less than the cost of new construction and to bring greater attention to the plight of those seeking low-cost housing within the city. A subsequent book offered details about this social experiment but the pilot project has not been replicated.[28] In 2012 Somers Cocks resigned from her role as chair due to her concerns that the Venice in Peril Fund had become highly "inefficient" and "politicized."[29] In previous chapters we have seen that with certain exceptions (e.g., Expo 2000), Save Venice has steered clear of the larger environmental and tourist-related issues Venice faces, preferring to focus on art conservation and employment of local restorers. Most members of the APC similarly avoided political issues from 1970 to 2015, but in recent years more of them have gone on the record about environmental concerns as sea rise and climate change have increased in risk.[30]

Jonathan Keates, an author and former teacher at the City of London Schools, became chair in 2013.[31] He has steered Venice in Peril back to historic conservation and striven for a greater variety of projects in order to reflect the wider perspective of Venetian civilizations. On an administrative level, Keates has sought to overhaul the infrastructure of the organization to make it more efficient and simultaneously to expand the organization's outreach to supporters across the United Kingdom. The work of sculptor Antonio Canova (1757–1822) has been a significant focus for the British group during the past decade, beginning in 2012 with the conservation of three small preparatory models (*bozzetti*) created by Canova out of wood, wax, and terracotta, as well as the cleaning and reconditioning in 2013 of a pair of plaster casts of two crouching lions created by Canova and donated to the Gallerie dell'Accademia as models for students. All were featured in the new Palladio Wing of the Accademia, opened in 2016; Venice in Peril further contributed to a 2017–18 exhibition at the Accademia featuring Canova and the "last glory of Venice" in a post-Napoleonic world.[32] Canova was a celebrated visitor to London in 1815 and worked almost exclusively for English patrons late in his life; Venice in Peril's selection of him provided an obvious link to its British members. The artist's own funeral monument in the church of the Frari is the most ambitious Canova-related project undertaken by Venice in Peril. This white marble pyramid stands in dramatic contrast to the red bricks of a gothic church; however, it is threatened by creeping damp from the floor as noted in a 2012 appeal: "This extraordinary ensemble has essentially become a massive sponge, soaking up the water beneath and around it."[33] Like SV, Venice in Peril has supported other types of projects as

well, including cleaning and rebinding fifteen volumes containing the papers of the seventeenth-century Venetian commander Francesco Morosini and restoration of eighteen pieces of Renaissance painted pottery (*maiolica*) at the Museo Correr.[34]

Comité Français pour la Sauvegarde de Venise (France)

The Comité Français pour la Sauvegarde de Venise (The French Committee for the Saving of Venice) has its origins in the Association France-Italie, established in 1967 by the former French ambassador to Italy Gaston Palewski, which was absorbed by the French Committee in 1969 and over which Palewski presided as president until his death in 1984. He was succeeded by Ambassador Gérard Gaussen from 1985 to 1999 and then historian Jérôme-François Zieseniss, who has been president since 1999. The French Committee thus has shown unusual stability in its executive leadership. Like SV, the French Committee has attracted support from leading members of fashion, industry, and finance, as well as from foundations and corporations.[35] It is headquartered in Paris, participates regularly in meetings of the APC, and was praised in 2011 by the Italian Ministry of Culture as a "model of public-private collaboration" for its work in Italy.[36]

The mission of the French Committee is similar to that of the other private committees: to restore monuments and works of art in Venice and—in the words of Ashley Clarke—to serve as a "watchdog" for Venice.[37] However, the French Committee takes a particular (and understandable) interest in restoring works in Venice of historical importance to France. From the arrival of King Henry III in 1574 to that of Napoleon in 1797, and to more recent diplomatic and cultural collaborations, France shares a long history with Venice. Considering that, it is no surprise the committee has emphasized the restoration of the Royal Palace of Venice (now the Museo Correr), redesigned from 1808 to 1814 while Venice was under French control. The French Committee has spent nearly 5 million euros over the course of two decades to renovate twenty-seven rooms within the Royal Palace, nearly doubling the space available to the Museo Correr. Zieseniss has described the Royal Palace as "an encyclopedia of decorative arts for nineteenth-century Venice . . . and definitive evidence of the artistic vitality of the city in that period."[38] The adjacent Napoleonic Wing, full of neoclassical ornament, was partially restored in just three years (2000–2003). The committee followed in 2012 with the renovation of nine imperial rooms, originally designed for the young sovereigns Franz Joseph and Elizabeth ("Sissi") in the 1850s. Additional apartments include those for Emperor Maximilian and later for King

Victor Emmanuel.[39] Such restorations have not been without the occasional faux pas. In 2003 the committee paid $300,000 at a New York Sotheby's art auction for an eight-foot marble statue of Napoleon created by Venetian sculptor Domenico Banti, lost for nearly two hundred years, assuming this would be a welcome gift for the city of Venice. The statue had been commissioned circa 1808–10 by Venetian merchants, who were grateful to Napoleon for turning Venice back to a free port. Although the mayor of Venice Paolo Costa and the director of the Civic Museums Giandomenico Romanelli agreed to accept the gift in the interest of Venetian history and to have it displayed in Piazza San Marco, the citizenry of Venice were furious with the statue and saw it as a symbol of French oppression. Some Venetians put Napoleon on mock trial for the crime of "destruction of the Most Serene Republic of Venice in 1797." The offending statue was sentenced to "solitary confinement" in a corner of the Museo Correr where it has remained.[40]

The French Committee began work in the late 1960s with the frescoes by Giovanni Battista Pittoni in the church of San Cassiano, the ceilings of the Ca' d'Oro, paintings by Palma il Giovane in the church of Sant'Antonin in Castello, and the altarpiece cover (*pala feriale*) for the Pala d'Oro in the basilica of San Marco.[41] The most significant early conservation was the facade of the church of Santa Maria della Salute as well as the cleaning of statutes at the gates (1970– 76). Marble pavements, frescoes, and fireplaces of the Venier Casinò were also restored between 1977 and 1979. The sacristy of the church of Santi Giovanni e Paolo, including additional paintings by Palma il Giovane, was the subject of intensive conservation between 1986 and 1993. Substantial attention to the porch and the *piano nobile* (main floor) of the Fondazione Querini Stampalia, including the reopening of the Chamber of Ambassadors, was completed from 1997 to 2000. In addition, the replicas of the four bronze horses of San Marco adorning the facade of the basilica were restored in 2006, and the gilded, winged lion on the facade of San Marco followed suit in 2016.[42] Other notable projects have included the Tiepolo ceiling paintings of the Gesuati church (1975–76) and the salons of the first floor of the Levi Foundation (1993–94).[43] As is evident, the French Committee has adopted a wide range of media (paintings, frescoes, marble and bronze sculpture, ceilings, facades) during its fifty-year history in Venice.

In 1979 the French Committee organized a campaign to draw attention to the humble brick—the most widely used building material in Venice, and one that is particularly susceptible to humidity and salt encrustation. An international symposium at the Fondazione Cini in October 1979, attended by 150 participants, surveyed the state of knowledge. Three years later in October 1982 the Ateneo Veneto

hosted an international conference on "the pathology, diagnoses, and therapy of brick." Eighteen analyses were presented and subsequently published as *Il Mattone di Venezia* (The Brick in Venice).[44]

One of the striking parallels between the French Committee and Save Venice is the active participation of young professionals in fundraising and project sponsorship. From 2008 to 2013 the Groupe des Jeunes regularly attended the Cavalchina Ball at La Fenice theater during Carnevale and celebrated conservation work at the Casinò Venier and the Royal Palace. Aged twenty-five to thirty-five, these young enthusiasts have sought to support the committee's restorations, improve its visibility through social media, and host cocktail parties and weekend trips to Venice. With the assistance of Clémentine Martini and Amandine Durr, François Pignol has raised awareness of Venice's artistic patrimony and the threats of mass tourism and depopulation.[45] The efforts of these French young professionals are remarkably similar to those of the Save Venice Young Friends in New York and Boston.

Schweizerische Stiftung / Fondation Suisse / Fondazione Svizzera Pro Venezia (Switzerland)

The Fondazione Svizzera Pro Venezia was established on 3 July 1972 by the Swiss Federal Council with the mandate to "collect funds for the safeguarding of the cultural heritage of Venice, to employ them for this purpose in the framework of the international aid effort and to ensure that Swiss initiatives to this end are well-coordinated."[46] The foundation has its headquarters in Bern, sharing space with the Swiss UNESCO commission. It is a longstanding member of the APC, and in 2013 the president of Pro Venezia, Giordano Zeli, was elected vice president of the APC. The foundation's steering committee is made up of Swiss representatives in the fields of culture, economy, and politics. Since 2008 the Swiss bank Banca della Svizzera Italiana has been an institutional partner with Pro Venezia. In contrast to the other private committees, the Swiss foundation is more closely linked to its national government, functioning under the supervision of the Federal Department of the Interior and in close collaboration with the Federal Office of Culture. In 1994 Pro Venezia established a membership program "Friends of Pro Venezia," which gathers principally in Lugano for lectures, reunions, book launches, and an annual meeting. The group also organizes occasional trips to Venice to view exhibitions or to learn more about the history of Swiss people within the Serenissima. Membership fees, together with private donations, state funds, and cantonal contributions, support its conservation activities. The Friends of Pro Venezia is similar

to SV's Young Friends (or even to the Boston and California chapters) in that it represents a small, activist group that engages in regular activity on behalf of the larger organization but is largely self-directed.

Like the other committees with their respective promotion of projects linked to national interest, Pro Venezia has sought to "highlight and reinforce the cultural relationship between Switzerland and Italy, and to reinforce the ancient ties that link our nations by focusing mainly on the work of Swiss architects and artists in Venice or on creations that have some other connection with the Confederation."[47] Throughout the early modern period, Swiss-Italian artisans from canton Ticino migrated to Venice to work as plasterers, sculptors, and architects. Similar to the French Committee and Venice in Peril, Pro Venezia prides itself on conserving a broad range of art, noting that the survival of minor objects is just as crucial as those that are better known. Pro Venezia's well-organized website describes—in four languages—its administrative structure, history, conservations, publications, and funding. Its initial steps were to support two exhibition catalogues about the artistic links between Venice and Switzerland: the first by Carlo Palumbo-Fossati about the presence of Swiss residents in Venice (1977) and the second by Georg Germann about Venetian art in Switzerland and Liechtenstein (1978).[48] A third publication by Paola Piffaretti traces the history and works of the Swiss-Italian architect Giuseppe Sardi (1624–1699) in Venice, particularly his work at the church of Santa Maria del Giglio.[49]

The first restoration by Pro Venezia focused on the church of San Stae between 1977 and 1979. The facade of the church, facing directly onto the Grand Canal, was designed by Domenico Rosso of the town of Morcote (near Lugano) in 1709. Pro Venezia restored the entire building, receiving the Torta Prize in 1980 from the Ateneo Veneto and publishing an account of the church's restoration by architect Arnoldo Codoni in 1981.[50] There was a temporary scare in the summer of 1990 when a patient suffering from mental illness stole the painting *The Martyrdom of St Bartholomew* by Giambattista Tiepolo from San Stae. Fortunately, the painting was recovered soon after without damage and the thief arrested. One account claimed that while a new alarm system had been installed during the church's restoration, it had been turned off "because the noise might disturb the people living nearby."[51]

Subsequent conservation projects included the granite column of Saint Mark overlooking the lagoon at the edge of the Piazzetta San Marco (1985); the facade of Santa Maria del Giglio (1996), designed by Giuseppe Sardi of Morcote; and Tommaso Lombardo's marble sculpture of the Madonna and child with Saint John located on the altar of the church of San Sebastiano (1997). Additional projects have included the monumental altar of Sant'Antonio in Santa Maria Gloriosa dei

Frari (1998), the funeral monument to Alvise Mocenigo in the church of San Laz-
zaro dei Mendicanti (2004), and the tomb of Giuseppe Sardi in the church of the
Carmini (2010). Pro Venezia's most recent project restored the Silk-Weavers' Cha-
pel in Cannaregio's church of the Gesuiti, designed again by architect Domenico
Rossi of Morcote.[52]

Stichting Nederlands Venetië Comité (Netherlands)

If any people in Europe could empathize with the Venetians about destructive
flooding, it would certainly be the Dutch. In addition to a longstanding mutual
preoccupation with water management, the Dutch and the Venetians shared a
common artistic heritage. As the current leader of the Dutch Committee, Ber-
nard Aikema, put it: "Many indeed are the relationships, grown up and deepened
over the centuries, between Venice and the Netherlands in political, economic
and artistic terms."[53] The Dutch founded a national committee on 11 December
1973 to assist Venice. The initial chair of the Stichting Nationaal Comité Ned-
erland was Theodoor Tromp, an engineer, industrialist, and executive at Phillips
Research who served briefly as water minister in Holland's postwar government in
1945.[54] Described as a manager who "did not suffer from a lack of self-confidence,"
Tromp recruited important figures from the banking, culture, and government sec-
tors, including financier W. van Lanschot, Rijskmuseum director Simon Levie,
and F. J. Tunnissen, director of UNESCO Netherlands. Soon the Dutch Commit-
tee invited Gerard Metzelaar to help professionalize the committee's fundraising
activities. Initially as a consultant and later as secretary, Metzelaar was instrumental
in organizing cultural and financial activities; in the words of Aikema, Metzelaar
was considered the "true soul of the Committee" due to his tireless efforts on its
behalf.[55] In 1978 Metzelaar founded a companion association of the Dutch Com-
mittee, De Poorters van Venetië (Citizens of Venice), which has become respon-
sible for a great deal of the fundraising activity carried out by the Dutch Com-
mittee.[56] In 1984, Tromp was succeeded as chair by Hendrik (Han) Boon, former
Dutch ambassador to Italy. In 1993 the committee changed its name slightly and
registered in The Hague as Stichting Nederlands Venetië Comité. In 1999 Boon
was succeeded by Aikema, a renowned art historian at the University of Verona
who has now served more than two decades as Dutch Committee chair.[57]

If the French Committee is associated with the church of the Salute, and Save
Venice with the church of the Miracoli, then the Dutch Committee is widely rec-
ognized for its patronage of the church of San Zaccaria. Located close to Piazza

San Marco, San Zaccaria formerly housed a significant community of Benedictine nuns and boasted a large collection of medieval relics and Renaissance paintings. The Dutch Committee began the first of many conservations at San Zaccaria in 1981, and its work there was recognized in 1994 by the Torta Prize from the Ateneo Veneto. The Dutch Committee has maintained its focus on this one church, conserving frescoes, statues, mosaics, and interior chapels, as well as an ambitious cleaning of the facade in partnership with Venetian Heritage. Limiting the scope of work to one church has been a sensible strategy for a medium-sized committee, in contrast to a larger committee like SV that could take on multiple sites simultaneously. The narrower focus also reflects the philosophy of Aikema, who hopes to make a substantive, long-term difference for the neighborhood of San Zaccaria by restoring and perhaps repurposing the original church.[58]

The most significant recent conservation in San Zaccaria concerns the vaults of the Cappella dell'Addolorata; begun in 2012, restoration of this chapel is the Dutch Committee's longest-running individual project to date. The committee has recently supported a collaborative restoration of a mid-fifteenth-century crucifix hanging above the high altar there, in addition to repairing the broken right arm of Saint John the Baptist (son of Saint Zaccaria), damaged by vandals in 2005.[59] The crypt below the San Tarasio chapel in San Zaccaria regularly floods and has pushed the Dutch Committee to engage more directly with the environmental risks of sea rise and climate change. One very recent effort in this regard is the "Red Venice" campaign led jointly by the Italian embassy in the Netherlands and the Dutch Committee. Like SV's Immediate Response Fund, the Red Venetië effort featured specific fundraising days in Amsterdam and a concert of Vivaldi's music.

In recent years (2018–20) De Poorters has raised an average of about 62,000 euros ($72,000) per year, with about one-third coming from membership fees and small contributions, and more than half from legacies and testamentary gifts. The substantial funds from posthumous gifts suggest that SV was correct to establish Venezia per Sempre to accept such donations. The reserve funds for Dutch projects fluctuates but is generally a bit under 300,000 euros ($354,000). The treasurer for De Poorters estimates that the Dutch Committee has spent a total of about 580,000 euros ($685,000) on all restorations at San Zaccaria.[60] In comparison to SV, which has spent $3–4 million on the conservation of the Miracoli church and about $5 million on San Sebastiano, the Dutch Committee is clearly operating at a smaller scale, but that is to be expected for many of these private committees that have fewer resources.

Venetian Heritage (USA)

Founded by Larry Lovett and his allies after the split with Save Venice in 1998, Venetian Heritage has established itself as a significant entity in the world of cultural heritage preservation. Like SV and the other private committees, Venetian Heritage supports conservation and related activities that raise awareness of, and funds for, Venetian art and architecture. Yet Venetian Heritage differs from the other private committees in several distinct ways. First, Venetian Heritage has a broader geographical scope that includes former dominions of the Republic of Venice rather than just the historic center within the lagoon. Second, Venetian Heritage established both a U.S.-based corporation and an Italy-based ONLUS foundation, with separate but parallel boards of directors. The two work closely together; this bifurcated structure allows European and U.S. citizens to each make tax-deductible donations. Third, Venetian Heritage is more forthright at establishing and promoting its corporate partnerships and elite donors. As a result of its success in recruiting affluent donors, foundations, and luxury business partners, Venetian Heritage has been able to sponsor a significant number of projects during the first two decades of the twenty-first century.[61] Indeed, with an average of six to nine projects per year since its founding in 1999, Venetian Heritage has supported more projects in that time period than any other committee except SV.[62] Lastly, Venetian Heritage has promoted exhibitions, conferences, and publications to a greater degree than most of the private committees.

After leaving SV, Lovett remained an important figure with Venetian Heritage, collaborating with longtime allies and bringing in new officers too. The initial president was Khalil Rizk; the current president and chair is architect Peter Marino. Other long-term directors of Venetian Heritage who had previously been part of SV included the late Alexis Gregory, founder and publisher of Vendôme Press; Larry Lovett's sister-in-law Elizabeth (Betsy) Lovett; and Priscilla Miller. Venetian Francesco (Toto) Bergamo Rossi transitioned from an early career as a sculpture restorer, including some projects completed for SV, to become an important figure in Venetian Heritage around 2010. Admired for his social network and his media savvy—a profile in *Vogue* described him as "wildly convivial"—Bergamo Rossi has increased the visibility of Venetian Heritage in numerous ways.[63] The International Committee and the advisory board of Venetian Heritage initially featured an array of princesses and other royals but (at least in comparison with SV) fewer professors and curators. Venetian Heritage has partnered with the Getty Foundation and the Rothschild Foundation, as well as with JTI Japan Tobacco International, Louis Vuitton, and Bulgari, in support of its restorations.[64]

Among the most prominent of its conservations in Venice are the facade of the church of the Gesuiti and the facade of the church of San Zaccaria (the latter in partnership with the Dutch Committee). The gothic altarpiece of the church of San Salvador, and the installation of improved exhibition spaces in the Accademia, represent two additional projects in Venice. Paintings by Giovanni Bellini, Paolo Veronese, Anthony van Dyck, and Giovanni Battista Piazzetta, as well as a monumental staircase by Mauro Codussi for the Scuola Grande San Giovanni Evangelista, have all been refurbished (and often exhibited) by Venetian Heritage. Projects just outside of Venice have been completed too, such as the cleaning of the Cappella dell'Arca in the Basilica di Sant'Antonio (Padua) and several restorations in the church of San Pietro Martire (Murano).[65]

Venetian Heritage has long showcased its work through exhibitions. One spectacular example in 2019 was *Domus Grimani, 1594–2019*, an ambitious effort to reassemble in Palazzo Grimani at Santa Maria Formosa the important collection of classical sculpture originally housed there in the late sixteenth century. An exhibition of two Veronese paintings from Murano was shown at the Accademia and later at the Frick Collection in New York and at the New Orleans Museum of Art in 2018–19. *The Lost Treasures of the Venice Ghetto* began at Sotheby's in London and traveled around the world to New York, Houston, Vienna, Paris, and Perth between 2013 and 2015 before a permanent installation at the Jewish Museum of Venice.[66] Even for those exhibitions that travel the globe, the group has focused on paintings, sculptures, and objects from within Venice itself.

The emphasis upon conservation of cultural patrimony *outside* of Venice, however, has been Venetian Heritage's most noteworthy contribution. That began in 1999 with conservation of the later fourteenth-century Panaghia Pausolypi icon in the church of the Holy Trinity Monastery on the island of Halki in Turkey.[67] Venetian Heritage then sponsored several projects in the cathedral of Saint Lawrence in Trogir, Croatia, beginning with the Giovanni Orsini chapel (2000–2002), followed by the portal, narthex, and baptistery (2004–6), and finally the pulpit (2007). All together these three projects cost about 1 million euros. Other projects in Croatia included the chapels of Saint Doimus and Saint Anastasius (2002–3) in the historic city of Split; a pair of portals from the church of the Holy Annunciation in Dubrovnik (2010); and the facade, bell tower, and chapel of Saint Roch in the cathedral of Saint Mark on the Dalmatian island of Korcula (2012–13).[68] In virtually all of these cases there was substantial damage from factories, dust, and smoke, as well as shrapnel and destabilization from the civil war of the 1990s. The majority of these projects have been works in stone, often designed and carved by craftsmen

who traveled to and from Venice itself. On the island of Crete, Venetian Heritage has sponsored two Renaissance fountains bearing inscriptions to the nobles who lived and ruled there on behalf of Venice.[69] In addition to ecclesiastical buildings, Venetian Heritage has supported preliminary research on the four Venetian fortresses of Butrint in Albania. Venetian Heritage has displayed a determination to reach beyond Venice itself and to recognize the vast *stato da mar* that the Serenissima controlled in the Adriatic and Mediterranean Seas for nearly half a millennium. The interaction of Venice with Ottoman, Dalmatian, Greek, and other cultures of the Mediterranean basin has in recent years become a focus of historians and art historians too.[70]

Other Committees

More than a dozen other private committees in Venice operate in a manner similar to the five examples above, although none functions at the scale of SV. An additional measure of the success of SV's model is the existence of similarly structured, American-based committees in Italy. Those range from very modest scholar-led groups like the American Friends of the Marciana [Library] to a medium-size nonprofit like the America-Italy Society of Philadelphia, and even to ambitious, affluent organizations like Friends of Florence or the World Monuments Fund. All raise funds for the conservation of Italian patrimony but with significantly different approaches and results from each other—and from SV.

The earliest of these parallel groups is the America-Italy Society of Philadelphia, founded in the late 1950s to "promote friendship and cultural understanding between Italy and the U.S." Although it never established its own office in Venice, the society has been a consistent donor to restorations there since the great flood of 1966 and is a current member of the APC.[71] It has been supported in its project donations by other organizations such as the IFM Venice Committee, UNESCO, and the APC. The initial project of the America-Italy Society in the late 1960s restored fifty-eight ceiling paintings in the church of Santa Maria della Visitazione depicting saints from the Old and New Testaments, executed by Pietro Paolo Agabiti in the early fifteenth century.[72] Subsequent projects included the ballroom ceiling frescoes by Giambattista Crosato in the Ca' Rezzonico, an early cleaning of Titian's *Assumption of the Virgin* in the church of the Frari, three wooden statues in the church of San Michele in Isola, and (most recently) a wooden crucifix in the church of San Zaccaria.[73] While its "Venice Project" has been a significant focus of the society for decades, it supports other activities too, including an Italian book

club of Philadelphia, occasional Italian trips, and Philadelphia-based classes and lectures in Italian language, culture, and art.

Tax returns from the America-Italy Society indicate that between 2001 and 2018 it maintained net assets of between \$350,000 and \$550,000.[74] Approximately 25 percent was allocated to staff salaries each year, with the remainder devoted to restoration and programming, a ratio consistent with both SV and the industry average. Unlike SV, which witnessed consistent growth in its bottom line in the twenty-first century, the donations to and expenses by the society during the past two decades were largely flat year over year.

The IFM and its successor organization, the World Monuments Fund (WMF), maintained a focus on Venice for decades within a global portfolio of projects. As discussed in previous chapters, the organization's Venice Committee was active from the late 1960s through the late 1980s, initially with John McAndrew and James Gray, and then later under Gray alone. During the 1970s the campaign to preserve Venice was the IFM's priority: restorations included the cathedral of San Pietro di Castello, the church of Santa Maria della Visitazione, the Scuole Grandi of San Giovanni Evangelista and of the Carmini, the Ca' d'Oro, and the Schola Canton in the Jewish Ghetto.[75] During the 1980s the Venice Committee returned to the Biblioteca Marciana to clean and restore Titian's allegorical painting of *Sapienza* (wisdom) on the ceiling of the foyer. Joint projects with SV and other private committees included an altarpiece at the church of San Giovanni in Bragora, selected rooms of the Royal Palace in San Marco, and the multicommittee projects at Torcello and the Ospedaletto.[76] By the time it began to look at projects outside of Italy in the 1980s, the IMF/WMF estimated that it had contributed to conservation of twenty-five buildings in Venice.[77]

In an internal history of the organization's first three decades, executive director Bonnie Burnham noted that "by 1980, the IFM began to apply the skills learned in Venice—orchestration, constituency-building, and project management—to other projects."[78] This transition from Venice to a more global focus was spurred by Gray's retirement in 1984, the name-change in 1985, and the dissolution of the Venice Committee in 1988. Conservation sites in Spain, France, and Ireland were soon followed by others in Nepal and Haiti, and in the 1990s by still more projects in Armenia, Poland, and Portugal. When the WMF established affiliate organizations in the 1980s and 1990s it did so in London, Madrid, Paris, and Lisbon. The WMF did partner with an Italian affiliate, the Comitato Italiano in Vicenza (now known as ARPAI), to place the equestrian monument of Bartolomeo Colleoni on the WMF watch list in 1996 and to clean the statue in 2003.[79] To commemorate

the fiftieth anniversary of the flood in 2016, the WMF supported the window restoration project at the Schola Tedesca and the Schola Spagnola in the Ghetto, but it is clear that these were exceptions; since the 1980s its primary interests lie well outside the lagoon. Indeed, it is telling that in its annual report of 2021, celebrating its fifty-fifth anniversary, no Italian projects are listed and the word "Venice" appears only as a caption on a picture of a deserted Piazza San Marco meant to evoke the impact of COVID-19 around the world.[80]

Given their closely intertwined early histories, it is no surprise that SV and the WMF share similarities. Both nonprofits have been headquartered in New York for decades; both instituted a central committee supported by local chapters and affiliates; both have engaged in successful fundraising from individual, corporate, and foundation donors in order to support cultural heritage preservation; and both were (and remain) willing to take on large conservation projects even when there was no clearly established process to do so. Both partnered with other private committees, and with each other on at least two projects. Both organizations faced a crisis when their charismatic founders stepped aside, and both were fortunate to identify effective, long-term leaders in the mid-1980s: Bob Guthrie (1987–2006) for SV and Bonnie Burnham (1985–2015) for WMF. Both organizations subsequently hit their stride in the 1990s, expanding their respective donor bases as well as the scopes of their conservation programs.

Yet there are important differences between the World Monuments Fund and Save Venice too, which can be instructive as we analyze their respective routes to success. The most obvious difference is SV's enduring focus on Venice alone, in contrast to the WMF's expansive efforts in more than ninety countries around the world. A second difference is that SV has focused primarily on art and art conservation, especially at the level of individual paintings or sculptures, with entire buildings like the Miracoli or San Sebastiano being the exception rather than the rule. The WMF, on the other hand, increasingly moved toward restoration of larger sites or building ensembles. A third difference is that the WMF is deeply interested in the historical significance of the monuments it has chosen, whereas SV is at least as interested in the aesthetic and artistic importance of the works it restores.

Furthermore, each organization has pursued, and obtained, diverse sources of funding with important consequences. We have seen the ability of SV to raise monies from costumed balls, excursions, membership programs, and other techniques; the WMF engaged in some similar activities but was particularly successful in acquiring large-scale corporate and foundation gifts. Soon after its inception, the WMF established a close relationship with the Samuel H. Kress Foundation and its chair,

Franklin D. Murphy. The presence of art historian Marilyn Perry was critical here; after living in Venice for more than a decade, she returned to New York to preside at the Kress Foundation and then subsequently became a trustee and chair of the WMF. James Gray confirmed the critical role of the Kress Foundation in his final newsletter of 1984: "Early during our formative years, we were fortunate to make an arrangement with the Samuel H. Kress Foundation whereby IFM would accept, in trust, funds for restoring a Kress-sponsored monument or work of art and then supervise the project to ensure its proper completion; Kress is spared the chore of supervision, and IFM has had interest income from Kress funds awaiting disbursement."[81] Certainly SV has been the fortunate recipient of corporate- and foundation-sponsored generosity during its five decades, but it never had a large institutional partner to provide consistent funding year after year. In 1987 the Kress Foundation offered $1 million over five years to launch the European Preservation Program through the WMF, a pledge that was renewed in 1993.[82] Kress funding, acting as "seed money," spurred matching grants from other foundations or individuals, both in the United States and in the host country.

In 1995 WMF partnered with American Express to launch its World Monuments Watch program, identifying imperiled cultural sites around the world in need of critical intervention. As the WMF put it at the time, the World Monuments Watch "will be an instrument of public conscience analogous to the endangered-species list."[83] Anchored by a $5 million grant from American Express, WMF thus expanded its philanthropy in the arena of the built environment; it would become a signature element of WMF in the decades to follow, and American Express would remain its major corporate sponsor. In 1999, with the launch of the first Robert W. Wilson Challenge, the "savvy philanthropist" Wilson offered $100 million over ten years to WMF, with certain conditions.[84] Wilson asked WMF to raise a one-to-one match from sources outside the United States, usually from the local government or *in situ* donors. Thus, at least half (and often more) of the money would be raised locally, and the jobs produced at the site would also redound to local benefit. Beyond these substantial grants, the WMF also looked to individual donors, such as Ronald Lauder's million-dollar gift in 1988 to launch the Jewish Heritage Program (inspired primarily by the IMF's success with the Schola Canton in Venice), or Paul Mellon's donations in the 1990s to create WMF Britain and to restore churches in the United Kingdom. Event-based fundraising was important too, but the WMF never relied on galas and excursions to the same extent as SV.[85]

One result of WMF's success at securing major grants was an increasing gap in the scope of financial operations between SV and WMF. Whereas in 1985 each

organization had assets of several hundred thousand dollars, by 2001 the WMF was raising the eye-popping sum of $12 million annually and disbursing nearly two-thirds of that for restorations, training, and publications.[86] By 2012 its revenue had doubled to more than $24 million and its net assets totaled $64 million. Such amounts vastly exceeded the monies raised, and spent, by SV (or any other private committee in Venice).

Beyond the issues of finance, an additional difference between the organizations can be found in the WMF's willingness to take on current, controversial topics. For example, in its 2021 report, the WMF identified imbalanced tourism, underrepresented heritage, and climate change as three global challenges with which it must engage. The WMF also pointed to the Black Lives Matter movement as an example of the "unprecedented worldwide recognition of painful histories embodied in the statues and monuments erected in public squares," and recognized WMF's own responsibility to address such an issue.[87] SV, by contrast, has shied away from these topics, preferring to keep its eye squarely on conservation matters and leaving the political issues to others. This is not to suggest that one approach is "right," only to note that this is an area where the two organizations diverge. The example of the WMF illustrates the potential success of an organization that takes on a much larger mandate, while that of SV shows the impact that a nonprofit can have on a local area.

Another successful group, albeit founded much more recently, is the Washington, DC–based organization Friends of Florence. Florence suffered grievously from the 1966 flood and received an outpouring of support for short-term conservation and structural repairs. The city recovered more quickly and has not faced the same kind of environmental challenges as Venice (though certainly mass tourism, decline of arts funding, and air pollution have had significant impacts on Florence too). Founded in 1998 by Simonetta Brandolini d'Adda and her sister Renée Gardner (who continue to serve as president and secretary, respectively), Friends of Florence has the twin goals of historic preservation and education.[88] From the beginning it has strongly emphasized educational outreach via seminars with the Aspen Institute, travel-study programs, and partnerships with Stanford University, New York University, and other study-abroad programs in Florence. Friends of Florence has sponsored a wide variety of conservation projects, from statues by Michelangelo, frescoes by Perugino, and the bronze *Gates of Paradise* by Ghiberti to restoration of museum galleries and individual chapels.[89] Unusual projects have included sound recordings of Florentine church bells, conservation and exhibition of the Medici gem collection, and restoration of the lunette frescoes and marble statues in the Cloister of the Vows at the basilica of Santissima Annunziata.[90]

More than two hundred projects were completed in the first two decades, with nearly two dozen more currently underway or in the planning stages.

Like SV, Friends of Florence focuses on one city and maintains offices in the United States and in Italy. Similarly, it offers symposia and lectures, sponsors educational travel, partners with local institutions, and publishes a regular newsletter. It has an equivalent group to the SV Young Friends (the Council for the Future), sponsors an annual appeal, and has recently begun to accept estate bequests. Matthew White was an early supporter of Friends of Florence, just before he cofounded the California chapter of SV in 1999; White and recent SV president Richard Almeida remain in the Leadership Circle of Friends of Florence in 2021.[91] These similarities in purpose and structure stem in part from the fact that Simonetta Brandolini d'Adda had volunteered with SV in the mid-1980s on the early galas in Venice and then returned to consult with Bea Guthrie in the mid-1990s when founding her own organization.[92] These similarities also reflect the successful model that SV and its fellow committees devised in the 1960s and 1970s. Unlike Venice, which has benefited from dozens of private committees focused on historic conservation, Florence has no other international nonprofit dedicated solely to art conservation and education in the city, thus Friends of Florence has been able to fill a gap left by the closure of CRIA in the 1970s. Friends of Florence has two part-time staff in the United States and one in Italy; it has not (yet) transitioned to a full-time executive director or staff. One particularly successful initiative has been its Restoration Prize, offered every other year since 2012 to restorers for smaller projects costing less than 20,000 euros. Each competition brings in at least fifty projects, thus providing a pipeline of future projects (some of which can be adopted by donors) and generating goodwill among the community of restorers in Florence.

In terms of finances, Friends of Florence relies chiefly on contributions from supporters in the United States, Italy, and a smattering of other countries.[93] Unlike SV, however, Friends of Florence has not pursued external grants nor does Friends of Florence stage an annual gala for raising funds. In just its third year of existence in 2001, Friends of Florence collected $311,000 and disbursed $240,000 to restore marble statues by Giambologna and Pio Fedi, among others, in the Loggia dei Lanzi in the Piazza della Signoria. In 2005 it raised $662,000 and had net assets of more than a million dollars; by 2009, within a decade of its founding, it had over $2 million in net assets and was regularly distributing more than half a million dollars to conservation projects each year.[94] From 2010 to 2020 it has remained more or less at that financial level. Its early growth actually outpaced SV's first two decades and is reminiscent of SV's dramatic expansion after 1987.

In commemoration of the fiftieth anniversary of the 1966 flood, SV and Friends of Florence jointly sponsored a pair of restorations in 2016. Those included conservation of forty-eight drawings by Venetian Giambattista Tiepolo from around 1740, now held in the Horne Museum of Florence, and restoration of a large Tuscan panel painting from the early fourteenth century by the Maestro di Badia a Isola, today in the Palazzo Cini Gallery in Venice.[95] The American art historian Edward Goldberg, who has lived in Florence for many decades and who cofounded the Medici Archive Project there in 1992–93, observed that "Friends of Florence is a wildly successful organization, which could never have existed without the Save Venice precedent."[96] If perhaps an overstatement, this endorses what a potent model SV has been.

Another American-based nonprofit operating in Italy has been the American Friends of the Marciana (which in 2016 became the "International Friends of the Marciana"). As its name suggests, this group has focused specifically on raising funds to benefit Venice's national library, particularly in the areas of staffing, supplies, database management, exhibitions, and capital improvements. Founded in New York City in 1997 by historian Patricia Labalme, with the assistance of the Marciana's director Marino Zorzi, the group boasted sixty American scholars as initial subscribers.[97] In subsequent years professors Stanley Chojnacki (University of North Carolina), Edward Muir (Northwestern), and Joanne Ferraro (San Diego State) served in turn as president, while George Labalme, Patricia Labalme's spouse, served as vice president for more than two decades before his death in 2018.[98] The focus has been on assisting the Marciana to deliver services that were necessary and important for all scholars: for example, building an online database of printed books, supplying lamps for the reading room, supplementing the acquisition budget for printed materials, and supporting digitization and web access for unique manuscript materials.[99] Perhaps due to its narrow focus, or because of its small scale, the Friends of the Marciana has never joined the APC.

Given that dues were very low and that nearly all members were graduate students or professors, the Friends of the Marciana has never exceeded $30,000 in total assets and rarely distributes more than $5,000–7,000 each year in grants to the library. In most years it received total contributions between $6,500 and $9,500.[100] This comparison is useful to show that expanding and sustaining a successful nonprofit in Italy is not easy, and that the success of prior examples in this chapter, including Save Venice, Friends of Florence, and the other private committees in Venice, should be viewed as exceptional rather than the norm.

UNESCO

Previous chapters have briefly described UNESCO's International Campaign for the Safeguarding of Venice and the subsequent Joint Programme with the APC. Launched in 1966 to preserve cultural heritage and to rebuild from the flood, but quickly expanded to include broader environmental, industrial, and socioeconomic issues, the UNESCO Campaign for Venice engaged all of the private committees and worked closely with local and national government agencies. UNESCO provided scientific and technical advice for the setting up of research projects, as well as a framework in which the private committees could pursue conservation activities.[101] For example, in 1967–68 UNESCO compiled an index of sixteen thousand cards to catalogue the state of paintings, sculptures, and frescoes.[102] In 1969, in partnership with the Superintendency of Monuments, it created a similar catalogue detailing the condition of four hundred palaces, one hundred churches, thirty convents, and twenty *scuole*.[103] Also that year UNESCO promoted the establishment of an international advisory committee to assist UNESCO and the Italian government in identifying problems and proposing solutions through annual meetings during the 1970s. In 1973 UNESCO transferred its Bureau de Liaison from Rome to Venice and appointed Baroness Maria Teresa Rubin de Cervin as liaison officer, a post she would hold for almost two decades. In that same year UNESCO published the first edition of *Venice Restored*, in order to describe the conservation work carried out since 1967 by Italian authorities and by the private committees.[104] Also in 1973 UNESCO offered early publicity (and self-congratulations) about the plight of Venice after the flood.[105]

During the 1970s and 1980s UNESCO underwrote publications, conferences, inventories, laboratories, and training courses, often in partnership with SV and the other committees.[106] UNESCO played an important role in cajoling the Italian government into passing the Special Laws of 1973 and 1984, respectively, which directed substantial monies toward Venice. As we have seen, from 1977 UNESCO also provided a conduit through which funds could flow from SV and its fellow committees to local restorers and businesses. The arrangement between the private committees, UNESCO, and the superintendency has been described admiringly as a "triangle trade" where each side benefited from the presence of the others.[107]

In December 1987 the city and its lagoon were placed on UNESCO's World Heritage List, to provide further protection and support for conservation activity. The World Heritage program includes more than one thousand sites "of outstanding universal value to humanity" that the United Nations believes should be

protected for future generations.[108] More broadly, UNESCO promoted the principle that "Venice—and therefore its entire cultural heritage—belongs not to one single country or to one fortunate region but to the whole world."[109] In 1988, at the invitation of the Italian government, UNESCO relocated its Bureau for Scientific Cooperation from Paris to Venice and renamed it the Regional Office for Science and Technology in Europe (ROSTE).[110] The Italian National Research Council provided substantial financial and logistical support as well as office facilities at Palazzo Loredan dell'Ambasciatore (ROSTE moved to Palazzo Zorzi in 2002). ROSTE's principal function was to promote scientific and technological exchange in the wider region, particularly in Eastern Europe and the Balkans after the fall of the Berlin Wall in 1989, but it also worked closely with Venetian institutions on projects concerning the lagoon. For example, in 2000 UNESCO published *The Venice Lagoon Ecosystem: Inputs and Interactions between Land and Sea* as part of its "Man and the Biosphere" series.[111]

This broad mandate to protect Venice was not always popular, however, nor was UNESCO always successful. The Italian socialist Gianni di Michelis, who was born in Venice and was a student and later a chemistry professor at Ca' Foscari before his political career, complained bitterly about UNESCO's intervention: "UNESCO came on the Venice scene only because it was finished at Abu Simbel [Egypt] and now it would have us become a cross between a Nubian monument and Disneyland."[112] The United States and the United Kingdom each withdrew from UNESCO in 1984–85 with claims of "excessive expenditures" and financial waste as well as their perceptions of UNESCO's anti-Israel, pro-Soviet stance.[113] As noted previously, after Maria Teresa Rubin and Alvise Zorzi convinced SV and other private committees in 1989 to object to bringing Expo 2000 to Venice, the Italian government limited its funding for UNESCO. The private committees then agreed in 1993 to form the APC to work directly with UNESCO. That arrangement continued for another two decades: the superintendencies prepared lists of possible projects from which APC members might choose to provide funding, UNESCO would formally adopt the project, and the superintendency would plan and direct the work.

Increased geopolitical tensions, coupled with a desire for greater autonomy by SV and some private committees, however, caused the traditional system to unravel and eventually collapse. As UNESCO began to add additional fees and require payment in advance, SV realized that the former advantages and prestige of working through UNESCO were no longer always applicable. Around 2008 SV began to administer some conservation projects without UNESCO involvement,

beginning with the conservation of San Sebastiano. SV was able to do so because of its strong office presence in Venice; the private committees without offices continued to rely on the APC and UNESCO. In 2011 the United States cut funding to UNESCO to protest the inclusion of Palestine in the United Nations.[114] In that same year, political scientist Dominic Standish argued in his book about Venice that UNESCO was a "claims-maker" primarily interested in raising its own profile and saw Venice as a convenient vehicle to do so.[115] By 2014 SV had ceased running any of its projects through UNESCO. In 2015 UNESCO notified the APC of several changes, including an increase in the project handling fee to 13 percent, an additional estimated 7 percent fee to cover its staff time, and yet another 5 percent for projects valued at more than 500,000 euros. This meant that the total handling fees were likely to be equivalent to the value-added tax and could not always be calculated in advance with certainty.[116] The APC and its members wished to have greater autonomy in administering their projects and were further concerned about UNESCO's intention to no longer adopt projects valued at less than 100,000 euros.[117] Therefore, the APC withdrew from the Joint Programme with UNESCO. In a sign of the increasing separation, in early 2021 at UNESCO's request the APC moved from UNESCO's Palazzo Zorzi to the starkly modern building of the Fondazione Venezia along Rio Novo in Dorsoduro. Such a transfer marked the end of an era for UNESCO and the APC.

At the same time that the Joint Programme was coming to an end in 2015, the new superintendent of fine arts and monuments, Emanuela Carpani, raised concerns about the traditional process by which conservation projects were proposed, planned, directed, and verified by her office. In her view, the Venice superintendency could be accused of operating a system in which there was no effective checks and balances because it retained control over all aspects of the process. Therefore, she proposed a new agreement whereby the Venetian superintendency would propose projects, the private committees would select and pay for one, and a different superintendency would plan and direct the work. The APC accepted this proposal, and some of the smaller committees utilized this new agreement while the larger private committees (including SV) administered their own projects. SV and other APC members often partnered with restorers who were well-known by the superintendency as having particular expertise, and this eased the process of approval. Sometimes the private committees would request the owner of the artwork or of the building obtain permission from the superintendency.[118] Under the new procedures since 2015, the ultimate cost of the restorations did increase,

but in exchange the projects could be run with greater autonomy and efficiency. As SV marked its fiftieth anniversary, it was in the enviable position of consistently increasing its revenue year over year and thus could afford the higher expenditures that came with increased flexibility.

An additional complication arose in 2016 when UNESCO expressed concern that ongoing transformation and proposed construction projects within Venice might degrade the city's ecosystem to the point where its historic value could be compromised.[119] UNESCO insisted that local authorities and the national government devise a sustainable tourism strategy, regulate boat traffic, and review more carefully any permits for new projects. UNESCO threatened to remove Venice from the World Heritage List. Mayor Luigi Brugnaro promised to address those concerns in a "Pact for Venice" that included additional investments of 457 million euros over four years for historic preservation. By 2020 a substantial amount of money had been spent on Project MOSE, cleanup of the 2019 floods, and new research institutions, but UNESCO remains cautious about the extent to which Venice has a sustainable strategy for the future.[120]

Notwithstanding these recent developments, UNESCO's role in Venice has been a vital one and it deserves recognition for its good work. At least one historian of Venice, the British expatriate Peter Lauritzen, praised the UNESCO director in Venice, Maria Teresa Rubin, as "one of the most outstanding personalities in the entire international campaign to see Venice preserved."[121] Lauritzen noted that UNESCO's mandate in Venice (as elsewhere) was to organize analysis of the problem by recruiting experts and organizing conferences or scholarly symposia, followed by publication of reports for the benefit of the host government. For more than four decades, UNESCO has been intimately involved in identifying, organizing, and helping to finance conservation projects in Venice.

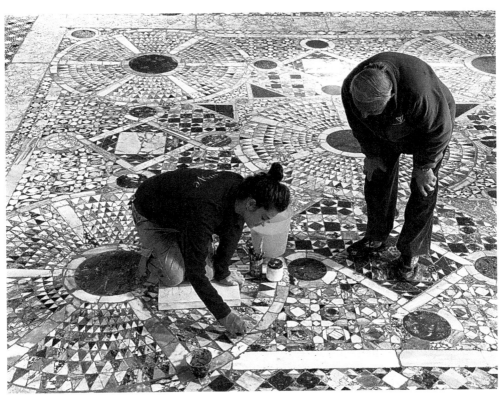

FIGURE 34. Mosaic Conservation, Santi Maria e Donato, Murano, ca. 2020. Giovanni Cucco supervises a restorer working on the floor tiles in Murano. Save Venice supports training of young restorers and the preservation of conservation knowledge through its projects and programs. Photo by Matteo De Fina, courtesy Save Venice Photo Archives

Conclusion

VENICE HAS long defied easy categorization: beyond its unique topography with canals as streets, it has been a republic amid monarchies, a compact city directing a sprawling empire, and a crossroads between East and West. Its unusual political stability for more than a millennium, combined with its vast artistic and intellectual output, has fascinated generations of scholars, poets, artists, and travelers. One consequence of the Serenissima's unusual history is the enduring "myth of Venice," which for centuries promoted the concept of Venetian exceptionalism.[1] Despite the ravages of time and tide on its physical and cultural heritage, Venice continues to retain a singular status, living up to the claim attributed to the Victorian critic John Addington Symonds as "the Shakespeare of cities—unchallenged, incomparable and beyond envy."[2] Remarkable today is the city's unique blend of setting and monuments, and the fact that so many of its statues, paintings, and buildings remain *in situ*. Unlike a modern mega-museum in New York or elsewhere, which collects works from around the world to display in a neutral environment, Venice has been unusually successful in retaining its artistic heritage in place. To put it another way, Venice is itself a work of art (and artifice), as well as a locus for works of art.[3] Thus, a challenge for Save Venice and its fellow organizations has been to balance conservation of the artworks with the preservation of the broader context in which that art is located.

In pursuit of that goal, SV has embraced a mission that is simultaneously academic, financial, and social, all linked to its core objective (and former motto) of "preserving the artistic and architectural heritage of Venice." John McAndrew and his allies on the Venice Committee, and later within Save Venice Inc., understood that in order to raise funds to preserve Venice, they would need a combination of scientific expertise, sound bookkeeping, academic rigor, and social appeal. The printed materials and digital media from SV and its chapters demonstrate that the focus often oscillated from one priority to another. Thus an annual appeal might seek cash donations, a lecture would emphasize education, and a cocktail party would target future supporters. From McAndrew to the Guthries to today, the most successful ventures have been those that merged the scholarly and the social: for example, the Regatta Week Gala in Venice with its lectures each day or a cruise

with onsite scholars or a wine reception with an address by a local professor. The membership of the board of directors has reflected this same effort to achieve complementary strengths, balancing socially oriented philanthropists, cost-conscious businesspeople, and scholars. Some of the most effective leaders have combined all three traits. Save Venice has striven, with considerable success, to integrate these different constituencies around a shared passion for Venice.

Over the course of five decades, SV's identity and methods have evolved to correspond with its steady expansion. John McAndrew's academic expertise and passionate enthusiasm were paired with Betty McAndrew's financial means to help direct the IFM Venice Committee and then SV. Their Italophile colleagues Sydney and Katherine Freedberg, Peter and Kathleen Wick, and Rollin and Shelagh Hadley (to name just three couples) were similar to the McAndrews in their combination of skills and Boston-based networks. Supplemented by the presence of others like Walter Bareiss and Hedy Allen, this model remained effective through the early 1980s. With the ascension of Larry Lovett and Beatrice and Bob Guthrie to leadership positions after 1986, the traditional profile began to expand beyond those in academia and their friends, in favor of board members with deeper pockets, more diverse interests, and greater ambitions. This is not to suggest that SV has abandoned its academic roots; there continue to be multiple distinguished historians, art historians, and curators on the board. Nor should it be inferred that the devotion of board members in the 1990s and later is somehow less (or less important) than in the earlier phase. Yet there is no denying the transformation that occurred after 1986 in terms of expanded fundraising and correspondingly ambitious projects, along with the growth of paid professional staff in New York and Venice, and with the use of rented rather than donated office space. Such changes occurred in tandem with the diversification and increased size of the board, as well as a stronger public presence. In recent years SV has engineered more success in fundraising and an increased scale and scope of restoration projects, often with several major conservation treatments taking place simultaneously. While it may be true that SV has evolved in terms of *how* it conducts its operations, and the scale at which such restorations occur, the core mission and functions of the organization have not changed in any significant way.

Why has SV been so successful and for so long? Compared to many charitable efforts that respond to disaster and wind down operations after a few years, it is flourishing half a century later. My research points to about a dozen factors that have propelled SV to its current position as the largest and most influential of the twenty or so private committees that support historic preservation in Venice.

The first reason is a clear and unwavering sense of mission that began with John McAndrew's efforts in the late 1960s. SV has remained focused on preserving and protecting the artistic heritage of Venice and its lagoon. Unlike Venice in Peril, it has not been sidetracked into larger environmental and sociopolitical issues. Nor has it chosen to extend its reach to the far corners of the former Venetian Empire, as Venetian Heritage elected to do, or to the entire globe, like the World Monuments Fund. Instead, SV has kept its aim squarely on the conservation of art and architecture in the *centro storico*. As past president Richard Almeida put it, SV has sought to "stay in its lane" and to leave the broader issues (e.g., housing policy, *acqua alta*, or over-tourism, however urgent they may be) to Venetians and elected officials.[4] The sums required to address those larger issues are enormous and far beyond the means of SV, given that well over 5 billion euros have been spent in designing and constructing MOSE alone. At the same time, SV's emphasis on art conservation may spur others to address other challenges. As chair Frederick Ilchman has argued, "Prudence might dictate moving some of Venice's greatest treasures to the mainland, far from the encroaching sea. For example, the contents of the Accademia could be moved to the Brera, and the Ca' d'Oro transferred, stone by stone, to Padua. But this would only leave a hollow Venice, one not meriting extraordinary measures. If Save Venice can keep this city as intact as possible, it will be imperative for governments local, national, and international to do their part."[5]

The second reason for success is strong executive leadership at both the corporate and chapter levels. SV has benefited from a series of charismatic and visionary leaders at the top, along with equally competent and passionate chapter chairs in Boston, New York, and Los Angeles. Those leaders have been able to attract significant support from their friends and from a broader pool of members, foundations, corporate sponsors, and other nonprofits; they have also been successful in identifying and promoting effective staff members. As suggested above, these leaders frequently combined scholarly, institutional, and social agendas in ways that appealed to a broad demographic and offered a template for their successors.

A third reason is the scholarly expertise that SV has always brought to bear on its work. The initial leaders of the organization were chiefly professors and curators with deep knowledge of Italian art history. In recent decades the leadership has come more from the worlds of business, medicine, and philanthropy. Yet the presence of eminent scholars within SV has never wavered, and the Projects Committee in particular has been able to draw from a group of committed academicians, curators, and museum directors for advice. Other private committees may have a

respected scholar or two, but SV generally has a half-dozen or more. This concentration of experts enhances the credibility of the organization and reassures donors that the conservation projects are well-chosen.

A fourth reason is the engagement, size, and unity of the board of directors. Unlike many nonprofits where the board plays more of a passive or advisory role, SV's board has always been deeply involved in all decisions and in their execution. It picks the restoration projects and follows their progress; it approves the location and theme of all major fundraisers; it oversees the educational mission inherent in lectures and excursions. The executive director and staff have been tasked with carrying out the will of the board, rather than setting the agenda for it. As we have seen, the unusually large size of the board in the twenty-first century has been a critical factor in raising revenue from board members and from their social networks. Furthermore, the board has demonstrated cohesiveness, enthusiasm, and loyalty, with the directors observing how the board resembles an extended "family" that gathers year after year, combining business and pleasure. Although many nonprofits insist on term limits, their absence within SV has promoted a strong sense of familial connection and continuity. The emphasis on family has been evident in a literal sense too, as board members have made a practice of bringing spouses, parents, and children to the Venice galas and to other events, an approach that several directors have pointed out is unusual for a nonprofit. At least one current director is the child of a board member, and a number of the Young Friends group are children of board members.

Fifth, SV has been effective in leveraging its local connections to become part of the Venetian setting. McAndrew, Hadley, and successive leaders have utilized their friendly relationships with superintendency officials, restorers, and a wide variety of residents to facilitate the group's work. One of the three board meetings a year is generally held in Venice. A number of board members have maintained residences in Venice, often for many years. Above all, the presence of a permanent staff in Venice has been a critical part of that reliability and consistency, from Marialuisa Weston in 1975 to Melissa Conn today. Just as the New York office maintains relationships with donors, the Venice office fosters collaborations with numerous Venetian individuals and entities. Such local connections have been critical for the other private committees too, and those with long-term staff in Venice (e.g., Venice in Peril, Venetian Heritage) have been the most successful. SV, however, probably maintains the largest presence, including fellows and interns as well as the Rosand Library and Study Center. In early 2021 Save Venice created a new

subcommittee, Save Venice–Italia, led by Alberto Nardi, to seek more supporters and advocates from Venice and the Veneto.

Sixth, the intangible allure of Venice itself has been essential, with SV providing an outlet for that devotion. As expressed by executive director Amy Gross, Save Venice enables a favorite city to become someone's cause. The enduring fascination with Venice, combined with social opportunities and more than a whiff of glamor, have persuaded many donors and members to remain with the organization for years. A seventh reason behind SV's ability to attract and retain its audience has been its balance between accessibility and exclusivity—the former through news-letters, lectures, memberships, and the website, which are available more broadly, and the latter through ticketed events and the corresponding insider access to Venetian palaces, museums, and restoration sites.

A consistent track record over five decades represents another factor in the suc-cess of SV. The organization has been remarkably prescient in picking projects, large and small, that can be fully completed. SV has almost never fallen short in raising the required funds in time or adopted a project too ambitious for the skills and technology of the conservators. A reputation as a thoughtful, effective, and reliable partner in historic conservation means that Venetian institutions often turn first to SV. Integral to this positive reputation (and the ninth reason on my list) is a tradition of fiscal discipline. In the absence of a permanent endowment, SV has for years maintained a three-year reserve of operating expenses plus funds to cover all conservation commitments, thus ensuring that no project has ever been abandoned due to financial exigency.

Paradoxically, a tenth cause of Save Venice's achievements has been the terrible floods of 1966 and 2019, and the degradation of Venetian art and architecture more generally, which continue to galvanize supporters. The threats to the Venetian pat-rimony are not disappearing, nor is the willingness of SV supporters to address them. As Alexis de Tocqueville observed during his tour of the United States in 1831, Americans have a propensity to see a problem and form an association to solve it. (Or as Bob Guthrie put it more bluntly in his remarks to the board in 1991, Americans have an "incurable disease" of feeling that they have the answers to everyone's problems.)[6]

An additional factor is that SV has been willing and able to evolve its operations and personnel. Every organization needs to refresh its leadership and tactics from time to time. The galas in Venice, for example, have rotated from one historic event to another (e.g., Regatta Week, Carnevale, Biennale), just as the balls in New York,

Boston, and Los Angeles have regularly shifted their themes and locations. The excursions led by the Guthries began as longer-term and larger-capacity outings, but in recent years have been condensed into shorter trips for fewer participants. The various approaches employed by the Young Friends provide further examples of this adaptability. Just as it has varied its fundraising formula, SV has been successful at identifying new members and new leadership on a regular basis.

A final reason for the success of Save Venice lies in its very structure, the sturdy institution of the American 501(c)3 organization. Observers from de Tocqueville to the present have seen such associations as characteristic of the American outlook. Today such groups incorporate common features, beginning with a deduction for federal taxes, a powerful incentive for many donors. The federal government in turn requires regular disclosures of financial information from all 501(c)3 organizations to maintain tax-deductible status, ensuring transparency and honesty. American non-profits combine several kinds of dedicated stakeholders: a volunteer board, a paid staff, and diverse volunteers, all of whom consider their efforts to be a calling. The board itself is subdivided into committees and governed by by-laws and charters, thus achieving a variety of checks and balances and a respect for procedures. These conditions privilege stability and longevity yet also allow a measure of flexibility to adapt as conditions change. Nonprofits like Save Venice have honed methods for raising funds, including organizing ticketed galas, selling memberships, running capital campaigns, establishing planned giving programs to encourage bequests, developing extensive systems of donor recognition and naming rights, and much more. Recalling the mixed charitable and social aims of the *scuole grandi* of Renaissance Venice, serving today as an officer in a nonprofit organization in the United States is typically seen as a prestigious, community-oriented activity.

This profound sense of calling is felt by the board and staff, as well as by scores of individual supporters, in their efforts to merge professional and volunteer spheres. The American poet Robert Frost saw wisdom in combining work and play:

> My object in living is to unite
> My avocation and my vocation[7]

For the SV family, these efforts are a shared enterprise. They also offer an ongoing reward. Many on the board have served two decades or more, not wavering in their commitment to the mission. The strict term limits and rotation of officers required by other groups would probably suppress this dedication and work against

the organization's long-term success. Of course, SV offers a particularly successful example of a 501(c)3, but the formula of the American nonprofit provides an excellent starting point.

A corollary to the tendency of U.S. citizens to immerse themselves in charitable activity is another American characteristic: a deep faith in the power of capitalism. Government and business leaders have long advocated for capitalist competition, the efficient allocation of resources, the fostering of innovation, and the notion of comparative advantage, ascribing to the tenets of classical economics in Adam Smith's *The Wealth of Nations* (1776) and David Ricardo's *On the Principles of Political Economy and Taxation* (1817), for example. A claim that nonprofits admire capitalism may seem paradoxical in that they do not aim to earn a profit and repay investors. Rather, supporters of charities understand that competition requires each nonprofit to operate at a high level. Each association must secure supporters, raise money, and fulfill its mission(s), often refining goals to serve a niche better than other groups can. Organizations compete within their sector and across nonprofits generally, vying for dollars, donors, and attention. Those that consistently accomplish their goals are able to enlarge their family of supporters, raise more money, and in turn do more good, creating a virtuous cycle.[8] By contrast, organizations that consistently lag, run deficits, or become corrupt deserve to lose their tax-deductible status and go out of business.

Save Venice has flourished by balancing its charitable mission with certain aspects of the capitalist mindset. The presence of other organizations in its sector, from the World Monuments Fund to Venetian Heritage to Friends of Florence, has pushed SV to work harder to raise money, communicate effectively with supporters, increase its presence in Venice, and so on. Frederick Ilchman has observed that the many other groups working on behalf of Venice, including those not chartered in the United States, such as Venice in Peril or the Stichting Nederlands Venetië Comité, "keep Save Venice on our toes. We all feed off the energy of other groups. We need to be ambitious and claim the great restoration projects to remain on the forefront."[9] The growth of SV over recent decades can be attributed in part to this competitive desire to seize opportunities in order to increase the prominence of the organization and do as much as possible for Venice.

For a city that has survived plague, invasion, conquest, and flooding over more than sixteen centuries, the most recent fifty years is a remarkably brief span. Yet the period since 1966 has been momentous in its own way too, with milestone events and important developments sandwiched one after another. The good news includes increased interest in the fate of Venice around the world and the influx of

money (both domestic and foreign) for restoration and infrastructure. The manifestations of the Biennale, including the Festival del Cinema, are internationally recognized cultural events. Ca' Foscari has become an important Italian university, and Venice remains a popular tourist destination. The long-awaited success of the mobile sea barriers (MOSE) in 2020 should slow the incidence of the most drastic cases of *acqua alta* for at least two decades. Establishment of a doctoral program in Science and Management of Climate Change at Ca' Foscari (2007), the creation of a Climate Policy Initiative office in Venice (2010), and the opening of a Euro-Mediterranean Center on Climate Change in Marghera (2018) all suggest that Venice can continue to innovate in response to contemporary concerns, and demonstrate that Venice's problems are not *sui generis* but indeed are related to those the world over. The private committees have raised the profile of cultural heritage and conservation, with deep-pocketed corporate sponsors sometimes picking up the tab on restoration costs. Venetian monuments and buildings, and their contents, are cleaner and more stable than they have been for decades.

On the other hand, a litany of problems and deep concerns remain about the future of Venice. Can it remain a viable city or is it condemned to become a "museum on the sea"? How can the city reverse the depopulation that has thinned out its residents and skewed the population older? Will mass tourism engulf the city—or will pandemics and recessions reduce visitors to a point where the city cannot survive? What about flooding, sea rise, and climate change? These are weighty problems to be sure, but there is some cause for optimism, as Venetians and foreigners have pointed out in recent years.[10]

As Venice contemplates its future, the case study of Save Venice may help to identify what types of initiatives are more likely to succeed. The policies and procedures SV has adopted might provide other nonprofits and civic leaders with a roadmap for the future. In these closing paragraphs, I offer possible lessons from SV's example, both for the organization itself and for the city to which it has been devoted. If Venice is to be a vibrant, living city rather than a fragile reliquary, it must identify new ways to contribute and be relevant.

International collaboration will be essential to the future of Venice, as it has been for Save Venice. The Serenissima has a long history as an international entrepôt; merchants, sailors, students, craftsmen, and artists have all migrated to or passed through Venice. From the *scuole grandi* of the Renaissance to the study-abroad programs and training institutes of recent decades, the major institutions that have sustained Venice have always looked to new arrivals and to international cooperation.

Looking ahead, one might point to exhibitions, book fairs, commercial expositions, and conferences as means to bring higher-end, overnight visitors to Venice rather than the day trippers disgorged from buses or cruise ships. In an open letter to Venetian mayoral candidates in August 2020, art historian David Landau suggested that Venice could reinvent itself as a perennial "capital of European culture" on the model of the Edinburgh Festival, with a vibrant slate of musical, artistic, and other cultural offerings to attract international visitors year-round.[11] Landau mused that the dozens of grand *palazzi* within the city could provide splendid performing spaces for musicians, choruses, quartets, orchestras, actors, directors, designers, and so forth, who would participate in this rich cultural experience. Save Venice has limited its own intervention to historic preservation of artistic and cultural heritage but certainly has helped to restore churches, libraries, and museums that could complement the public and private palaces as venues. Many of these buildings are closed in the evening, and cultural performances would bring them to life after dark.

Climate change offers one specific theme where Venice should take a leading role; indeed, the examples cited previously of doctoral programs and climate centers established within the past decade indicate that the interest and political will already exist. Landau described options in this sector too, suggesting that every climate-related institution or organization around the world could be invited to transfer its headquarters to Venice, thus creating a central hub of climate science and policy. Landau advocated specifically for the transfer of climate-focused officials from the United Nations and European Union, hoping that the reality of wading through *acqua alta* to work might prompt progress in identifying solutions. The field of restoration ecology represents a related area where Venice's centuries-long experiment with managing the lagoon might be relevant for other regions attempting to "make nature whole" in response to human activity.[12]

Art conservation represents another area where the experience and expertise of Venetian residents might be leveraged for growth. The expansion of the Biennale and the Venice Film Festival have firmly ensconced Venice on the world stage for contemporary art. Currently, Italy has two main schools of art conservation, in Florence and Rome; might Venice become the host of a teaching institution to train conservators to deal with specialized issues of water and salt? Venetian restorers have been grappling with the adverse effects of the sea on art and architecture for generations (and perhaps centuries). Their expertise could be shared with other coastal cities in Europe and around the world. Young art conservators might come to Venice to train in an international laboratory specializing in maritime

conditions, and to use the city's abundant artwork and buildings as part of their training ground. Save Venice already serves as a conduit for funds to support training institutes, such as the Istituto Veneto per i Beni Culturali, and educational programs to increase the number of conservators within the city. Similarly, the restoration roundtables at the Rosand Library have served as a venue for disseminating cutting-edge practice. Perhaps the programs sponsored by SV could be replicated to create partnerships or internships for aspiring conservators.

Another proposal by Landau is to revive the island of Murano as a leading center of research and production in glassmaking, and simultaneously determine how to capture and recycle the enormous amount of energy expended in Murano's kilns. Still another is to leverage Venice's storied maritime history to create an enormous marina in Marghera for pleasure boats, and to construct the shipyards, docks, houses, and parks on the adjacent mainland, making this the largest marina in the Adriatic, if not the Mediterranean.[13] Given the growth in airports, train stations, and ports around the world, such an investment seems sensible, if it can be paired with manageable tourism. The network of civic museums in Venice offers still another opportunity to attract tourists, 2.1 million of whom visited in 2019. However, the decision by Mayor Luigi Brugnaro, faced with minimal tourist traffic during the pandemic, to close all those museums for three months at the start of January 2021 demonstrates how fragile these proposed solutions can be.[14]

A further idea to generate jobs is to make Venice an incubator for high-tech innovation. Former WMF president Bonnie Burnham and Cini Foundation conference members in 2016 advocated for "developing attractive research centers and creating incubators for start-ups and spin-offs," and suggested linking the unused space in the Arsenale with local universities and research centers.[15] Fabio Carrera, a native Venetian and a professor at Worcester Polytechnic Institute in Massachusetts, recently launched a startup factory in a former church on the island of Giudecca in a partnership with MIT. Both the Venice Project Center and the Serenissima Development and Preservation through Technology program (known as SerenDPT) aim to create jobs and new technologies in Venice, which will address some of the city's strategic problems, and then license those solutions to other cities.[16] The corporate accelerator VeniSIA, in collaboration with Ca' Foscari, is taking a similar approach.[17] In a world now comfortable with the concept of "remote work," Venice may be as good a base as any for many kinds of jobs. Waves of foreign residents have been absorbed into Venice over the centuries in other industries, so high-tech workers and their families could help repopulate the city

in the 2020s. Save Venice obviously has negligible experience in manufacturing, construction, or high-tech startups, but its story might exemplify some of the necessary characteristics for organizations to survive and prosper in Venice, especially if they are of foreign origin. The goal of all of these proposals is to generate jobs across multiple sectors by taking advantage of Venice's historic strengths and the beauty of its setting.

Given the continued decline in Italian government and corporate funding for the arts, it seems likely that more—not less—foreign assistance will be needed in the coming years. As noted, Save Venice has benefited from local staff and local allies, as well as a board that regularly visits the city and its restoration projects. Foreign organizations must be sensitive to the people, and not just to the buildings or artwork, that they are endeavoring to assist. Successful organizations in Venice must have a clear sense of identity and mission, rooted in past achievements and yet able to pivot when the situation demands. Those with an established record of accomplishment will be called first when disaster strikes, as occurred with the 2019 flood when Ambassador Armando Varricchio contacted SV as a partner to help the city. The result was the Immediate Response Fund, the #AmericaLovesVenice campaign, and more than $700,000 disseminated toward emergency needs in ground-floor spaces.

In the end, Venice's challenges are larger than any single organization can tackle. The city's residents have displayed creativity and resilience in the past when faced with disasters, suggesting they will find a way forward once again. The assistance of groups like Save Venice, the example they provide as nonprofits, and the goodwill for Venice around the globe, will help Venetians preserve their unique cultural patrimony. This collaborative sentiment was expressed in October 2021 by Frederick Ilchman at a ceremony in front of a recently conserved painting by Palma il Giovane in the church of the Frari. There he reflected on the achievements of Save Venice at its fiftieth anniversary:

> Over the course of five decades, Save Venice has sponsored the conservation of hundreds of objects across Venice and the lagoon. . . . These masterpieces of art and architecture have been preserved to fulfill a promise made in 1971 to protect the Serenissima for future generations. Tonight, in front of this magnificent painting and its altar and frame, I confirm that Save Venice will not forget our promises to Venice and to the citizens of this incomparable city. There is much more work to do, and together we will do it.[18]

Appendix
Officers of Save Venice Inc.

PRESIDENTS

John McAndrew (1971–73)
Rollin van Nostrand Hadley (1974–85)
Laurence D. Lovett (1986–89)
Randolph H. Guthrie (1990–97)
Paul F. Wallace (1998–2000)
John H. Dobkin (2001–2)
Beatrice Rossi-Landi (2003–6)
Sarah Schulte (2007–9)
Matthew White (2010)
Beatrice Rossi-Landi (2011–16)
Richard J. Almeida (2016–20)
Tina Walls (2020–present)

BOARD CHAIRS

John McAndrew (1975–78)
Rollin van Nostrand Hadley (1986–88)
Laurence D. Lovett (1989–97)
Randolph H. Guthrie (1997–2006)
Jesse Robert Lovejoy (2006–10)
Matthew White (2010–16)
Frederick Ilchman (2016–present)

EXECUTIVE DIRECTORS

Bruce Duff Hooton (1973)
Beatrice H. Guthrie (1988–98)
Tia (Fuhrmann) Chapman (1999–2001)
Michael John Dagon (2001–2)
Beatrice H. Guthrie (2003–5)
Elizabeth S. Makrauer (2006–13)
Amy Gross (2013–present)

Notes

INTRODUCTION

1. "Venice and Its Lagoon" (no. 394), UNESCO World Heritage Center, http://whc.unesco.org.

2. Salvatore Settis, *If Venice Dies*, trans. André Naffis-Sahely (New York: New Vessel Press, 2016); John Keahey, *Venice against the Sea: A City Besieged* (New York: St. Martin's Press, 2002); Caroline Fletcher and Tom Spencer, *Flooding and Environmental Changes for Venice and Its Lagoon: State of Knowledge* (Cambridge: Cambridge University Press, 2005).

3. I am grateful to Amy Gross, executive director of SV, for providing these figures in November 2021.

4. "To solicit and receive gifts, grants, contributions and bequests, and to perform services and engage in activities (such as the exhibition of works of art) which are designed to raise funds, all such receipts and funds to be used for conservation and restoration of works of art including paintings, buildings, sculptures, and decorative arts, in Venice, Italy, and for research and study pertaining to conservation and restoration of such works of art." See chapter 2 for more details on the founding charter.

5. Kevin C. Robbins, "The Nonprofit Sector in Historical Perspective: Traditions of Philanthropy in the West," in *The Non-Profit Sector: A Research Handbook*, 2nd ed., ed. Walter W. Powell and Richard Steinberg (New Haven, CT: Yale University Press, 2006), 13–31. See also Paul Vallely, *Philanthropy: From Aristotle to Zuckerberg* (London: Bloomsbury Continuum, 2020). For comparative and non-Western perspectives, see Warren F. Ilchman, Stanley N. Katz, and Edward L. Queen II, eds., *Philanthropy in the World's Traditions* (Bloomington: Indiana University Press, 1998).

6. Terisio Pignatti, ed., *Le scuole di Venezia* (Milan: Electa, 1981); Gianfranco Levorato and Orlando Barbaro, eds., *Scuole a Venezia, storia e attualità* (Venice: Digital Offset, 2008).

7. These and other primary sources are collected in Dwight F. Burlingame, ed., *Philanthropy in America: A Comprehensive Historical Encyclopedia* (Santa Barbara, CA: ABC Clio, 2004), 3:564–68, 570–74, 574–77.

8. Alexis de Tocqueville, *Democracy in America*, trans. Henry Reeve (1835; reprint London: Longman Green, 1862). The most relevant (and widely quoted) portion is vol. 2, book 2, sec. 2, chap. 5, "Of the Use Which the Americans Make of Public Associations in Civil Life." For a brief timeline of key events in the history of American philanthropy, see Burlingame, *Philanthropy in America*, 1:xxvii–xxxvii. For a chapter-length narrative, see Peter Dobkin Hall, "A Historical Overview of Philanthropy, Voluntary Associations, and Nonprofit Organizations in the United States, 1600–2000," in Powell and Steinberg, eds., *The Non-Profit Sector*, 32–65.

9. Andrew Carnegie, "Wealth," *North American Review* 148 (June 1889), 653–65, reprinted in Carnegie, *The Gospel of Wealth and Other Timely Essays* (New York: Century, 1901), 1–46.

10. Olivier Zunz, *Philanthropy in America: A History* (Princeton, NJ: Princeton University Press, 2012). See also Joel L. Fleishman, *The Foundation: A Great American Secret* (New York: Perseus, 2007).

11. Elizabeth T. Boris, "The Nonprofit Sector in the 1990s," in *Philanthropy and the Nonprofit Sector in a Changing America*, ed. Charles T. Clotfelter and Thomas Ehrlich (Bloomington: Indiana University Press, 2001), 6. For a recent critique of American philanthropy, see Emma Saunders-Hastings, *Private Virtues, Public Vices: Philanthropy and Democratic Equality* (Chicago: University of Chicago Press, 2022).

12. Boris, "The Nonprofit Sector," 12–13.

13. Boris, "The Nonprofit Sector," 9.

14. Boris, "The Nonprofit Sector," 6. "Charitable Giving Statistics," National Philanthropic Trust,

https://www.nptrust.org. As of 1 Dec. 2020, the NPT gave a figure of $449.64 billion in individual giving by Americans in 2019. One simple comparison would be that in 1971–72, John McAndrew and his colleagues collected about $200,000 while in 2017 SV received total contributions of almost $2.7 million. Save Venice Inc., Form 990, 2018, ProPublica, https://projects.propublica.org. Of course inflation must be factored in when calculating such numbers but the point remains that philanthropic giving has increased substantially.

15. International Council of Monuments and Sites (ICOMOS), "International Charter for the Conservation and Restoration of Monuments and Sites" (Venice, 1964), https://www.icomos.org; Cevat Erder, "The Venice Charter under Review" (self-published[?], Ankara, 1977), https://www.icomos.org; Matthew Hardy, ed., *The Venice Charter Revisited: Modernism, Conservation and Tradition in the 21ˢᵗ Century* (Newcastle upon Tyne: Cambridge Scholars, 2008).

16. For example, the APC organized on 1 Oct. 2020 a Study Day to discuss the necessity of a new charter that would prioritize urban culture and sustainable heritage tourism. My thanks to APC president Paola Marini for sharing this with me.

17. Liam Heneghan, "Can We Restore Nature?" Aeon, 15 Dec. 2020, https://aeon.co: "Our museums are full of objects that have their stories etched into their surfaces. The complex historical trajectory of a piece's cultural significance needs to be considered in conservation practice."

18. Heneghan, "Can We Restore Nature," observes that since 1994 the term "restoration" has not been used in the Code of Ethics and Guidelines for Practice of the American Institute for Conservation of Historic and Artistic Works. For a polemical summary of the case against restoration, see James Beck and Michael Daley, *Art Restoration: The Culture, the Business, and the Scandal* (New York: Norton, 1996).

19. Margherita Asso, [Preface], in *Venice Restored, 1966–1986* (Milan: Electa, 1991), 10–11. Nicknamed the "Iron Superintendent" for her steadfast opposition to development projects in Venice's historic center during her tenure at the Venetian Superintendency from 1982 to 1991, Asso in this preface wrote an impassioned plea for scientific research and knowledge as a necessary element of any restoration project.

20. Rollin van N. Hadley, "Venice Celebrates 20 Years since the Flood," SV Newsletter, Fall 1986, 2–3, SVNY. All of the SV newsletters are preserved in the SVNY and SVV offices. Hadley's brief article is descriptive rather than analytical.

21. John Berendt, *The City of Falling Angels* (New York: Penguin, 2005), 287–330. He relied chiefly on personal interviews with locals, including numerous Venetians and SV supporters; many of the conversations and events alleged by him cannot be verified.

22. Peter Fergusson, "Save Venice: The First Forty Years," in *Serenissima on the Charles* (Boston: Save Venice Inc., 2009), 1–6. Fergusson's essay draws from extensive personal experience, particularly his friendships with the founders, and from his own files but is limited in scope. In 2021 Fergusson was elected an honorary director of Save Venice.

23. "Save Venice," Wikipedia, https://en.wikipedia.org. This webpage was substantially expanded in June 2020.

24. The opinions and analysis expressed in this book are those of the author and do not necessarily reflect the official positions or views of Save Venice Inc. Nothing in the book should be construed as asserting or implying SV's authentication of the information presented nor of SV's endorsement.

25. Eric Dursteler, "A Brief Survey of Histories of Venice," in *A Companion to Venetian History, 1400–1797*, ed. Eric Dursteler (Leiden: Brill, 2013), 1–25.

26. Thomas F. Madden, *Venice: A New History* (New York: Penguin, 2013); Elizabeth Horodowich, *A Brief History of Venice: A New History of the City and Its People* (Philadelphia: Running Press, 2009); Joanne Ferraro, *Venice: History of the Floating City* (Cambridge: Cambridge University Press, 2012).

27. Margaret Plant, *Venice: Fragile City, 1797–1997* (New Haven, CT: Yale University Press, 2002).

28. Robert C. Davis and Garry Marvin, *Venice, the Tourist Maze: A Cultural Critique of the World's Most Touristed City* (Berkeley: University of California Press, 2004).

29. Stephen Fay and Phillip Knightley, *The Death of Venice* (New York: Praeger, 1976).

30. Peter Lauritzen, Jorge Lewinski, and Mayotte Magnus, *Venice Preserved* (Bethesda, MD: Adler and Adler, 1986).

31. Dominic Standish, *Venice in Environmental Peril? Myth and Reality* (Lanham, MD: University Press of America, 2012).

32. Settis, *If Venice Dies.*

33. John Millerchip and Leo Schubert, eds., *Un Restauro per Venezia* (Milan: Mazotta, 2006).

CHAPTER 1: ALLUVIONE

1. René Maheu, "Appeal of 2nd December 1966," UNESCO, https://whc.unesco.org.

2. Margaret Plant, *Venice: Fragile City, 1797–1997* (New Haven, CT: Yale University Press, 2002), 331–32, notes further that "it was in these years [1950s] that the tourists began the take-over of the city." On Tronchetto, see Mahnaz Shah, *Le Corbusier's Venice Hospital Project* (Farnham, England: Ashgate, 2013), 93n45.

3. "Popolazione Residente nel Comune di Venezia, 1871–2020," Comune di Venezia, Ufficio Statistica, Serie storiche miste, https://www.comune.venezia.it. This table is updated annually.

4. Plant, *Venice: Fragile City*, 314–25, 337–53.

5. Elisabeth Crouzet-Pavan, *Venice Triumphant: The Horizons of a Myth*, trans. Lydia G. Cochrane (Baltimore: Johns Hopkins University Press, 2002), offers a multilayered, thematic history of Venice and its environment from Roman times to the sixteenth century. Additional scholarship on the floods in Venice are in the following notes.

6. Massimo Roisin, "Aquagranda a Venezia: Cronaca di quel 4 Novembre 1966," Altritaliani.net, 30 Oct. 2018, https://altritaliani.net. My translation.

7. Peter Lauritzen, Jorge Lewinski, and Mayotte Magnus, *Venice Preserved* (Bethesda, MD: Adler and Adler, 1986), 34.

8. Stephen Fay and Phillip Knightley, *The Death of Venice* (New York: Praeger, 1976), 28. The authors do not identify the mayor, but it was likely Giovanni Favaretto Fisca (in office 1960–70).

9. John Pope-Hennessy, "Artistic Heritage Protection of Venice," *Bulletin* (New York: Metropolitan Museum of Art, 1968), 165–75, as cited in John H. Stubbs and Emily G. Makas, *Architectural Conservation in Europe and the Americas* (Hoboken, NJ: Wiley, 2011), 28. For more analysis of the flood, see Fabio Trincardi et al., "The 1966 Flooding of Venice: What Time Taught Us for the Future," *Oceanography* 29, no. 4 (Dec. 2016): 178–86; Caroline Fletcher and Tom Spencer, eds., *Flooding and Environmental Challenges for Venice and Its Lagoon: State of Knowledge* (Cambridge: Cambridge University Press, 2005); and Giulio Obici, *Venezia fino a quando?* (Padua: Marsilio, 1967; reprint, Venice: Marsilio, 1996). For a contrary view that the 1966 flood was "unexceptional," see Dominic Standish, *Venice in Environmental Peril? Myth and Reality* (Lanham, MD: University Press of America, 2012), 8–12.

10. Perhaps thirty to thirty-five people died in Florence itself, and the death toll from the flood overall was close to one hundred. The best studies of the flood are Helen Spande, ed., *Conservation Legacies of the Florence Flood of 1966* (London: Archetype, 2009), and Paul Conway and Martha O'Hara Conway, eds., *Flood in Florence, 1966: A Fifty-Year Perspective* (Ann Arbor: University of Michigan Press, 2018), both of which include first-person accounts as well as chapters on conservation practices, disaster preparedness, and cultural stewardship. Several commemorative books offer minimal text and abundant photos: Silvia Messeri and Sandro Pintus, *4 Novembre 1966: l'alluvione a Firenze* (Florence: Ibiskos Editrice Risolo, 2006) (bilingual text in Italian and English); Swietlan Kracyna, *The Great Flood of Florence, 1966: A Photographic Essay* (Florence: Syracuse University Press, 2006); and Erasmo D'Angelis, *Angeli del Fango* (Florence: Giunti, 2006). Note that the Florentine flood was caused primarily by rainfall whereas the Venetian flood was principally tidal.

11. Fay and Knightley, *The Death of Venice*, 42–45.

12. Standish, *Venice in Environmental Peril?* 6; Robert L. France, "*Acqua Alta*: Venice, the New Atlantis?" in *Handbook of Regenerative Landscape Design*, ed. Robert L. France (Boca Raton, FL: CRC Press, 2008), 21–32; Fay and Knightley, *The Death of Venice*, 25–32.

13. Caroline Fletcher and Jane Da Mosto, *The Science of Saving Venice* (Torino: Umberto Allemandi, 2004), 40. See also Fletcher and Spencer, eds., *Flooding and Environmental Challenges*. Plant, *Venice: Fragile City*, includes abundant Italian bibliography on the flood; see especially 358–62.

14. The term *angeli del fango* was coined by Italian journalist Giovanni Grazzini, "Si Calano nel Buio della Melma per Amore di Libri di Firenze," *Corriere della Sera*, 10 Nov. 1966, 1, praising young Italians who defied their previous reputation as cynical and self-interested by selflessly volunteering in Florence. Personal recollections and oral histories are gathered in Spande, ed., *Conservation Legacies*.

15. Messeri and Pintus, *4 Novembre 1966*; Spande, ed., *Conservation Legacies*; "1966 Flood of the Arno River," Wikipedia, https://en.wikipedia.org.

16. Founded in Rome in 1955 to protect that city's historic center, Italia Nostra created a chapter in Venice in 1959.

17. Standish, *Venice in Environmental Peril?* 15. See also France, *"Acqua Alta,"* 21. UNESCO established a Bureau de Liaison, initially in Rome in 1967 and then transferred to Venice in 1973, to ensure consistent communication with the Italian government.

18. Fay and Knightley, *Death of Venice*, 107–14. See also "Our History," Venice in Peril, http://www.veniceinperil.org.

19. Peter Fergusson, "Save Venice: The First Forty Years," in *Serenissima on the Charles* (Boston: Save Venice Inc., 2009), 1.

20. *Venezia Restaurata, 1966–1986: La campagna dell'UNESCO e l'opera delle organizzazioni private* (Milan: Electa, 1986), translated as *Venice Restored, 1966–1986: The UNESCO Campaign and the Contribution of Private Organizations* (Milan: Electa, 1991), which is the version that I cite hereafter. No individual author is listed for this book. On the private committees, see chapter 9.

21. "We Must Help Save Florence," *Life*, 2 Dec. 1966, 4.

22. The CRIA Archives are held at Harvard University's Villa I Tatti in Florence; see the electronic finding aid at http://nrs.harvard.edu. I am not aware of a good study of the history of CRIA.

23. Francesco Valcanover, [Preface], in *Venice Restored, 1966–1986*, 17.

24. *World Monuments Fund: The First Thirty Years* (London: Christie's, 1996), 10–14; John Julius Norwich, "WMF in Venice," *Icon*, Winter 2005–6, 18–20. In Jan. 2016 WMF archivist Margot Note sent me IFM newsletters from 1969–81 and 1984–85. Additional newsletters and "progress reports" from 1980–85 are preserved in "Venice Committee—IFM," SVB 3.5.7. Particularly useful are the opening pages of the 1985 IFM newsletter, which included Colonel James Gray's account of the origins of the IFM, written on the eve of his retirement (hereafter Gray, "Last Newsletter"). The WMF website (www.wmf.org) includes annual reports, magazines, and newsletters dating back to 1995 but not prior to that.

25. Gray, "Last Newsletter," 4. Gray noted that one month prior to the flood in Venice, he had "surveyed a number of *palazzi* with a view to creating what would be called an 'International Center For Venice' with a graduate study center and a focal point for research into the problems affecting Venice." However, wrote Gray, the $3 million needed was simply too much, and he shelved the idea.

26. McAndrew to Gray, 31 Dec. 1968, Correspondence, SVNY: "I have a few names of people who might contribute money, which I will send you when you think the time to start has come. I will send you also a list of those to whom I will write personally. I should think that no one would want to get a begging letter at the end of the holidays right now. If you have an idea of the ideal time to beg do let me know, and I will write a few very moving (I hope) letters."

27. IFM Newsletter, 31 May 1969, 6, recounts the foundation, early actions, and supporters of the VC. The two-year lapse between the floods and McAndrew's initial letter of 1969 is puzzling but the sources consulted do not explain the delay.

28. "Venice Committee (USA) Miscellaneous," 31 March 1969, SVB 3.3.2, O'Leary Library, University of Massachusetts Lowell. The title here refers to the folder name. The call number SVB 3.3.2 refers to series, box, and folder number (i.e., series 3, box, 3, folder 2). The folders and items inside the folders are in the original order according to the donor.

29. Gray, "Last Newsletter," 4.

30. IFM Newsletter, 31 May 1969, 6.

31. IFM Newsletter, 31 May 1969, 6.

32. McAndrew to "Friend of Venice," n.d. (summer 1969), Correspondence, SVNY.

33. *World Monuments Fund: The First Thirty Years*, 10–11; "Countess Alessandra," *New York Times*, 6 Feb. 1971; James A. Gray, *The Walls of Verona* (New York: International Fund for Monuments, n.d. but 1969 or later). The title page says this fifteen-page booklet was "a brief of a study written in 1954"; a short note on the inside of the back cover explains that when the VC was being organized in 1969, it selected the anchor and dolphin symbol of Venetian printer Aldo Manuzio for its logo.

34. Quoted in Joan Huntoon, "Colonel James A. Gray, Cavaliere di San Marco," *Art Research News* 2, nos. 2–3 (1983): 15–16.

35. For an enthusiastic description of Gray, see Fay and Knightley, *Death of Venice*, 118–24, and *World*

Monuments Fund: The First Thirty Years, 10–14. Marilyn Perry, later the chair of the WMF from 1990 to 2007, recalled, "It was there, in 1970s Venice, that I first met Jim Gray. . . . He was tall and fair, with a military bearing and an energetic, purposeful, no-nonsense manner. Surprisingly (to me, an art historian), he took no particular interest in the artistic qualities of IFM projects—rather he saw his role as facilitator between the donor who financed and the superintendency that organized the work. What fascinated him—he was himself an inventor— were the actual processes of restoration." Perry, *Hadrian's Way: Creating World Monuments Fund, 1965–2015* (New York: World Monuments Fund, 2016), 12.

36. Gray, "Last Newsletter," 1; *World Monuments Fund: The First Thirty Years*, 10.

37. Gray, "Last Newsletter," 2–3. Both projects were curtailed when revolutionary governments came to power, although the IFM remained involved with Easter Island for years afterward.

38. On McAndrew, see Fergusson, "Save Venice," 2–3; Lee Sorensen, "McAndrew, John," Dictionary of Art Historians, https://arthistorians.info; obituary, *New York Times,* 20 Feb. 1978; obituary, *London Times*, 23 Feb. 1978; obituary, *Boston Globe*, 20 Feb. 1978; and tributes from Sydney Freedberg in the *Fogg Museum Newsletter* 15, no. 3 (April 1978): 6, and Freedberg, SV Newsletter, Winter 1979, 1, 3, SVNY. Mardges Bacon, *John McAndrew's Modernist Vision: From the Vassar College Art Library to the Museum of Modern Art in New York* (Princeton, NJ: Princeton Architectural Press, 2018), provides more detail about McAndrew's colorful career at Harvard, Vassar, and the Metropolitan Museum of Art, although it contains less than a page about his involvement with SV. McAndrew left more than a dozen incomplete curriculum vitae among his papers at Wellesley Special Collections, Wellesley College, Wellesley, MA, which have been used here to reconstruct his career.

39. Several of the McAndrews' longtime friends have confirmed to the author that Betty regularly explained the couple's outstanding art collection in this way: "It was John's eye and my money."

40. In recognition of her service to Venice, she was decorated by the Italian government at a ceremony in the Boston Athenæum in 1985; see Peter Fergusson to "Dear Sir" (probably editor of the *Boston Globe*), 21 Feb. 1986, SVB 4.6.6.

41. Fergusson, "Save Venice," 2.

42. Edgar Driscoll Jr., "Venice: Salt, Acids, Dampness Threaten Art Today—While City Fears Sinking Tomorrow," *Boston Globe*, 30 March 1969.

43. John McAndrew, *Venetian Architecture of the Early Renaissance* (Cambridge, MA: MIT Press, 1980).

44. McAndrew to Hadley, 21 July 1972, Correspondence, SVNY. Hadley was the director of the Isabella Stewart Gardner Museum and chair of the Boston chapter of SV.

45. McAndrew to Gray, 31 Dec. 1968, Correspondence, SVNY. McAndrew praised Light as "a well-known and important dealer with an excellent reputation." Light agreed to forgo his commission and donate the costs of producing and distributing the catalogue.

46. McAndrew to Gray, 31 Dec. 1968, Correspondence, SVNY. Attached to that letter is a memorandum for record by Gray, dated 23 Jan. 1969 in Boston, wherein he confirmed the details in McAndrew's letter. See also "Drawing and Prints to Aid Venice," ca. 1969, Correspondence, SVNY, a one-page "fact sheet" with similar details. The catalogue enjoyed considerable success but the proceeds were disputed when McAndrew and the IFM later parted ways; see Muriel Howells to Charles Grace, 24 Aug. 1972, SVB 3.5.7, where Howells (chair of the New England chapter of the VC) expressed to IFM Chair Grace her disappointment in the allocation of the proceeds from Light's catalogue, and the rebuttal of Grace to Howells a week later (Grace to Howells, 30 Aug. 1971, Correspondence, SVNY), citing numerous other documents as evidence that the funds were always destined for the IFM General Fund. The issue was resolved in a 20 Oct. 1971 letter from Howells to Grace (SVB 3.5.7) with a compromise, but that same letter terminated all connections between the New England chapter of the VC and the IFM.

47. McAndrew to Gray, 31 Dec. 1968, Correspondence, SVNY.

48. SV Newsletter, Fall 1975, 3, SVNY.

49. Francesco Valcanover, "The Role of Save Venice," *Gala Journal,* 1987, n.p. [10–15], SVV. The *Gala Journal* was a glossy magazine produced by SV on the occasion of each biannual Venice Gala beginning in 1987; from 1987 to 2008 SV also published the scholarly articles from each *Gala Journal* as a separate booklet, entitled *Studies in Venetian Art and Conservation.* Some of these articles are online under "Conservation Archives" at https://www.savevenice.org. On the Madonna Nicopiea, see Melissa Conn and David Rosand, eds., *Save Venice Inc.: Four Decades of Restoration in Venice* (New York: Save Venice Inc., 2011), 308–9.

50. McAndrew to Gray, 31 Dec. 1968, Correspondence, SVNY. The letter is one of several attached to a letter from art dealer Robert M. Light of Boston to Gray, dated 25 Aug. 1971. McAndrew wrote, "Just after speaking with you yesterday afternoon, I had a call from Robert Light, who has found that he can sell all the prints and drawings fairly quickly. Before he disposes of any, however, he would like a letter from you (since the works now belong to the IFM) authorizing him to proceed. He will buy outright, to put in his firm's stock, the Picasso, the two Vuillards, and the Klee lithograph for $10,000 and send you a check. I took the liberty of telling him to send you a check for each sale of the remaining works as soon as he sells them, and hope that is satisfactory to you. After all, the pictures are now yours and not mine."

51. It may never be possible to estimate how much the McAndrews donated to SV, for they regularly did so anonymously as well as making numerous in-kind donations. It is also clear that they played a leadership role in soliciting donations from affluent friends.

52. IFM Newsletter, 31 May 1969, 6.

53. "40 Years of WMF in Venice," *Icon,* Winter 2005–6, 21–22; Conn and Rosand, eds., *Save Venice Inc.: Four Decades,* 458.

54. Richard J. Goy, "Matteo Raverti at the Ca' d'Oro: Geometry and Order in Venetian Gothic Tracery," *Renaissance Studies* 8, no. 2 (June 1994): 115–37.

55. IFM Newsletter, 30 April 1970, 1. The newsletters do not specify the number of donors nor of members, but "Donors to Venice Committee," 15 May 1970, SVB 3.3.2, lists twenty-one names and the amounts given in 1969, and a letter from James Gray to VC supporters of 30 April 1970 mentions substantial donations from the Edgar J. Kaufmann Charitable Trust and expected contributions from various U.S. chapters, another anonymous foundation, and the Comitato Italiano per Venezia organized by Anna Maria Cicogna, Ida Borletti Noble, and Bruno Visentini. I am grateful to Margot Note for sharing with me some of Gray's professional correspondence.

56. Mary Leonard (secretary, Kaufmann Foundation) to James Gray, 20 Oct. 1970, SVB 3.3.11, regarding reporting requirements for the initial $50,000 disbursement. The Kaufmann Trust eventually donated $260,000 to the IFM for the Tintoretto restoration.

57. IFM Newsletter, 28 April 1981.

58. IFM Newsletter, 31 May 1969; 30 April 1970.

59. "Chapters of Venice Committee," 1 Feb. 1970, on IFM letterhead, SVNY; this document is attached to Robert Light to Gray, 25 Aug. 1971, SVNY.

60. "Chapters of Venice Committee," 1 Feb. 1970, SVNY.

61. Henry J. Seldis, "L.A. Helping to Save Venice Treasures," *Los Angeles Times,* 25 Oct. 1970; IFM Newsletter, 30 April 1970, 2. Subsequent IFM newsletters track the progress of San Pietro di Castello. The Los Angeles chapter later wanted to switch from IFM to SV but it could not be done until completion of the San Pietro di Castello project; see Vandervoort to Board of Directors, 24 Jan. 1975, Correspondence, SVNY. On Murphy, who served as chancellor of the University of Kansas, chancellor at UCLA, and president of the Kress Foundation, see the Franklin D. Murphy Papers, 1948–94, UCLA Special Collections, Los Angeles. On Seldis, a longtime art critic, lecturer, and author of a book on the sculptor Henry Moore, see his obituary in the *New York Times,* 28 Feb. 1978. As of 2022, Terry Stanfill retains the title of vice president emerita for SV; her contributions are discussed later in the book.

62. "Art News from Colleges and Elsewhere," *Art Journal* 30, no. 1 (Autumn 1971): 92–93.

63. Seldis, "L.A. Helping."

64. Terry Stanfill, interview with author, 27 Feb. 2015.

65. Seldis, "L.A. Helping."

66. The precise founding date of the New England chapter (later called the Boston chapter) of VC is unclear. It must have been established after Feb. 1969 (when the VC first met) and prior to April 1970 (when the chapter announced its "red carpet" tour). Muriel Howells wrote to Charles Grace on 24 Aug. 1971 that "the New England Chapter was functioning *long before* October 6, 1970 when the name was changed to the Boston chapter and the present officers were elected." Howells to Grace, 24 Aug. 1971, Correspondence, SVNY.

67. Chapter officers were elected at the annual meeting in Cambridge. "Venice Committee—Boston Chapter, Minutes," 6 October 1970, SVB 3.5.9.

68. IFM Newsletter, 30 April 1970, 2, 4; Howells to "Friend of Venice" (on VC-IFM letterhead), n.d., SVB 3.3.2.

69. "Venice Committee—Boston Chapter, Minutes," 24 Sept. 1970, SVB 3.5.9. Kathleen Wick and her husband, Peter, were two of the cofounders of SV in December 1971, as detailed in chapter 2.

70. "Venice Committee—Boston Chapter, Minutes," 6 Oct., 10 Nov. 1970, SVB 3.5.9.

71. "Venice Committee—Boston Chapter, Minutes," 6 Oct. 1970, SVB 3.5.9.

72. IFM Newsletter, 30 April 1970, 2, 4, for the initial announcement; "Venice Committee—Boston Chapter, Minutes," 24 Sept., 10 Nov. 1970, SVB 3.5.9.

73. Virginia Murray Bacon (Mrs. Robert Low Bacon) was a venerable figure; a 1980 obituary described her as "a Washington landmark, a link between generations, and a monument to style and accomplishment." Martin Weil, "Mrs. Robert Low Bacon, Hostess, Patron of Arts," *Washington Post*, 26 Feb. 1980. Other founding members of the DC chapter included professor of architectural history Mario di Valmarana, biochemist Giulio Cantoni, and Giulia Ortona, the wife of career diplomat and Italian ambassador to the United States Egidio Ortona.

74. "Venice Committee—Washington Chapter," Eleanor Garvey to Bacon, 11 June 1971, SVB 4.8.2, with an accounting of receipts and disbursements for 1970–71 for the Washington chapter; Bacon to members of the Washington Chapter of the VC-USA, 23 June 1971, SVB 4.8.2, noting a net profit of $31,231. A letter of 23 June 1971 from Garvey to Bacon confirmed a deposit to the VC-USA of $34,522, in addition to the earlier deposit of $4,500, all credited to the Washington chapter. Another letter on the same date from Garvey to Janet Adams (Mrs. W. Howard Adams) in DC thanked her for "a splendid job in making the lists and keeping track of all the details of this vast undertaking," which Garvey termed "a great success in every way." Note that by late 1971 the Washington chapter (like Boston and others) had broken away from the IFM and affiliated with McAndrew.

75. For Cleveland, see SV Board minutes, 8 Feb. 1972, SVB 3.1.1; for Pittsburgh, SV Board minutes, 9 Dec. 1971, SVB 3.1.1; for New Orleans, SV Board minutes, 23 Nov. 1971, SVB 3.1.1. Chapter activities are also discussed in the IFM Newsletter, 30 April 1970, 2. A possible chapter in Denver was discussed in correspondence between Eleanor Garvey and Elizabeth Blow, 22, 27 July 1971, SVB 3.5.7.

76. IFM Newsletter, 30 April 1970, 2: "We like to believe that the establishment of the Venice Committee and its auspicious beginning was instrumental in the formation of other national committees trying to help Venice." On the other private committees in Venice, see chapter 9.

77. IFM Newsletter, 30 April 1970, 2, 4.

78. IFM newsletters for 1971–79 describe in detail the various restorations sponsored by the VC.

79. Freedberg graduated from Harvard in 1939 and taught art history there for nearly three decades (1954–83). He published monographs on Parmigianino (1950) and Andrea del Sarto (1961) and is best known for his survey *Painting in Italy: 1500–1600* (Harmondsworth, England: Penguin Books, 1971). See Holland Cotter, "Art Historian Sydney Freedberg Dies," *New York Times*, 8 May 1997. A few of Freedberg's papers are preserved at the Harvard University Archives, Cambridge, MA, but nothing related to SV. See also SV Newsletter, Autumn 1989, 12, SVNY, regarding Freedberg's retirement from the SV board.

80. 1969–71, Correspondence, SVNY.

81. McAndrew to Freedberg, 31 May 1969, Correspondence, SVNY: "[I have] recently written Gray a rather sharp bit to stop the circulation of the piece in the Globe some weeks ago, and to stop listing me as chairman." Driscoll, "Venice: Salt, Acids, Dampness Threaten Art Today," lionized McAndrew and included a photo of him, as well as dire predictions about the risks faced by Venice.

82. Freedberg to Merrill, 8 Sept. 1969, Correspondence, SVNY. An educator, author, and philanthropist, Charles E. Merrill Jr. was the son of the founder of Merrill Lynch. A Harvard graduate who served in the army during World War II, Merrill Jr. founded the Commonwealth School in 1958 and remained as headmaster until 1981. He also served as chair of the Charles E. Merrill Trust, which made the donation to SV.

83. Merrill to Freedberg, 20 April 1970, Correspondence, SVNY; IFM Newsletter, 27 April 1971, 2. In a letter to McAndrew, Freedberg described the letter from Merrill as "a rocket."

84. James Gray, "Memorandum for Record, Conversations in Washington D.C. on Jan. 21–22, 1970," and "Memorandum for Record, Conversations in Italy, Feb. 1970," Correspondence, SVNY. In addition to Valcanover and Padoan, Gray met with Terisio Pignatti, Alessandro Marcello, Barry Hannegan, and representatives of Gladys Krieble Delmas; he also visited multiple restoration sites and recorded a series of teas, cocktails, and dinners with Venetians.

85. McAndrew to "Colleagues," 16 April 1970, Correspondence, SVNY: "Let there be more suggestions, more ideas. There was little or no enthusiasm."

86. Freedberg to Gray, 12 May 1970, Correspondence, SVNY.

87. McAndrew to Freedberg, 8 Oct. 1970, Correspondence, SVNY. McAndrew's reference to "ours" appears to refer to assistance from the VC, although it could be read as referring to Palazzo Barbaro.

88. SV would come to adopt this same policy in subsequent years.

89. The sources are limited for understanding Gray's motivation and state of mind in the late 1960s and early 1970s. I have reviewed his correspondence with McAndrew and many of his IFM newsletters as well as the celebratory volume *World Monuments Fund: The First Thirty Years* but I know more about McAndrew's perspective.

90. Peter Fergusson has observed that McAndrew resented Gray's attempts to shift money from Venice to restorations elsewhere, but the documents I have read offer no evidence of this. Rather, the record suggests that their differing assessments of what needed to be done in Venice drove them apart. Peter Fergusson, interview with author, 14 Oct. 2019.

CHAPTER 2: NASCITA

1. For an overview of UNESCO's actions, see Rolande Cuvillier and Edward Thompson, *UNESCO for Venice: International Campaign for the Safeguarding of Venice (1966–1992) Review of Results* (Rome: Council of Ministers, 1993). The epigraph at the beginning of this chapter comes from "Preservation and Restoration of Monuments and Works of Art," Office of Director-General of UNESCO (24 June 1969), Annex E, para. 1–3, quoted in Cuvillier and Thompson, *UNESCO for Venice*, 78n36.

2. Margaret Plant, *Venice: Fragile City, 1797–1997* (New Haven, CT: Yale University Press, 2002), 355–75, discusses the pessimism and despair of the 1970s and includes citations for all of these works.

3. SV Board minutes, 12 Dec. 1970, SVB 3.1.1. The minutes of this first board meeting bear the title "Venice Committee (USA Corp), First Meeting of Incorporators." Its purpose was to establish the corporation by approving the agreement of association and the by-laws as well as electing a chair, clerk, treasurer, and eight directors. A second meeting, entitled "Special Meeting of the Board of Directors," was held immediately afterward in the same room with the same participants to create a corporate seal, open a checking account, and ask the IRS for tax-exempt status as a 501(c)3 corporation. Subsequent meetings in 1971 were described as meetings of the "Directors" or "Members" but in reality it was the same small group each time. By early 1972 the attendees are generally referred to as "Board of Directors," and I refer to their proceedings as "SV Board minutes" thereafter.

Peter A. Wick earned a B.F.A. from Yale and an M.A. from Harvard, served in the U.S. Navy during World War II, and was a curator in the print departments at the Boston Museum of Fine Arts, Fogg Art Museum, and Houghton Library; he was also a noted connoisseur and collector of rare nineteenth-century illustrated books. See his obituary in the *Boston Globe*, 18 Dec. 2004, and in the *Beacon Hill Times*, 11 Jan. 2005. His wife, Kathleen Wick, was a master bookbinder and a Francophile who studied in Paris and spent many summers there; see her obituary in the *Boston Globe*, 4 Dec. 1997. Eleanor M. Garvey graduated from Wellesley College in 1940 and joined the Department of Printing and Graphic Arts at Houghton Library in 1953, becoming chief curator in 1975 and retiring in 1990. Like Peter Wick, she was an internationally recognized expert on printing and a member of the Grolier Club; see her obituary in the *Boston Globe*, 6 April 2013, and a remembrance by Hope Mayo at the Houghton Library Blog, "Eleanor Martha Garvey, 1918–2013," 21 Feb. 2013, https://blogs.harvard.edu. Stuart R. Johnson was an attorney with Herrick, Smith, Donald, Farley & Ketchum of Boston, at 294 Washington Street; he and Thomas J. Kelly served as attorneys for SV until the mid-1980s. The designated headquarters of the organization was initially specified in 1971 as McAndrew's house at 107 Dover Road in Wellesley, later transferred to Harvard University in 1972, and thence to New York; "Certificate of Change of Principal Office," 12 Dec. 1972, SVB 3.4.10.

4. "Agreement of Association," 1, in SV Board minutes, SVB 3.1.1. This document, and other important papers such as corporate resolutions or applications or certifications, are regularly interfiled with the SV Board

minutes. Beginning in 1986, such documents are more often described as "Attachments." I identify both the name of the document and the date and location of the minutes where it can be found.

5. SV Board minutes, 12 Dec. 1970, SVB 3.1.1; "Corporate Resolution for Opening and Maintaining a Corporate Checking Account," 12 Dec. 1970, in SV Board minutes, SVB 3.1.1.

6. Walter Bareiss (1919–2007) was a Swiss textile manufacturing businessman and art collector who served the Museum of Modern Art (MoMA) in New York as trustee (1964–73), interim director (1969–70), and member of the committee of prints and drawings (1972–2003); he was particularly fascinated with African art but also collected classical Greek ceramics, Japanese pottery, and contemporary American and European art. Presumably his connection to McAndrew was through MoMA or as art collectors. Bareiss would play a fundamental role as SV's vice president for more than fifteen years; his financial acumen, European connections, and attention to detail were crucial for SV's success. See his obituary by Holland Cotter in the *New York Times*, 27 April 2007.

7. Bareiss to Gray, 30 Dec. 1971, Correspondence, SVNY. In this letter, Bareiss summarized the conversation of 16 Dec. and reiterated the demands of the VC-USA.

8. Bareiss to Gray, 30 Dec. 1971, Correspondence, SVNY.

9. Gray to Bareiss, 4 Jan. 1971, Correspondence, SVNY.

10. Gray to Bareiss, 8 Jan. 1971, Correspondence, SVNY. On behalf of the IFM executive committee, Gray declared that the current IFM by-laws "establish adequate support and guidance for Venice Committee" and that the current procedure "is a clear and proven formula for the operations of Venice Committee chapters."

11. Bareiss to Gray, 1 April 1971, SVB 3.3.4; Charles M. Grace to Freedberg, 6 April 1971, Correspondence, SVNY.

12. Grace to McAndrew, 5 April 1971, Correspondence, SVNY. The following day, Grace wrote to Freedberg to explain that the resignations of McAndrew and Bareiss had been accepted. Grace to Freedberg, 6 April 1971, Correspondence, SVNY.

13. Freedberg to Grace, 12 April 1971, Correspondence, SVNY. Harvard architectural historian James Ackerman sent a similar letter on the same day noting, "I intend to stay on his team." Ackerman to Grace, 12 April 1971, Correspondence, SVNY.

14. SV Board minutes, 26 April 1970, 3, SVB 3.1.1; Freedberg to Grace, 12 April 1971, Correspondence, SVNY, describing his "great distress" at the separation between the VC-USA and the IFM.

15. "New Co-Chairmen," IFM Newsletter, 27 Apr. 1971, 6. Replacing McAndrew and Bareiss were IFM trustees James Grote Van Derpool (1903–1979) and Louis Bancel LaFarge (1900–1989). Van Derpool was an architectural and art historian at Columbia University as well as a librarian and preservationist, while LaFarge, a distinguished architect and Boston native, had played a critical role during World War II as a "monuments man" reclaiming art looted by the Nazis.

16. Howells told McAndrew that "the Cleveland chapter should definitely stay with you!" but that the St. Louis chapter under Paul Rava was "committed to IFM" owing to Gray's recent visit. Howells to McAndrew, 11 June 1971, Correspondence, SVNY. McAndrew responded to "let sleeping dogs lie" and that in the future he would revivify the St. Louis chapter. McAndrew to Howells, 16 June 1971, Correspondence, SVNY.

17. Howells to McAndrew, 11 June 1971, Correspondence, SVNY.

18. McAndrew to Howells, 16 June 1971, Correspondence, SVNY.

19. McAndrew to Garvey, 12 July 1971, Correspondence, SVNY. A year later McAndrew wrote to Hadley to express the hope that Gray might become interested in saving the Roman Forum and thus transfer his interests from Venice to Rome. McAndrew to Hadley, 21 July 1972, Correspondence, SVNY.

20. Howells to McAndrew, 23 July 1971, Correspondence, SVNY. In September 1971 the Boston chapter officially divorced itself from the VC-IFM. Howells to Grace, 2 Oct. 1971, Correspondence, SVNY. On Hadley, see the beginning of chapter 3.

21. Thomas B. Hess (1920–1978) rose from editorial assistant to executive editor to managing editor of *Art News* between 1945 and 1967; he also served as New York correspondent for *Le Monde*, published an important book in 1951 on abstract painting in America, and served as consultative chair for the Department of Twentieth-Century Art at the Metropolitan Museum of Art before his death, collapsing from a heart attack at his desk at the museum. See "Hess, Thomas B.," Dictionary of Art Historians, https://arthistorians.info.

22. SV Board minutes, 24 July 1971, SVB 3.1.1. The Washington, DC, chapter had a committee of Virginia Murray Bacon, Dr. Richard H. Howland, and Janet Woodbury Adams; the Los Angeles chapter had a committee of Terry Stanfill, Henry J. Seldis, Gifford Phillips, and Francesco Roselli Lorenzini. This special meeting also discussed "the present membership of the Board of Directors, the formation of a new General Committee, new writing paper, and certain projects which are in gravest danger, such as I Gesuiti, Palazzo Barbaro, Scuola Canton." In addition, the VC-USA board interviewed Sergio Pizoni-Ardemani as a possible executive secretary.

23. McAndrew to Garvey, 26 July 1971, Correspondence, SVNY. This is confirmed in "Venice Committee—Washington Chapter," 1 July 1971, Garvey to Jan Adams, SVB 4.8.2: "Mr. [Stuart] Johnson [lawyer for the VC-USA] suggests that the Washington chapter, having decided to join the VC-USA Corporation, take steps to make this affiliation an official one. This must be done with certain legal arrangements, and Mr. Johnson suggests that our chairman appoint a Washington lawyer to get in touch with him. Together they can initiate the necessary procedures."

24. McAndrew to Garvey, 26 July 1971, Correspondence, SVNY. On 1 Aug. 1971 McAndrew wrote to Howells, "The Atlanta chapter is well on its way; New Orleans may be; Miami wants to get one together; New York is forming; we are about to put out feelers to Chicago and San Francisco. . . . It will be a nice busy (and profitable?) fall." McAndrew to Howells, 1 Aug. 1971, Correspondence, SVNY. Bareiss on 10 June 1971 had filed an application to create a New York chapter of the VC; it was approved on 25 June 1971 by Judge Hyman Korn of the New York Supreme Court. "Venice Committee Application for Authority," 25 June 1971, SVB 3.3.5. Additional documentation about the creation of a New York chapter, including correspondence in July 1971 with attorneys and the court in New York, is preserved in SV Board minutes, 24 July 1971, SVB 3.1.1.

25. "Venice Committee (USA Corporation) By-Laws," 1971, in SV Board minutes, 12 December 1970, SVB 3.1.1. Circumstantial evidence suggests the by-laws were drafted by Stuart Johnson. There is no date, but McAndrew's reference to "By-Laws" in the Board meeting of 24 July 1971 indicates that they must have been completed prior to that date. The copy of the by-laws in SVB 3.1.1 originally bore the heading "Venice Committee (USA Corporation)" but that has been crossed out and in blue pen someone has written in "Save Venice, Inc." and the date "1971."

26. "Venice Committee (USA Corporation) USA By-Laws," sec. 6.5, "Respecting Certain Contracts," SVB 3.1.1.

27. "Venice Committee (USA) Corporation, Boston Chapter, Rules and Regulations," SVB 3.3.10.

28. Johnson to Hadley, 22 Sept. 1971, "History of Boston Chapter," Correspondence, SVNY.

29. The VC-IFM had a logo of an anchor intertwined with a dolphin, based on the impresa of Venetian Renaissance printer Aldo Manuzio. The general IFM logo was a pair of Ionic columns superimposed on top of a globe. The lawsuit against VC-USA appears to have been filed in July or August 1971; it was withdrawn in September 1971 as noted by Johnson in his letter to Hadley: "Now, to report on the Col. Gray suit, I have been informed by counsel in New York that this case has been settled. I also understand that part of the settlement package is that we are going to modify our name." Johnson to Hadley, 22 Sept. 1971, "History of Boston Chapter," Correspondence, SVNY.

30. Garvey to McAndrew, 7 May 1971, Correspondence, SVNY. Garvey credits Stuart Johnson with recognizing the conflict.

31. Garvey to McAndrew, 23 July 1971, Correspondence, SVNY. Antonio Visentini (1688–1782) was an eighteenth-century Italian architectural engraver and painter as well as professor at the Venetian Academy who specialized in issues of perspective; Garvey had studied his work carefully. The Battle of Lepanto (7 Oct. 1571) was a decisive victory for Venice and its allies in the Holy League versus the Ottoman Empire; it was a frequent point of celebration for Venetians. The "shaky polaroids" are not included in the extant correspondence that I have seen, but a letter from SV executive director Bea Guthrie to Garvey in 1997 confirms that the leonine logo was adapted from a woodcut at Houghton Library. Bea Guthrie to Eleanor Garvey, 13 Dec. 1997, SVB 1.5.1.

32. Garvey to McAndrew, 28 July 1971, Correspondence, SVNY; McAndrew to Garvey, 1 Aug. 1971, Correspondence, SVNY. See below regarding the alternate name "Friends of Venice."

33. As noted in the next paragraph, McAndrew conceived of the name "Save Venice" in Sept. 1971, so the newsletter could not have appeared with that name on the masthead in Spring 1971. Additional internal clues in

the first newsletter suggest an actual print date of Summer 1972; thus, I indicate this newsletter's date with a question mark in brackets, as "Spring 1971[?]."

34. McAndrew to Garvey, 21 Sept. 1971, Correspondence, SVNY. I have not seen the cable referenced by McAndrew. Duke Arturo Umberto Pini of San Miniato was a noted interior designer. Previously an antiques dealer in Bologna, he became an American citizen and renovated (among other projects) New York's Waldorf Astoria Hotel and the restaurant Hyperbole. He founded Friends of Venice Inc. in 1966 to address pollution, depopulation, and art restoration. See Mary Leonhard, [no title], *Arizona Republic* (Phoenix), 15 March 1970, and "NSID President Arrives Here," *Desert Sun* (Palm Springs, CA), 11 March 1970. NSID is the National Society of Interior Designers. In UNESCO's report *Venice Restored* (printed "in the workshops of UNESCO," 1978), 70, there is a reference to "Friends of Venice—Dallas Texas" and funds that it raised in 1974 to restore a ceiling in Ca' Pesaro in the parish of San Stae, but the organization seems to have been very short-lived. The group "Friends of Venice, Italy Inc." is an active American nonprofit founded in 2012 by Franca Coin to "preserve and enhance the art of Venice and its cultural heritage." See "Friends of Venice, Italy, Inc.," http://friendsofvenice.us/.

35. McAndrew to Howells, 30 Sept. 1971, Correspondence, SVNY.

36. SV Board minutes, 1 Oct. 1971, SVB 3.1.1: "It was proposed that the corporation change its name from Venice Committee (USA) Corporation to save [*sic*] Venice, Inc. Miss Garvey stated that she had communicated with the absent members of the corporation and all were agreeable to this change. It was pointed out that the absent members could not be present to the meeting in view of their locations in sundry places on the globe." This name change is confirmed by a document filed by Sydney Freedberg on 1 Oct. 1971 and signed on 22 Oct. 1971 by John F. X. Davoren, secretary of the Commonwealth of Massachusetts, for a corporate name change from "Venice Committee (USA) Corporation" to "Save Venice Inc." "History of the Boston Chapter," Correspondence, SVNY. Copies of this corporate name change document are also preserved in the SVB archives.

37. McAndrew and Bareiss to [Freedberg, in this example], 6 Oct. 1971, Correspondence, SVNY. This open letter clarified the circumstances around the creation of the VC-USA and the separate existence of the two entities; it also emphasized that the VC-IFM was continuing to do business in Venice and to establish additional chapters in the United States, including in New York. In the same file exists an undated telegram with nearly identical language but the proposed name is "Friends of Venice"; this must have been prepared earlier in the summer.

38. SV Board minutes, 23 Nov., 9 Dec. 1971, SVB 3.1.1, use the title of Save Venice Inc. "Loose Docs 1," SVB 3.3.14, includes several documents dated Dec. 1971 on Save Venice Inc. letterhead featuring the leonine logo and the name of six directors as well as the General Committee. Note that the SV Board minutes, 26 April 1971, SVB 3.1.1, briefly changed the name of the corporation from "Venice Committee (USA Corporation)" to "Venice Committee (USA) Corporation." As this temporary (and very minor) name change seems unimportant, I have omitted it from the discussion above.

39. SV Newsletter, Spring 1971[?], SVNY. As noted above, this newsletter must have been published in summer 1972; the correspondence from that time period indicates that newsletters often came out months behind schedule.

40. Formerly known as the Lincoln Building and now as One Grand Central Place, 60 East 42nd Street was a fifty-three-story skyscraper completed in 1930, designed in a neo-gothic style by architect James Edwin Ruthven Carpenter Jr.

41. Elena Drake Vandervoort graduated from Wheaton College in 1967; she later founded the "Main Street" program in Bath, Maine, through the National Trust for Historic Preservation and served on the board of the Maine Maritime Museum.

42. Alvise Zorzi, "The 'Cry of Nations' and the Reality of Venice," in *Venice Restored, 1966–1986: The UNESCO Campaign and the Contribution of Private Organizations* (Milan: Electa, 1991), 21.

43. SV Board minutes, 19 May, 11 July 1972, SVB 3.1.1. In July 1972 the SV board appointed Harry Halpern as treasurer. A native New Yorker, Halpern was an accountant for Bareiss; the two men shared a mutual passion for art collection (albeit on different scales). In 1972 Bareiss gave to Halpern as a gift two untitled compositions by the German artist E. R. (Eva Renée) Nele Bode described as "trial proofs of relief etchings," and an Ibibio

polychromed masquerade headpiece from early twentieth-century Nigeria; the property title from the sale of those in Litchfield, Connecticut, in May 2011 by the firm iGavel Auctions includes a brief description of Halpern's biography: https://bid.igavelauctions.com, 4–6 May 2011, items 2183139 and 2164444.

44. Thomas J. Kelly, interview with author, 4 Nov. 2016. See also SV Board minutes, 17 Oct. 1972, SVB 3.1.1, for Kelly's appointment as SV clerk, and SV Board minutes, 2 May 1986, SVB 3.1.1, noting that Kelly's firm was being dissolved and unanimously ratifying a motion to keep Kelly as the "Statutory Clerk" and to have his new firm represent SV as its legal counsel. See also "Annual Reports," 1972–82, SVB 3.4.4, and "SV Correspondence-Spindle 2," SVB 3.4.2, for Kelly's correspondence about the annual reports (discussed below).

45. In addition to those already mentioned (Scuola Grande di San Giovanni Evangelista, San Pietro di Castello, Scuola Grande di Santa Maria dei Carmini, Santa Maria Assunta in Torcello), the VC-IFM deserves credit for restoring the exterior spiral staircase of the Palazzo Contarini del Bovolo, the bell tower of the church of Santa Maria Gloriosa dei Frari, and paintings of the Sala del Maggior Consiglio inside the Palazzo Ducale. For a brief summary, see "Restoration Overview," *Icon,* Winter 2005–6, 21–22. Furthermore, the VC-IFM sponsored Giovanni Bellini's *Madonna and Child with Giacomo Dolfin* at the church of San Francesco della Vigna and Gaspare Diziani's *Saint Peter and Saint Jerome* at the church of San Moisè in 1968, as well as Bellini's *Madonna and Child* at the church of Madonna dell'Orto in 1969; see *Save Venice, 1968–1994: Venetian Treasures Restored and Preserved* (New York: Save Venice Inc., ca. 1995), 3–5, and Melissa Conn and David Rosand, eds., *Save Venice Inc.: Four Decades of Restoration in Venice* (New York: Save Venice Inc., 2011), 458.

46. SV Newsletter, Spring 1971[?], 1–2, SVNY, provides details on fundraising and events for the Boston and DC chapters. The Carmini restoration was completed in 1976; the Giglio restoration in 1973.

47. SV Newsletter, Spring 1971[?], 1, SVNY; Executive Committee Boston (ECB) minutes, 22 Feb. 1972, SVB 4.4.6, note a net profit of about $4,300 for the film. Note that in the SV newsletters the church is sometimes referred to as "Grisostomo" or "Grysostomo."

48. Noble was director of the Museum of the City of New York.

49. SV Newsletter, Spring 1971[?], 3, SVNY.

50. SV Newsletter, Fall 1973, 2, SVNY.

51. The Boston chapter gave $25,000 for San Giovanni Crisostomo, with "the remainder to come, as far as necessary, from funds administered by the parish priest, Padre Zanin." SV Board minutes, 11 July 1972, SVB 3.1.1. McAndrew gave a frank explanation to Hadley for why Boston paid only half the estimated cost, citing the opinion of Padoan and Valcanover that Zanin oversaw the richest parish in Venice because of its wonder-working Madonna; see McAndrew to Hadley, 19 June, 2 July 1972, Correspondence, SVNY. The 1971 SV Annual Appeal, SVB 4.8.1, a five-page pamphlet including text and photographs by McAndrew and drawings of the facade and a cross-section of the San Giovanni Crisostomo church, pleaded for "preventive first aid" to the roof, walls, paintings, and stonework. An image of Donatello's John the Baptist appeared on the front page of the SV Newsletter, Fall 1973, SVNY, and a description on p. 4.

52. For the personal donation by the McAndrews, see John McAndrew to Rollin Hadley, 30 Oct. 1973, Correspondence, SVNY, describing it as "Top Secret" and as a memorial to Betty's stepmother, Gertrude Lee.

53. H. W. Janson, *The Sculpture of Donatello* (Princeton, NJ: Princeton University Press, 1957), 2:187–91.

54. For the revised view of the *Saint John* in Donatello's development, see, for example, John Pope-Hennessy, *Donatello Sculptor* (New York: Abbeville, 1993), 137–40.

55. For the annual appeal of the Boston chapter to restore the church of the Gesuiti, see Annual Appeal, SVB 4.8.2, which describes the condition of the church as "truly appalling" and in danger of collapse. Additional information is in the SV Newsletter, Fall 1973, 2, SVNY, and ECB minutes, 30 Oct. 1972, SVB 4.6.6. Substantial correspondence about these projects is also in Correspondence, 1972–75, SVNY, and Weston Correspondence, SVV. See also Conn and Rosand, eds., *Save Venice Inc.: Four Decades,* 283.

56. SV Newsletter, 1974, 6, SVNY; Conn and Rosand, eds., *Save Venice Inc.: Four Decades,* 55.

57. SV gave $28,000 for the Scuola Levantina restoration, most of which had been raised by Danielle Gardner, wife of the American ambassador in Rome Richard Gardner. SV Board minutes, 11 July 1972, SVB 3.1.1. See also Conn and Rosand, eds., *Save Venice Inc.: Four Decades,* 298, 301.

58. SV Newsletter, Fall 1973, 3, SVNY; Conn and Rosand, eds., *Save Venice Inc.: Four Decades,* 210–11.

59. Francesco Valcanover, "The Role of Save Venice," *Gala Journal,* 1987, n.p. [10–15], SVV.

60. McAndrew to Hadley, 7, 26 Feb. 1972, Correspondence, SVNY.

61. See, for example, the SV Annual Appeals, 1971–74, SVB 4.8, largely from the Boston chapter.

62. SV Newsletter, Spring 1971[?], 2, SVNY. Parke-Bernet Galleries was a large auction house at 980 Madison Ave, New York.

63. SV Newsletter, Spring 1971[?], 2, SVNY.

64. SV Board minutes, 9 Dec. 1971, SVB 3.1.1. The minutes do not indicate the outcome of the *Otello* benefit planned for Feb. 1972.

65. SV Board minutes, 11 July 1972, SVB 3.1.1. This June 1973 tour was organized in collaboration also with the Committee of Friends of the Art Museum of Princeton University.

66. SV Board minutes, 20 March 1973, SVB 3.1.1.

67. SV Board minutes, 20 March, 13 Nov. 1973, SVB 3.1.1. Plant, *Venice: Fragile City,* 318–19, briefly explains the context of Rauschenberg's award at the Biennale and describes his innovative sculptures known as *Venetians* at the Castelli Gallery in 1973, among the first examples of "found" collages.

68. SV Board minutes, 13 Nov. 1973, SVB 3.1.1.

69. SV Board minutes, 13 Nov. 1973, SVB 3.1.1. The New York chapter purchased seven thousand copies of the card from the Boston chapter; I suspect they were designed by Eleanor Garvey.

70. SV Board minutes, 13 Nov. 1973, SVB 3.1.1 (Miguel de la Cueva); SV Board minutes, 7 May 1973, SVB 3.1.1 (Franklin Mint). On 31 May the board voted to cease negotiations with Franklin Mint, both because "the risk to our tax status would be too great for us to go ahead now" and because of concern about product quality. However, six weeks later Franklin Mint sent a formal proposal to Freedberg, and on 25 Jan. 1973 McAndrew wrote to Hadley, "The Franklin Mint has sent a sample contract, giving in to us on all points, and we hope to dedicate all their $85,000 to the [church of the] Gesuiti." Franklin Mint to Freedberg, 28 July 1972, Correspondence, SVNY; McAndrew to Hadley, 25 Jan. 1973, Correspondence, SVNY.

71. SV Board minutes, 5 March 1974, SVB 3.1.1. No vote was taken at this meeting.

72. SV Board minutes, 2 April 1974, SVB 3.1.1; Federico Zeri, with Elizabeth Gardner, *Italian Paintings: A Catalogue of the Collection of the Metropolitan Museum of Art,* vol. 2, *The Venetian School* (New York: Metropolitan Museum of Art, 1973).

73. Alison Arnold, "To Rescue Art in Venice," *Boston Herald,* 7 Feb. 1971; Marjorie Sherman, "Night in Venice Looks Promising," *Boston Globe,* 11 Feb. 1971; "Venice on the Charles: Boston Rescue Party for a Venetian Beauty," *Vogue,* ca. 7 March 1971. These and the articles cited in the two subsequent notes are all conserved in "Newspaper Clippings," SVB 4.9.

74. Alison Arnold, "Ball Held at Cambridge Museum to Raise Funds for Venice," *Boston Herald,* 22 May 1972; Vinzo Comito, "Trionfo del 'Viva Venezia Ball,'" *Il Progresso Italo-Americano,* 24 May 1972.

75. SV Newsletter, Fall 1973, 3, SVNY; Alison Arnold, "A Revival of Venice," *Boston Globe,* 23 March 1973; Bill Fripp, "Boston Does Its Part for Venice," *Boston Globe,* 21 May 1973; Alison Arnold, "Boston Helps Venice," *Boston Globe,* 26 May 1974.

76. McAndrew to Hadley, 11 May 1974, Correspondence, SVNY. McAndrew noted that the Kandinsky had cost him eight hundred dollars when he purchased it years before.

77. Pope-Hennessey to Hadley, 2 Sept. 1974, Roland Hadley Correspondence, Isabella Stewart Gardner Museum, Boston.

78. Elmo de Paolo, "Saving Venice" [Letter to the Editor], *New York Times,* 2 June 1974.

79. The text of the law, no. 171, passed 16 April 1973 and in effect from 23 May 1973, is at the Italian website Normattiva, https://www.normattiva.it, created by the Italian Parliament in 2000 to computerize and classify government legislation for free research and consultation. See also Plant, *Venice: Fragile City,* 358–64, and Thomas Madden, *Venice: A New History* (New York: Viking, 2012), 415–17. Gray's IFM Newsletter, 1 Sept. 1972, 1–2, offers a preview of what the law was intended to do; the SV newsletters from 1973 to 1985 regularly included updates on Italian politics and the Special Law. SVB 4.9 includes a clipping entitled "Loan of $400 Million May Prove Just Enough to Save the Treasures of Venice," *Boston Globe,* 3 Dec. 1972.

80. *OECD Territorial Reviews: Venice Italy, 2010* (Paris: OECD Publishing, 2010), 160–62; this includes a flow chart taken from Jane Da Mosto's *The Venice Report* (Cambridge: Cambridge University Press, 2009) that shows the overlapping responsibilities of the agencies and government entities responsible for the Venetian lagoon.

The OECD (https://www.oecd.org) is the Organization for Economic Cooperation and Development, a forum of thirty democracies (primarily European but including the United States, Australia, and Mexico) created "to address the economic, social and environmental challenges of globalization."

81. Cuvillier and Thompson, *UNESCO for Venice*, 81.

82. MOSE stands for Modulo Sperimentale Elettromecccanico (Experimental Electromechanical Module); the prophet Moses is known as Mosè in Italian. The project was designed to install seventy-eight gates on the seabed floor; when the tides reached a certain height (110 cm), the gates would be raised temporarily until the tide receded.

83. Wladimiro Dorigo, *Una legge contro Venezia: Natura, storia e interessi nella questione della città e della laguna* (Rome: Officina Edizioni, 1973). Madden, *Venice: A New History*, 415, observes that Dorigo believed the law was intended to keep historic Venice "embalmed in historical stasis."

84. SV Newsletter, Spring 1973, 2, SVNY.

85. SV Board minutes, 13 Nov. 1973, SVB 3.11. In Oct. 1972 McAndrew announced to the Boston chapter executive committee that "a Venice office of Save Venice Inc. has been opened" but this appears to have been premature. ECB minutes, 30 Oct. 1972, SVB 4.6.6.

86. SV Board minutes, 5 March 1974, SVB 3.1.1.

87. The earliest reference to Weston in the SV records is a telegram from John McAndrew to Weston on 5 April 1973, asking her to obtain photographs of the Bisa panels and to send them via airmail to the Interax office in New York City. A letter from Weston to Hedy Lanham in New York on 18 July 1973 is the first of several hundred that Weston sent with her observations about the details and status of various restorations sponsored by SV in Venice; in these she regularly offered her own opinions about what should be done and who should do it. In Sept. 1974 Countess Cicogna dismissed her household staff, and Weston wrote a desperate letter on 3 Oct. 1974 to McAndrew. In response, the SV board agreed to hire her on a regular salary beginning in 1975. Rollin Hadley wrote to Weston on 15 Nov. 1974 expressing delight "now that you are with us full time," but in response to Weston's concerns he clarified on 2 Jan. 1975, "When I wrote you last I should not have said that *all* of your work would be for Save Venice because you obviously have loyalties to Contessa Cicogna. . . . The Save Venice directors do not expect that our work will occupy every day." On 17 Dec. 1974 McAndrew and Hadley sent a telegram to Weston declaring that "in the absence of [an] officer of Save Venice we expect you to act for us and empower you herewith to do so." All of this documentation is preserved in Weston Correspondence, SVV; the telegrams and letters are in one volume organized by date, while a second volume contains many additional letters loosely sorted by recipient's last name. In a letter of 8 March 1976 regarding the Premio Torta for McAndrew, Weston identified herself in the opening line as "segretaria 'veneziana' di questo Comitato." Weston Correspondence, SVV.

Marialuisa Rampin Weston was a native Venetian; she married an Englishman and moved to Britain where she raised one daughter before separating from her husband and returning to Venice. There she worked at Ca' Cicogna in Dorsoduro and lived on the Lido. For the biographical information here I am indebted to Melissa Conn, who worked with Weston full-time from 1989 to 1991.

88. SV Board minutes, 17 Oct. 1972, SVB 3.1.1. Anna-Maria Cicogna was the daughter of Giuseppe Volpi, who served as governor of the Italian colony of Libya, as minister of finance, and as founder of the Venice Film Festival; Cicogna was also the mother of well-known actress and filmmaker Marina Cicogna. SV had other European aristocrats on its General Committee by 1972, including Countess Teresa Foscari Foscolo and H.R.H. Prince Franz of Bavaria, but Cicogna was the first titled Venetian to join the board of directors. On the transformation of SV under Lovett, see chapters 4 and 5 below.

89. SV Board minutes, 3 April 1974, SVB 3.1.1; see the letterhead.

90. SV Board minutes, 13 Nov. 1973; 5 March 1974, SVB 3.1.1. The contact for St. Louis is identified in SV minutes only as "Mrs. Joseph Pulitzer." Coincidentally, her husband, Joseph Pulitzer Jr., had in 1939 established a Fogg Museum Fellowship at Harvard for postgraduate study abroad, and the third recipient of that fellowship was John McAndrew. See "Harvard Art Museum Receives Major Gift from Emily Rauh Pulitzer," Harvard University Gazette Online, 17 Oct. 2008, http://www.news.harvard.edu.

91. SV Board minutes, 7 May 1973, SVB 3.1.1. Hooton founded and edited the monthly newspaper *Art/*

World in New York from 1975 to 1991, using an unconventional tabloid format; he also founded the Drawing Society (1960) and ran the New York office of the American Archives of Art. Prior to joining SV, he worked for Gray at the IFM and was associate director at the Lee Ault Gallery. McAndrew to Hadley, 23 April 1973, IFM-Correspondence, 1972–75, SVNY. See also the announcement of his appointment in SV Newsletter, Fall 1973, 3, SVNY, and his obituary in the *New York Times*, 19 May 1995.

92. Peter Fergusson, "Save Venice: The First Forty Years," in *Serenissima on the Charles* (Boston: Save Venice Inc., 2009), 4.

93. SV Board meeting minutes, 30 April 1974, SVB 3.1.1; McAndrew to Hadley, 4 May 1974, telegrams and letter, Correspondence, SVNY, clearly show McAndrew's glee at Hadley's appointment. On Hadley, see chapter 3.

94. Named in honor of Venetian engineer Pietro Torta in 1974, the prize recognizes those who have contributed significantly to the restoration of Venice's architectural patrimony. McAndrew's acceptance speech is preserved in his papers at Wellesley: John McAndrew Papers, box 2, folder, 1, Wellesley College Special Collections, Wellesley, MA. Gladys Delmas, a longtime member of SV's General Committee, would receive the award in 1977, as would SV director Wolfgang Wolters in 1985; the awarding of the Torta Prize to Larry Lovett in 1997 would spark a disagreement within the SV board later that year.

95. Hadley to Bareiss, 9 Dec. 1975, Correspondence, SVNY.

CHAPTER 3: STABILITÀ

1. Hadley was SV president for eleven years (1974–85) and chair for three more (1986–88); Bob Guthrie was president for seven years (1990–96) and chair for ten more (1997–2006). As noted elsewhere in the book, prior to 1999 the position of president was more important but after that date the chair exercised greater authority. Thus Guthrie served more years as chief executive and certainly played a more transformative role.

2. After serving in the U.S. Army (1946–47) and graduating from Harvard (1950), Hadley (1927–1992) worked as a reporter in Pennsylvania and then for Corning Glass Works (1952–60), for the Bocconi University in Milan (1960–62), and for the Isabella Stewart Gardner Museum (1963–88), including eighteen years as museum director. On his achievements at the museum, see "Biographical Note" (p. 2) in the finding aid for the Rollin Hadley Papers (1954–1989), Isabella Stewart Gardner Museum (ISGM) Archives, Boston. He was a visiting scholar at Harvard University's Villa I Tatti (1972) and published multiple books about the Gardner Museum, including *Drawings [at the Isabella Stewart Gardner Museum]* (1968), a general guide to the museum (1981), and *The Letters of Bernard Berenson and Isabella Stewart Gardner* (1987). He was awarded the Commander Order of Merit by the Consul General of Italy in Boston, Franco Faà di Bruno, in May 1978, and honored as a Cavaliere of San Marco by the city of Venice in fall 1983. SV Newsletter, Fall 1984, 2, SVNY; Franco Faa' di Bruno to Rollin Hadley, 3 Feb. 1978, Hadley Correspondence, ISGM Archives. See also Hadley Correspondence, ISGM Archives, for the typescript of Hadley's acceptance speech in Italian. In his memory SV restored Bartolomeo Vivarini's triptych in the church of San Giovanni in Bragora. SV Board minutes, 23 April 1992, SVNY. See also Hadley's obituary in the *New York Times*, 6 Feb. 1992. I am grateful to Shelagh Hadley for her observations about this chapter.

3. SV Board minutes, 19 Nov. 1976; 14 April 1977, SVB 3.1.1.

4. SV Newsletter, Winter 1977–78, 3, SVNY; Melissa Conn and David Rosand, eds., *Save Venice Inc.: Four Decades of Restoration in Venice* (New York: Save Venice, 2011), 452. The Fortuny Museum contained many theatrical models collected by Mariano (Mario) Fortuny. See Guillermo de Osma, *Fortuny: His Life and Work* (New York: Skira Rizzoli, 2016), and A. S. Byatt, *Peacock and Vine* (New York: Knopf, 2016).

5. SV Board minutes, 19 Nov. 1976, 14 April 1977, SVB 3.1.1; Conn and Rosand, eds., *Save Venice Inc.: Four Decades*, 334–52; SV Newsletter, Winter 1977–78, 1–2, SVNY. Tintoretto's *Wedding of Ariadne and Bacchus* was restored again in 2017 and appeared on the cover of the 2018 exhibition catalogue celebrating Tintoretto's five hundredth anniversary. Other paintings restored in the Palazzo Ducale included works by Jacopo Tintoretto, Tiziano and Marco Vecellio, Andrea Michieli (also called Il Vicentino), Gabriele and Carletto Caliari (sons of Paolo Veronese), and Giovanni Contarini.

6. On the Lando Chapel, see Conn and Rosand, eds., *Save Venice Inc.: Four Decades,* 220–23. Elena Vandervoort on 20 Jan. 1975 had asked Marialuisa Weston to investigate the status of the San Pietro di Castello project on behalf of Henry Seldis, so that when it was finished, the Los Angeles chapter of the IMF could join SV. Weston replied on 31 March that Terry Stanfill had made clear to Countess Cicogna her desire to stay with IFM for the time being; therefore Weston was unable to act. Weston Correspondence, SVV.

7. Hadley to Clarke, 15 Nov. 1975, Correspondence, SVNY; McAndrew to Bareiss, 24 Feb. 1976, Correspondence, SVNY.

8. SV Newsletter, Winter 1977–78, 4; 1979, 1–2, SVNY.

9. Additional correspondence about the Torcello debate exists from March to July 1976; by the end of 1976 Bareiss had been convinced to try out a new electrolytical technique developed in Germany for drying out the walls. Bareiss to Clarke, 27 Dec. 1976, Correspondence, SVNY. See also Marialuisa Weston to Walter Bareiss, 22 Sept. 1976, Weston Correspondence, SVV, expressing her advice. On SV's additional conservation of the Torcello cathedral in 2020–21, see chapter 8.

10. Delmas to Hadley, 13 Jan. 1976, Weston Correspondence, SVV.

11. SV Board minutes, 11 July 1972; 2 Dec. 1975; 16 Nov. 1976; 14 April 1977, SVB 3.1.1.

12. Conn and Rosand, eds., *Save Venice Inc.: Four Decades,* 436–40; SV Newsletter, Winter 1984, 4, SVNY.

13. Similar to the prior examples at Murano and at Torcello, SV would return to the Ca' Pesaro painting for subsequent conservation; see the discussion in chapter 8.

14. For example, SV Board minutes, 2 Dec. 1975, SVB 3.1.1, with $162,000 at the end of 1975; SV Board minutes, 3 Aug. 1976, SVB 3.1.1, for $85,000 invested in CDs and $60,000 in cash; SV Board minutes, 19 Nov. 1976, SVB 3.1.1, for $75,000 in CDs and $40,000 in cash; SV Board minutes, 14 Apr. 1977, SVB 3.1.1, for $85,000 in CDs and $40,000 in cash.

15. Bareiss's letters to Secretary Elena Vandervoort and his fellow board members regularly asked for more precise figures and clearer statements about intended payments and outstanding debts.

16. SV Board minutes, 23 July 1975, SVB 3.1.1.

17. SV Board minutes, 2 Dec. 1975, SVB 3.1.1; Thomas Kelly to Rollin Hadley, 3 Sept. 1975, Correspondence–Spindle 2, SVB 3.4.2. In Bareiss to Hadley, 13 Nov. 1976, Correspondence, SVNY, Bareiss describes "several long and pleasant conversations" with Maccoun about options for the Maine estate.

18. Nicola Hilton of the Trust for the Preservation of Oxford College Barges confirms that Maccoun was a marine engineer who restored the Corpus Christi barge in Oxford and who founded that trust in November 1966. Email to author, 14 Nov. 2016. Stephen Fay and Phillip Knightley, *The Death of Venice* (New York: Praeger, 1976), 115–18, confirm that Maccoun was an engineer and claim that he volunteered to help McAndrew analyze the problems in the Gesuiti church; in their account, Maccoun identified a completely different problem (and solution) than that proposed by McAndrew and Padoan.

19. The Hadleys visited the Maccoun property in Vinalhaven, Maine, several times during the summer before Maccoun eventually sold it to a local realtor. Shelagh Hadley, email to author, 3 Oct. 2019.

20. SV Newsletter, Spring 1983, 4, SVNY.

21. SV Board minutes, 9 May 1988, SVNY: "The Board declined to accept funds from Robert MacCoun [*sic*] to participate with him in maritime technology." One year later, on 1 May 1989, the board was notified of a bequest between $10,000 and $25,000 "to benefit the restoration and preservation of Venice's ships and naval heritage." In a subsequent meeting of 1 Oct. 1990, the board authorized $7,270 to restore two nineteenth-century boats found by Robert Maccoun (a *burella* and a *s'ciopon,* the latter used in lagoon valleys for hunting birds), using funds from the Maccoun bequest of $60,000 earlier that year and intended for a "marine-related project." SV Board minutes, 3 May 1990, SVNY. On 23 April 1992 the board acknowledged receipt of a total of $116,000 from the Maccoun estate. In 1995 that bequest, facilitated by SV, permitted the restoration of three additional historic Venetian boats: a *battella Buranella,* a *sandal s'ciopon,* and a *gondolin da fresco;* see SV Board minutes, 11 May 1995, SVNY, and Conn and Rosand, eds., *Save Venice Inc.: Four Decades,* 452.

22. Paolo Terni, "Action of the Italian Authorities," in UNESCO, *Venice Restored* (printed "in the workshops of UNESCO," 1978), 16–24. See also SV Newsletter, Fall 1974, Fall 1975, Spring 1976, Winter 1976, Winter 1977, SVNY.

23. SV Board minutes, 15 April 1975, SVB 3.1.1. SVB 4.8.2 contains three dozen pieces of correspondence between Eleanor Garvey and others about the Washington chapter, dated from 7 May 1971 to 27 Sept. 1972.

24. SV Newsletter, Spring–Summer 1976, 3, SVNY. The correspondence from Weston indicates interest in a "public building" from the superintendent's list, but I have not identified the name of a specific edifice. Lilian Larke "Solie" Tootle married diplomat George Frederick Reinhart in 1949; his final posting was as U.S. ambassador to Italy (1961–68). He died in 1971; she lived until 2009.

25. SVNY appears to have files about the early years of the New Orleans chapter but the coronavirus pandemic made it impossible to review them.

26. Executive Committee Boston (ECB) minutes, 11 April 1978, SVB 4.6.6.

27. Walker O. Cain (1915–1993) was an important American architect. After winning the Rome Prize while studying at Princeton in 1940, he worked for the firm of McKim, Mead & White and later established his own firm of Walker O. Cain Associates in 1971; he also served as chair of the board for the American Academy in Rome (1974–84). See Cain's obituary by William H. Honan in the *New York Times*, 4 June 1993, and the Walker O. Cain Papers (1892–1994) at Avery Library, Columbia University, New York. Hedy Giusti-Lanham (later Hedy Allen) was born in Venice and attended the Sorbonne and University of Vienna. She was part of the Resistance in Italy in World War II and later became a journalist in Berlin. Moving to New York, she became executive secretary of the America-Italy Society, founded two Italian culinary academies in New York, and in 1986 brought a gondola to New York's Central Park. See SV Newsletter, Autumn 1989, 13, SVNY.

28. SV Board minutes, 3 Aug. 1976, SVB 3.1.1.

29. Directed by Humphrey Burton, *The Great Gondola Race* describes the annual two-man gondola race up the Grand Canal, the culmination of the Regatta Storica; the subtext included the "race" to save Venice.

30. SV Board minutes, 19 Nov. 1976; 14 April 1977, SVB 3.1.1.

31. Organized by the Venice Tourist Office, this exhibition also traveled to New Orleans (1977), Philadelphia and New York (1978), and Los Angeles (Oct. 1979). SV Newsletter, Winter 1977–78, 5, SVNY.

32. SV Board minutes, 2 Dec. 1975, 19 Nov. 1976, SVB 3.1.1; ECB minutes, 30 March 1976, SVB 4.6.6; SV Newsletter, 1975, 3, SVNY.

33. SV Newsletter, Winter 1977–78, 5, SVNY; ECB minutes, 27 April 1977, SVB 4.6.6.

34. "Report on Activities of Boston Chapter of Save Venice Inc. 1976, 1977, 1978" (prepared by treasurer Harry Halpern), no date, in SV Board minutes, 23 March 1978, 1, SVB 3.1.1.

35. The Weston Correspondence, SVV, contains multiple expressions of affection to Vandervoort, especially Weston's letter to Vandervoort of 31 July 1974 regarding the McAndrews' "enormous loving warmth which touched me deeply"; see also Weston to Bareiss and to Hadley, both 9 Sept. 1975, about being "very, very sad" after Hadley and Bareiss had questioned her competence.

36. Elena Vandervoort to Marialuisa Weston, 3 Sept. 1975, Weston Correspondence, SVV.

37. SV Board minutes, 15 April 1975, SVB 3.1.1.

38. John and Betty McAndrew are buried in the Protestant section (*reparto evangelico*) of the cemetery at San Michele in Isola. The graves feature matching headstones by sculptor Joan Fitzgerald, designed to mimic the arch of Mauro Codussi, an early Venetian architect whom John McAndrew admired and whom he had described as "appearing as suddenly and as brilliantly as a comet." J. McAndrew, *Early Renaissance Venetian Architecture* (Cambridge, MA: MIT Press, 1980), 232. Betty's tombstone bears the epitaph "Love Always" while John's, with his characteristic wit, reads in dialect "Dear Venice, I shall never leave you again" (*Venessia benedetta no ti vogio più lassar*).

39. Sydney Freedberg, "John McAndrew, 1905–1978," SV Newsletter, Winter 1979, 1–3, SVNY. See also the Memorial Resolution of 2 March 1978, adopted by SV's board of directors, SVB 3.1.1.

40. SV Board minutes, 9 Aug. 1978, SVB 3.1.1.

41. SV Newsletter, Winter 1979, 1–3; Fall 1979, 2, SVNY; ECB Minutes, 11 April 1978, SVB 4.6.6; Francesco Valcanover, ed., *Quaderni della Soprintendenza ai Beni Artistici e Storici di Venezia* (Venice: Soprintendenza ai Beni Artistici e Storici, 1979).

42. SV Newsletter, Winter 1979, 3, SVNY.

43. Conn and Rosand, eds., *Save Venice Inc.: Four Decades*, 196–200. See also Bea Guthrie's eloquent rationale for why she and her husband admired the McAndrews and wished to dedicate the chapel in memory of a couple whom they never met, in Beatrice Guthrie, "Badoer Giustinian Chapel in the Church of San Francesco della Vigna Restored in Memory of John and Betty McAndrew," *Gala Journal*, 1999, 9–10, SVV.

44. ECB minutes, 7 Feb. 1989, SVB 3.5.2, lists the net income from the annual appeal and from the benefit gala, and the total amount sent to New York, for the years 1980–88.

45. SV Board minutes, 23 March 1978, SVB 3.1.2. Thomas S. Buechner (1926–2010) was trained as an artist at the École des Beaux-Arts in Paris and later in Amsterdam, but he turned quickly to museum administration instead of painting. In 1951 he was named as founding director of the Corning Museum of Glass and in 1960 (at only thirty-three years old) director of the Brooklyn Museum where he oversaw an ambitious restoration program; from 1973 to 1980 he headed the Steuben Glass Museum before retiring to paint in 1987. See the obituary by William Grimes in the *New York Times,* 17 June 2010.

46. SV Board minutes, 25 April 1980 (Wolters); 7 Dec. 1981 (Stanfill and Lovett), SVB 3.1.2. Wolters (b. 1935) is a distinguished scholar of art history and architecture, specializing in Gothic and Renaissance Venice, and in scientifically based restoration. He first came to Venice in 1969 and was affiliated with institutes in Venice and Florence for many years; he was a professor at the Technical University of Berlin from 1979 to 2001. SV Newsletter, Winter 1981, 6, SVNY. On Stanfill, see below on the Los Angeles "chapter"; on Lovett, see chapter 4.

47. SV Board minutes, 8 Dec. 1982; 20 Sept. 1983, SVB 3.1.2. Lily Auchincloss (1922–1996) was an American journalist, philanthropist, and art collector. After graduating from Radcliffe (1944), she worked in New York City as a writer and editor for a series of newspapers and magazines, and was married to editor Douglas Auchincloss from 1956 to 1979. In 1971 she became a trustee of the Museum of Modern Art, and in 1982 a board member of the American Academy in Rome; she later established the Lily Auchincloss Foundation. See her obituary by Roberta Smith in the *New York Times,* 8 June 1996. Sir John Pope-Hennessy (1913–1994) was a highly regarded and prolific scholar of Italian Renaissance art, especially sculpture. After studying modern history at Oxford and serving in intelligence for the British Air Force during World War II, he was appointed director of the Victoria and Albert Museum (1967–73) and of the British Museum (1974–76) before emigrating to the United States as head of European paintings at the Metropolitan Museum of Art (1977–86) and professor at New York University's Institute of Fine Arts. See John Higgins, "Hennessy, Sir John Wyndham Pope," in *Oxford Dictionary of National Biography,* https://www.oxforddnb.com, and John Russell's obituary in the *New York Times,* 1 Nov. 1994. Danielle L. Gardner (d. 2008) was the wife of Richard N. Gardner, U.S. ambassador to Italy (1977–81) and Spain (1993–97); she lived in New York for many years while her husband (d. 2019) taught law at Columbia University (1957–2012).

48. SV Board minutes, 10 May 1984, SVB 3.1.2 (Lovett as treasurer); Loose minutes, 5 Sept. 1985, SVB 3.2.2 (Guthrie as director).

49. Conn and Rosand, eds., *Save Venice Inc.: Four Decades,* 194–95, 201, 206–9.

50. Conn and Rosand, eds., *Save Venice Inc.: Four Decades,* 270–75.

51. Conn and Rosand, eds., *Save Venice Inc.: Four Decades,* 95 (Guggenheim), 316–17 (baptismal font), 318–19 (Zen chapel); see also SV Newsletter, Spring 1982, SVNY.

52. Not only was this church studied (and praised) by John McAndrew but partial funding for this project came from Betty McAndrew just prior to her death. Conn and Rosand, eds., *Save Venice Inc.: Four Decades,* 435.

53. SV Newsletter, Autumn 1984, 1, SVNY. SV funded Tintoretto's *Doge Girolamo Priuli Presented by Saint Jerome to Justice and Peace* in the Palazzo Ducale (1983), his *Wedding Feast at Cana* in the church of Santa Maria della Salute (1983), and his *Paradise* in the Palazzo Ducale. See Conn and Rosand, eds., *Save Venice Inc.: Four Decades,* 96, 332. Jean-Paul Sartre's study of Tintoretto made a similar point about the artist's prolific output: "Left to himself, he would have covered every wall in the city with his paintings, no campo would have been too vast, no sotto portico too obscure for him to illuminate. He would have covered the ceilings, people would have walked across his most beautiful images, his brush would have spared neither the facades of the palaces nor the gondolas." Jean-Paul Sartre, "The Venetian Pariah," in *Essays in Aesthetics,* selected and trans. by Wade Baskin (London: Peter Owen, 1964), 11, as quoted in Margaret Plant, *Venice: Fragile City, 1797–1997* (New Haven, CT: Yale University Press, 2002), 335.

54. Conn and Rosand, eds., *Save Venice Inc.: Four Decades,* 352–53; SV Newsletter, Spring 1983, SVNY; SV Board minutes, 5 May, 8 Dec. 1982..

55. SV Board minutes, 25 April 1980, SVB 3.1.1; Conn and Rosand, eds., *Save Venice Inc.: Four Decades,* 455–56. The publication (funded by UNESCO) was Ennio Concina, *Structure Urbaine et Fonctions des Bâtiments du XVI au XIX Siècle: Une Recherche à Venise* (Venice: UNESCO and Save Venice, 1981). The UNESCO liaison described Concina's results as "a data bank of inestimable value which no other historic Italian city possesses." Maria Teresa Rubin de Cervin, "Preface," in UNESCO, *Venice Restored, 1966–1986* (Milan: Electa, 1991), 12–15.

56. "Save Venice Archives Finding Aid," 71–72, Save Venice Inc., https://www.savevenice.org. This finding aid lists archival materials in the Venice office of Save Venice (SVV), XII 1/1, for each of the projects in this paragraph but I have not seen those materials.

57. Conn and Rosand, eds., *Save Venice Inc.: Four Decades*, 455–56.

58. Conn and Rosand, eds., *Save Venice Inc.: Four Decades*, 455–56.

59. Philip Rylands, "The New Special Law for Venice," SV Newsletter, Autumn 1985, 1, 4, SVNY. Rylands worked for the Peggy Guggenheim Collection in Venice as administrator (1979–85), deputy director (1986–99), director (2000–2018), and director emeritus (2019–present). He became an SV honorary director in 2020.

60. SV Board minutes, 5 April, 20 Sept. 1983; 31 Jan., 10 May 1984, SVB 3.1.2; bound within those minutes are also memoranda from Rollin Hadley to SV directors, 7 Nov., 27 Dec. 1983, summarizing his conversations with Lucius Eastman and Marilyn Perry. Art historian Marilyn Perry served as president of the Samuel H. Kress Foundation (1984–2007) and chair of the board of the World Monuments Fund (1990–2007). In 1983–84 she was representing the IFM in the absence of Gray and as the IFM's temporary host at the Kress Foundation. For Perry's perspective on this transition, see Marilyn Perry, *Hadrian's Way: Creating World Monuments Fund, 1965–2015* (New York: World Monuments Fund, 2016), 14–20.

61. SV Board minutes, 10 May, 5 Dec. 1984, SVB 3.1.2; SV Newsletter, Fall 1984, 2, SVNY. The large Misericordia building was constructed in the thirteenth century, deconsecrated in 1634, and subsequently used by silk weavers in the eighteenth century. The IFM, SV, and Kress Foundation helped to fund the stone laboratory, which was later sponsored by the Italian government.

62. SV Board minutes, 9 May 1988, SVNY. On the WFM and further comparisons with Save Venice, see chapter 9.

63. SV Board minutes, 31 Jan. 1984, SVB 3.1.2. The SV directors were especially intrigued by this offer as there were strong indications that the United States might cease contributing to UNESCO, and thus SV would need an independent office in Venice. The United States left UNESCO in 1984 and rejoined in 2003. But the SV board apparently did not take up the offer of the IFM to share space.

64. SV Board minutes, 15 April 1987, SVNY.

65. SV leased office space in Palazzo Marcello beginning in 1987 for "cultural activities" (as defined in the lease) and remained there until moving to Palazzo Contarini Polignac in 2015. The Guthries leased the adjacent house and garden known as the Casetta Rossa.

66. "Save Venice Boston Chapter Officers," 1973–90, SVB 4.8.7. Peter Wick served one year as acting Boston chair in 1984–85. Rollin Hadley to Peter Fergusson, 7 May 1984, SVB 4.6.6.

67. Fergusson to "Friend of Venice," 30 May 1986, SVB 4.6.6.

68. Fergusson to Larry Lovett, 24 Aug. 1986, SVB 4.6.6; SV Board minutes, 9 Nov. 1986, SVB 3.1.2: "Watson B. Dickerman was welcomed to the Board with acclamation. Mr. Dickerman, after graduation from Harvard [1969], has been involved in various philanthropic causes, and is very knowledgeable in the field of art history. He served as a director of the International Fund for Monuments, and currently heads the Boston Chapter of Save Venice."

69. On Dickerman, see the brief, anonymous obituaries in the *New York Times*, 26 June, 15 July 2004, and a much longer obituary in Swann Brumfield to Peter Fergusson, 1 July 2004, SVB 4.2.14. The honorary chairs of the Boston chapter included at various points Senator (and Ambassador) Henry Cabot Lodge Jr., Governor (and Ambassador) John Volpe, Anne Seddon Kinsolving (wife of John Nicholas Brown), and Italian consuls general Vittorio Fumo and Ranieri Fornari. Ranieri Fornari to Peter Fergusson, 15 Nov. 1985, SVB 4.6.6. For typescript annual lists of officers and their addresses from 1973 to 1990 (for both Boston and New York), see also "Save Venice Boston Chapter Officers," SVB 4.8.7.

70. SV Newsletter, Spring 1983, 6; Fall 1984, 5; Fall 1985, 4, SVNY. See also ECB Minutes, 20 May, 16 Sept. 1985, SVB 4.6.6; Peter Fergusson to Rinaldo (*sic*) Fornari, 18 Oct. 1985, SVB 4.6.6.

71. SV Newsletter, Fall 1984, 5, SVNY; *Americans in Venice, 1879–1913* (New York: Coe Kerr Gallery, 1983).

72. SV Newsletter, Spring 1982, 5, SVNY.

73. "Five Year Review of Fund Raising," 18 Nov. 1986, SVB 4.6.6.

74. SV Newsletter, Fall 1979, 4, SVNY. I have been unable to locate the minutes of the New York chapter.

75. SV Newsletter, Winter 1979, 5, SVNY.

76. SV Newsletter, Winter 1981, 2, SVNY. Barbetta celebrated its one hundredth anniversary in 2006 and is

the oldest Italian restaurant in New York; see Julie Besonen, "Elegant Relic of Restaurant Row," *New York Times,* 3 Feb. 2018.

77. SV Newsletter, Winter 1981, 6, SVNY. This is the only reference to Mrs. Montaldo, and I have been unable to identify her further.

78. SV Newsletter, Spring 1982, 5, SVNY.

79. SV Newsletter, Spring 1983, Fall 1984, Fall 1985, SVNY.

80. SV Newsletter, Fall 1983, 2, SVNY: "A Junior Committee is being formed to help the standing committee." See also Mark Fehrs Haukohl, letter to author, 30 Aug. 2019.

81. Marie Brenner, "The Inside Story of the Carlyle," *New York Magazine,* Dec. 1983, 34, 42–43.

82. Invitation to the event, provided to the author by Mark Fehrs Haukohl. See also articles describing the event in *Women's Wear Daily,* 11 July 1986, n.p., and in *W,* 28 July–4 Aug. 1986, 12, both provided by Mark Fehrs Haukohl. On Lombardo's pilasters, see Conn and Rosand, eds., *Save Venice Inc.: Four Decades,* 300.

83. Mark Fehrs Haukohl, letter to author, 30 Aug. 2019. Art historian Edward Goldberg, who knew Haukohl in Boston in the late 1980s and in New York and Florence in the 1990s, confirms that the SV Junior Committee offered "glamorous associations and opportunities for social networking," and that membership on the Junior Committee "was considered one of the best values in New York." Edward Goldberg, email to author, 22 June 2020.

84. Medici Archive Project Director Alessio Assonitis, email to author, 15 June 2020; Edward Goldberg, email to author, 17 June 2020; Medici Archive Project, Guidestar, https://www.guidestar.org; Anita Gates, "Hester Diamond, Passionate Art Collector, Is Dead at 91" *New York Times,* 5 Feb. 2020.

85. SV Newsletter, Fall 1979, 4, SVNY.

86. SV Board minutes, 7 Dec. 1981, SVB. 3.1.2. Board minutes and newsletters are silent about other Los Angeles–based activities until the twenty-first century.

87. Rollin Hadley, "Venice Celebrates 20 Years since the Flood," SV Newsletter, Fall 1986, 3–4, SVNY.

88. Fergusson to Howard Burns, 28 Sept. 1986, SVB 4.6.6.

CHAPTER 4: CRESCITA

1. Peter Fergusson to Nina Thompson, 5 Oct. 1986, SVB 4.6.6, as Fergusson resigned from being Boston chapter chair.

2. Quoted in Margaret Plant, *Venice: Fragile City, 1797–1997* (New Haven, CT: Yale University Press, 2002), 390. Bettino Craxi was prime minister from 1983 to 1987.

3. Although both are on the Grand Canal, the Peggy Guggenheim Collection, in an unfinished palazzo, was more intimate and featured its permanent collection, while Palazzo Grassi was enormous and focused on temporary exhibitions.

4. *Atlante di Venezia della città* (Venice: Marsilio, 1989).

5. Plant, *Venice: Fragile City,* 402–6: "The 1980s was Venice's most significant and positive building period in the field of domestic architecture in the twentieth century" (402). See also Deborah Howard, *The Architectural History of Venice* (New Haven, CT: Yale University Press, 2002), 294–301.

6. William Echikson, "Il sorpasso has Italians Riding High," *Christian Science Monitor,* 8 May 1987, 9; Fabio Massimo Signoretti, "Abbiamo superato anche la Francia secondo Business International," *La Repubblica,* 16 May 1991.

7. Clyde Haberman, "Pop vs. Patrimony in Italy," *New York Times,* 5 Aug. 1989; Jennifer Parmelee, "Venice Sees Red Over Pink Floyd," *Washington Post,* 19 July 1989.

8. Quoted in Plant, *Venice: Fragile City,* 423.

9. Bruno Pellegrino and Luigi Zingales, "Diagnosing the Italian Disease," National Bureau of Economic Research Working Paper No. 23964, May 2019, doi: 10.3386/w23964.

10. Lovett graduated from Harvard Law School (1954), served in the U.S. Army (1954–56), and worked as a cargo ship broker in New York, becoming vice president of Eastern Steamship Lines. In New York he served as president (1971–79) and chair (1979–86) of the Metropolitan Opera Guild as well as chair of the Chamber Music Society of Lincoln Center (1988–93). He was the founder of Venetian Heritage in 1998 and died in February 2016; see his obituary in the *New York Times,* 6 Feb. 2016, and the *Florida Times-Union,* 7 Feb. 2016. The *New York Times* spells his name as both "Lawrence" and "Laurence."

11. Randolph (Bob) Guthrie graduated from Harvard Medical School (1961) and later served as a professor at Cornell Medical School, a surgeon at Sloan-Kettering, and chief of surgery at New York Downtown Hospital, before retiring in 2001. He visited Venice as a child with his father, an international lawyer, and later returned there while stationed in Heidelberg as an army doctor. He and Beatrice Guthrie brought their own young children to Venice for numerous summers. Bob and Bea Guthrie, interview with author, 27 June 2019.

12. Bea Guthrie formally became executive director on 1 Jan. 1987, but the board minutes of 12 Dec. 1986 already refer to her as "Executive Director" and the October–November minutes of 1986 clearly show her working on behalf of SV. She has confirmed that she began in Sept. 1986. She also served for many years on the board and executive committee of the Metropolitan Opera Guild.

13. SV Board minutes, 2 May 1986, SVB 3.1.2.

14. SV Board minutes, 2 Oct. 1986, SVB 3.1.2.

15. SV Board minutes, 2 Oct. 1986, SVB 3.1.2. In the meeting of 2 May 1986, at which he was formally appointed as treasurer, Bob Guthrie had promised to "clean the list of all non-contributors."

16. In 1975 the Venice in Peril Fund had negotiated a deal with the British chain Pizza Express to create a new "Pizza Veneziana" and donate a percentage of each sale to Venice in Peril, which netted nearly £2 million from 1975 to 2015. For details, see chapter 9.

17. SV Board minutes, 2 May, 2 Oct., 7 Nov., 12 Dec. 1986, SVB 3.1.2; SV Board minutes, 1987–89, SVNY. As noted in the introduction, SV Board minutes for 1970–86 are held in Lowell and those from 1987 to the present are held in New York.

18. SV Board minutes, 2 Oct. 1986, SVB 3.1.2. Bob Guthrie has estimated the final cost of the Miracoli restoration at $3 million: Randolph H. Guthrie, "Santa Maria dei Miracoli: A Miracle of Restoration," *Gala Journal,* 1995, 9–11, SVV.

19. SV Board minutes, 2 Oct. 1986, SVB 3.1.2. Lovett had proposed the concept of a ball in Piazza San Marco two years earlier, together with Elizabeth Peabody from the General Committee. SV Board minutes, 5 Sept. 1984, SVB 3.1.2. In a 2019 interview, the Italian director of Venetian Heritage, Toto Bergamo Rossi, characterized Lovett's contribution in this way: "He was the first to import the system of American-style charity into Italy—you know, the big ball that you pay to attend? It had never existed before in our country." Jason Ysenburg, "Venetian Heritage," *Gagosian,* Summer 2019, 114–18, https://gagosian.com.

20. Lovett rented the Palazzetto Pisani from Countess Anna Maria Ferri. Today a boutique hotel, it is located off Campo Santo Stefano, on the Grand Canal side of the large Palazzo Pisani that houses the Conservatorio Benedetto Marcello. In the late 1980s Lovett purchased the nineteenth-century Palazzo Sernagiotto at San Giovanni Crisostomo with its sizeable terrace facing the Grand Canal; Lovett had it restored by architect Peter Marino and used it until retiring to Monaco ca. 2010. Melissa Conn, email to author, 12 April 2021; Ysenburg, "Venetian Heritage"; Raffaella Vittadello, "Asta a Venezia: venduto appartamento al piano nobile di Palazzo Sernagiotto," *Il Gazzettino di Venezia,* 21 Dec. 2019, https://www.ilgazzettino.it.

21. SV Board minutes, 7 Nov. 1986, SVB 3.1.2: "*Church of the Miracoli*—Mr. Lovett expressed his belief in this undertaking, shared also by the present Directors. The church is very beautiful but badly endangered by raising humidity and general decay despite an attempt made by the German Committee some years ago. Dr. Guthrie said that this project should not be lost as the church could prompt good fundraising. Prof. Wolters suggested a meeting calling together both Soprintendenze (Valcanover-Asso), Istituto Centrale del Restauro in Rome, and other experts. . . . The experts should then work out a study campaign over a period of about one year to ascertain all causes of humidity, pollution, atmospheric agents responsible for the deterioration of the interior and exterior of the church; the results should indicate whether restoration is feasible, which method to be followed and eventual costs. . . . Agreement was reached to finance the meeting and the research work."

22. SV Board minutes, 7 Nov. 1986, SVB 3.1.2. See SV Newsletter, 1988, 10, SVNY, which describes Berlingieri as "Milanese by birth but Venetian by adoption and by marriage to Marchese Alberto Berlingieri. She is the chatelaine of one of the most important Venetian palazzos still in private hands, and a most gracious and generous friend of Save Venice." For a more recent portrait, see Myra Robinson, "Living in a Palace on the Grand Canal," *Italy Magazine,* 25 Nov. 2019, www.italymagazine.com.

23. SV Board minutes, 12 Dec. 1986, SVB 3.1.2.

24. Bea Guthrie, interview with author, 27 June 2019. Multiday events, whether for charities, weddings, or wineries, were rare in the 1980s even if they have become more common in recent years.

25. The restoration of the Miracoli church was significant not only as the impetus for the Regatta Week Gala but as a catalyst for the expansion of SV, as observed by executive director Michael Dagon in 2003: "The restoration of the Church of Santa Maria dei Miracoli was a defining moment. [SV] had never remotely taken on a project of this size and scale. It was an entire church, inside and out, head to toe, and a big financial commitment, a multiyear project. At that point the organization really became a professional organization: hiring a staff, creating an office in Venice itself, and implementing a fund-raising structure." Quoted in Jeffrey Klineman, "Charity's CEO Sees Young People as Key to Restoration of Antique City," *Chronicle of Philanthropy*, 7 Aug. 2003, 38.

26. Mary Davis Suro, "In Venice, a Party Worthy of a Doge," *New York Times*, 5 Sept. 1987. See also Guy D. Garcia and Cathy Booth, "Saving La Dolce Venice," *Time*, 14 Sept. 1987, 72.

27. SV Board minutes, 15 April 1987, SVNY.

28. Bob and Bea Guthrie, interview with author, 27 June 2019.

29. SV Board minutes, 26 Oct. 1987, SVNY.

30. SV Board minutes, 26 Oct. 1987, SVNY.

31. "Bank Balances," 22 Oct. 1987, attached to SV Board minutes, 26 Oct. 1987, SVNY.

32. SV Board minutes, 25 Jan. 1988, SVNY; see also attached Treasurer's Report.

33. SV Board minutes, 26 Oct. 1987, SVNY.

34. SV Board minutes, 26 Oct. 1987, SVNY.

35. SV Newsletter, Fall 1988, 12, SVNY; Karen Marshall, interview with author, 13 Jan. 2015.

36. Liz Makrauer, interview with author, 21 March 2019.

37. SV Board minutes, 26 Oct. 1987, SVNY, documents approval for a new office in Venice at a cost of $15,000 per year; the minutes further note that "Mrs. Weston could work there, and eventually we could add someone [else]." The SV Newsletter, Fall 1988, 12, SVNY, includes the announcement of the new office, a photo of it, and a brief description of the staff. SV Board minutes, 2 May 1991, SVNY, note that "Mrs. Weston has not been feeling well and wishes to retire. The Board acknowledged her devoted and valuable assistance, and expressed its desire to provide her with a pension."

38. A native of Ohio, Conn earned a B.A. in art history from Wake Forest University in 1987, which included a senior semester in Venice. Following graduation, she worked for a year in Washington, DC, at the Smithsonian Museum of American Art. She came to Venice as an au pair, volunteered for SV there, and began working for SV in 1989 in New York and in Venice; she was promoted to director of the Venice office in 1998, a position that she retains today. She possesses a deep knowledge of Venetian culture and of restoration techniques; her critical role is discussed in later chapters.

39. SV Newsletter, Fall 1988, 10, SVNY.

40. On Fahy, see Lee Sorensen and Emily Crockett, "Fahy, Everett, Jr.," Dictionary of Art Historians, https://arthistorians.info, and the obituary by Richard Sandomir in the *New York Times*, 2 May 2018.

41. SV Newsletter, Fall 1988, 10, SVNY; SV Board minutes, 25 Jan. 1988, SVNY, amended the by-laws to permit an increased number of eighteen directors.

42. For example, see annotations in SV Board minutes, 23 Jan. 1989, and a letter from Everett Fahy to Bea Guthrie, 29 Oct. 1988, attached to SV Board minutes, 23 Sept. 1988, SVNY.

43. SV Board minutes, 25 Jan. 1988, SVNY; Melissa Conn and David Rosand, eds., *Save Venice Inc.: Four Decades of Restoration in Venice* (New York: Save Venice Inc., 2011), 257, 380–81, 388–89, 121.

44. Conn and Rosand, eds., *Save Venice Inc.: Four Decades*, 328–29. The *Pillars of Acre* were paid for by 1988 but not actually restored until 1992.

45. See SV Board minutes, 26 Oct. 1987, SVNY, including an attachment (pp. 14–17), "Restorations to Date, 1968–1987," and the detailed report on restorations in progress prepared by Wolfgang Wolters on 10 Oct. 1987, which is attached to the Oct. 1987 minutes, SVNY; see also SV Newsletter, Fall 1988, 7, SVNY.

46. John McAndrew, *Venetian Architecture of the Early Renaissance* (Cambridge, MA: MIT Press, 1980), 159–70. An excerpt of his observations was reprinted in John McAndrew, "Santa Maria dei Miracoli," *Gala Journal*, 1987, n.p. [1–6], SVV, and online at https://www.savevenice.org.

47. Ralph Lieberman, "The Church of Santa Maria dei Miracoli in Venice" (Ph.D. thesis, New York University Institute for Fine Arts, 1971).

48. Ralph Lieberman, *The Church of Santa Maria dei Miracoli in Venice* (New York: Garland Press, 1986), vii.

49. SV Board minutes, 25 Jan. 1988, SVNY; Conn and Rosand, eds., *Save Venice Inc.: Four Decades*, 262–67; Guthrie, "Santa Maria dei Miracoli," 9–11; Barbara Lazear Ascher, "The Restoration of Santa Maria dei Miracoli: Begun 1987, Completed 1997," *Gala Journal*, 1997, 9–13, SVV.

50. SV Board minutes, 23 Sept. 1988, SVNY.

51. SV Board minutes, 23 Sept. 1988, SVNY.

52. SV Board minutes, 9 May 1988, SVNY. The board deferred further discussion about "auxiliary chapters" to its Jan. 1989 meeting but did not discuss it then or at all in 1989. With the exception of efforts by executive director Michael Dagon to initiate a chapter in Chicago in 2002–3 (see chapter 6), I have found no other evidence of an SV chapter there.

53. Equally ironic is that in this same period of the late 1980s the SV directors would confuse the tax identification numbers of SV in Boston and in New York, as discussed later in this chapter.

54. SV Newsletter, Fall 1988, 11, SVNY.

55. SV Newsletter, Fall 1988, 11, SVNY. The Au Bar was described that year as the "hottest haunt" in New York. Elizabeth Snead, "Au Bar: The Place to Be and to Be Seen in New York," *Orlando Sentinel*, 17 July 1988.

56. SV Newsletter, Fall 1988, 11, SVNY. The date of the Vidal film in New York is not specified but it was also shown by the Boston chapter on 25 April 1988 as part of their benefit for the Miracoli church. SV Board minutes, 25 Jan. 1988, SVNY.

57. SV Newsletter, Fall 1985, 5, SVNY; Executive Committee Boston (ECB) minutes, 10 June 1986, SVB 4.6.6. The ECB minutes of 12 Sept. and 21 Nov. 1986 also mention a bike-a-thon proposed by Art and Architectural Restoration, but the Boston executive committee "expressed no particular enthusiasm for the project and there were concerns about liability."

58. Peter Fergusson to Larry Lovett, 24 Aug. 1986, SVB 4.6.6. Terrorist attacks were sponsored by Hezbollah and Abu Nidal in Paris and by the Spanish separatist group ETA in Madrid.

59. SV Board minutes, 25 April 1987, SVNY. See also ECB minutes, 1981–97, SVB 4.6.6, which contains gala-related correspondence, minutes, contributor lists, and so forth.

60. ECB minutes, 9 Jan. 1987, SVB 4.6.6.

61. Dana Bisbee, "Party Swells 'Save Venice' Coffers," *Boston Herald*, 15 May 1988. This article quoted attendee Mary Forde Kingsley: "We had what you have to call the insiders' tour of Venice." The following paragraph noted that Watson Dickerman "took charge of the Bostonians at that time. He introduced them to ancient countesses and brought them into homes filled with privately-owned art." Thus the idea of touring private Venetian homes and meeting royalty was not exclusive to the Guthries and Lovett, even if they expanded it on a larger scale in subsequent years.

62. SV Board minutes, 23 Jan. 1989, SVNY; ECB minutes, 24 May, 13 Sept. 1988, SVB 4.6.6.

63. SV Board minutes, 23 Sept. 1988, SVNY: "Mr. Dickerman reported that Boston is interested in undertaking another small project on its own instead of contributing funds toward the Miracoli. They would like to find a project similar in scope to the restoration of the Acritani Pillars for which they raised $30,000. As the Board had no objection to this, it was agreed that projects for consideration would be presented at the January meeting."

64. ECB minutes, 13 Sept. 1988, SVB 4.6.6.

65. ECB minutes, 10 Jan. 1989, SVB 4.6.6.

66. Attorney Thomas J. Kelly of Mintz Levin had filed annual reports for SV from 1972 to 1982. "Annual Reports," SVB 3.4.4. In a 1987 letter to Bob Guthrie, Kelly acknowledged that a mistake by a paralegal had resulted in failure to file annual reports in 1983, 1984, and 1986. Kelly to Guthrie, 14 April 1987, SVB 3.3.14, "Loose Papers 2."

67. "Save Venice Inc.," Secretary of the Commonwealth of Massachusetts, Corporations Division, https://www.sec.state.ma.us, reveals a "date of involuntary revocation" of 17 Nov. 1986 and a "date of revival" of 13 June 1990. I further rely on a statement in the document titled "Save Venice Inc. Chronology," 30 Nov. 1998, SVB 3.5.3. This nineteen-page document was prepared by attorney Christian Hoffman in Boston to help untangle the complicated history of SV's legal status, and runs from 15 March 1965 to 8 Oct. 1998 (for authorship, see ECB minutes, 19 Jan. 1998, SVB 3.5.3): "Chris Hoffman, at our request, has researched and reconstructed the history of the Boston Chapter." As explained in the opening paragraph of the 30 Nov. 1998 document, the "Chronology" is derived from three sources: (1) the files of Peter Fergusson, Eleanor Garvey, and Donna Hoffman; (2) the corporate records of SV retrieved from attorney Thomas Kelly; and (3) a synopsis of SV board meetings held in New York from the mid-1980s to the late 1990s provided by Priscilla Miller. Note that there are several similar

documents in SVB 3.5.3: (a) the initial version of the "Save Venice Inc. Chronology" (dated 19 Jan. 1998); (b) a "Save Venice Chronology (Abridged)" (dated 1 Dec. 1998) of one page; and (c) the "Save Venice Inc. Chronology" of 30 Nov. 1998 (hereafter "Hoffman's Chronology"), which is the one that I rely on. All were prepared by Christian Hoffman. Hoffman had access to some documents that I have been unable to find; I find his account to be credible.

68. Kelly to Guthrie, 18 Nov. 1987, SVB 3.3.14, "Loose Papers 2."

69. "Save Venice Inc.," Secretary of the Commonwealth of Massachusetts, Corporations Division. In Emily Livingston to Paul Wallace, 10 Dec. 1998, SVB 3.5.3, she offered Boston's view of "relevant historical information" about SV as background for a meeting of 16 Dec. 1998.

70. SV Board minutes, 15 April 1987, SVNY.

71. The letterhead of the minutes from 15 April 1987 lists the SV officers, all of whom (with the exception of chair Rollin van N. Hadley in Boston and Wolfgang Wolters in Berlin) were based in New York: president Lawrence Lovett, vice presidents Hedy Lanham Allen and Walter Bareiss, treasurer Randolph Guthrie, and secretary Priscilla Barker. SV Board minutes, 15 April 1987, SVNY.

72. Wasserman's letter of 17 Sept. 1998 is quoted in a draft of a letter from Emily Livingston to Paul Wallace, SVB 3.5.3. The final version of her letter, dated 10 Dec. 1998, did not include the sentence that I quote here. I have not seen Jack Wasserman's original correspondence and rely instead on the SVB files in Boston, which contain paraphrases or responses to Wasserman's correspondence.

73. The incorporation date of 23 March 1988 comes from "Hoffman's Chronology"; the tax identification number of SV/NY is in Emily Livingston to Paul Wallace, 10 Dec. 1998, SVB 3.5.3.

74. Emily Livingston to Paul Wallace, 10 Dec. 1998, 3, SVB 3.5.3.

75. Walter Bareiss and Wolfgang Wolters were also vice presidents; Anthony L. Geller was treasurer and Priscilla C. Miller continued to serve as secretary. These officers were proposed in January 1989 and formally confirmed in Sept. 1989.

76. SV Board minutes, 3 Sept. 1991, SVNY.

77. SV Board minutes, 23 Jan. 1989, 1, SVNY.

78. SV Board minutes, 23 Jan. 1989, 2–4; 23 Sept. 1988, SVNY. For example, the board declined a partnership when the Scoletta di San Rocco did not follow through on its promise to seek matching funding from the Italian government; the board also queried why the WMF had deducted a 10 percent "administrative fee" for the funds that it was holding for the Lazzaretto Nuovo project. At the SV board meeting of 1 May 1989, the assets held by SV topped $1 million for the first time. Every board meeting includes detailed consideration of various restoration projects; I mention those when they are especially important or symptomatic of broader trends, but I do not attempt to track all of them individually. The comprehensive and well-illustrated book by Melissa Conn and David Rosand, eds., *Save Venice Inc.: Four Decades,* catalogues all restorations through 2010.

79. SV Board minutes, 23 Jan., 1 May 1989, SVNY(Saladino); SV Board minutes, 23 Sept. 1988, 23 Jan., 1 May 1989, 25 Jan. 1990, 1 Oct. 1990, SVNY (Danielle Gardner); SV Board minutes, 1 May 1989, SVNY (Consorzio Venezia Nuova). The minutes do not specify the identity of the book published in 1989 but it was likely Susanna Grillo, *Venezia, Le Difese di Mare: Profilo Architettonico delle Opere di Difesa Idraulica nei Litorali di Venezia* (Venice: Arsenale, 1989). At least three books were published about the Jewish cemetery on the Lido in the twentieth century but none seem to be by Driscoll Devons. SV did help to drain swampy land, excavate sunken grave markers, and catalogue tombstones there.

80. The "Vignettes of Venice" ball raised $200,068. SV Board minutes, 24 Jan. 1991, SVNY.

81. SV Board minutes, 23 Sept. 1988; 1 May 1989, SVNY.

82. "A Party to Aid Venice," *New York Times,* 3 Sept. 1989. The first treasure hunt booklet *Riddles of Venice* (Venice: Save Venice, 1989) was designed by artist Douglas Sardo with Paul Stiga and included a foreword by John Julius Norwich; later versions of the treasure hunt booklets were edited by the Guthries and illustrated by Sardo around specific themes, such as *Venetian Epigraphs* (Venice: Save Venice, 1995) or *Thirty Lions and a Pig* (Venice: Save Venice, 1997).

83. Suzy Menkes, "Canaletto and High Fashion: Doing Good in Venice," *International Herald Tribune,* 1 Sept. 1989.

84. Beatrice Guthrie, interview with author, 27 June 2019.

85. SV Board minutes, 3 Oct. 1989, SVNY; Guthrie and Lovett to McKee Tappe, 7 Nov. 1989, filed between

SV Board minutes of 3 Oct. 1989 and 25 Jan. 1990, SVNY; Guthrie to SV Board, 11 Nov. 1989, in SV Board minutes, SVNY.

86. SV Board minutes, 3 May 1990, 1–2, SVNY; Jean Cyrile Godefroy *Venice or Expo: It Is Up to You,* ed. Rossella Brook Browne (no publication information available), https://www.wmf.org. This sixty-four-page booklet included a foreword by Mayor Casellati and brief statements by John Julius Norwich and Wolfgang Wolters, as well as reproductions of newspaper editorials across Europe that were opposed to the Expo in Venice.

87. Larry Lovett and Bob Guthrie to Heather Cohane (publisher of *Quest* magazine), 7 Nov. 1989, included in SV Board minutes, Fall 1989, SVNY, in response to her editorial that Venetians (and not New Yorkers) should be responsible for saving Venice.

88. SV Board minutes, 24 Jan. 1991, SVNY; earlier discussion of the gala is found in the minutes for 3 May and 1 Oct. 1990.

89. SV Newsletter, Fall 1992, 20, SVNY.

90. SV Board minutes, 23 April 1992, SVNY. This included a substantial donation from Ambassador Amalia Lacroze de Fortabat, who then joined the board along with Oscar de la Renta in April 1992.

91. Quoted in Giorgio Cecchetti, "Fuoco sulla festa dei VIP," *La Repubblica,* 27 Aug. 1991. Lionello Puppi (1931–2018) was a prominent and prolific art historian at the University of Padua (1971–91) and Ca' Foscari (1992–2005) who also served briefly in the Italian Parliament representing the Communist Party (1985–87). See the obituary of Puppi by Deborah Howard in *Burlington Magazine,* Feb. 2019, 179–80.

92. Cecchetti, 'Fuoco sulla festa dei VIP." I have been unable to find Puppi's original article but Cecchetti quotes Puppi and Guthrie at some length; the translations here are my own.

93. "RHG Statement to the Board," addendum to SV Board minutes, 3 Sept. 1991, SVNY.

94. "RHG Statement to the Board," addendum to SV Board minutes, 3 Sept. 1991, SVNY.

95. "Report of the October 1991 Meeting of the Private Committees," bundled with the SV Board minutes, 3 Sept. 1991, SVNY. This report has no date nor author but was likely prepared by Bea Guthrie in October 1991 and distributed to the SV board. John Millerchip, an expatriate Briton who has lived in Venice for more than half a century and who was an important link between the private committees and UNESCO, confirmed many statements in the report and provided additional context about UNESCO's decisions. John Millerchip, interview with author, 28 Sept. 2020. The ostensible reason for closing the San Marco office was the $130,000 per year required to keep it open. In 1988 UNESCO had established another office in Venice known as ROSTE (Regional Office for Science and Technology for Europe), which monitored scientific and technical matters for all of Eastern and Western Europe. ROSTE was in Palazzo Loredan dell'Ambasciatore and independent of UNESCO's efforts at restoration. UNESCO had placed ROSTE in Venice in part to counter the trend of banks, insurance companies, and other businesses leaving for the mainland; UNESCO also wished to decentralize its Paris headquarters and to emphasize its commitment to the Balkans and Eastern Europe. Furthermore, UNESCO wanted to conclude the Campaign for Venice (begun in 1967), in order to close other campaigns that had begun subsequent to that in Venice. Margaret van Vliet was dispatched from the UNESCO Paris office to wind up the Venice Campaign.

96. As noted in a memorandum to the SV board, probably written by Beatrice Guthrie: "UNESCO's administrator, Mrs. Van Vliet, admitted that Paris' need to close the San Marco office was not only a question of money, as previously put forth, but also an administrative necessity. . . . UNESCO also wants to have both its offices in Venice under one roof. . . . Mrs. van Vliet understands the ongoing 'fall-out' in Italy from the Private Committee's anti-EXPO battle, which among other effects, probably led to the Italian government's withdrawal of funding for the Venice Liaison Office. . . . Our [SV's] Board should be aware of the loss of prestige and of the potential future problems." "Report of the October 1991 Meeting of the Private Committees [with] UNESCO, San Marco, Venice," attachment to SV Board minutes, 3 Sept. 1991, SVNY.

97. Margaret van Vliet nominated Venice in Peril trustee John Millerchip to coordinate the private committees' work. SV Board minutes, 10 Oct. 1992, SVNY; John Millerchip, interview with author, 28 Sept. 2020. Ten years later in 2002 UNESCO moved to Palazzo Zorzi, where it remains today.

98. "Resume of Round Table Discussion October 19, 1991 at the Ateneo Veneto," attachment to SV Board minutes, 3 Sept. 1991, SVNY.

99. Following a year of discussion and negotiation, the APC agreement was signed in November 1993.

100. SV Board minutes, 25 Jan. 1990, SVNY. The board routinely declined other projects too, citing the need

for the Italian government to take responsibility for some projects, waiting for matching grants, or suggesting another private committee as a more appropriate sponsor.

101. SV Board minutes, 24 Jan. 1991, SVNY. A similar example exists in SV Board minutes, 3 Sept. 1991, 30 Jan. 1992, SVNY, where the board approved payment of 38 million lire ($31,700) for salaries of photographers to create an inventory of religious items in the sacristies of Venetian churches—but insisted that film and photographic paper be supplied by local institutions and individuals.

102. SV Board minutes, 30 Jan. 1992, SVNY.

103. SV Board minutes, 10 Oct. 1992, SVNY; previously discussed in prior meetings of 1991–92.

104. SV Board minutes, 2 May 1991, SVNY.

105. "Summary of Report from Wolfgang Wolters, 4/30/90," in SV Board minutes, 3 May 1990, SVNY.

106. SV Board minutes, 24 Jan. 1991, SVNY.

107. Ottorino Nonfarmale (1929–2020) was regarded as one of the leading Italian restorers of the twentieth century. Born in Mantua and resident in Bologna, for nearly seventy years he restored paintings and frescoes by Bolognese artists (Guido Reni, Annibale Carracci) and was regularly called to Venice to work on masterpieces by Titian, Veronese, Mantegna, and Carpaccio. Nonfarmale and his team also developed expertise in stone conservation, restoring the facade of the basilica of San Marco in Venice and of San Petronio in Bologna. See the obituaries by his pupil Silvia Conti, "È morto a Bologna Ottorino Nonfarmale," 17 Sept. 2020, https://www.artribune.com, and by Vittorio Sgarbi, "Nonfarmale, il più grande dei restauratori italiani," *Il Giornale*, 13 Sept. 2020, https://www.ilgiornale.it.

108. SV Board minutes, 30 Jan. 1992, SVNY.

109. SV Board minutes, 10 Oct. 1992, SVNY, for the board's resolution accepting the obligation to raise $500,000 and related correspondence from Jack Wasserman, as well as various invoices related to the Miracoli church. SV asked the city of Venice to dredge and restore the canal next to the Miracoli in conjunction with the restoration of the church; this process required much delicate negotiation by Lesa Marcello and Bea Guthrie.

110. SV Board minutes, 10 Oct. 1992, SVNY.

111. SV Board minutes, 23 April 1992.

112. The descriptions in this paragraph are based on Guthrie, "Santa Maria dei Miracoli."

113. SV Board minutes, 1 Oct. 1990; 3 Sept. 1991, SVNY. The organ doors were deferred on 30 Jan. 1992 in order to concentrate on the Miracoli church.

114. SV Board minutes, 3 Sept. 1991, SVNY. After repeated delays, this project was eventually turned over to the WMF. SV Board minutes, 30 Jan., 10 Oct. 1992, SVNY.

115. SV Board minutes, 10 Oct. 1992, SVNY.

116. SV Board minutes, 5 May 1982, SVNY, granting the scholarship to "architect Armani" working under Piana's supervision; the scholarship was terminated sixteen months later. SV Board minutes, 20 Sept. 1983, SVNY. This was clearly linked to Armani's "Venetian Plaster Project" discussed above. In a board meeting of 10 May 1984, Piana received $1,000 toward a proposed book.

117. Conn and Rosand, eds., *Save Venice Inc.: Four Decades*, 454; SVV, X 1/2 a. (SVV uses a numbering system indicating series and box/folder number; see its online finding aid for more information.) Recipients included Francesca Bortolaso (1987–90), Elisabetta Zendri (1990), Gabriella Baron (1991–92), Marisol Rossetti (1992), and Rosanna Arbizzani (1993–95). There is occasionally a discrepancy between the SV Board minutes and the *Four Decades* book regarding the first names of some recipients.

118. The renewal of Piegari's fellowship appears regularly in the SV Board minutes for 1991–97; he was granted additional fellowships for other projects in 2000, 2002, 2004. See SVV, X 1/2 b.

119. Conn and Rosand, eds., *Save Venice Inc.: Four Decades*, 454; SV Board minutes, 30 Jan. 1992, SVNY; SVV, X 1/2 b. Students included Teresa Santostasi and Marin Lupnitz.

120. Conn and Rosand, eds., *Save Venice Inc.: Four Decades*, 454. See also SVV, X 1/1 b. Volpin is mentioned regularly in the SV Board minutes, 24 Jan., 1 Oct. 1990; 24 Jan., 2 May 1991; 30 Jan., 23 April, 10 Oct. 1992, SVNY.

121. SV Board minutes, 23 April, 10 Oct. 1992, SVNY; Conn and Rosand, eds., *Save Venice Inc.: Four Decades*, 455.

122. SV Board minutes, 6 Sept. 1993, SVNY; SVV, X 1/2.

123. SV Board minutes, 16 Sept. 1994, SVNY.

124. SV Board minutes, 25 Jan., 3 May 1990, 24 Jan., 2 May 1991, SVNY; SV Newsletter, Fall 1990, 15, SVNY. Gabriella Lorenzotti had organized a trio of lectures in 1988 but it was not an annual series.

125. SV Board minutes, 30 Jan. 1992, SVNY. See also SV Newsletter, Fall 1992, 19, SVNY.

126. SV Board minutes, 2 May 1991, SVNY.

127. SV Board minutes, 3 May 1990, SVNY. The Titian Seminar offered a precedent for the Tintoretto 500 celebration in October 2018.

128. The earliest reference to a luxury cruise is in the aftermath of the 1987 Regatta Week Gala, when the newly formed special events committee was proposing multiple ideas. SV Board minutes, 26 Oct. 1987, SVNY. In 1989 the board informed the president of the Windsor Line that "Save Venice is not interested in a cruise at this time." It soon changed its view. SV Board minutes, 23 Jan. 1989, SVNY.

129. Sea Goddess Sales Manager Judy S. Perl to Bea Guthrie, 27 Dec. 1990, included with SV Board minutes of 24 Jan. 1991, SVNY. First mention of the Sea Goddess Cruise is in SV Board minutes, 1 Oct. 1990, SVNY.

130. ECB minutes, 4 May 1989, SVB 3.5.2.

131. SV Board minutes, 5 Sept. 1989, addendum, SVNY. See also ECB minutes, 10 Jan., 7 Feb., 4 April 1989, SVB 4.6.6.

132. "Save Venice Masked Ball, 26 April 1989, Income and Expenses," SVB 4.6.6.

133. SV Board minutes, 5 Sept. 1989; 3 May 1990, SVNY. Waters would eventually be appointed director of development for the Boston chapter.

134. ECB minutes, 23 May 1990, SVB 3.5.2. See also Muriel Howells to Watson Dickerman, 21 March 1990, SVB 4.6.6, in which she expressed her unhappiness with this decision and raised several pointed questions.

135. ECB minutes, 4 May 1989, SVB 3.5.2.

136. SV Board minutes, 5 Sept. 1989, SVNY.

137. SV Board minutes, 3 May 1990, 24 Jan. 1991, SVNY; ECB minutes, 23 May 1990, SVB 3.5.2. Attached to these latter minutes is the SVB treasurer's report of Nov. 1990, prepared by James R. Hammond.

138. Boston Annual Meeting minutes, 20 Nov. 1991, SVB 3.5.2.

139. SV Board minutes, 29 April 1993, SVNY. The Ritz-Carlton event was entitled *Una Serata di Primavera* (A Night of Spring). For specific amounts raised at each of these events, see the treasurer's report in Boston Annual Meeting minutes, 16 Nov. 1992, SVB 3.5.2.

140. SV Board minutes, 23 April 1992; 7 Feb. 1994, SVNY. Jack G. Wasserman is a member of the Bar Association in New York, Florida, and Washington, DC, with expertise in international law, contracts, and business law. He was a senior partner at the Manhattan law firm of Wasserman, Schneider, Babb & Reed from 1966 to 2001, after which he practiced law as a solo practitioner; he has also served as a director for (among others) Cadus Corp, Icahn Enterprises LP, The Wendy's Co., Atlantic Coast Holdings, and the National Energy Group. Wasserman has collected more than 1,500 books by (or about) Lord Byron and was president of the Lord Byron Society of America. He attended one of the very early Regatta Week Galas in Venice and joined the SV board soon after.

141. Gianluca Amadori, *Per quattro soldi: Il Giallo della Fenice dal rogo alla ricostruzione* (Rome: Editori Riuniti, 2003). See also Plant, *Venice: Fragile City*, 452–55.

142. SV Board minutes, 16 Feb. 1995 (Pope-Hennessy); 10 Sept. 1996 (Auchincloss), SVNY.

143. These elections are contained in the SV Board minutes; brief biographies of each new director appear in the SV newsletters in the years of their appointments. "Meeting Agendas and Treasurer's Reports, 1996–2000," SVB 3.5.2, contains a spreadsheet of all directors from 1971 to 1999, presumably created by Bob Guthrie.

144. SV Board minutes, 29 April, 15 July, 6 Sept. 1993, SVNY. The issue was resurrected in a special telephone meeting of the board on 5 Feb. 1998 when the directors agreed to register for status as an ONLUS (Organizzazione Non Lucrativa di Utilità Sociale, a nonprofit organization for social benefit). SV Board minutes, 5 Feb. 1998, SVNY, spell out the requirements and benefits of such status. Melissa Conn and Jack Wasserman explored this issue and concluded that it was not feasible. Since all of SV's financial records were held in New York, the Italian government would be unable to review them annually. I am grateful to Melissa Conn who in June 2019 showed me the *codice fiscale* and attendant paperwork as well as explaining the rationale for the various decisions. The board revisited this issue at its meetings of 13 Feb. and 5 June 2020, in the context of deciding whether the Venice office should be a "registered office" or a "representative office"; the board concluded that the costs and burden on the staff were not worth the possible donations, and thus declined to pursue ONLUS status. SV Board minutes, 5 June 2020, 3, SVNY. See also SV Board minutes, 13 Feb. 2020, SVNY, for additional description of the steps needed to become an ONLUS and for the possibility of registering SV as a United Kingdom entity so that donors there could receive tax deductions.

145. SV Board minutes, 2 May 1996; 8 Sept. 1997, SVNY.

146. Jack Wasserman, interview with author, 18 Nov. 2015.

147. SV Board minutes, 2 May 1996, SVNY; Ernst & Young LLP to Jack G. Wasserman, 1 May 1996, attached to SV Board minutes, SVNY, outlining the scope of services and fees.

148. SV Board minutes, 2 May, 10 Sept. 1996, SVNY. Audits for 1996 and 1997 from Ernst & Young are in SVB 1.4.2 and in the SV Board minutes, SVNY.

149. SV Board minutes, 1 May 1997, SVNY.

150. SV Board minutes, 16 Feb. 1995, SVNY. No change was made at that time, but in 2020 the board selected J. P. Morgan as investment manager, due to its promise of more active partnership and portfolio management. SV Board minutes, 13 Feb. 2020, SVNY.

151. SV Board minutes, 25 Jan. 1996, SVNY.

152. SV Board minutes, 29 April 1993, SVNY.

153. SV Board minutes, 16 Feb. 1995, SVNY. See also minutes of 25 Jan. and 2 May 1996 (Attachment C), SVNY, regarding a special subcommittee to approve emergency funding.

154. SV Board minutes, 4 Sept. 1995; 2 May 1996, SVNY.

155. SV Board minutes, 2 May 1996, SVNY, for example.

156. John Berendt, *The City of Falling Angels* (New York: Penguin, 2005), 302–6. His book includes no footnotes, and the date and location of such conversations are not specified or verifiable.

157. SV Board minutes, 30 Jan., 11 Oct. 1992; 29 April, 6 Sept. 1993, SVNY. The letter from Philip Rylands to Bea and Bob Guthrie, dated 27 July 1993, is one of several letters from 1993–94, all filed together between the SV Board minutes of 6–7 Sept. 1993 and 7 Feb. 1994, SVNY.

158. SV Board minutes, 29 April 1993, SVNY.

159. SV Board minutes, 7 Feb. 1994, SVNY. In 1994, Tia Chapman (née Fuhrmann) was identified as a "Director" of Young Friends of Save Venice, responsible for managing day-to-day administration of the group; she became SV's executive director from 1999 to 2002 and as of 2022 serves as the SV secretary and chair of the nominating committee.

160. SV Board minutes, 11 May 1995, SVNY. According to Beatrice Rossi-Landi, the YF chair initially had greater authority and then gradually transitioned to be equal with the YF president; thus the YF leaders did not necessarily reflect the formal operations and by-laws of the SV board, but worked together as a team with the other YF officers. Beatrice Rossi-Landi, email to author, 6 June 2022.

161. "Save Venice Correspondence" (of Cristina Coletta), cover letter, 24 Jan. 1995, from Giorgio Pace with attachment "Young Friends' Tentative Schedule at '95 Gala," SVB 5.2.

162. Tia Chapman to Committee Members, 30 Nov. 1994, SVB 5.2; Lindsay Brooks to Francesco di Valmarana, 6 Feb. 1995, SVB 5.2.

163. SV Board minutes, 25 Jan., 2 May 1996; 16 Jan., 8 Sept. 1997; 7 May 1998, SVNY.

164. SV Board minutes, 29 April, 6 Sept. 1993; 7 Feb. 1994, SVNY.

165. SV Board minutes, 16 Jan., 8 Sept. 1997; 6 May 1999, SVNY. The minutes of 8 Sept. 1997 include discussion of whether SV should accept the risk (and potential reward) of chartering the entire ship, or leave it to Cunard to see whether the ship was filled thus potentially diluting the group experience.

166. "Save Venice Cruise and Excursion, Athens to Jerusalem," attachment to SV Board minutes, 8 Sept. 1997, SVNY.

167. SV Board minutes, 25 Jan., 28 Feb. 1996, SVNY. The consultants were Anthony C. Manning of Mitchell Manning Associates Ltd. and Carl Levine of Carl Levine Consulting and Licensing; together they formed Manning & Levine.

168. SV Board minutes, 25 Jan. 1996, SVNY.

169. SV Board minutes, 28 Feb. 1996, SVNY.

170. SV Board minutes, 28 Feb., 10 Sept. 1996, SVNY. SV was to bear some responsibility for "creative content" in partnership with Manning & Levine.

171. SV Board minutes, 28 Feb., 10 Sept. 1996, SVNY.

172. SV Board minutes, 10 Sept. 1996, SVNY. In the Board minutes of 2 May 1996, Attachment E, "Typical List," SVNY, includes fourteen categories of items that could be licensed; this document is on letterhead from

Carl Levine Consulting & Licensing. For correspondence and press articles from 1997–98, and a copy of the trademark application letter from 1996, see "Venice Collection," SVB 1.5.1.

173. SV Board minutes, 16 Jan. 1997, SVNY. The trademark application was eventually abandoned. Some information is at the website https://uspto.report. This appears to be a private website that draws information from the U.S. Patent and Trademark Office. The *Trademark Manual of Examining Procedure*, 4th ed. (Washington, DC: United States Patent and Trademark Office, April 2005), cites the example of SV and the Venice Collection in the case of *In re Save Venice New York Inc.*, 259 F.3d 1346, 59 USPQ2d 1778 (Fed. Cir. 2001)—1210.02(a); 1210.04(a); 1210.05(b)(i); 1210.02(c); 1210.07(b); 1216.02.

174. SV Board minutes, 16 Jan. 1997, SVNY. The new companies were Century Furniture Industries (furniture), and Abbey Co. (floor and table lamps), with Kravet Fabrics Inc. expected soon (printed and woven upholstery fabrics). See an announcement about Century Furniture's deal with SV in Elizabeth Large, "Window Treatment . . . The Venetian Collection," *Baltimore Sun*, 22 Feb. 1998. See also M. T. M, "Venice Collection Rich in History and Its Preservation," *Home Accents Today*, October 1997, n.p., and Kathleen Brannigan, "Saving Venice," *Home Furnishings News*, 8 Sept. 1997, 17, 20; both are conserved in "Venice Collection," SVB 1.5.1.

175. SV Newsletter, Fall 1997, 14, SVNY. Carol Wasserman (spouse of Jack Wasserman), Lesa Marcello, and Bea Guthrie guided this trip.

176. SV Board minutes, 10 Sept. 1996, SVNY.

177. SV Board minutes, 10 Sept. 1996, SVNY. See Jane Mulvagh, "Eleanor Lambert" [obituary], *The Independent*, 9 Oct. 2003, https://www.independent.co.uk. In 1999 and 2000, SV would name a restoration fellowship in honor of Lambert.

178. SV Board minutes, 10 Sept. 1996; 8–9 Sept. 1997, SVNY.

179. SV Board minutes, 6 Sept. 1993, SVNY, for the newsletter; 30 March 1994, SVNY, for a letter from Bea Guthrie to Lesa Marcello regarding a list of projects.

180. SV Board minutes, 6 Sept. 1993, SVNY. The minutes do not specify how or by whom this matter appeared before the board.

181. SV Board minutes, 6 Sept. 1993, SVNY. It is not clear to me the origin of the board's position that it must "disseminate information" about Venice; that charge does not appear in the original charter of SV from Dec. 1970 but perhaps was included in a later mission statement.

182. SV Board minutes, 10 Sept. 1996, SVNY.

183. SV Board minutes, 29 April 1993, SVNY.

184. SV Board minutes, 7 Feb. 1994; 16 Feb. 1995, SVNY.

185. SV Board minutes, 7 Feb. 1994; 16 Feb. 1995; 25 Jan. 1996; 29 April 1993, SVNY. Note that for the latter, this was the "sense" of the board but there was no formal vote or resolution.

186. SV Board minutes, 2 May 1996, SVNY.

187. Mario Piana and Wolfgang Wolters, eds., *Santa Maria dei Miracoli a Venezia: La storia, la fabbrica, i restauri* (Venice: Istituto Veneto di Scienze, Lettere, ed Arti, 2003). The initial plan was to produce the book with the publisher Canal & Stamperia in both English and Italian. SV Board minutes, 11 May 1995, SVNY. Instead, Bob Guthrie and Barbara Lazear Ascher wrote shorter articles in English for the 1995 and 1997 *Gala Journal*.

188. SV Board minutes, 16 Feb. 1995, SVNY.

189. SV Board minutes, 16 Feb., 11 May 1995, SVNY.

190. SV Board minutes, 4 Sept. 1995, SVNY. In the same meeting the board also approved restoration of the funeral monument of Doge Michele Morosini in the church of Santi Giovanni e Paolo, in honor of Ambassador Amalia Lacroze de Fortabat; this included marble, mosaic, and fresco elements at a cost of $60,000.

191. SV Board minutes, 25 Jan., 2 May 1996; 8 Sept. 1997, SVNY.

192. SV Board minutes, 11 May, 4 Sept. 1995, SVNY.

193. SV Board minutes, 16 Feb., 11 May 1995, SVNY. SV initially had difficulty fulfilling the terms of this bequest to fund research into the relics of traditional marine craft construction of the lagoon of Venice and declared that it might be "impracticable." But one month later it had identified four projects and committed $41,470, or about one-third of the bequest. SV Board minutes, 3 March 1995, SVNY.

194. SV Board minutes, 10 Sept. 1996, SVNY.

195. SV Board minutes, 6 Sept. 1993, SVNY.

196. SV Board minutes, 29 April 1993; 7 Feb. 1994, SVNY. The "Fava Library" appears to be part of the collection of the church of Santa Maria della Consolazione in Campo della Fava.

197. "Carmela Gennaro Bequeaths $300,000 to Save Venice Inc.," *Gala Journal,* 1993, n.p., [9], SVV; SV Newsletter, Fall 1992, 18, SVNY.

198. ECB minutes, 25 May, 14 June 1993, SVB 3.5.2.

199. ECB Annual Meeting minutes, 16 Nov. 1993, SVB 3.5.2. New members included Janice and Roger Hunt, Boardman and Barbara Lloyd, Richard and Lucille Spagnuolo; Donald Freeman had been appointed in 1992. Dickerman remained as vice-chair and continued to give reports in New York; indeed, in 1993–95 he was the chair (and sole member) of the board's "Boston Committee."

200. ECB minutes, 7 Sept. 1994, SVB 3.5.2.

201. ECB minutes, 21 Nov. 1994; 21 March, 18 April, 29 June 1995, SVB 3.5.2.

202. SV Board minutes, 16 Feb. 1995, SVNY; ECB minutes, 7 Sept. 1994, 21 March, 18 April, 19 June 1995, SVB 3.5.2. The minutes of 19 Jan. 1995 note that "the New York chapter will be sharing this opportunity with us and is willing that all proceeds above expenses go to the Boston chapter." ECB minutes, 19 June 1995, SVB 3.5.2. New York provided twenty participants and Boston provided eleven. The trip raised a net profit of $4,432.

203. SV Board minutes, 11 May 1995, SVNY; ECB minutes, 17 May, 7 Sept. 1994, 21 March, 29 June 1995, SVB 3.5.2. Net income was $10,000, far below the $50,000 initially projected. In a meeting of 5 Oct. 1995 the Boston group agreed to send $20,000 to New York for Titian's *Transfiguration* and provided additional money to install a plaque within the church noting its contribution.

204. Christine Temin, "Boston Gives Venice Art a Boost," *Boston Globe,* 24 May 1995.

205. ECB minutes, 6 Feb. 1996, SVB 3.5.2. The event netted $9,510, of which $3,270 was donated to the La Fenice restoration. A series of smaller events ensued in the autumn of 1996 too: the chapter's annual general meeting featuring Hilliard Goldfarb of the Gardner Museum on the complex history of Titian's *Rape of Europa*, a cocktail party at the Tavern Club with Eleanor Garvey speaking on "Venetians at Home: Books and Prints in the Eighteenth Century," and the annual appeal at year's end. See ECB minutes, 16 Sept. 1996, SVB 3.5.2; "Events of 96–97," SVB 3.5.3.

206. Tia Chapman to Francesco di Valmarana, 24 March 1994, SVB 5.2, "Save Venice Correspondence," with suggestions on how to start a YF group in Boston.

207. ECB minutes, 19 Jan. 1995, SVB 3.5.2; "Save Venice 1995," SVB 5.2. Events included cocktails at the Tavern Club, a lecture at the Somerset Club, a reception at the Gardner Museum, and a dinner-dance at the Somerset. See ECB minutes, 29 June 1995, SVB 3.5.2, for an addendum that lists the expenses and income for each of these events. In March 1995 it claimed to have two hundred potential supporters.

208. Juliana Zinger to Irving Taube, 13 Nov. 1995, SVB 5.2: "It was a lively and erudite group of people, we brought in some new faces, the music was good, and we actually raised a bit of money."

209. ECB minutes, 21 March, 21 May 1996, SVB 3.5.2.

210. ECB minutes, 17 Feb., 27 Oct. 1997, SVB 3.5.2; SVB 5.2 for related correspondence. Allison Drescher played a significant role in this 1998 party.

211. ECB minutes, 21 March 1996, SVB 3.5.2.

212. SV Board minutes, 7 May 1998, SVNY. Drescher announced the launch of the Boston chapter website, www.saveveniceboston.org, in June 2001, noting that many tickets for the Carnevale gala that year had been sold via the internet. ECB minutes, 12 June 2001, SVB 1.5.3.

213. SV Board minutes, 7 Feb. 1994; 16 Feb. 1995, SVNY. The cost was $54,700.

214. SV Board minutes, 16 Feb. 1995; 25 Jan. 1996, SVNY. Boston raised $20,000 for this project.

215. SV Board minutes, 25 Jan. 1996, SVNY.

216. ECB minutes, 12 Dec. 1995; 6 Feb., 22 Oct. 1996, SVB 3.5.2.

217. ECB minutes, 22 Oct. 1996, SVB 3.5.2.

218. SV Board minutes, 25 Jan. 1996, SVNY. ECB minutes, 21 March 1996, SVB 3.5.2, briefly acknowledged Guthrie's request for copies of the minutes.

219. SV Board minutes, 25 Jan. 1996, SVNY.

220. SV Board minutes, 10 Sept. 1996, SVNY: "Dr. Guthrie raised the matter of the Boston Committee. At present there is no president and the Committee needs direction."

221. SV Board minutes, 16 Jan. 1997, SVNY. She noted that Boston had nearly $50,000 in its bank account,

all of which was intended for the Baglioni equestrian monument. The minutes of the ECB one month earlier (5 Dec. 1996) contain discussion of almost a dozen different possible events for 1997–98. Prior to becoming chapter chair, Donna Nealon Hoffman served as assistant secretary and secretary from 1991–95; she was also a member of the steering committee of the McMullen Museum of Art at Boston College and served as a board member of the Catholic Charitable Bureau of Boston and the Good Samaritan Hospice. "Biographical Sketch," SVB 3.5.3. Her husband, Christian Hoffman, an attorney, played an important behind-the-scenes role in the discussions between New York and Boston in 1996–98.

222. SV Board minutes, 1 May 1997, SVNY; ECB minutes, 17 Feb., 12 June 1997, SVB 3.5.2; "Events of 96–97," SVB 3.5.3. The Fly Club dinner netted $6,127.

223. SV Board minutes, 16 Jan. 1997, SVNY.

224. Quoted in the draft version of Emily Livingston's letter to Paul Wallace, 7 Dec. 1998, SVB 3.5.3.

CHAPTER 5: SCISMA

1. John Tagliabue, "Police End Armed Protest for 'Free Venice,'" *New York Times*, 10 May 1997. The Lega Nord (Northern League) is a populist conservative party founded in 1989 that advocates for greater regional autonomy and the creation of a new northern Italian state to be known as Padania. The timing of the event in May 1997 was no accident; it coincided both with the dissolution of the Venetian Republic on 12 May 1797 and the loss of local elections in Milan and elsewhere by separatist candidates during the previous two weeks of 1997.

2. John Martin and Dennis Romano, "Lessons from Venice, 200 Years after Its Fall," *Christian Science Monitor*, 18 Sept. 1997; John Martin and Dennis Romano, eds., *Venice Reconsidered: The History and Civilization of an Italian City-State, 1297–1797* (Baltimore: Johns Hopkins University Press, 2000); Margaret Plant, "After Two Hundred Years," in *Venice: Fragile City, 1797–1997* (New Haven, CT: Yale University Press, 2002), 457–60; Antonio Alberto Semi, *Venezia in fumo, 1797–1997* (Milan: Raffaello Cortina, 1996). Plant summarizes the conferences and exhibitions of 1996–97, including the Fondazione Cini's conferences "1797 and the Metamorphoses of Venice: From State Capitol to City of the World" (2–14 Sept. 1996) and "Venice and Austria" (28–31 Oct. 1997). Plant, "After Two Hundred Years," 457. See also the exhibition catalogues: Giandomenico Romanelli, ed., *Dai Dogi agli Imperatori: La fine della Repubblica tra storia e mito* (Milan: Generali, 1997), and Alessandro Bettagno, ed., *Venezia da Stato a Mito* (Venice: Marsilio, 1997).

3. Roberta Smith, "Another Venice Biennale Shuffles to Life," *New York Times*, 16 June 1997.

4. Executive Committee Boston (ECB) minutes, 12 June 1997, SVB 3.5.2. Donna Hoffman, who attended the Jan. 1997 Board meeting in New York, described the "factional positions" there. For details of the meeting, see SV Board minutes, 16 Jan. 1997, SVNY.

5. ECB minutes, 12 June 1997, SVB 3.5.2. This was confirmed by SV Board minutes, 16 Jan. 1997, SVNY.

6. ECB minutes, 19 Jan. 1988, SVB 3.5.3.

7. Certainly there were other events and activities with Save Venice in 1997–98 (e.g., restorations, fellowships, masked balls, lectures) but the focus in this chapter is principally on these two conflicts because they were so central to the development of SV.

8. SV Board minutes, 1 May 1997, SVNY.

9. SV Board minutes, 1 May 1997, SVNY.

10. The information in this paragraph is drawn from correspondence and other documents preserved in the SV Board minutes, attached to the meeting minutes of 1 May 1997, SVNY. The rationale for creating an "international chairman" is discussed in more detail below.

11. SV Board minutes, 1 May 1997, attachment: Barbara Berlingieri to Bob Guthrie and Larry Lovett, 5 June 1997, SVNY.

12. SV Board minutes, 1 May 1997, attachment: Bea Guthrie to Gabriella [Lorenzotti?], no date but clearly written in response to Berlingieri's letter of 5 June 1997, SVNY. Bea Guthrie was correct that the draft version offered by Berlingieri stated that the international chair would have no day-to-day responsibility for remaining in contact with SV officers nor for management of SV activities, even while appointing that individual to be "principal spokesperson" and to preside over all meetings or events.

13. *Gala Journal, 1997*, SVV.

14. SV Board minutes, 8 Sept. 1997, SVNY. Until a new president was elected, Guthrie retained that position as well as the chair. John Berendt, *City of Falling Angels* (New York: Penguin, 2005), 310–11, writes that Lovett was given the new position of international chair (which does not appear in the by-laws) because Lovett had quietly renounced his American citizenship some years before to become a citizen of Ireland for tax purposes. In Berendt's interpretation, "The Board felt it was unwise for a tax-exempt American charity to be headed by someone the IRS might view as a tax fugitive." This account is supported by the letter from Bea Guthrie to Gabriella [Lorenzotti?], written in early June 1997 and filed with SV Board minutes, 1 May 1997, SVNY.

The issue of Lovett's citizenship clearly disturbed the Guthries and their allies, but they were not alone. In 1996 the U.S. Congress passed legislation to punish anyone who gave up U.S. citizenship and who was worth more than $500,000 by permitting the IRS to tax all of their earnings for ten years after renouncing citizenship. In what the *Wall Street Journal* described as "a cloud of patriotic umbrage that passed over America in the mid-1990s," Congress also declared that beginning in 1996, everyone who renounced their U.S. citizenship would have their name published in the quarterly *Federal Register*. A 1995 report from the Joint Committee on Taxation included the names of all expatriates from early 1994 through late 1995. Such expatriates could also be barred from returning to the United States by the Immigration and Naturalization Service. Larry Lovett's name does not appear in any of these documents from 1994 to 1998, suggesting that if he did become an Irish citizen (as alleged by Berendt), he must have done so prior to 1994. The number of voluntary expatriates was generally quite low, typically only three to four hundred per year from the 1960s to about 2010, when the rate began to rise dramatically. See Barry Newman, "Renouncing U.S. Citizenship Becomes Harder Than Ever," *Wall Street Journal*, 28 Dec. 1998; for additional references, statistics, and analysis, see "Quarterly Publication of Individuals Who Have Chosen to Expatriate," Wikipedia, https://en.wikipedia.org.

15. SV Board minutes, 8 Sept. 1997, SVNY.

16. SV Board minutes, 8 Sept. 1997, SVNY.

17. SV Board minutes, 8 Sept. 1997, untitled attachment with Guthrie's statement, SVNY; see also another attachment, "Salary Received by Save Venice's Executive Director 1987–1997."

18. SV Board minutes, 8 Sept. 1997, untitled attachment with Guthrie's entire statement, SVNY.

19. SV Board minutes, 4 Dec. 1997, SVNY.

20. SV Board minutes, 4 Dec. 1997, SVNY.

21. SV Board minutes, 4 Dec. 1997; 5 Feb. 1998, SVNY.

22. Bea Guthrie to Lesa Marcello, 16 Jan. 1998, SVV. The rationales included preference for an American staff member working for an American committee, a desire to promote Conn after ten years of dedicated service, and a concern about how board members might respond to Conn's termination.

23. Bea Guthrie to Lesa Marcello, 16 Jan. 1998, SVV: "Everyone has [the] greatest admiration and appreciation of your performance with Save Venice. *Your work has been excellent in every way.* You have been an enormous help over many years. You are largely responsible for the successful completion of the Miracoli, in which you can take great pride. Your efficiency made this year's gala the smoothest-running we have ever had in the midst of all the other problems."

24. Berendt, *City of Falling Angels*, 287–92, 311–12. For another perspective, see memo to Boston chapter officers, 13 Dec. 1998, SVB 1.4.2. The Torta Prize was instituted in 1974 in memory of engineer Pietro Torta (1896–1973), for many years the president of the Order of Engineers of Venice. Awarded by the Ateneo Veneto and the Order of Engineers annually until 1999, and biennially after that, it recognizes those who within the previous two years had planned, directed, or carried out exceptional conservation and restoration on a historic Venetian building. The founding decree specified that it could be awarded to both Italians and non-Italians. In November 2019 it was given for the thirty-fifth time.

25. SV Board minutes, 7 May 1998, SVNY, include as an attachment a full copy of Count Marcello's remarks.

26. SV Board minutes, 7 May 1998, SVNY: "Dr. Guthrie explained the careful process involving the senior members of the board that had led to the decision. He and Mr. Wallace expressed the board's unhappiness at having to reduce its Venice overhead, assured Count Marcello of the board's appreciation of his wife's many years of effective service and her loyalty and dedication to Save Venice's restoration work, and promised Count Marcello that the board would write an expression of its gratitude to and affection for Countess Marcello."

27. Jack Wasserman to Paul Wallace, 30 July 1998, quoted in "Hoffman's Chronology," 30 Nov. 1998, SVB 3.5.3.

28. An effort to reduce the number of Lovett's supporters may have prompted a countervailing effort to

move the headquarters of SV from New York to Venice. This claim is made in Monique P. Yazigi, "Send the Gondolas: 'Save Venice' Is Sinking," *New York Times*, 11 Oct. 1998, but I have found no evidence supporting it.

29. SV Board minutes, 14 Sept. 1998, SVNY.

30. SV Board minutes, 14 Sept. 1998, SVNY.

31. SV Board minutes, 14 Sept. 1998, SVNY.

32. SV Board minutes, 14 Sept. 1998, SVNY. The minutes note that Gregory "objected again to the processes for the nomination and the election of Directors, stating that they did not conform to the procedures set forth in the by-laws of Save Venice." More specifically, he claimed that the nominating committee had disregarded the responsibility of screening and presenting candidate names to the board.

33. SV Board minutes, 14 Sept. 1998, SVNY; Yazigi, "Send the Gondolas."

34. SV Board minutes, 14 Sept. 1998, SVNY. For the perspectives of Bob Guthrie and Larry Lovett, see Yazigi, "Send the Gondolas."

35. SV Board minutes, 14 Sept. 1998, SVNY.

36. SV Board minutes, 14 Sept 1998, SVNY.

37. Yazigi, "Send the Gondolas."

38. D.S., "Save Venice, diaspora di nobiltà," *Il Gazzettino*, 16 Sept. 1998. My thanks to Matteo Casini for providing a copy.

39. Yazigi, "Send the Gondolas"; D.S., "Save Venice, diaspora di nobiltà," 2.

40. Christopher Mason, "Out There—Venice; Art, Commerce, and Tons of Parties," *New York Times*, 17 June 2001.

41. "Venetian Heritage" pamphlet (no author, no date, but likely 2001). This booklet of forty pages, explaining the history, mission, leadership, and restorations of Venetian Heritage, must have been printed by the organization, perhaps in conjunction with its gala of June 2001 and the simultaneous exhibition at the church of San Barnaba (9 June–4 Nov. 2001) on "Tesori della Croazia." Additional information about Venetian Heritage's mission, activities, and membership is included in chapter 9.

42. One exception for SV at this time was Baroness Mariuccia Zerilli Marimò of Milan and Monte Carlo, who was also deeply involved with the Casa Italiana at New York University that bears her name.

43. In March 1997 Wasserman inquired whether Boston was operating as an association, a corporation, or other. Boston's legal counsel, Emily Livingston, replied in April 1997 that the Boston group "operates in Massachusetts as a not-for-profit corporation [that has] filed Annual Reports with the Secretary of the Commonwealth from 1987 through 1992, and must file Annual Reports for the years 1993 through 1996." Emily Livingston to Jack Wasserman, 23 April 1997, quoted in "Hoffman's Chronology," 9, SVB 3.5.3.

44. ECB minutes, 28 Aug. 1997, SVB 3.5.3: "All the reports and figures requested by the New York Chapter for the last several years have been forwarded to New York and to the auditors, as requested."

45. SV Board minutes, 8 Sept. 1997, SVNY.

46. SV Board minutes, 8 Sept. 1997, "Introduction" in the attached audit prepared by Ernst & Young for 1996, SVNY.

47. SV Board minutes, 8 Sept. 1997, SVNY.

48. This intent of dissolution is clear from Wasserman's memo of 19 Nov. 1997 to Bob Guthrie, summarizing Wasserman's telephone conversation with Donna Hoffman and another conversation with Karen Goldman, assistant attorney general for the State of New York. Wasserman's memo is quoted in Emily Livingston to Paul Wallace, 7 Dec. 1998, draft, SVB 3.5.3.

49. ECB minutes, 17 Nov. 1997, SVB 3.5.2.

50. Donna Hoffman to Jack Wasserman, 25 Nov. 1997, SVB 3.5.3.

51. Cited in "Hoffman's Chronology," SVB 3.5.3, claiming a filing date of 13 Nov. 1997 and listing Peter Fergusson, Ronald Fleming, Watson Dickerman, Janice Hunt, Emily Livingston, and Eleanor Garvey, among others.

52. Quoted in "Hoffman's Chronology," SVB 3.5.3. Wasserman confirmed these filings of 17 Nov. 1997 in his report to the board, in SV Board minutes, 4 Dec. 1997, SVNY.

53. Bob Guthrie to SV directors, 20 Nov. 1997, memo, quoted in "Hoffman's Chronology," SVB 3.5.3.

54. SV Board minutes, 4 Dec. 1997, SVNY, confirm this: "A meeting was held on November 17, 1997, in Boston with Dr. Guthrie, Mr. Wasserman and several members of the Save Venice Boston Board who indicated that they were agreeable as long as they could maintain autonomy over planning their own events and determining how the funds raised should be spent."

55. ECB minutes, 19 Jan., 18 Feb. 1998, SVB 3.5.3. See also Janice Hunt to Donna Hoffman et al., 27 Jan. 1998, SVB 1.4.2, outlining her rationale for the Boston chapter to remain independent.

56. ECB minutes, 13 May 1998, SVB 3.5.3.

57. Emily Livingston et al. to Paul Wallace, 12 June 1998, SVB 1.4.2: "Whatever state we now find ourselves in, it cannot be disputed that Save Venice owes its existence to the efforts of the Boston group. Accordingly, it seems only right that, in recognition of its historic and pivotal role, Boston be given a special status. We are willing to be a chapter of SV/NY but we insist on being a chapter different from any other and on maintaining our Massachusetts corporate status. . . . In addition, if we find we cannot, for whatever reason, function well within the proposed new structure, we would like to retain the right to resume our previous independent corporate existence."

58. Donna Hoffman to SV Directors, 11 Sept. 1998, via fax to Priscilla (Muffy) Miller, SVB 1.4.2. In Hoffman's view, if they were the by-laws of SV/NY, the New York–based directors could alter them, but if they were the by-laws of the Massachusetts corporation, that should be dealt with in Boston.

59. Jack Wasserman to Donna Hoffman, 17 Sept. 1998, SVB 1.4.2. Wasserman's reasoning was that "by the late 1980s virtually all of the original directors of the original Mass. corporation had died or retired and there were no longer any Boston-based directors. Within minor exceptions, the succeeding directors were based in New York and in 1990 [sic] they caused the formation of a New York corporation . . . and enacted by-laws; thereafter all activities, elections, and procedural matters were conducted pursuant to those by-laws." Thus Wasserman believed that the original SV in Boston had mutated into a New York–based organization, but his position ignored the continued existence of the Massachusetts corporation and of the New York–based corporation, SV/NY.

60. ECB minutes, 20 Jan. 1999, SVB 3.5.3. A copy of the two motions is also included as an attachment with the materials from the 6 Oct. 1999 annual general meeting of the Boston chapter in SVB 3.5.3.

61. Eleanor Garvey and Peter Fergusson to Bob Guthrie, 21 Jan. 1999, SVB 3.5.3; a copy of the letter is also in "Bylaws," SVB 5.2.

62. Randolph Guthrie to Eleanor Garvey and Peter Fergusson, 8 Feb. 1999, SVB 1.4.2: "Thank you for your nice letter of 21 January informing us of the decisions of your Executive Committee. We here believe that you and we are a bit at sixes and sevens and that there are some misunderstandings about which we, too, are shaking our heads, but we also believe, as you do, that we have no reason to quarrel and every reason not to. We are very impressed by how well you are doing and only wish for your continued success. We, too, wish to continue as we have in the past, and we see no reason why we should not do so. We hope that this means that you will continue to utilize our office in the choosing and financing of projects, and that you will provide our accountants with annual financial information."

63. ECB minutes, 3 Oct. 2000, SVB 3.5.3. Victoria DiStefano was appointed as chair-elect at the Oct. 1999 annual general meeting, but by the next annual meeting in Oct. 2000 had been replaced by Peter Fergusson as chair, with Lucille Spagnuolo as vice-chair. This was Fergusson's second stint as chair. DiStefano remained active with the Boston chapter for more than a decade.

64. Frederick Ilchman, email to author, 16 Apr. 2021; John Millerchip, email to author, 18 Apr. 2021. In 2000 Ilchman was a Ph.D. candidate who had lived in Venice for several years and had received a SV fellowship there; he would subsequently become Boston chapter chair and then the chair of SV, as discussed in later chapters. Ilchman recalls that this conversation occurred during lunch at the Hotel Monaco, immediately following a board meeting in Venice on 4 Oct. 2000. He remembers that "I was really struck that someone very knowledgeable envisioned Save Venice to be capable of moving beyond the conservation of art and architecture to engage in high-level discussion of city planning and policy." Millerchip confirms that, given SV's standing within the Private Committees at that time, he believed that it should be involved in such deliberations with the Committee for the Arsenale. In the event, SV did not take part, but the anecdote indicates that some believed SV was destined to be even more influential going forward.

CHAPTER 6: RICOSTRUZIONE

1. Paolo del Giovane and Roberto Sabbatini, "Perceived and Measured Inflation after the Launch of the Euro: Explaining the Gap in Italy," in *The Euro, Inflation and Consumer's Perceptions* (Berlin: Springer, 2008), 13–49.

2. Matthew White, interview with author, 28 June 2019, for the quotation at the beginning of this chapter. White was a cofounder of the California chapter in 2000, along with Terry Stanfill and Hutton Wilkinson.

Although SV consistently defined this chapter as including the entire state, it was clearly centered in Los Angeles.

3. SV Board minutes, 21 Jan. 1999, SVNY.

4. SV Board minutes, 21 Jan. 1999, SVNY. At this meeting only twelve directors were present. New board members included (in alphabetical order) Bernadette Berger, Tia Chapman, Dayssi Olarte de Kanavos, John Loring, Maria Manetti, Mara Robinson, and Mariuccia Zerilli-Marimò. Later that winter of 1999 the board also elected Alida Brill Scheuer, thus bringing the board to twenty-four members. SV Board minutes, 6 May 1999, SVNY.

5. SV Board minutes, 6 May 1999, SVNY. New board members included Marion Antonini, John Day, Peter Duchin, Beatrice Esteve, Jean Lindsey, Sidney Stires, Nadja Swarovski, and George White.

6. SV Board minutes, 6 May 1999; 4 May 2000, SVNY. As discussed below, the California chapter was thriving and it was sensible to invite more West Coast members to join the board.

7. SV Board minutes, 12 Oct. 1999, SVNY. The new board members were Melva Bucksbaum, Hilary Califano, Anne Hawley, and Theodore K. Rabb (none of whom were from the West Coast). In this same meeting Isabella del Frate Eich resigned, and the board adopted a resolution recognizing her important contributions during the prior seven years, especially her financial support of art and music and her "many intangible qualities of charm and intelligence."

8. SV Board minutes, 27 Jan. 2000, SVNY.

9. SV Board minutes, 27 Jan. 2000; 6 May 1999, SVNY.

10. SV Board minutes, 8 Feb. 2001, SVNY. New members included Barbara Bergreen, Elizabeth Locke, Emily Mead, Matthew White, Hutton Wilkinson, and John Leopoldo Fiorilla (*ex officio* as president of YF). At a subsequent meeting of 31 Jan. 2002 Laura Maioglio Blobel and Robert Lovejoy were also elected to the board, and Anne Hawley was identified as the "Massachusetts Legal Representative" (a new category). The revised by-laws omitted any mention of the Boston chapter's "special status," thus contravening the recommendation of the board three years earlier.

11. SV Board minutes, 8 Feb. 2001, attachment (p. 11) to minutes, "Draft: Save Venice Inc. Board Membership: Commitments and Expectations," SVNY.

12. SV Board minutes, 8 Sept. 1997, untitled attachment with Guthrie's statement, SVNY.

13. SV Board minutes, 21 Jan. 1999, SVNY. Wallace informed the board that "Ms. Morse speaks Italian as well as four other languages, and [that] she and her partner currently represent several authors in their publishing efforts, and would most likely need a few months to terminate this relationship."

14. SV Board minutes, 6 May, 12 Oct. 1999, SVNY.

15. SV Board minutes, 12 Oct. 1999, SVNY.

16. Tia Chapman, interview with author, 12 Jan. 2015.

17. SV Board minutes, 3 May 2002, attachment A, "Resolution Honoring Tia Fuhrmann Chapman," SVNY.

18. SV Board minutes, 29 Oct. 2002, SVNY; SV Newsletter, Fall 2002, 16, SVNY.

19. Jeffrey Klineman, "Charity's CEO Sees Young People as Key to Restoration of Antique City," *Chronicle of Philanthropy*, 7 Aug. 2003, 36–38.

20. SV Board minutes, 29 Oct. 2002, SVNY. I have been unable to locate such a report in the board minutes.

21. SV Board minutes, 29 Oct. 2002; 30 Jan., 16 May 2003, SVNY.

22. Klineman, "Charity's CEO," 36; SV Board minutes, 16 May 2003, SVNY; Melissa Conn, interview with author, 13 June 2019.

23. SV Board minutes, 30 Oct. 2003, SVNY.

24. Paul F. Wallace was chair and CEO of MOA Hospitality and twice president of the Broadstone Group, as well as the principal shareholder of a privately held manufacturing company and an investor in and operator of various real estate projects.

25. SV Board minutes, 25 Oct. 2001; 29 Oct. 2002, SVNY. On Dobkin's prior appointment, see Roberta Smith, "New Job for Ex-Leader of Academy of Design," *New York Times*, 15 Dec. 1989. The Oct. 2002 minutes note only that "Mr. John Dobkin submitted his letter of resignation effective immediately."

26. SV Board minutes, 30 Oct. 2003, SVNY. The board agreed to amend the by-laws in accordance with her request.

27. SV Board minutes, 16 Feb. 2006, SVNY. Rossi-Landi outlined this goal in her president's report to the board.

28. SV Board minutes, 3 Nov. 2006, attachment A, SVNY. Rossi-Landi returned to be SV president in 2011–15.

29. SV Board minutes, 16 May 2003, SVNY: "Dr. Guthrie said that he had helped to make the by-laws, that they were specifically made to prevent any one person from dominating the organization, and that he was unwilling to break them for himself."

30. SV Board minutes, 30 Oct. 2003, SVNY; see also the attached memo from Bob Duke (chair, nominating committee) to SV Board of Directors, 25 Sept. 2003, SVNY, informing the board that Bob Guthrie had agreed during the trip to Turkey to continue as board chair and explaining the mechanism for altering the by-laws to permit that to happen.

31. The SV Board minutes, 30 Oct. 2003, SVNY, note that the Guthries only agreed to stay through September 2004, but in fact both of them remained in leadership positions through 2006. Bob Guthrie was elected chair emeritus in the 3 Nov. 2006 board meeting.

32. W. R. Rearick (1930–2004), known as Roger, earned his Ph.D. in art history at Harvard under Sydney Freedberg. Following appointments at the Frick Collection, Johns Hopkins University, and Villa I Tatti, he served as a full professor at the University of Maryland from which he retired in 1991. In his later years he was a resident of Venice. An expert on Venetian paintings and drawings, particularly those by Bassano, Titian, and Veronese, he joined the SV board in 1993 but had served SV informally for at least a decade before that. See the obituary (in Italian) by Fulvio Zuliani in *Artibus et Historiae* 55 (2007): 8–10, and Anne Varick Lauder, "W. R. Rearick: A Tribute," *Master Drawings* 42, no. 4 (Jan. 2004): 297–98.

33. Roger Rearick to Ted Rabb, 31 Jan. 2003, SVNY; this and additional correspondence is attached to SV Board minutes, 29 Oct. 2002, SVNY.

34. Roger Rearick to Bob Guthrie, 2 Feb. 2003, attached to SV Board minutes, 29 Oct. 2002.

35. SV Board minutes, 16 May 2003, SVNY.

36. SV Board minutes, 16 May 2003, SVNY.

37. Roger Rearick to Bob Guthrie, undated but clearly between 16 Sept. and 30 Oct. 2003, attached to the SV Board minutes, 29 Oct. 2002, SVNY. Rearick was in poor health at this time and that may have contributed to his resignation. For a brief memorial of Rearick, see SV Newsletter, Fall 2004, 20, SVNY.

38. SV Board minutes, 27 Jan. 2000, SVNY.

39. SV Board minutes, 27 Jan. 2000, SVNY, as one example.

40. SV Board minutes, 29 Oct. 2002, SVNY.

41. SV Board minutes, 29 Oct. 2002, SVNY.

42. Bob Guthrie to Beatrice Esteve, 4 April 2003, appended to the SV Board minutes of 16 May 2003, SVNY. I suspect that this three-page letter, which lays out Guthrie's narrative of how the financial crisis unfolded in 2002–3, was sent to each board member, but only this copy is extant.

43. Bob Guthrie to Beatrice Esteve, 4 April 2003, SVNY.

44. SV Board minutes, 30 Jan. 2003, SVNY.

45. Bob Guthrie to Beatrice Esteve, 4 April 2003, SVNY.

46. Sidney D. Wexler to Michael J. Dagon, 23 April 2003, appended to SV Board minutes, 16 May 2003, SVNY.

47. Bob Guthrie to SV Board, 1 May 2003), memo, attached to SV Board minutes, 16 May 2003, SVNY.

48. SV Board minutes, 16 May 2003, SVNY. "If major reductions in operating expense were not made immediately, the organization would be at severe risk."

49. SV Board minutes, 16 May 2003, SVNY.

50. SV Board minutes, 16 May 2003, SVNY.

51. SV Board minutes, 30 Oct. 2003, SVNY.

52. Bob Duke (chair, nominating committee) to SV Board, 25 Sept. 2003, appended to SV Board minutes, 30 Oct. 2003, SVNY.

53. SV Board minutes, 3 Sept. 2004, SVNY.

54. SV Board minutes, 20 Jan. 2005, SVNY. The audit was presented by Gary Puwin of Pustorino, Puglisi & Co. Uncommitted funds had risen to $1.62 million; by May 2005 that number had risen to more than $2 million.

55. SV Newsletter, 1999, 10, SVNY; "Crystal Ball," *WWD*, 25 Feb. 1999, https://wwd.com.

56. SV Newsletter, 2000, 13, SVNY.

57. SV Newsletters, 2002–5, SVNY. See also "Pretty in Mink," *WWD*, 11 March 2004, https://wwd.com.

58. SV Newsletter, 2001, 2002, 2003, SVNY.

59. SV Board minutes, 14 May 2005, SVNY; SV Newsletter, 2005, 14, SVNY. This event was described in the May 2005 minutes as "one of the most beautiful parties ever held by Save Venice."

60. SV Board minutes, 27 Oct. 2005, SVNY. Forty-eight artists participated in this exhibition entitled "Venice Now."

61. SV Board minutes, 3 Oct. 2000, SVNY.

62. SV Board minutes, 30 Jan., 16 May 2003, SVNY. The Chicago chapter never materialized.

63. SV Board minutes, 4 May, 3 Nov. 2006, SVNY.

64. SV Board minutes, 29 Jan. 2004, SVNY.

65. SV Board minutes, 29 Jan. 2004, SVNY. The Serenissima Society had been created in Jan. 2002 by SV for donors who gave more than $1,000 annually. In return they received a discount card of 10–20 percent at participating shops, hotels, museums, and restaurants in Venice. For a detailed listing of the merchants and the conditions, see the four-page attachment to SV Board minutes, 31 Jan. 2002, SVNY. In 2003, twenty-two additional merchants joined the program, and it was suggested that New York restaurants be added to the list. In his brief tenure as executive director, Michael Dagon promoted this program. The idea of a discount card in Venice had been introduced by the IFM in the 1970s, when Venetian merchants were eager to lure American consumers to Venice. By the early twenty-first century, however, the dramatic increase in tourism and in internet-based shopping made such a card less attractive.

66. SV Board minutes, 21 Jan. 1999; 4 May 2000, SVNY. For details about sponsors, see Melissa Conn and David Rosand, eds., *Save Venice Inc: Four Decades of Restoration* (New York: Save Venice Inc., 2011), 454.

67. On Ilchman, see chapters 7 and 8. For Fassl, who completed a Ph.D. under David Rosand at Columbia in 2004, taught at Franklin University in Lugano, and was director of Columbia's Casa Muraro in Venice, see SV Board minutes, 25 Oct. 2001, SVNY.

68. SV Board minutes, 21 Jan. 1999, SVNY.

69. On Serena Urry, who later became chief conservator at the Cincinnati Art Museum, see SV Board minutes, 27 Jan. 2000, SVNY. On Wirsing, see SV Board minutes, 3 May 2001, SVNY, for an attachment that is Wirsing's letter of 26 April 2001 to the board describing his "most rich and rewarding experience," which included meeting "painters, sculptors, restorers, singers, musicians, composers, stuccoists, carvers, gondola makers, gold beaters, nobility, poverty, and a few lawyers." His SV fellowship was the "Eleanor Lambert Fellowship in Objects Restoration"; Wirsing later transitioned to a career in costuming for cinema and television.

70. SV Board minutes, 29 Oct. 2002; 11 June 2007, SVNY. It is not clear if the music fellowship was awarded. In 2008 and 2010 a fellowship in Rearick's memory was awarded to Enrico Lucchese to catalogue eighteenth-century drawings by Gian Maria Zanetti at the Giorgio Cini Foundation, with funding from SV board members. Conn and Rosand, eds., *Save Venice Inc: Four Decades*, 454.

71. SV Board minutes, 23 May 2002, SVNY; Conn and Rosand, eds., *Save Venice Inc: Four Decades*, 455.

72. SV Board minutes, 6 May 1999, 25 Oct. 2001, SVNY; Richard Almeida, interview with author, 24 Dec. 2020; Matthew White, interview with author, 28 June 2019.

73. SV Board minutes, 27 Jan. 2000, SVNY.

74. SV Board minutes, 4 May, 3 Oct. 2000; 3 May, 25 Oct. 2001, SVNY.

75. SV Board minutes, 25 Oct. 2001, SVNY. This meeting was a telephone conference call rather than an in-person meeting owing to disruption from the 9/11 attacks. These minutes acknowledged White and Wilkinson "for their tireless efforts and enthusiasm in establishing the California Chapter and for their work to help make the Regatta Week Gala the success that it was." The theme of the 2001 treasure hunt designed again by Douglas Sardo was "Saints in the Six Sestieri."

76. SV Board minutes, 29 Oct. 2002, SVNY (Fowlkes quotation); supplementary materials from 2003, filed immediately after the minutes of 29 Oct. 2002, SVNY (Guthrie quotation).

77. SV Board minutes, 25 May 2004; 20 Jan. 2005, SVNY.

78. SV Newsletter, Fall 2004, 17–18, SVNY.

79. In 1994, at the request of Bea Guthrie, Michael LaPlaca designed SV's twenty-fifth anniversary brochure, and in subsequent years created invitations, brochures, newsletters, *Gala Journals*, etc. After "The Mosaic of Venice" (2004), LaPlaca continued with treasure hunt booklets "Venetian Hunts and Puzzles" (2006), "Palladio Hunts and Puzzles" (2008), and others up through the 2020 Carnevale.

80. James H. Johnson, *Venice Incognito: Masks in the Serene Republic* (Berkeley: University of California Press, 2011); Danilo Reato, *Storia del Carnevale di Venezia* (Venice: Filippi, 1991).

81. SV Board minutes, 14 May 2005, SVNY; Virginio Favale and Paolo Alei, *Venice Carnival* (Philadelphia: Trans-Atlantic, 2006).

82. SV Board minutes, 14 May, 27 Oct. 2005, SVNY. SV Newsletter, 2006, 10, SVNY, includes an elaborate description of events; see also Kim Devore, "Lost in a Masquerade," *Malibu [CA] Times*, 15 March 2006. Due to colder weather, the 2006 treasure hunt featured more indoor clues (at Ca' d'Oro, Museo Correr, Gallerie dell'Accademia, Ca' Rezzonico, and of course the church of the Miracoli), as well as a 135-clue crossword puzzle. Michael LaPlaca, email to author, 18 April 2021.

83. The tradition continued with a Carnevale Gala in Venice in February 2010 and again in February 2020.

84. SV Board minutes, 19 Dec. 2005, SVNY, offer one case study of a deposit abandoned for the 2007 cruise on the *Casanova* down the Rhine-Main-Danube Rivers. This special meeting of Dec. 2005 was called exclusively to discuss options for various cruises and contains a wealth of detail demonstrating how carefully the Guthries planned such trips. Information about other trips is scattered through the board minutes.

85. Bob Guthrie to SV Board, 15 Oct. 2003, attached to SV Board minutes, 30 Oct. 2003, SVNY. For another equally enthusiastic perspective on this trip written after it concluded, see Pietro Alessandro Vigato to Beatrice Rossi-Landi, 19 May 2004, attached to SV Board minutes, 25 May 2004, SVNY, which reads in part: "This was a trip quite unlike any other that Save Venice had ever undertaken. There were no private visits to museums or palaces, no caviar, no lectures. And we soon discovered there were no telephones, no newspapers and no hot water. What we found instead was an immense but calm dark river, a vast sky filled with stars we had never seen before, a landscape of every shade of green imaginable, strange birds with unfamiliar songs, lazy sloths asleep on slender branches and pale pink dolphins who came to visit us when we swam in the warm, cola-colored water of the Rio Negro. What we had were long conversations and shared cups of coffee at dawn and the daily frustration of having Bob Guthrie beat us at the toothpick game over and over again each evening. For eight days we were all back at summer camp."

86. Bob Guthrie to SV Board, 15 Oct. 2003, SVNY.

87. Beatrice Esteve, interview with author, 6 June 2019.

88. Martha Stires Wright, interview with author, 6 June 2019.

89. SV Board minutes, 27 Jan., 3 Oct. 2000, SVNY.

90. SV Board minutes, 8 Feb. 2001, SVNY. The Guthrie/Rabb lecture was filmed and later featured on the SV website; the event included a video message from Venice mayor Paolo Costa and a presentation from Consul General Radicati. Griswold's lecture took advantage of research for an exhibition that he had co-curated at the Metropolitan Museum from 11 Jan. to 27 March 1994. William Griswold and Linda Wolk-Simon, *Sixteenth-Century Italian Drawings in the New York Collections* (New York: Metropolitan Museum of Art, 1994).

91. SV Board minutes, 3 May 2001, SVNY.

92. SV Board minutes, 31 Jan. 2002, SVNY; SV Newsletter, Fall 2002, 12, SVNY; Louis Begley and Anka Muhlstein, *Venice for Lovers*, transl. Anne Wyburd (New York: Grove Press, 2008). It was originally published in German (2003) and then in English (2005) in Great Britain.

93. SV Board minutes, 3 May 2002, SVNY.

94. SV Board minutes, 3 Sept. 2004; 14 May 2005, etc., SVNY.

95. SV Board minutes, 3 May 2001; 29 Oct. 2002, SVNY.

96. SV Board minutes, 16 May 2003, SVNY. By 2006 the Venice lectures were designated in memory of W. R. Rearick, who played a fundamental role in founding the series.

97. SV Board minutes, 31 Jan., 29 Oct. 2002; 30 Jan. 2003, SVNY. Bonino was a professor at Mount St. Mary's University in Los Angeles; Evers also held a Ph.D. from U.C. Berkeley and was an independent scholar in San Francisco; Nardi was a prominent jeweler in Venice.

98. SV Board minutes, 31 Jan. 2002, SVNY; SV Newsletter, Fall 2003, 6; Fall 2004, 1–3, SVNY.

99. SV Board minutes, 29 Jan. 2004; 14 May 2005, SVNY. A small bronze plaque honoring Rearick was prepared in summer 2004 but he died before it could be installed. This plaque and the fact that the *Venezia Restaurata* lecture series honored Rearick were gestures of posthumous reconciliation by SV.

100. SV Board minutes, 3 Oct. 2000; 31 Jan. 2002; 29 Jan. 2004; 14 May 2005, SVNY. Attachment E with the SV Board minutes, 27 Oct. 2005, SVNY, is a detailed book proposal about the San Marco restoration but it appears that the book was never published. See also SV Newsletter, Fall 2002, 3, SVNY.

101. SV Board minutes, 4 May 2000, undated attachment "Update on Fenice Theater" by John Millerchip, SVNY. The donation is described in SV Board minutes, 29 Oct. 2002, SVNY.

102. SV Board minutes, 14 May 2005, SVNY.

103. SV Newsletter, Fall 2000, 1–11, SVNY.

104. SV Newsletter, Fall 2002, 1–11, SVNY.

105. SV Board minutes, 30 Jan. 2003, SVNY. By comparison, in Oct. 2020 Christopher Apostle reported that SV was sponsoring forty-three projects and educational initiatives. SV Board minutes, 2 Oct. 2020, SVNY.

106. SV Board minutes, 12 Oct. 1999; 27 Jan. 2000, SVNY. These were titled "Board List Projects" and "Sponsor List Projects."

107. Between 2002 and 2006 the Projects Committee included Roger Rearick, David Rosand, Richard Oldenburg, David Bull, Beatrice Rossi-Landi, Ted Rabb, Alida Brill-Scheuer, Mary Frank, Patricia Fortini Brown, and Frederick Ilchman.

108. SV Board minutes, 3 May 2001; 31 Jan. 2002; 29 Jan., 3 Sept. 2004; 14 May 2005, SVNY, offer examples of these diverse tasks. The question of donor plaques has always been a thorny one. Donors often want to be recognized, and this could be accommodated with temporary signage or in the acknowledgments of a publication or exhibition. However, SV does not own any of the buildings where conservation occurs nor the art inside and thus cannot insist on a plaque. One recent innovation is to incorporate recognition of donors along with didactic materials about the artist, the context, and the conservation process, most recently via video, at the worksite.

109. SV Board minutes, 21 Jan. 1999, SVNY.

110. SV Board minutes, 21 Jan. 1999, SVNY.

111. SV Board minutes, 6 May 1999, SVNY.

112. SV Board minutes, 4 May, 3 Oct. 2000, SVNY.

113. SV Board minutes, 3 May 2001, SVNY.

114. SV Board minutes, 16 May 2003, SVNY.

115. SV Board minutes, 27 Jan. 2000, SVNY.

116. SV Board minutes, 6 May 1999, SVNY. Beyond its initial grant of $40,000 in 1999, the Cynthia Hazen Polsky Foundation gave another $35,000 to redesign the website in 2006. SV Board minutes, 3 Nov. 2006, SVNY. The website is www.savevenice.org.

117. SV Board minutes, 3 Oct. 2000, SVNY.

118. SV Board minutes, 27 Jan. 2000, SVNY: Board president Paul Wallace "reported that he and [SV executive director] Ms. Fuhrmann had a wonderful meeting with Terry Stanfill and her friends in California to discuss the formation of the California chapter. There is an enormous amount of enthusiasm within the new group." As noted previously, the chapter was always centered in Los Angeles.

119. SV Board minutes, 4 May 2000, SVNY. The Lando Chapel is part of the cathedral of San Pietro in Castello, and the funds were raised in honor of Dr. Franklin Murphy, an important early supporter of the Venice Committee in Los Angeles. This Lando chapel of San Pietro in Castello should not be confused with the eponymous Lando chapel in the church of San Sebastiano, restored by SV at a later date.

120. SV Newsletter, Fall 2000, 14, SVNY. See also "The California Chapter of Save Venice Inc.," attachment to SV Board minutes, 4 May 2000, SVNY.

121. SV Board minutes, 3 Oct. 2000, SVNY.

122. Matthew White, "'Un Ballo in Maschera' Raises Funds for Save Venice Inc.," *San Marino [CA] Tribune*, 5 Oct. 2000, included as an attachment to SV Board minutes, 3 Oct. 2000, SVNY.

123. SV Board minutes, 8 Feb. 2001, SVNY.

124. SV Board minutes, 3 May, 25 Oct. 2001, SVNY. The Fortuny event on 23 Sept. 2001 was ultimately canceled because of the 9/11 attacks.

125. SV Board minutes, 29 Jan., 25 May 2004, SVNY.

126. SV Board minutes, 30 Oct. 2003, attachment "Report for Save Venice" from Terry Stanfill, SVNY. Other events were held at the homes of California chapter members, such as Dawnridge (Hutton Wilkinson) or Castle Green (Matthew White and Thomas Schumacher).

127. Additional references to fundraising events can be found in SV Board minutes, 20 Jan., 14 May, 27 Oct. 2005; 16 Feb., 4 May, 3 Nov. 2006; 11 June 2007, SVNY.

128. Matthew White, interview with author, 28 June 2019.

129. Anne Hawley, director of the Isabella Stewart Gardner Museum (1980–2015), was appointed by the board as the "Massachusetts Legal Representative" in 2002, 2004, and 2005 but there are few references to Boston in those years.

130. SV Newsletter, Fall 2002, 12; Fall 2003, 13, SVNY; Spagnuolo, email to author, 16 Sept. 2020.

131. SV Newsletter, Fall 2003, 13–14, SVNY. Juan Prieto became involved with SV around 1987 when he attended a Young Friends gala in New York. In 1990 he relocated to Boston and attended a lecture at the Somerset Club by Mario di Valmarana, followed by the 2001 gala in Venice. Juan Prieto, interview with author, 26 Feb. 2015. His achievements as chapter chair are discussed below and in chapter 7.

132. "Save Venice Meetings/Minutes," SVB 2.1.2. This file includes minutes of both the annual general meeting and the executive committee (1999–2014). Susan Angelastro and Anne Fitzpatrick replaced Eleanor Garvey as secretary while Liana Cheney and Lilian Armstrong served in turn as chair of the nominating committee.

133. ECB minutes, 10 Dec. 2002, SVB 2.1.2.

134. The AGM featured talks by Paola Malanotte-Rizzoli (a native Venetian and professor of physical oceanography at MIT), Donald Harleman (an MIT professor and longtime consultant to UNESCO on tidal issues), Fabio Carrera of Worcester Polytechnic Institute (a native Venetian and an expert on the mapping of the Venetian built environment), and Rafael Bras of MIT (a civil engineering professor and expert on hydrometeorology). See AGM minutes, 6 Oct. 1999 (Malanotte-Rizzoli); AGM minutes, 2 Oct. 2001; ECB minutes, 12 June 2001 (Harleman); AGM minutes, 21 Oct. 2003, 19 Oct. 2004 (Carrera and Bras), SVB 2.1.2.

135. ECB minutes, 7 Dec. 2000; 31 Jan., 12 June 2001, SVB 2.1.2. The minutes noted that this event "brought us a number of new friends and increased our visibility," and that "a real opportunity awaits us with Lydia Shire, who so enjoyed her role with Julia Child that she offered to work with us on another such event."

136. ECB minutes, 21 Oct. 2001; 14 May 2003, SVB 2.1.2.

137. ECB minutes, 14 May 2003, SVB 2.1.2. Lloyd organized a similar event on 13 Nov. 2004 ("Una Cena Veneziana") at the Boston Athenæum, and again on 1 Nov. 2006 with Nicolò Rubelli speaking on "Venice and Silk."

138. SV Board minutes, 3 Sept. 2004, SVNY. After opening in Boston, the exhibit traveled to Venice's Marciana Library from Oct. to Dec. 2004. Elizabeth Anne McCauley et al., eds., *Gondola Days: Isabella Stewart Gardner and the Palazzo Barbaro Circle* (Boston: Isabella Stewart Gardner Museum, 2004).

139. ECB minutes, 2 Dec. 2003, SVB 2.1.2, is the initial reference to the Boston lecture series; ECB minutes, 10 Feb. 2004, SVB 2.1.2, confirms the first lecture on 29 Jan. 2004.

140. AGM minutes, 25 Sept. 2002, SVB 2.1.2.

141. SV Newsletter, Fall 2002, 12–13; Fall 2003, 13, SVNY.

142. Extensive files on these Boston YF parties are conserved in three boxes: SVB 5.1, 5.2, and 5.3 (donated to the author by Juan Prieto), including correspondence, invoices, invitations, program books, and press clippings.

143. ECB minutes, 21 Oct. 2003, SVB 2.1.2. This small booklet, entitled "Save Venice Boston," includes a very short history of the organization, a list of its annual program of events, and suggestions on how to participate and donate. For press coverage, see *Boston Courant*, 15 March 2004; *Boston Sunday Globe*, 9 March 2003, 7 March 2004; *Boston Herald*, 7 May 2006; and *Improper Bostonian*, 16 July 1996.

144. The 2002 Carnevale party supported conservation of three large ceiling canvases by Gaspare Diziani in the former Scuola del Vin, attached to the church of San Silvestro, and contributed to cleaning of Tintoretto's *Birth of John the Baptist* in San Zaccaria. SV Newsletter, 2002, 12–13, SVNY. The 2003 Carnevale party raised money to restore the side portal of the church of San Francesco della Vigna and for the cleaning and consolidation of Camillo Capelli's frescoes in the sacristy of the church of San Salvador. SV Newsletter, 2003, 13, SVNY. In 2005 Boston's Young Friends sponsored the refurbishment of the altarpiece by Fra Antonio da Negroponte in San Francesco della Vigna. SV Newsletter, 2005, 15, SVNY.

145. SV Newsletter, 2005, 8–9, 12, SVNY.

146. Juan Prieto to Boston EC, 25 April 2006, SVB 4.2.10; SV Newsletter, 2006, 7, SVNY.

147. SV Newsletter, Fall 2002, 12–13, and other SV newsletters, 1999–2006, SVNY. Details on the "Venetian Discovery" trip of 23–27 Oct. 2002 are in the folder "Venetian Discovery 2002," SVB 5.2.

148. During Drescher's seven years as YF chair, the Boston YF raised in excess of $350,000; see SV Newsletter, 2005, 12, SVNY.

149. SV Board minutes, 20 Jan., 14 May 2005, SVNY. Neither the SV board minutes nor the Boston executive committee minutes indicate whether the Newport party occurred.

150. ECB minutes, 2000–2006, SVB 2.1.2; the same minutes and additional correspondence are in SVB 4.2.6, 4.2.9, and 4.2.10. See also SV Newsletters, 2000–2005, SVNY.

151. SV Board minutes, 14 May 2005, SVNY. See also 105n212. The site was www.saveveniceboston.org. The date at which this website ceased to function is not known but was probably in 2018–19. Substitute pages were created at Facebook.com and at Square.com; the Boston chapter also began to use the SV website more consistently.

152. Lucille Spagnuolo to Robert [sic] Guthrie, 12 Sept. 2002, SVB 4.3.1; Michael Dagon to Peter Fergusson, 11 Oct. 2002, SVB 4.3.1 (quotation).

153. Peter Fergusson to Michael Dagon, 22 Nov. 2002, SVB 4.3.1. Fergusson noted that "the protection and restoration of architectural monuments sculpture, and paintings in Venice has to take account of matters [such as] . . . the raising of buildings, the effect of the eco-system on the fabric of Venice, techniques to mitigate the lateral and vertical migration of water and salts." See also Peter Fergusson to Juan Prieto, 17 Jan. 2003, and Liz Makrauer to Peter Fergusson, 5 June 2003, SVB 4.3.2. Transferring the money was complicated; see extensive correspondence in SVB 4.3.2.

154. Harold Carroll to Randolph Guthrie, 18 March 2003, SVB 4.2.15.

155. Randolph Guthrie to Harold Carroll, 22 March 2003, SVB 4.2.15.

156. Randolph Guthrie to Harold Carroll, 22 March 2003, SVB 4.2.15: "Those involved in BC are very good friends. They do an excellent job and are, and always have been, a major asset to SV. SV certainly does not want an open quarrel with them. . . . In a meeting that I had with some of the BC board a few years ago, I gently told them all of this and asked them to let the matter lie. That is still my hope."

157. "Joint Venture Agreement between Save Venice Inc. and Save Venice of Boston, Inc.," SVB 4.3.6. This document was produced in 2005 by Juan Prieto and the Boston chapter's new attorney, J. Robert Connor.

158. ECB minutes, 8 March 2005, SVB 2.1.2.

159. SV Board minutes, 27 Oct. 2005, SVNY.

160. SV Board minutes, 27 Oct. 2005; 16 Feb. 2006, SVNY, especially attachment C for the Feb. 2006 minutes, a letter from Planning Committee chair John Day to the SV board about the purpose and timing of his committee. Other members included Frederick Ilchman (secretary), Mary Frank, Bob Lovejoy, Ted Rabb, David Rosand, and Sarah Schulte. In addition to the treasure hunt booklets noted previously, LaPlaca had helped Liz Makrauer to design a revamped SV website.

CHAPTER 7: UNITÀ

1. Jane Da Mosto, *The Venice Report: Demography, Tourism, Financing and Change of Use of Buildings* (Cambridge: Cambridge University Press, 2009).

2. Sylvia Poggioli, "In Venice, Huge Cruise Ships Bring Tourists and Complaints," National Public Radio, 15 July 2013, https://www.npr.org.

3. Alessandra Stanley, "Venice Journal: Boat Gobbles Waves, but Bobbles in Political Seas," *New York Times*, 14 Jan. 1999; "Chuck Robinson's 'Mangia Onda' Boat, Designed to Minimize Detrimental Waves, Arrives in Venice," *Gala Journal*, 1999, 44–45, SVV. Chuck Robinson, the spouse of SV board member Mara Robinson, designed a sleek fiberglass powerboat that reduced waves produced by a boat by funneling them through wings along both sides of the hull.

4. Anna Somers Cocks, "This Is No Way to Solve the Cruise Ship Issue in Venice," *Art Newspaper*, 4 Dec. 2017, https://www.theartnewspaper.com.

5. MUVE (www.visitmuve.it) comprised Palazzo Ducale, Museo Correr, Torre dell'Orologio (Clock Tower), Ca' Rezzonico, Ca' Pesaro, Museo del Vetro (Glass Museum), Museo di Storia Natural (Natural History Museum), Palazzo Mocenigo, Palazzo Fortuny, Casa di Carlo Goldoni, and Museo del Merletto (Lace Museum).

6. SV Board minutes, 4 May 2006, and attachment A, Report of the Executive Committee, SVNY, endorsing the nominations of Robert Lovejoy as chair and Liz Makrauer as executive director; they were officially welcomed in the board meeting of 18 Jan. 2007.

7. Lovejoy worked as a lawyer for Davis Polk & Wardwell LLP on Wall Street (1971–84) and as an investment banker and managing director at Lazard Frères (1984–99) and then at Ripplewood Holdings LLC (2000–2006) and

as principal at J. R. Lovejoy & Co. He has been a board member of Orient-Express Hotels, Rye Country Day School, the Joffrey Ballet, and the New York City Opera. Invited by Sarah Schulte to attend the 2001 Venice Gala, he was astonished at SV's ability to restore priceless paintings for a relatively low amount of money. Born in 1944, he joined the SV board in Jan. 2002, became treasurer in Jan. 2004, served as chair from 2007 to 2010, and continued to serve on the board thereafter. Bob Lovejoy, interview with author, 15 Oct. 2020. See also Lovejoy to SV, 16 Jan. 2002, attached to SV Board minutes, 8 Feb. 2001, SVNY, narrating his professional biography from 1971 to 2002.

8. Although he initially thought that the three-year reserve rule was "ridiculously conservative," Lovejoy came to realize such a policy was crucial to ensure job security for the staff, to preserve SV's reputation in Venice for following through on its commitments, and to protect the board from trying to raise more money than it was capable of. Bob Lovejoy, interview with author, 15 Oct. 2020. The "Financial Management Principles" continue to be updated by the board every January.

9. SV Board minutes, 11 June, 19 Oct. 2007, SVNY.

10. SV Board minutes, 22 Jan. 2010; 14 Jan. 2011, SVNY. One example of diversifying the revenue stream was to expand beyond the dates of Regatta Week and Carnevale; Lovejoy promoted the 2008 Palladio Gala in mid-July, as described below.

11. SV Board minutes, 22 Jan., 7 May 2010, attachment A ("Resolution in Honor of Sarah Schulte"), SVNY. Schulte served on the search committee for an executive director in 2002, chaired the Serenissima Society in 2004, was part of the SV Planning Committee in 2005–6, and returned to the board 2010–13. She was also admired as an artist whose works on paper and canvas, as well as a special edition Swatch, often celebrated Venice.

12. Bob Lovejoy, interview with author, 15 Oct. 2020.

13. SV Board minutes, 22 Jan. 2010; 14 Jan. 2011, SVNY.

14. A native of Amarillo, Texas, (born 1958) White moved west to dance professionally for five years with the Los Angeles Ballet and then owned an antique shop in Pasadena for another decade, during which he helped to establish the nonprofit Friends of Florence. In 1999 he attended the Venice Gala at the invitation of Terry Stanfill; during a water taxi ride they agreed to cofound a California chapter of SV in the following year. Matthew White, interview with author, 28 June 2019. White recalled his initial Venice Gala thus: "I had already been to Venice, but through this Save Venice event, I enjoyed a magical, surprising experience. I lived Venice in a completely new way, entering the history of the city, with its monuments and works of art bearing witness to its great past. It's a place that strikes me in a profound way that is hard to explain." As quoted in Peter Ash Lee and Daniele Rielli, "Matthew White," L'Uomo Vogue, May–June 2014, https://www.vogue.it. Chapter 6 contains details on the founding of the California chapter.

15. Matthew White, Italy of My Dreams (New York: Pointed Leaf Press, 2010).

16. SV Board minutes, 20 Jan. 2005 (Brown and Ilchman); 3 Nov. 2006; 18 Jan. 2007 (Wasserman, Tolstoy, and Staelin); 25 Jan. 2008 (Kuhnert and Ettelson); 23 Jan. 2009 (for Sonia [Sunnie] Evers); 22 Jan. 2010 (Costagli and Nardi and Walls), SVNY. The SV Newsletter frequently includes brief biographies of new board members.

17. SV Newsletter, 2012–13, 16; 2013–14, 16, SVNY.

18. For example, Wellesley professor Peter Fergusson, Peggy Guggenheim Collection Director Philip Rylands, and baroque musicologist Randy Mickelson.

19. The quotation is from SV Newsletter, 2013–14, 13, SVNY. Liz Makrauer initially became familiar with Venice and with SV as a summer intern at the Peggy Guggenheim Collection in 2000; following college graduation in 2001 she accepted an internship with SV in New York. An art history major, she had always planned to work at a museum or a gallery but she remained at SV for more than a decade "because it just felt right." Liz Makrauer, interview with author, 21 March 2019.

20. SV Newsletter, 2013–14, 16, SVNY; SV Board minutes, 19 May 2013, SVNY; Amy Gross, interview with author, 3 Feb. 2021. Gross visited Venice as a teenager and then studied abroad in Rome while in college; her interests in art history and in development, her family roots in Calabria, and her admiration for the mission of SV, led her to SV. Her appointment was the first one completed with the help of an external recruiting firm. In 2021 she received the Cavaliere nell'Ordine della Stella d'Italia decoration from the Italian government for her promotion of friendship and collaboration between Italy and the United States. As of February 2022, she remains as the executive director.

21. Dagna Rucewicz served as administrative coordinator in turn for Liz Makrauer and Amy Gross from 2012 to 2014. Kimberly Tamboer (Manjarres) started at SV on a contract basis in 2013 and became a

full-time employee in 2014 as a development officer under Amy Gross and remains there in 2022 as director of development.

22. SV Board minutes, 19 Sept. 2014; 23 Jan. 2015, SVNY. Bob and Bea Guthrie agreed that Conn was highly effective in establishing an "essential rapport" with restorers and local Venetians which significantly improved SV's credibility. Bob and Bea Guthrie, interview with author, 27 June 2019.

23. Frederick Ilchman, email to author, 22 June 2019. For more on Conn's biography and her role in Venice, see Kerry M. King, "Saving the 'Impossible City,'" *Wake Forest Magazine,* Fall 2020, https://magazine.wfu.edu/.

24. Mary Frank, interview with author, 11 April 2020.

25. In 2019 the city of Venice voted to impose a modest entry fee for day visitors but that did not happen due to concerns about the impact on the cruise ship business as well as disagreements about who would be exempt beyond local residents (i.e., students, tradesmen, scholars, seniors).

26. Frederick Ilchman, email to author, 27 March 2020.

27. SV Board minutes, 23 Jan. 2015, SVNY.

28. SV Board minutes, 19 Sept. 2014, SVNY.

29. SV Board minutes, 19 Oct. 2007, SVNY; SV Newsletter, 2007, 12, SVNY.

30. SV Board minutes, 14 May, 9 Dec. 2005; 16 Feb. 2006, SVNY; SV Newsletter, 2007, 12, SVNY.

31. SV Board minutes, 27 Oct., 19 Dec. 2005; 16 Feb. 2006; 11 June 2007, SVNY. The trip initially included stops in Tunis and Tripoli but visas were unavailable, so the Libyan and Tunisian portions were dropped. SV Board minutes, 18 Jan. 2007, SVNY. See the trip brochure in SVB 5.1.

32. SV Board minutes, 14 May 2005; 16 Feb., 3 Nov. 2006; 18 Jan., 11 June 2007, SVNY. See SVB 4.2.9 for a cover letter from Juan Prieto dated 31 Oct. 2006 and the full itinerary.

33. SV Board minutes, 19 Oct. 2007, SVNY.

34. SV Board minutes, 19 Oct. 2007; 25 Jan., 22 July 2008, SVNY; SV Newsletter, 2009, 12, SVNY.

35. SV Board minutes, 9 May 2009, SVNY.

36. SV Board minutes, 9 May 2009, SVNY; SV Newsletter, 2010, 16, SVNY.

37. SV Board minutes, 9 May 2009, SVNY; SV Newsletter, 2010, 20, SVNY.

38. SV Newsletter, 2013–14, 14, SVNY.

39. Frederick Ilchman, email to author, 22 June 2019.

40. SV Newsletter, 2013–14, 12, SVNY; "Paolo Veronese: A Master and His Workshop in Renaissance Venice," curated by Virginia Brilliant and Frederick Ilchman (Dec. 2012–April 2013), Ringling Museum of Art, Sarasota, Florida.

41. SV Newsletter, 2014–15, 13, SVNY.

42. The Festa del Redentore is held on the third weekend in July to commemorate the end of the 1576 plague, for which Palladio built a church (Il Redentore) on the island of Giudecca. The feast is famous today for its fireworks and for the temporary floating bridge built each year to connect Giudecca to Zattere, joining the island to the rest of Venice.

43. SV Board minutes, 19 Oct. 2007, 22 July 2008, SVNY; SV Newsletter, 2008, 12, SVNY.

44. SV Board minutes, 22 July 2008, SVNY.

45. SV Board minutes, 22 July 2008, SVNY.

46. SV Board minutes, 30 Oct. 2008, SVNY. Anna Lisa Prata presented the audit for 2006 and 2007 and noted that "Save Venice has wisely held 3 years of operating costs in reserve which will likely carry the organization through this difficult time." This three-year reserve policy was explicitly described in the "Fiscal Policies" approved at the 23 Jan. 2009 Board meeting, SVNY.

47. SV Newsletter, 2010, 15, SVNY.

48. Patti Diroll, "Honoring Italia," *Daily News* (Los Angeles), 1 March 2010, https://www.dailynews.com. Board member Cat Jagger Pollon sang an aria too.

49. SV Board minutes, 23 Jan. 2009, attachment H, "Carnival Gala," SVNY. Adult tickets were $4,500, junior tickets were $2,500, and children's tickets were $1,500 (the latter were limited to ten). In these same minutes, Liz Makrauer emphasized that "securing underwriting for the event was crucial."

50. SV Newsletter, 2012–13, 14, SVNY.

51. Elizabeth Anne McCauley et al., eds., *Gondola Days: Isabella Stewart Gardner and the Palazzo Barbaro Circle* (Boston: Isabella Stewart Gardner Museum, 2004).

52. SV Newsletters, 2007–11, SVNY.

53. I am grateful to Adelina Wong Ettelson for providing extensive press clippings from the 2011 ball and for explaining its success to me. See Ralph Gardner Jr., "All Dressed Up to Save Venice," *Wall Street Journal*, 17 March 2011: "Also, there was the cause. Venice, with its history, art, beauty, and permanent need of rescue, has a way of outshining even the most resplendent socialite, and focusing everybody on the task at hand." The party was also reported in the *New York Social Diary*, *WWD*, *Vogue*, *New York Post*, and *Bloomberg*.

54. SV Newsletter, 2013–14, 15, SVNY.

55. SV Board minutes, 23 Jan. 2015, SVNY; SV Newsletter, 2014–15, 14, SVNY. Matthew White was a lead organizer of the luncheon and Alberto Nardi designed the Golden Doge award.

56. Information about the New York lectures in this and the following two paragraphs is drawn from SV Newsletters, 2008–14, SVNY, as well as from SV Board minutes, SVNY, for the same time period.

57. SV Newsletter, 2007, 15, SVNY; event program, "The Travel of Marco Polo: From the Silk Road to Venice," SVB 4.2.9; ECB minutes, 10 Jan., 10 Sept. 2007, SVB 2.1.2.

58. Peter Fergusson, "Save Venice: The First Forty Years," in *Serenissima on the Charles* (Boston: Save Venice, 2009), 1–6. On the gala weekend, see SV Newsletter, 2009, 15, SVNY, and SV Board minutes, 30 Oct. 2008; 23 Jan., 19 May, 9 Oct. 2009, SVNY. See also ECB minutes, 12 Jan. 2009, SVB 2.1.2.

59. Beyond the examples in this and the following paragraph, there were the exhibitions in Fort Worth and Dallas in 2017 (about Casanova) and Washington, DC, in 2019 (about Tintoretto), organized by the New York office.

60. SV Newsletter, 2010, 13, SVNY; SV Board minutes, 1 Oct. 2010, SVNY; White, *Italy of My Dreams*; Christopher Carlsmith, "A Venetian Doge in a Yankee Court: Venetian and Byzantine Wall Murals (1889–90) of Jean-Joseph Benjamin Constant in Frederick Ames' House at 306 Dartmouth Street in Boston," *Nineteenth-Century Art Worldwide* 14, no. 3 (Autumn 2015), http://www.19thc-artworldwide.org/. In addition to the cited archival and published sources in the notes, details about Boston events are drawn from the author's personal experience.

61. ECB minutes, 23 Jan. 2011, SVB 2.1.2; SV Newsletter, 2012–13, 12, SVNY.

62. For Biblioteca di Notte, see ECB minutes, 9 Sept. 2013, SVB 2.1.2, and SV Newsletter, 2013–14, 12, SVNY. For the Capriccio Veneziano, see ECB minutes, 9 Sept. 2013; 14 April 2014, SVB 2.1.2; SV Newsletter, 2014–15, 12, SVNY; and SV Board minutes, 7 June, 9 Sept. 2014, SVNY.

63. SV Newsletter, 2008, 14, SVNY.

64. SV Board minutes, 20 Jan., 11 May 2012 (the latter noted that this event brought in $94,000), SVNY. See also "The Fellini Ball" invitation packet, SVB 5.2, and SV Newsletter, 2012–13, 13, SVNY.

65. SV Newsletter, 2011, 13, SVNY.

66. SV Board minutes, 3 Sept. 2004; 20 Jan. 2005, SVNY. The latter includes a spreadsheet attachment with details on the preliminary studies and condition reports to be completed, estimated at 80,000 euros.

67. SV Board minutes, 18 Jan. 2007, SVNY.

68. SV Newsletter, 2010, 4–7, SVNY.

69. SV Board minutes, 19 Oct. 2007, attachment F, "Church of San Sebastiano Restoration Campaign Report," SVNY.

70. Giulio Manieri Elia, ed., *Veronese: The Stories of Esther Revealed* (Venice: Marsilio Editore, 2011); "Veronese: Le Storie di Ester Rivelate," Palazzo Grimani (20 April–24 July 2011).

71. SV Board minutes, 2 June 2009, 7 May 2010, SVNY; SV Newsletter, 2010, 3–5, SVNY.

72. SV Board minutes, 22 Jan. 2010, SVNY.

73. SV Newsletter, 2013–14, 4; 2015–16, 4, SVNY.

74. SV Newsletter, 2013–14, 4–5, SVNY. The Podocataro (also spelled "Podacataro") tomb had not been cleaned in over four hundred years. See Sarah Blake McHam, "Cyprus Meets Venice and Rome: The Tomb of Livio Podocataro," *Source: Notes in the History of Art* 36, nos. 3–4 (Spring–Summer 2017): 190–200.

75. See quotation at the very beginning of this chapter, from SV Newsletter, 2009, 2, SVNY.

76. SV Board minutes, 7 May 2010, SVNY. See also SV Newsletter, 2010, 8–9; 2011, 6–7; 2012–13, 2–5, SVNY.

77. SV Newsletter, 2013–14, 6, SVNY.

78. SV Newsletter, 2013–14, 8–10, SVNY. This Carpaccio cycle is described in the following chapter.

79. Giulio Manieri Elia, ed., *Masterpieces Restored: The Gallerie dell'Accademia and Save Venice Inc.* (Venice:

Marsilio, 2010). Details, including the estimated cost of the book, are in the "Project Proposal" appended to SV Board Minutes, 30 Oct. 2008, attachment J, SVNY.

80. SV Newsletter, 2011, 15, SVNY; Melissa Conn and David Rosand, eds., *Save Venice Inc.: Four Decades of Restoration* (New York: Save Venice Inc., 2011).

81. SV Board Executive Committee meeting minutes, 2 June 2009, attachments A and B, SVNY; Donald Fox to Juan Prieto, 17 Nov. 2008, attached to SV Board minutes, 2 June 2009, SVNY.

82. ECB minutes, 12 Jan. 2009, SVB 2.1.2.

83. SV Board Executive Committee meeting minutes, 2 June 2009, attachment B, "Correspondence between Donald Fox and Juan Prieto," which includes a letter from Bob Lovejoy to SV board, 4 May 2009, SVNY. For final approval, see SV Board minutes, 19 May 2009, SVNY.

84. Various correspondence, Oct. 2006–Feb. 2007, SVB 4.2.9.

85. For example, Prieto wanted an initial one-year term for new members, staggered three-year terms for established members, and a removal of those who were underperforming. He also insisted on a $100,000 reserve fund. See ECB minutes, 10 Jan., 10 Sept. 2007, SVB 2.1.2.

86. Prieto to Ilchman and Drescher, 1 Oct. 2006, SVB 2.1.2.

87. ECB minutes, 10 Jan., 10 Sept. 2007; 28 Jan. 2008, SVB 2.1.2, for what Ilchman called "Time, Talent and Treasure."

88. See "Resolution in Honor of Donald Craig Freeman," SVB 6.1.1, presented by the Boston executive committee at its AGM on 11 Oct. 2018, praising his many roles.

89. The Italian consul general of Boston had been honorary chair of the Boston chapter since at least 1980; see SVB 4.6.6, SVB 4.8.7. The Italian ambassador sometimes fulfilled a similar role; see, for example, Ambassador Egidio Ortona to Rollin Hadley, 15 Feb. 1972; 22 Jan., 21 May 1973; 9 May 1974, Rollin Hadley Correspondence, Isabella Stewart Gardner Museum, Boston, in which Ortona agreed to be "honorary patron" of Boston benefit balls in 1972 and 1973.

90. In addition to the financial summary presented at the AGM each autumn, treasurer Don Freeman always prepared a treasurer's report for each meeting of the executive committee showing activity since the prior meeting.

91. AGM 22 Sept. 2008, "Restoration Projects Sponsored by Boston, 1998–2008," SVB 2.1.2.

92. ECB minutes, 19 March 2013, SVB 2.1.2.

93. ECB minutes, 10 Jan. 2007, SVB 2.1.2. For example, treatment estimates for Vicentino's *Wedding at Cana* in San Trovaso jumped from $22,000 to $57,000; Salviati's *Annunciation* increased from $12,000 to $16,000; the Tiepolo drawings rose from $9,700 to $15,800. Faced with the much higher price of the first work, the Boston executive committee rescinded the decision to undertake the Vicentino work.

94. SV Newsletter, 2007, 14; 2008, 15, SVNY. The exhibitions were *L'ultimo Tiziano e la sensualità della pittura* (Gallerie dell'Accademia, 2008), and *Titian, Tintoretto, Veronese: Rivals in Renaissance Venice* (Museum of Fine Arts Boston, 2009).

95. ECB minutes, 6 March 2012, SVB 2.1.2; Manieri Elia, ed., *Veronese: The Stories of Esther Revealed.*

96. SV Newsletter, 2013–14, 4, SVNY. The restoration proved that Sansovino and his team finished the architecture of Podocataro's tomb prior to Veronese's fresco work above the monument. This discovery was significant because it demonstrated that Veronese followed Sansovino's architectural design when the painter designed the imposing organ shutters opposite the tomb and the high altar structure (rather than the other way around, with Sansovino emulating Veronese's design).

97. McHam, "Cyprus Meets Venice and Rome." For further discussion of Titian's *Assumption,* see chapter 8.

98. SV Newsletter, 2014–15, 10, SVNY.

99. ECB minutes, 9 Sept. 2013, SVB 2.1.2; SV Newsletter, 2013–14, 11, SVB 2.1.2.

100. SV Newsletter, 2010, 12; 2013–14, 11, SVNY.

101. Information in this paragraph comes primarily from the author's personal experiences as well as consultation of the Boston chapter's annual newsletter.

102. ECB minutes, 28 Jan., 9 Sept. 2008 (Wilkinson); 23 Jan. 2011 (Rabb); 9 Sept. 2013 (Van Doren); 28 Jan. 2014 (Vivaldi), SVB 2.1.2.

103. ECB minutes, 20 Jan. 2007; 4 April 2008, SVB 2.1.2.

104. SV Newsletter, 2011, 13; 2012–13, 12, SVNY; ECB minutes, 14 Jan. 2013, SVB 2.1.2.

105. This move represented the first time that SV presented itself to the outside scholarly community as a serious educational organization.

CHAPTER 8: SERENITÀ

1. SV Board minutes, 30 Sept. 2016, SVNY.

2. SV Board minutes, 5 Oct. 2018, SVNY. President Richard Almeida recommended against the creation of new "chapters," which implied significant commitments by both SV and potential supporters; instead he suggested a roster of "focus cities" that would receive regular attention from board and staff. That evolved into the Conservation Patron Council, discussed below. The term "focus cities" comes from the airline industry for cities that are less than a hub in scale but have potential for growth.

3. As of November 2021 events were taking place in thirty-five cities and in seven countries, with fifty-six hosts involved in the effort.

4. Curated by Andrea Bellieni, Robert Echols, Frederick Ilchman, and Gabriele Matino, the exhibition *Venetia 1600 Nascite e rinascite* (Venice 1600: Births and Rebirths) was held at Palazzo Ducale from 4 Sept. 2021 through 5 June 2022, with thirteen works conserved by SV. The exhibit featured paintings by Bellini, Carpaccio, Titian, Tiepolo, and Canaletto, as well as drawings, sculptures, ceramics, glassware, and important archival documents. The exhibition used monuments and turning points in Venice's history to provide a roadmap for the city's future. For initial discussion of this exhibition by the SV directors, see SV Board minutes, 13 Feb. 2020, 2, SVNY.

5. Ilchman lived in Venice for five years (1996–2001) as a graduate student before becoming a curate at the MFA Boston in 2001 and a SV director in 2005. Born in 1967 and the recipient of a Ph.D. in art history in 2014, Ilchman has curated major exhibitions at the MFA as well as co-curating other shows in Sarasota, Venice, and Washington, D.C.

6. Mary Frank, for example, possessed a similar profile to Ilchman in her combination of service to SV and a Ph.D. in art history as well significant board service with other nonprofits and strong social connections in New York City and Miami. As discussed previously and also below, she played the fundamental role in realizing the Rosand Library and Study Center as well as the membership and planned-giving programs, and has been a significant donor, speaker, and fundraiser for Save Venice.

7. SV Board minutes, 22 Jan. 2016, SVNY.

8. SV Board minutes, 5 June 2020, SVNY, include a resolution recognizing Almeida's "ever-upward attitude," generosity, experience in business, and efforts to promote SV strategic planning. Richard Almeida, interview with author, 6 June 2019, 24 Dec. 2020; Frederick Ilchman, interview with author, 2 Oct. 2020. Almeida was chair and CEO of the commercial finance company Heller Financial Inc. (1995–2001) and has served on the boards of several companies including eFunds and UAL Corporation; he has also been a director for nonprofits such as CARE and the Chicago Public Education Fund and a trustee of the Chicago Latin School. He joined the SV board in 2012.

9. Tina Walls joined the SV board in 2010 with more than thirty years' experience working for Altria, IBM, and Chemical Bank; her interest in the arts began with the Denver Art Museum and the Denver Center for the Performing Arts in the 1970s, and she later served as trustee of the Virginia Museum of Fine Arts and as president of the Virginia Center for the Creative Arts. She first traveled to Venice on a high school tour, returned (at the invitation of John Staelin) for the SV Carnevale Gala in 2006, and four years later joined the SV board. Tina Walls, interview with author, 23 Oct. 2020. Walls's election is recorded in SV Board minutes, 13 Feb. 2020, SVNY.

10. SV Board minutes, 21 May, 30 Sept. 2016, SVNY.

11. SV Board minutes, 21 May 2016; 27 Jan. 2017, esp. attachment E, "Chairman's Vision Statement," SVNY.

12. Frederick Ilchman, email to author, 4 April 2020; SV Board minutes, 27 Jan. 2017, SVNY.

13. SV Newsletter, 2017–18, 16, SVNY; SV Board minutes, 30 Sept. 2016, 27 Jan. 2017 (creation and initial nominations), 29 Jan. 2021 (four additional honorary directors), SVNY. These honorary appointments were different than the advisory committee created by the board from 2010 to 2014.

14. SV Board minutes, 23 Jan., 2 Oct. 2015; 30 Sept. 2016, SVNY.

15. Biographies of new board members are included in the minutes of their first meetings and in the SV

newsletters of their first years. Naturally some board members have relocated since their initial appointments. New board members in 2020–21 include Anthony Capuano, Davide Gasparotto, Joseph Rubinelli Jr., and Bara Tisch.

16. Conn had been promoted from associate director to director of the Venice office in 2012. Contarini worked part-time for the Venice office from 2006 to 2011, assisting with publications, special events, website development, and the photo archive. In 2012 she became program coordinator, and in 2017 was promoted to Venice Program director, where (among other responsibilities) she provides restoration tours, produces the e-newsletter, and oversees the internship program.

17. SV Board minutes, 29 Jan. 2021, SVNY. Save Venice–Italia also included Francesca Bortolotto Possati as a key member; the launch of this committee was delayed by the pandemic for more than a year.

18. Other New York staff members included Amanda Albanese, Jill Oakley, Laura Sico, Brendan Davey, and Chris Christner. In 2018 the New York office expanded from three to four full-time staff. Kim Tamboer added the surname Manjarres in 2019.

19. SV Board minutes, 2 Oct. 2015, SVNY; SV Newsletter, 2015–16, 21; 2016–17, 21 SVNY. The penultimate page of the SV Newsletter in this period regularly includes a half-page "Financial Summary" for the preceding year.

20. SV Board minutes, 27 Sept. 2019, SVNY. The auditor's report for the year ending 31 Dec. 2019, prepared by Condon O'Meara McGinty & Donnelly LLP, documented even higher sums: total assets of just under $8 million, including $5.4 million in unrestricted net assets. See SV Board minutes, 29 Jan. 2021, SVNY.

21. SV Board minutes, 7 June 2019, SVNY.

22. Amy Gross, email to author, 11 March 2022.

23. SV Board minutes, 30 Sept. 2016; 2 Oct. 2020, SVNY.

24. SV Board minutes, 21 May 2016; 29 Jan. 2021, SVNY. Board members frequently volunteered to support projects such as development of an SV app, underwriting of gala events, and individual restorations. In her president's report of Oct. 2020, Tina Walls recognized substantial gifts by a number of individual board members. SV Board minutes, 2 Oct. 2020, SVNY.

25. SV Board minutes, 13 Feb. 2020, SVNY; Amy Gross, email to author, 25 Oct. 2021. Gross estimates that the number of gifts rose from around six hundred in 2018 to more than a thousand in 2020, and the board minutes confirm that both the number and the amount of gifts increased substantially in this period.

26. SV Board minutes, 29 Jan. 2021, SVNY. The auditor's report presented at that meeting declared that 81.5 percent of total expenses were on program spending, which is consistent with prior years.

27. SV Board minutes, 27 Sept. 2019, SVNY.

28. SV Board minutes, 25 Aug. 2012, SVNY. The ERC became a permanent subcommittee in 2016, as noted in SV Board minutes, 22 Jan., 21 May 2016, SVNY.

29. Gianmario Guidarelli, Michel Hochmann, and Fabio Tonizzi, eds., *La chiesa di San Pietro di Castello e la nascita del patriarcato di Venezia* (Venice: Marcianum Press, 2018). See also Massimo Bisson, Isabella Cecchini, and Deborah Howard, eds., *La Chiesa di San Giacomo dall'Orio: Una trama millenaria di arte e fede* (Rome: Viella, 2018). More recently, the ERC supported research and publications about the church of San Rocco and the Church of the Servi; see SV Board minutes, 29 Jan. 2021, SVNY.

30. SV Board minutes, 21 May 2016, 7 June 2019, SVNY; Thomas Dalla Costa, Robert Echols, and Frederick Ilchman, eds., *Tintoretto in Venice: A Guide* (Venice: Marsilio, 2018); Patricia Fortini Brown and Gabriele Matino, *Carpaccio in Venice: A Guide* (Venice: Marsilio, 2020).

31. SV Board minutes, 29 Jan. 2021, SVNY.

32. SV Board minutes, 30 Sept. 2016, SVNY.

33. SV Board minutes, 19 May 2013; 24 Jan. 2014, SVNY. SV became an Associate Organization (AO) of the Renaissance Society of America (RSA) in 2018. It is quite unusual for a nonprofit focused on historic conservation, like SV, to be granted the status of an AO by the RSA; as the RSA website notes, "All Associate Organizations are learned societies or research centers whose goals are consistent with the mission of the RSA." "Associate Organizations," Renaissance Society of America, https://www.rsa.org. The presence of SV as an AO speaks to the high quality of SV's publications, research, and affiliated scholars.

34. SV Board minutes, 2 Oct. 2015, SVNY; SV Newsletter, 2016–17, 13, SVNY. Donatella Calabi, *Venice, the Jews, and Europe, 1516–2016* (Venice: Marsilio, 2016), is the catalogue for the exhibition held 19 June–13 Nov. 2016 at the Palazzo Ducale. See Rosella Mamoli Zorzi and Katherine Manthorne, eds., *From Darkness to Light: American*

Writers in the Museums, 1798–1898 (Cambridge: Open Book, 2019), https://doi.org/10.11647/OBP.0151, for the exhibition at the Scuola Grande di San Rocco on 27 April 2016.

35. SV Board minutes, 7 June, 27 Sept. 2019, SVNY, are representative examples. The ERC reported on multiple activities at each board meeting.

36. SV Newsletter, 2014–15, 9; 2015–16, 12–13, SVNY; SV Board minutes, 20 June 2015, SVNY. The minutes are clear that the inauguration was 18 June; the newsletter dates it to July. The quotation comes from the SV Newsletter, 2015, 12.

37. SV Newsletter, 2016–17, 14–15; 2018, 11; 2019, 15, SVNY. In 2015–16 Jill Weinrich processed and rehoused the SV archives in new acid-free boxes with funding from the Delmas Foundation and consultation from the Archivio Patriarcale of Venice. In 2018 Angelo Lo Conte won a fellowship from SV and the Australasian Center for Italian Studies to work at the RLSC for three months. Beginning in 2012 Mary Frank funded a pair of art history majors each year from Lafayette College (her alma mater) to serve as SV interns.

38. SV Newsletter, 2019, 15, SVNY, for one page describing the activities of the ERC.

39. SV Newsletter, 2015–16, 10; 2016–17, 6–7, 13; 2017–18, 11; 2018, 11, SVNY. SV made a three-year commitment in 2019–21 to support the Instituto Veneto dei Beni Culturali; see SV Board minutes, 13 Feb. 2020, SVNY.

40. Mary Frank, interview with author, 11 April 2020. See also SV Board minutes, 11 May 2012, SVNY, and SV Newsletter, 2013–14, 17; 2014–15, 17, SVNY, for a brief interview with Charlotte Hermann. The donation from the estate lawyer never materialized.

41. SV Newsletter, 2019, 5, SVNY. San Giorgio degli Schiavoni (Scuola Dalmata) was and is a lay confraternity consisting primarily of immigrants from Dalmatia; this painted cycle is discussed in more detail below.

42. SV Newsletter, 2019, 20, SVNY.

43. SV Newsletter, 2019, 19; 2020, 22, SVNY. The Conservation Patron Council's members were in Boston, Denver, Houston, New York, San Diego, San Francisco, and London. In 2021 Los Angeles and Phoenix were added.

44. SV Board minutes, 24 June, 29 Sept. 2017; 26 Jan. 2018, SVNY. For the website, initially Anne Hawley, and later Amy Gross and Kim Tamboer Manjarres, interviewed multiple companies and consulted with other nonprofits like the WMF and ISGM. In March 2018 the firm Use All Five was selected to manage the redesign; it also coined the new motto. The old website had 2,800 pages of content, mostly about restorations, so the rebuilding/rebranding process was complex. The board had a public relations committee in this period but it seems to have played a minor role.

45. Sophia D'Addio was granted an additional fellowship in 2020 to add new art historical content and to address technical issues on the back end of the website. SV Board minutes, 5 June 2020, SVNY.

46. SV Board minutes, 27 Jan. 2017, SVNY.

47. "Save Venice, Inc.," Wikipedia, https://en.wikipedia.org. For Ilchman's comments about search engine optimization in Wikipedia, see SV Board minutes, 5 June 2020, SVNY.

48. SV Board minutes, 24 June, 29 Sept. 2017, SVNY. Derek Blasberg hosted the episode "A Tale of Two Cities" on 7 Sept. 2017, featuring a conversation with Jeremy Irons inside San Sebastiano; Irons appears in a photograph with SV restorers in the SV monthly E-Newsletter, Sept. 2017, 2. Irons would return to narrate the video "A Love Letter to Venice" in Oct. 2020.

49. SV Board minutes, 29 Sept. 2017, SVNY.

50. SV Board minutes, 13 Feb. 2020, SVNY.

51. SV Board minutes, 13 Feb. 2020, SVNY.

52. SV Board minutes, 7 June 2019, SVNY.

53. SV Board minutes, 27 Sept. 2019, SVNY.

54. SV Board minutes, 13 Feb. 2020, SVNY.

55. Shelby Hodge, "Rice University Transforms into Venice for One Magical Night—These Young Friends Party for a Cause," Paper City, 14 June 2021, https://www.papercitymag.com. This event was the first of the "50 x 50" celebrations in honor of SV's fiftieth anniversary.

56. SV Board minutes, 27 Sept. 2019, SVNY.

57. Patricia Labalme, ed., *Beyond Their Sex: Learned Women of the Past* (New York: New York University Press, 1980); Margaret King, *Humanism, Venice, and Women* (New York: Routledge, 2005); Margaret King, *Women of the Renaissance* (Chicago: University of Chicago Press, 1991); Babette Bohn, *Women Artists, Their*

Patrons, and Their Publics in Early Modern Bologna (University Park: Pennsylvania State University Press, 2021). See also "Save Venice Launches Women Artists of Venice," SV E-Newsletter, July 2021, and Karen Chernick, "Venice's Great Women Artists Step into the Limelight Through Major Restoration Project," *Art Newspaper,* 15 Feb. 2022, https://www.theartnewspaper.com.

58. Chernick, "Venice's Great Women Artists." WAV research results were presented at the RSA annual meeting in Dublin in spring 2022.

59. Information about the Education and Enrichment series in New York is based on analysis of SV Newsletters, 2016–21, SVNY, and of SV board minutes for the same period.

60. SV Newsletter, 2020, 20–21, SVNY.

61. "Inside This Year's Save Venice, the Mini Met Gala," *Town and Country,* 29 April 2019; Adelina Wong Ettelson, interview with author, 15 Jan. 2021. Un Ballo in Maschera was nicknamed the "Mini-Met" owing to its fashion focus, its sponsorship by fashion and luxury brands, and its deliberate timing just weeks before the Metropolitan Museum's major annual fundraiser in May.

62. Marshall Heyman, "A Masked Ball, in the Venetian Style," *Wall Street Journal,* 13 April 2015; Whitney Robinson, "This Year's Save Venice Masked Ball Was More Glam Than Ever," *Elle Décor,* 1 May 2019; Karen Wilkin, "Byways of La Serenissima: The Venice You (Probably) Don't Know," *Wall Street Journal,* 1 Aug. 2020.

63. SV Board minutes, 2 Oct. 2015, SVNY. This was the maximum amount donated; usually it was $50,000.

64. For a resolution acknowledging Lauren Santo Domingo's achievements, see SV Board minutes, 21 May 2016, attachment H, SVNY. The 2020 ball was canceled due to the pandemic but over $900,000 was retained from table and ticket sales. SV Board minutes, 2 Oct. 2020, SVNY. Lauren Santo Domingo became a vice president in 2020.

65. SV Board minutes, 26 Jan. 2018, SVNY. For the 2020 Ballo in Maschera, there were eleven tables at $30,000 each and nine tables at the $15,000 level. SV Board minutes, 13 Feb. 2020, SVNY.

66. SV Newsletters, 2015–20, SVNY. In her report of 24 June 2017 Amy Gross confirmed that a lower guest count at the Ballo in Maschera was the result of feedback that the 2016 ball was too crowded.

67. SV Board minutes, 29 Sept. 2017, SVNY.

68. SV Newsletter, 2015–16, 18–19, SVNY.

69. Mary Hilliard, "New York to Venice," New York Social Diary, 25 July 2015, www.NewYorkSocialDiary.com. Iglehart is best known for his role as the blue genie in Broadway's *Aladdin.* Matthew White and Thomas Schumacher arranged this concert.

70. Andrea di Robilant, *A Venetian Affair* (New York: Knopf, 2003).

71. SV Newsletter, 2017–18, 14, SVNY.

72. SV Board minutes, 24 June 2017, SVNY. Twenty-six directors attended.

73. SV Newsletter, 2017–18, 6–7, SVNY; Hannah McGivern, "Tintoretto's 500th Anniversary Takes Over Venice," *Art Newspaper,* 4 Sept. 2018, https://www.theartnewspaper.com.

74. SV Newsletter, 2018, 14–15, SVNY. The exhibitions were *Il giovane Tintoretto* at the Gallerie dell'Accademia; *Art, Faith and Medicine in Tintoretto's Venice* at the Scuola Grande di San Marco; and *Tintoretto, 1519–1594* at Palazzo Ducale (and later the National Gallery in Washington, DC). The last was curated by Robert Echols and Frederick Ilchman.

75. Casey Kohlberg, "New York Socialites Descend on Venice for Weekend of Glamorous Carnevale Parties and Galas," *Evening Standard,* 25 Feb. 2020, https://www.standard.co.uk.

76. "Inside Save Venice's Three Days of Galas During Venice Carnevale," *W,* 18 Feb. 2020, https://www.wmagazine.com.

77. "50 Celebrations for 50 Years" included events in a dozen U.S. states, as well as in Brazil, England, and Morocco, between June 2021 and June 2022. Each dinner host promised a net donation of $10,000, guaranteeing substantial total revenue.

78. SV Newsletter, 2016–17, 16, SVNY.

79. SV Newsletter, 2016–17, 16, SVNY.

80. SV Newsletter, 2016–17, 17, SVNY.

81. SV Newsletter, 2017–18, 15, SVNY.

82. The legend, probably apocryphal, is that the villa was nicknamed "La Malcontenta" because an owner's spouse was locked up there due to marital disharmony.

83. Cat Jagger Pollon was a frequent participant on excursions and galas as well as a significant donor, including sponsorship of a chapel in San Sebastiano, a votive image of the Madonna near San Giovanni in Bragora, and daytime activities at the 2015 Biennale Gala in honor of Bob Guthrie's eightieth birthday. She left Los Angeles for Morocco in early 2020 and died in May 2022. Sonia Evers of San Francisco had served on the board and gave a well-received lecture in New York on "Visualizing Love in the Renaissance." Annasue and John Wilson of San Diego hosted a cultivation event in their home and regularly attended galas in Venice. The last two joined Ilchman and Christopher Apostle for a visit to Los Angeles for a SV tour of the Bellini exhibition at the Getty Museum in 2018 with curator Davide Gasparotto (the latter joined the SV board in 2020). Both Wilsons became members of the Conservation Patron Council and hosted events in San Diego. Otherwise, activity in California was sparse.

84. Richard Baiano was president and co-owner of Childs Gallery on Newbury Street in Boston and principal in the interior design firm Platemark Design. The opportunity to study in Florence sparked his interest in old master prints and led him to a career as an art dealer despite his original training as an architect. SV Boston Newsletter, 2015, 3, author's personal copy.

85. Other Boston officers included lecture committee co-chairs James Johnson and Christopher Carlsmith, and Projects Committee chair Susan Angelastro. Tom McGauley replaced Donald Freeman as treasurer in 2018 before resigning in 2021; Pia Miller became secretary in Oct. 2020 and treasurer in 2022; Angelastro was elected chapter chair in Oct. 2021.

86. Keynote speakers in this period included MFA curator Emily Zilber on Murano glass today (2015), scholars Anne-Marie Eze and Lilian Armstrong on early Venetian printed books (2016), MFA curator Jen Mergel on contemporary art in Venice (2017), Suffolk University professor Matteo Casini on sixteenth-century Venice (2018), and Gardner Museum conservator Gianfranco Pocobene on the conservation of Titian's *Rape of Europa* (2019). In 2020 longtime members Peter Fergusson and Janice Hunt shared their memories of the early years of SV; in recognition of the coronavirus pandemic, the 2021 speaker was historian Michelle Laughran from St. Joseph's College of Maine, comparing the different plagues that have afflicted Venice over the centuries.

87. SV Newsletter, 2015–16, 16, SVNY.

88. ECB minutes, 14 Dec. 2015, SVB 6.1.1. A year later in May 2017 the Boston Young Friends hosted "A Night in the Garden of Earthly Delights," inviting partygoers to come as angels or demons for dancing and specialty cocktails at Yvonne's Lounge.

89. SV Newsletter, 2016–17, 20; 2017–18, 12, SVNY; ECB minutes, 9 Sept. 2017, SVB 6.1.1.

90. SV Newsletter, 2018, 12, SVNY.

91. SV Newsletter, 2014–15, 2, SVNY.

92. Frederick Ilchman, email to author, 3 April 2020.

93. SV Newsletter, 2017–18, 3, SVNY.

94. Frederick Ilchman, "Taking Veronese Seriously," in *Paolo Veronese: Itineraries in the Veneto,* ed. Bernard Aikema and Paola Marini (Venice: Marsilio, 2014), 8–15, esp. 13–14. Conservators are not always so fortunate, of course; investigations at this time revealed no trace of Veronese's frescoes nor the replacements by Sebastiano Ricci under the white plaster that coats the cupola.

95. SV Newsletter, 2017–18, 7, SVNY. This restoration was sponsored by Bob and Bea Guthrie.

96. SV Newsletter, 2017–18, 8, SVNY; RSA 2021 Annual Meeting Program, "Carpaccio's Enduring Appeal Preserved," Renaissance Society of America, https://rsa.confex.com.

97. Patricia Fortini Brown, "A Death in Venice: The Forgotten Tomb of Alvise Della Torre," *Artibus et Historiae* 67 (2013): 137–59; Brown, *The Venetian Bride: Bloodlines and Blood Feuds in Venice and its Empire* (New York: Oxford University Press, 2021).

98. Richard Riess was the largest individual sponsor in San Sebastiano; in addition to the high altar and lateral paintings described here, Riess was a major donor to the Sala dell'Albergo (2011), to Tintoretto's *Crucifixion* in the Accademia (2016), and to Titian's *Annunciation* in the Scuola Grande di San Rocco (2021). The Santo Domingo family also gave generously to multiple restorations; beyond the facade of San Sebastiano noted above and Veronese's organ loft and shutters mentioned previously, the family sponsored (among others) the garden casino at Ca' Zenobio (2002), the facade of the Scuola Grande di San Marco (2004), and Titian's *Assunta* in the Frari (2018).

99. SV Newsletter, 2018, 7.

100. SV Newsletter, 2015–16; 2017–18, 8, SVNY. The Optical, Spectroscopic, and Infrared Remote Imaging System was purchased by SV to aid conservators and scientists.

101. The retouching of the Saint Ursula cycle was more extensive, and thus costly, than originally anticipated due to the need to repair some of the previous overzealous cleaning. Conservation was carried out by both Arlango and by Conservazione Bene Culturali (CBC).

102. SV Newsletter, 2018, 2–3, SVNY; SV Board minutes, 25 Jan. 2019, SVNY (approval of the Scuola Dalmata project with 348,000 euros). This project was later dedicated to Professor Patricia Fortini Brown in honor of her defining contributions to Carpaccio amid her extensive work on Venice and for SV; sponsors included a combination of foundation gifts, individual donations, and a bequest. Carpaccio's *Miracle of the True Cross* was sponsored by Jon and Barbara Landau with support from Randa and K. C. Weiner.

103. David Rosand, "Titian in the Frari," *Art Bulletin* 53, no. 2 (1971): 196–213; Helen Ettlinger, "The Iconography of the Columns in Titian's Pesaro Altarpiece," *Art Bulletin* 61, no. 1 (1979): 59–68; Peter Humfrey, *Titian: The Complete Paintings* (New York: Abrams, 2007), 126.

104. SV Newsletter, 2015–16, 8; 2017–18, 9, SVNY.

105. A conservator based in Venice, Giulio Bono has had his own private practice since 1991. He focuses on early modern paintings on canvas and wooden panels, and because of several major treatments sponsored by SV is regarded as a Titian expert.

106. SV Newsletter, 2016–17, 5; 2017–18, 9, SVNY. I am grateful to Sarah Blake McHam and Frederick Ilchman for sharing their observations about these two works by Titian.

107. Sarah Blake McHam, "Conservation of Titian's *Assunta* and Its Frame," SV Newsletter, 2019, 6–7, SVNY. See also Lorenzo Buonanno, "Revisiting the Frari's High Altarpiece: The 'Assunta' Frame and Titian as 'Régisseur,'" in *Santa Maria Gloriosa dei Frari*, ed. Carlo Corsato and Deborah Howard (Padua: Centro Studi Antoniani, 2015), 223–31.

108. Works restored inside the Palazzo Ducale between 2017 and 2018 included four allegorical paintings from the Anticollegio, the ceiling canvas of *The Return of the Prodigal Son* and the four surrounding canvases representing the virtues in the Room of the Inquisitors, and a ceiling painting of *Doge Priuli Presented by Saint Jerome to Justice and Peace* in the Atrio Quadrato

109. Cristina Ruiz, "Getting to Know the Real Tintoretto," *Art Newspaper*, 16 March 2018, https://www.theartnewspaper.com. The review by Tom Nichols, "Coming of Age: Jacopo Tintoretto," *Burlington Magazine*, Dec. 2018, 1024–29, praised the "ambitious series of interlinked exhibitions."

110. SV Board minutes, 25 Jan. 2019, SVNY.

111. SV Board minutes, 20 Aug. 1974, 2 Dec. 1975, 9 Aug. 1978, SVNY (Scuola Levantina); SV Board minutes, 23 July 1975, 23 March, 9 Aug. 1978, SVNY (Torcello). In addition, SV had collaborated with the Scheuer Foundation in 1998 and 2001 to restore the Scuola Tedesca, and as previously noted had provided $50,000 for the Palazzo Ducale exhibition *Venice, the Jews and Europe: 1516–2016*.

112. Tracy Cooper, "Saving Torcello: Save Venice at Fifty Returns to the Origins of the *Serenissima*," SV Newsletter, 2019, 12, SVNY.

113. Christopher Apostle, "Restoring a Hidden Treasure in the Ghetto: the Scuola Italiana," SV Newsletter, 2019, 12–13.

114. James McAuley, "Silent Splendor," *New York Times*, 15 Nov. 2015; Hannah McGivern, "Project to Preserve Venice's Jewish Heritage," *Art Newspaper*, 22 March 2016, https://www.theartnewspaper.com.

115. SV Board minutes, 25 Jan. 2019, SVNY. The Scuola Italiana project began in spring 2021 and will conclude in early 2023.

116. SV Board minutes, 7 June 2019, SVNY. Both projects were fully funded by July 2021.

117. Melissa Conn to SV Board, 18 Nov. 2020, SVNY; reprinted in the SV Boston Newsletter, 2019–20, 3, author's personal copy.

118. Melissa Conn to SV Board, 18 Nov. 2020, SVNY; reprinted in the SV Boston Newsletter, 2019–20, 3, author's personal copy.

119. SV Board minutes, 13 Feb. 2020, SVNY.

120. SV Board minutes, 13 Feb 2020, SVNY: "As of [today], Save Venice had provided funding to twelve churches, two museums, two confraternities, five cultural institutions, two fellowships and research grants and

multiple preventative measures." See also SV Board minutes, 2 Oct. 2020, SVNY, and SV Newsletter, 2020, 8–9, SVNY.

121. SV Newsletter, 2020, 8–9, 22, SVNY.

122. SV Board minutes, 2 Oct. 2020, SVNY. The board narrowed the purpose of the fund and specified financial limits so that it would not be an indefinitely refilling fund.

123. Frederick Ilchman, email to author, 19 April 2021; SV Newsletter, 2020, 8–9, SVNY; SV Board minutes, 29 Jan. 2021, SVNY.

124. Elisabetta Povoledo, "Successful Test of Floodgates Leave Venice Dry at High Tide," *New York Times*, 4 Oct. 2020.

125. Anna Momigliano, "The Ghost Town of Venice," *New York Times*, 27 Feb. 2020.

126. E.T., "Save Venice mette al sicuro i pavimenti musivi a Murano," *La Nuova Venezia*, 1 April 2020.

127. Barbie Latza Nadeau, "Deserted Venice Contemplates a Future without Tourist Hordes", CNN, 16 May 2020. See also James Horowitz, "Picture Venice Bustling Again, Not with Tourists, but Italians," *New York Times*, 4 June 2020.

128. Gaia Pianigiani, "Italy to Ban Cruise Ships from Waters of Venice to Protect the Ecosystem," *New York Times*, 14 July 2021. According to a statement by the minister of culture, Dario Franceschini, the Italian government took action to avoid being placed on UNESCO's "World Heritage in Danger" list. In the same announcement, the Italian government proclaimed its intention to declare the lagoon a national monument.

CHAPTER 9: ALLEATE

1. A list of the private committees and their projects are included in Rolande Cuvillier and Edward Thompson, *UNESCO for Venice: International Campaign for the Safeguarding of Venice (1966–1992) Review of Results* (Rome: Council of Ministers, 1993), 38–39, 178–97. This bilingual report (Italian and English) is a detailed overview of UNESCO's activities in Venice. The 1973 statement from Maheu is quoted in Cuvillier and Thompson, *UNESCO for Venice*, 21.

2. "Elenco dei Lavori dei Comitati Privati Internazionali di Venezia dal 1966 al 2016 [List of Projects by the International Private Committees of Venice from 1966 to 2016]," Projects, Association of International Private Committees, https://www.comprive.org (hereafter APC). This spreadsheet lists chronologically all restorations sponsored by the private committees from 1966 to 2016. In March 2022 the APC reorganized its website, including a search function for its Projects but as of press time that search engine is not fully functional. As noted on its website, the APC is a federation of nonprofit organizations "whose primary objective is to promote and finance restorations of Venice's artistic heritage," as well as to "exercise constant vigilance over this heritage and over Venice's urban and natural heritage." See Home Page, APC. The APC has an office in Venice. Additional details about the evolution of the APC and its activities are discussed in this chapter. Other contributors in Venice from 1966 to 1969 included Fondazione Ercole Varchi, the Association France-Italie, and the Stifterverband fuer die Deutsche Wissenschaft (the "German Committee").

3. The founder and principal projects of each organization are discussed in several reports authored by UNESCO. *Venice Restored* (Paris: UNESCO, 1973) briefly describes in turn the projects done by private committees from seven countries (Germany, Australia, United States, France, Italy, United Kingdom, Switzerland) from 1966 to 1973, as well as nearly thirty additional projects. The eponymous *Venice Restored* (published "in the workshops of UNESCO," 1978) follows a similar format but includes a lengthy introduction about previous actions in Venice by UNESCO and the Italian government (5–30) and a description of the laboratories and workshops used for restoration in Venice (31–42). The 1978 book includes additional private committees from Belgium, Iran, and Sweden as well as new private committees in the United States (e.g., "Friends of Venice—Dallas, Texas"), and both text and photos are updated from the 1973 book. A third book is *Venice Restored, 1966–1986: The UNESCO Campaign and the Contribution of Private Organizations* (Milan: Electa, 1991), originally published in Italian as *Venezia Restaurata, 1966–1986: La campagna dell'UNESCO e l'opera delle organizzazioni private* (Milan: Edizioni Electa, 1986). The 1991 edition, which is the one that I cite throughout, includes prefaces from superintendents Margherita Asso and Francesco Valcanover and from UNESCO liaison Maria Teresa Rubin de Cervin.

In contrast to the 1973 and 1978 books, this 1991 work describes the projects according to their location (i.e., Cannaregio, Castello, Dorsoduro, etc.) with various authors composing each entry. Several organizations merged or changed their names around 1970: the Association France-Italie was absorbed by the Comité Français, IAARF became Venice in Peril, and as discussed in chapters 1 and 2, the IFM's Venice Committee broke away to become Save Venice Inc. For assistance with this chapter, I am grateful to my research assistant Magdalene Stathas; I also wish to acknowledge the contributions of Carla Toffolo, Paola Marini, Jérôme-François Zieseniss, and John Millerchip.

4. "List of Committees," Private Committees, APC.

5. Cuvillier and Thompson, *UNESCO for Venice*, 82. For a narrative description of the contributions of various private committees from the early 1960s through the late 1980s, see Francesco Valcanover, [Preface], in UNESCO, *Venice Restored, 1966–1986*, 16–18. The APC website estimates that between 1966 and 2021, APC members have enabled more than 1,000 restorations and spent more than 300 million euros. "History," Private Committees, APC.

6. As of 2020 San Gregorio is closed and the Misericordia is managed by the Gallerie dell'Accademia as an interdisciplinary scientific laboratory for restoration of paintings and wooden sculptures. For a description of the various laboratories and workshops used for restoration in Venice, see *Venice Restored* (1978), 31–42.

7. SV Board minutes, 7 Feb. 1994, SVNY. In those minutes Larry Lovett reported the registration on 12 Nov. 1993 of a new Association of Private Committees with seven members (Save Venice, Amici dei Musei, Società Dante Alighieri, Comitato per l'Arsenale, Comité Français, Venice in Peril, and Italia Nostra). Larry Lovett and Maria Berlingieri were SV's representatives. The date of Nov. 1993 is confirmed by John Millerchip, email to author, 17 Feb. 2021.

8. The APC remains active today and represents the private committees but as discussed in this chapter, the relationships and foci have shifted, especially in the past decade. TThe APC compiled a significant archive, estimated at 47,000 pages in 2011. That archive is now in possession of UNESCO and I have not seen it, but I have benefited from this project report "Digitizing the Archives of the Private Committees for the Safeguarding of Venice," prepared by undergraduates Lorey Aragon, Jeremy Brown, Gabriela Nunez, and Julia Wade, under the supervision of Professors Fabio Carrera and Frederick Bianchi at Worcester Polytechnic Institute, 17 Dec. 2011, Venice Project Center, https://www.veniceprojectcenter.org.

9. Cuvillier and Thompson, *UNESCO for Venice*, 92.

10. UN Director-General Federico Mayor to APC Executive Secretary John Millerchip, 25 June 1997, provided by Millerchip to the author in June 2019.

11. "Press Release—Annual Meeting 2009," 21 Oct. 2009, APC, provided to author by Save Venice. This press release and the one in the following note, do not yet appear on the the APC's website, "Our Media Coverage," APC.

12. "Comunicato Stampa" [Press Release], 25 June 2020, APC, provided to author by Save Venice.

13. Carla Toffolo and Paola Marini, interview with author, 15 Feb. 2021; "The Venice Appeal," APC. The first draft was presented on 1 Oct. 2020.

14. "Digitizing the Archives of the Private Committees," 6.

15. "Expenses for Projects in 2019," APC, from the APC's 28th Annual General Meeting (2020), copy provided to the author. This document indicates that the Venice Gardens Foundation spent $4.2 million in 2019, largely on the Royal Gardens next to the Marciana Library; the insurance company Assicurazioni Generali donated $2.8 million to this project. This significant expense represents only the first project for the Venice Gardens Foundation, and it has not yet specified future projects, thus it is difficult to accurately compare its activities to those of SV and other committees.

16. "Expenses for Projects in 2019," APC.

17. Stephen Fay and Phillip Knightley, *The Death of Venice* (New York: Praeger, 1976), 107–14. See also "Our History," Venice in Peril, https://www.veniceinperil.org. As noted above and in chapter 1, Venice in Peril was the successor to the IAARF, founded in 1966 to assist both Florence and Venice. By 1967 the Clarkes had already shifted their attention to Venice. Sir Ashley served as chair of the British-Italian Society (1962–67), then vice chair (1970–83) and president (1983–94) of Venice in Peril; see his obituary in the *New York Times,* 24 Jan. 1994, and a

remembrance by Sir Alan Campbell in the *Independent* (London), 25 Jan. 1994. Lady Frances (Molyneux) as of April 2022 continues to live in London and Venice.

18. John Julius Cooper inherited the title Viscount Norwich from his father. See the obituary of John Julius Norwich in *The Guardian*, 1 June 2018. Notable books by Viscount Norwich include *A History of Venice* (New York: Knopf, 1982) and *Five Centuries of Music in Venice* (New York: Schirmer Books, 1991), as well as histories of Byzantium and of Norman Sicily. Norwich also worked extensively as a broadcaster for the BBC. In memory of Norwich, beginning in 2018 Save Venice and Venice in Peril jointly restored the eleventh-century Byzantine iconostasis in Santa Maria Assunta on Torcello and the fifteenth-century panel paintings within.

19. Information in this paragraph comes primarily from the webpages "Projects" and "Newsletters," Venice in Peril.

20. Monica Favaro et al., "The Four Virtues of the Porta Della Carta, Ducal Palace, Venice: Assessment of the State of Preservation and Re-Evaluation of the 1979 Restoration," *Studies in Conservation* 50, no. 2 (2005): 109–27; Kenneth Hempel and Giulia Musumeci Hempel and Anne Moncrieff, "Letter to the Editors," 6 Jan. 2006, and Favaro's reply, 29 May 2006, both published in *Studies in Conservation* 51, no. 1 (2006): 237–39. The Hempels pointed out that regular monitoring and maintenance of the work had not been done and thus it was impossible to determine when the surface deterioration of the stone, found by Favaro twenty-five years after the initial treatment, had begun. I am grateful to John Millerchip for sharing with me these materials and related correspondence.

21. The International Torcello Committee included Venice in Peril, Save Venice, World Monuments Fund, Comitato Italiano per Venezia, Comitato dei Veneti per Venezia, America-Italy Society of Philadelphia, Deutsches Studienzentrum in Venedig, Arbeitskreis Venedig der Deutschen Unesco-Kommission, and Stichting Nederlands Venetie Comité, with additional funding from the Gladys Krieble Delmas Foundation. For a brief description, see "Basilica of Santa Maria Assunta, Torcello," Projects, Venice in Peril.

22. "Music Room, Ospedaletto," Projects, Venice in Peril.

23. "Our History," Venice in Peril.

24. "Newsletters," Venice in Peril. Venice in Peril's newsletter is published in winter and summer each year.

25. A British citizen who was born in Rome and who spent summers in her grandmother's palazzo in Venice, Somers Cocks founded the *Art Newspaper* in 1990.

26. See Anna Somers Cocks, "The Coming Death of Venice?" *New York Review of Books*, 20 June 2013, 21–24, https://www.nybooks.com, and her spirited exchange of letters in a subsequent issue (26 Sept. 2013, 92–94) with Mayor Giorgio Orsoni. Cocks's article received a prize in 2013 from the Istituto Veneto for best example of journalism about Venice in that year, and she was elected a fellow of the Istituto in 2019.

27. Anna Somers Cocks, "Venice-in-Peril and Cambridge University," *Insula Quaderni* 13 (2002): 39. For SV's role in this research project, see chapter 6.

28. John Millerchip and Leo Schubert, eds., *Un Restauro per Venezia* (Milano: Mazotta, 2006). See also Libby Purves, "Period Homes for Everyone!" *London Times*, 4 Oct. 2006. Recent chair Jonathan Keates has noted that subsequent attempts to replicate a similar project for affordable housing have not received much support from Venetian authorities. Jonathan Keates, email to author, 5 April 2021.

29. Rozalia Jovanovic, "Anna Somers Cocks Resigns from 'Inefficient' and 'Politicized' Venice-in-Peril Fund," *Observer* (London), 30 July 2012.

30. At the annual meeting of the APC in June 2020, for example, the APC voted to join the Climate Heritage Network as well as subscribe to the European Heritage Alliance. "Comunicato Stampa," 25 June 2020, APC, shared by Frederick Ilchman with the author.

31. Jonathan Keates, "Chairman's Letter," Venice in Peril Newsletter, Summer 2013, 1, https://www.veniceinperil.org; Rupert Christiansen, "Venice-in-Peril: Beauty Is a Cause Worth Saving Too," *Telegraph* (London), 13 Nov 2013.

32. *Canova, Hayez, Cicognara: L'ultima Gloria di Venezia* (29 Sept. 2017–2 April 2018), Gallerie dell'Accademia; Venice in Peril Newsletter, Summer 2013, 2–3, https://www.veniceinperil.org. Details on all of these restorations are on the Venice in Peril projects webpage.

33. "The Canova Monument Appeal," Projects, Venice in Peril.

34. The Morosini project was cosponsored by the Fondazione Svizzera Pro Venezia and by the Comitato Austriaco Venedig lebt.

35. The French Committee has two webpages: http://cfsvenise.org and http://cfsvenise.com (the latter appears to be the most up to date but I cite both as they have different content; cites below are to http://cfsvenise.org). A list

of principal sponsors appears on each site and includes companies like Groupe LMVH, Van Cleef & Arpels, Chanel, and Hermès; foundations such as the Florence Gould Foundation, Fondation Napoléon, and World Monuments Fund; and numerous individual donors as well as honorary members.

36. Home Page, Comité Français, http://cfsvenise.org.

37. "Histoire et Mission," Comité, Comité Français.

38. Jérôme-François Zieseniss, email to author, 24 March 2021, my translation. The renovations to the Royal Palace were completed in 2020–21 and are scheduled to be open to the public at the conclusion of the pandemic.

39. "Projets Palais Royal," Projets, Comité Français.

40. Daniel Williams, "Venetians Make a Point by Trying Napoleon," *Washington Post*, 24 May 2003; Judith Martin and Eric Denker. *No Vulgar Hotel: The Desire and Pursuit of Venice* (New York: Norton, 2008), 86–88.

41. "Projets," Comité Français, for brief descriptions. This *pala feriale* attributed to Ercole del Fiore from 1441 should not be confused with the original one created by Paolo Veneziano in 1345; the latter was restored by Save Venice in 1995. The church of Sant'Antonin is formally known as the church of Sant'Antonino Prete e Martire.

42. For the projects at the basilica of San Marco, see "Basilisque Saint-Marc," Projets, Comité Français, and Jayna Maleri, "The Famed Venice Lion Has Been Restored, Thanks to . . . Coco Chanel?" *Condé Nast Traveler*, 5 Jan. 2016, https://www.cntraveler.com.

43. Jérôme-François Zieseniss, "Comité Français Pour La Sauvegarde de Venise," *Insula Quaderni* 13 (2002): 70–73; "Projets," Comité Français.

44. Cuvillier and Thompson, *UNESCO for Venice*, 88; *Il Mattone di Venezia* (Venice: Consiglio Nazionale della Ricerca, 1982).

45. "Jeunes Donateurs," Comité Français. This webpage includes brief biographies of the organizers, an interview with François Pignol, and descriptions of the "Young Donor" activities.

46. Pro Venezia, https://www.provenezia.ch. Unless indicated otherwise, all information about Pro Venezia comes from this website. The quotation is from "Statutes and Board of Directors," About Us, Pro Venezia.

47. "From an Emergency to a Cultural Project," About Us, Pro Venezia. See also Alma Bacciarini, "Fondazione Pro Venezia Svizzera," *Insula Quaderni* 13 (2002): 50–53.

48. Carlo Palumbo-Fossati, *Presenza Ticinese a Venezia* (Lugano: Fondazione Svizzera Pro Venezia, 1977); Georg Germann, *Venezianische Kunst in der Schweiz und in Liechtenstein* (Zurich: Schweizerische Stiftung Pro Venezia, 1978).

49. Paola Piffaretti, *Giuseppe Sardi: Architetto Ticinese nella Venezia del Seicento* (Bellinzona: Arti Grafiche Salvioni SA, 1996).

50. Arnoldo Codoni, *Venezia: Chiesa di San Stae* (Lugano: Labor SA Arti Grafiche, 1981). See also "San Stae Church," Restorations, Pro Venezia, which has a link to the thirty-nine-page booklet published by the Ateneo Veneto that includes (in four languages) the text of the award as well as photographs.

51. Cuvillier and Thompson, *UNESCO for Venice*, 96, tells this colorful story, but an AP News story reports that the church had no alarm system in place. "Painting Stolen from Venetian Church," (no author), AP News, 23 June 1990, https://apnews.com.

52. "Restorations," Pro Venezia.

53. Bernard Aikema, "Stichting Nederlands Venetië Comité," *Insula Quaderni* 13 (2002): 54–55. My translation.

54. Personal website, https://www.dos4ever.com; "Theo Tromp," Wikipedia, https://en.wikipedia.org. A junior member of the Dutch Committee in the 1970s while still a doctoral student, Bernard Aikema remembers Tromp as an effective leader of the group. Bernard Aikema, interview with author, 24 Sept. 2020.

55. Aikema, "Stichting Nederlands," 54–55. Metzelaar also founded the Commercial Anglo-Dutch Society in 1972.

56. "De Poorters van Venetië," https://poortersvanvenetie.nl. This site is in Dutch. De Poorters is a separate legal entity from the Stichting Nederlands but in practice they function as one. Aikema has observed that De Poorters was necessary because of the lack of major corporate sponsors in Holland. Bernard Aikema, interview with author, 24 Sept. 2020. Similar to SV and other private committees, none of the Dutch Committee board members receive any compensation.

57. Other Dutch Committee board members, who also serve concurrently as board members of De Poorters van Venetië, include former minister Monique de Vries as vice chair and Dutch author Sybren Kalkman as treasurer. "Dutch Venice Committee Foundation 2019 Annual Report," Poorters van Venetië, https://poortersvanvenetie.nl.

58. Bernard Aikema, interview with author, 24 Sept. 2020.

59. "Dutch Venice Committee Foundation 2019 Annual Report." Partners on the San Zaccaria cruci-fix included SV, Venice in Peril, Comitato Austriaco, America-Italy Society of Philadelphia, and Stichting Nederlands.

60. I am grateful to the Dutch Committee treasurer, Sybren Kalkman, who shared these estimates with me via email on 8 Oct. 2020.

61. Toto Bergamo Rossi and Peter Marino, eds., *Venetian Heritage* (New York: Rizzoli, 2019), describe Vene-tian Heritage's principal restorations from 1999 to 2019.

62. Home Page, Venetian Heritage Inc., www.venetianheritage.eu in Europe; see also www.venetian heritage.org in the USA. The EU-based webpage contains the vast majority of links to project information and is the one cited below.

63. Hamish Bowles, "How a Master Restorer Turned a Ruined Croatian Monastery into a Personal Paradise," *Vogue*, 16 Feb. 2018, https://www.vogue.com. This article credits Bergamo Rossi with suggesting the name "Vene-tian Heritage." See also Matt Tyrnauer, "Canal Knowledge," *Vanity Fair*, Nov. 2007, https://www.vanityfair.com, about Bergamo Rossi's work on Palazzo Gradenigo in Venice. Rossi started his own company, Sansovino Restora-tion, in 1995 and sold it in 2010 to focus on Venetian Heritage. He is also the coauthor or coeditor of (among other works) *Domus Grimani, 1594–2019* (Venice: Marsilio, 2019), edited with Daniele Ferrara; *Inside Venice: A Private View of the City's Most Beautiful Interiors* (New York: Rizzoli, 2016); and *Venice: Guide to Sculpture from the Origins to the 20th Century* (Venice: Canal and Stamperia Editrice, 1997), with Renzo Salvadori.

64. "About Us," Venetian Heritage Inc.

65. "Conservations," Venetian Heritage Inc.

66. "Cultural Activities," Venetian Heritage Inc. Exhibition catalogues are Rossi and Ferrara, eds., *Domus Grimani*, and Agnes Husslein-Arco and Georg Muzicant, eds., *Treasures of the Jewish Ghetto of Venice*, transl. Andrew Horsfield (Vienna: Belvedere, 2014).

67. "Icon *Panaghia Pausolypi*," Venetian Heritage Inc. This project was funded by the late Khalil Rizk, first president of Venetian Heritage.

68. "Conservations—Croatia," Venetian Heritage Inc. See also Bowles, "How a Master Restorer."

69. "Conservations—Greece," Venetian Heritage Inc.

70. Eric Dursteler, *Venetians in Constantinople: Nation, Identity, and Coexistence in the Early Modern Medi-terranean* (Baltimore: Johns Hopkins University Press, 2006); Eric Dursteler, *Renegade Women: Gender, Identity, and Boundaries in the Early Modern Mediterranean* (Baltimore: Johns Hopkins University Press, 2011); Monique O'Connell, *Men of Empire: Power and Negotiation in Venice's Maritime State* (Baltimore: Johns Hopkins University Press, 2009); Siriol Davies and Jack L. Davis, *Between Venice and Istanbul: Colonial Landscapes in Early Modern Greece* (Princeton, NJ: American School of Classical Studies at Athens, 2007).

71. Home Page, America-Italy Society of Philadelphia, https://www.aisphila.org. The mission statement appears on the bottom of each webpage of the society. Its website claims a founding date of 1956 but the IRS declares it to be 1959. In either case, it obviously predates SV.

72. "Chiesa di Santa Maria della Visitazione," Wikipedia, https://it.wikipedia.org.

73. "AIS in Venice", America-Italy Society of Philadelphia.

74. America-Italy Society of Philadelphia, Form 990, 2001–19, ProPublica, https://projects.propublica.org.

75. Donatella Asta, "World Monuments Fund Venice Committee," *Insula Quaderni* 13 (2002): 44–47. See also Marilyn Perry, *Hadrian's Way: Creating World Monuments Fund, 1965–2015* (New York: World Monuments Fund, 2016), 6–16.

76. "Explore Sites and Projects," What We Do, World Monuments Fund, https://www.wmf.org, s.v. "Venice."

77. *World Monuments Fund: The First Thirty Years* (London: Christie's, 1996), 13, 89.

78. *World Monuments Fund: First Thirty Years*, 23. Burnham was WMF's executive director (1985–96) and president (1996–2015).

79. Bonnie Burnham, email to author, 9 April 2021. See also "Bartolomeo Colleoni Monument," World Monuments Fund, and Asta, "World Monuments Fund Venice Committee," 47. ARPAI is an acronym for the Associazione per il Restauro del Patrimonio Artistico Italiano.

80. *World Monuments Watch 2021, Commemorative Edition*, World Monuments Fund.

81. Quoted in *World Monuments Fund: First Thirty Years*, 14. The original quotation comes from James Gray's

final newsletter to IFM supporters, an undated copy of which was given to the author in June 2016 by WMF archivist Margot Note.

82. *World Monuments Fund: First Thirty Years*, 16–17; Perry, *Hadrian's Way*, 14, 24–25. The European Preservation Program continued until 2008, with $10 million eventually expended in challenge grants across Europe, the Soviet Union, and even Asia.

83. *World Monuments Fund: First Thirty Years*, 21.

84. Bonnie Burnham, interview with author, 5 Apr. 2021.

85. On individual donors and WMF trips, see Perry, *Hadrian's Way*, 32–40. On Burnham's role at the WMF and her success at raising $300 million over thirty years, see Emily Sharpe, "Celebrated Director of World Monuments Fund Retires," *Art Newspaper*, 24 Nov. 2015, https://www.theartnewspaper.com.

86. World Monuments Fund, Form 990, 2001, ProPublica.

87. *World Monuments Watch 2021*, 30.

88. "Mission Statement," Friends of Florence, https://friendsofflorence.org. This statement also appears in their annual Form 990 filed with the IRS. It reads, "Preserving and enhancing the cultural and historical integrity of the arts found in the city and region of Florence, Italy, and increase public understanding and appreciation through educational programs and events."

89. Friends of Florence initially sponsored many projects in the Accademia and in the Uffizi Museums. With the reorganization of arts funding and new directors at many Italian museums in 2016, those state-run museums now have more funding from their own ticket sales and exhibition revenue. Thus Friends of Florence has in recent years shifted its focus to lesser-known museums, churches, and tabernacles. Although Friends of Florence has done occasional projects in Siena, Pistoia, and other Tuscan towns, about 90 percent of its projects are within the city of Florence. Simonetta Brandolini d'Adda, interview with author, 28 Sept. 2020.

90. "Projects," Friends of Florence.

91. "Leadership and Advisory Committees," Friends of Florence.

92. Simonetta Brandolini d'Adda, interview with author, 28 Sept. 2020.

93. Similar to SV, Friends of Florence is a 501(c)3 nonprofit; in order to protect its charitable status with the IRS, it has chosen not to create an ONLUS.

94. See Friends of Florence, Form 990, 2001–17 compiled by ProPublica, https://projects.propublica.org.

95. "Saving At-Risk Art in Florence and Venice: Americans Contribute to Preserving Universal Cultural Heritage," Art Daily, 6 Jan. 2016, https://artdaily.cc; "New Preservation Partnership with Save Venice," Projects, Friends of Florence, Jan. 2016.

96. Edward Goldberg, email to author, 17 June 2020. See also Anthony Barzilay Freund, "Florence's Friend Indeed," *Town and Country*, April 2003, 89–94.

97. See the initial "newsletter" (but in reality a very simple web page) of summer 1998 that lists the initial sixty subscribers as well as the mission statement, which reads in part: "The association American Friends of the Marciana Library was created to provide intellectual, cultural and financial support to the Marciana National Library of Venice, in recognition of the Library's role both as the steward of an important part of the cultural heritage of Western Europe and as an institution that ably serves scholars and those concerned with Venetian culture." "American Friends of the Marciana Library, Biblioteca Marciana Newsletter," Summer 1998, https://bibliotecanazionalemarciana.cultura.gov.it.

98. The International Friends of the Marciana Library Inc., Form 990, 2001–20, ProPublica, https://projects.propublica.org.

99. These tasks were mentioned in an undated news update from president Joanne Ferraro at the "General Announcements" section of the website News on the Rialto entitled "International Friends of the Marciana," https://www.newsontherialto.com. Former president Edward Muir confirms that "we worked hard to keep the money going for services toward scholars and avoided paying for touristic exhibitions." Edward Muir, email to author, 22 Sept. 2020.

100. The International Friends of the Marciana Library Inc., Form 990, 2001–20, ProPublica.

101. As René Maheu observed in 1969, UNESCO had "a *moral authority* and an *organizing force* which makes itself felt by means of, and at the level of, international cooperation. UNESCO's role is, first, to ascertain the facts; secondly, wherever its voice is heard, to convince a wide audience of the need to act; thirdly to stimulate and co-ordinate action in order that it may be as productive as possible." "Address by Mr. René Maheu, Director-General

of UNESCO, at the Opening of the First Session of the Advisory Committee for Venice," 21 July 1969, document code DG/69/4, UNESCO Digital Library, https://unesdoc.unesco.org.

102. Peter Lauritzen, Jorge Lewinski, and Mayotte Magnus, *Venice Preserved* (Bethesda, MD: Adler and Adler, 1986), 34. See also UNESCO, *Venice Restored* (1978), 7.

103. Lauritzen, Lewinski, and Magnus, *Venice Preserved*, 34. See also Cuvillier and Thompson, *UNESCO for Venice*.

104. UNESCO, *Venice Restored* (1978), esp. 7–9.

105. See the quotation from René Maheu that opens this chapter.

106. UNESCO, *Venice Restored* (1978), 7–10; Maria Teresa Rubin de Cervin, [Preface], in UNESCO, *Venice Restored, 1966–1986*, 12–15.

107. John Millerchip, interview with author, 7 June 2019. According to Millerchip, UNESCO provided administrative expertise and organization; the private committees offered funding and passionate donors; the superintendencies contributed a list of suitable projects and knowledgeable architects and art historians to design and direct restorations.

108. Jessica Colley Clarke, "Will U.S. Withdrawal from UNESCO Affect Heritage Sites?" *New York Times*, 15 April 2018. The World Heritage Program began in 1972.

109. Tullia Carettoni Romagnoli, president of the Italian National Committee of UNESCO, as quoted in her preface in Cuvillier and Thompson, *UNESCO for Venice*, xi–xii.

110. ROSTE has slightly changed its name and its mission on several occasions (1988, 1999, 2006); it is currently known as the UNESCO Regional Bureau for Science and Culture in Europe and retains its location in Palazzo Zorzi; see https://en.unesco.org.

111. Pierre Lasserre and Angelo Marzollo, eds., *The Venice Lagoon Ecosystem: Inputs and Interactions between Land and Sea* (New York: Parthenon, 2000). The role of ROSTE is briefly discussed in chapter 4.

112. Cited in Fay and Knightley, *Death of Venice*, 61, and in Dominic Standish, *Venice in Environmental Peril? Myth and Reality* (Lanham, MD: University Press of America, 2012), 15. De Michelis was a major proponent of Venice as a candidate for Expo 2000 and thus locked horns with UNESCO on that issue.

113. Joanne Omang, "UNESCO Withdrawal Announced," *Washington Post*, 20 Dec. 1984. The United States returned to UNESCO in 2002 under President George W. Bush, suspended its contributions in 2011 under President Barack Obama, and withdrew again under President Donald Trump in 2019.

114. In 2017 the Trump administration announced its intent to withdraw from UNESCO altogether and followed through in 2019.

115. Standish, *Venice in Environmental Peril?* 13–17.

116. In 2013 the tax had risen to 22 percent on most goods and services (including restoration of paintings), with a reduced rate of 10 percent for selected items (including architectural restoration). Italy had planned to raise the rate to 25 percent in Jan. 2021 and to 26.5 percent in Jan. 2022 but has withdrawn that plan because of the pandemic.

117. Carla Toffolo and Paola Marini, interview with author, 15 Feb. 2021. Marini noted that smaller projects (i.e., less than 20,000 euros) often prompt larger projects, and that such smaller projects are also important for the ripple effect of hiring local conservators and craftspeople.

118. According to Melissa Conn, a common practice in recent years has been for the owners of the artwork (e.g., Catholic diocese or a public museum) to obtain authorization from the Ministry of Culture. Some owners prefer to sign contracts in their own names and to take legal responsibility for the restoration (with a later donation by SV for the exact amount of the work), while others ask SV to commission the work and pay the bills directly. Conn, emails to author, 14 Jan., 6 Feb. 2021.

119. Salvatore Settis, "Can We Save Venice before It's Too Late?" *New York Times,* 29 Aug. 2016. See also Salvatore Settis, *If Venice Dies*, transl. André Naffis-Sahely (New York: New Vessel Press, 2016).

120. "UNESCO Director-General Receives Mayor of Venice," UNESCO, 24 Jan. 2017, http://www.unesco.org; "UNESCO Closely Monitoring Ongoing Threats to Venice World Heritage Site," UNESCO, 14 Oct. 2019, https://whc.unesco.org. In July 2021 at its annual meeting in China UNESCO stripped the city of Liverpool of its World Heritage status owing to concerns about development along the city's waterfront that resulted in "serious deterioration and irreversible loss of attributes" as well as "significant loss to its authenticity and integrity." Quoted in Aina J. Khan, "Liverpool's Redevelopment Spurs Loss of a Key Status," *New York Times*, 21 July 2021. Also in

July 2021 UNESCO decided, in response to Venice's ban of cruise ships, to not place Venice on its World Heritage "danger list."

121. Lauritzen, Lewinski, and Magnus, *Venice Preserved*, 33–34. See also the memorial of Enrico Tantucci, "Addio a Maria Teresa Rubin, amica infaticabile di Venezia," *La Nuova di Venezia*, 30 March 2004, https://ricerca.gelocal.it.

CONCLUSION

1. James Grubb, "When Myths Lose Power: Four Decades of Venetian Historiography," *Journal of Modern History* 58, no. 1 (March 1986): 43–94; David Rosand, *Myths of Venice: The Figuration of a State* (Chapel Hill: University of North Carolina Press, 2001).

2. Quoted in Jan Morris, *Venice* (London: Faber, 1974), 318.

3. I am grateful to Peter Fergusson, Frederick Ilchman, Richard Almeida, and Bob Lovejoy for their thoughts on the significance and evolution of both Venice and Save Venice. On the importance of viewing artwork *in situ*, the recent comments of Uffizi director Eike Schmidt are instructive: Katherine Keener, "Eike Schmidt, Uffizi Director, Urges Religious Art Be Returned to Places of Worship," *Art Critique*, 4 June 2020, https://www.art-critique.com.

4. Richard Almeida, interview with author, 24 Dec. 2020.

5. Frederick Ilchman, interview with author, 6 Jan. 2021.

6. De Tocqueville's observations were briefly discussed in my introduction; Guthrie's remarks are recorded in "RHG Statement to the Board," addendum to SV Board minutes, 3 Sept. 1991, SVNY, and explained in chapter 4.

7. Robert Frost, "Two Tramps in Mud Time" (1936).

8. Michael M. Kaiser and Brett E. Egan, *The Cycle: A Practical Approach to Managing Arts Organizations* (Waltham, MA: Brandeis University Press, 2013). I am grateful to Frederick Ilchman for sharing with me his observations about nonprofit organizations.

9. Frederick Ilchman, email to author, 1 Feb. 2021.

10. Bonnie Burnham et al., "YES, There Is a Future for Venice . . . ," Fondazione Giorgio Cini, 12 Feb. 2016, https://www.cini.it. This document emerged from the conference "Sustainability of Local Commons with a Global Value: Venice and Its Lagoon," held at the Fondazione Giorgio Cini in 2016 on the fiftieth anniversary of the flood. The authors intended it as a "manifesto" addressed to public opinion.

11. David Landau, "Una Lettera Aperta ai Candidati a Sindaco di Venezia," *Nuova Venezia*, 29 Aug. 2020; it was reprinted in English in the *Art Newspaper*, 4 Sept. 2020, by Anna Somers Cocks, https://www.theartnewspaper.com. David Landau is a businessman and art historian, founder and longtime editor of *Print Quarterly*, coauthor of the book *The Renaissance Print: 1470–1550* (New Haven: Yale University Press, 1996); and a founder of Le Stanze del Vetro on the island of San Giorgio Maggiore. He has also led the campaign to restore the Jewish synagogues of Venice and the Museo Ebraico, for which SV is a partner.

12. Liam Heneghan, "Can We Restore Nature?" Aeon, 15 Dec. 2020, https://aeon.co, here quoting the definition coined by William Jordan II. Heneghan muses about how the field of art conservation might offer lessons to restoration ecologists but he does not discuss Venice.

13. Both of these proposals are discussed briefly in Landau, "Una Lettera Aperta."

14. Anna Somers Cocks, "Culture War Erupts over Venice Mayor's Closure of Doge's Palace and Other Civic Museums until April," *Art Newspaper*, 7 January 2021, https://www.theartnewspaper.com.

15. Burnham et al., "YES, There Is a Future," 4.

16. "About Us," SerenDPT, http://serendpt.net. SerenDPT defines itself on this website as a "benefit corporation."

17. Venice Sustainability Innovation Accelerator (VeniSIA), www.venisia.org.

18. Frederick Ilchman, "Remarks on 50th Anniversary of Save Venice," 7 Oct. 2021; originally delivered in Italian, from which this was translated by me; a slightly edited version was published in English in the Save Venice E-Newsletter, Oct. 2021, 1, SVV.

Index